O n S l o w n e s s

Columbia Themes in Philosophy, Social Criticism, and the Arts

O N S L O

T O W A R D A N A E S T H E T I C

 Columbia University Press New York

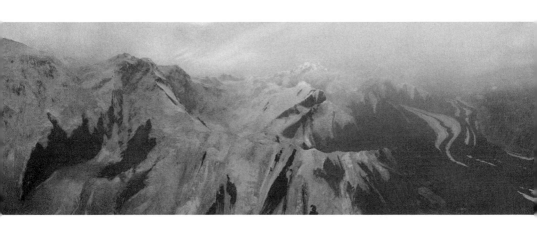

W N E S S

O F T H E C O N T E M P O R A R Y

Lutz Koepnick

Columbia University Press
Publishers Since 1893
New York Chichester, West Sussex
cup.columbia.edu
Copyright © 2014 Columbia University Press
All rights reserved

Library of Congress Cataloging-in-Publication Data
Koepnick, Lutz P. (Lutz Peter)
 On slowness : toward an aesthetic of the contemporary / Lutz Koepnick.
 pages cm.—(Columbia themes in philosophy, social criticism, and the arts)
 Includes bibliographical references and index.
 ISBN 978-0-231-16832-8 (cloth : alk. paper)—ISBN 978-0-231-53825-1 (e-book)
 1. Slow life movement. 2. Arts—Philosophy. I. Title.

BH39.K5877 2014
701'.17—dc23

2014003914

♾

Columbia University Press books are printed on permanent and durable acid-free paper.

This book is printed on paper with recycled content.
Printed in the United States of America
c 10 9 8 7 6 5 4 3 2 1

COVER IMAGE: Hiroyuki Masuyama, *McKinley Flight No. 2* (2006). Copyright © Hiroyuki
Masuyama.

COVER DESIGN: Milenda Nan Ok Lee

References to Web sites (URLs) were accurate at the time of writing. Neither the author nor
Columbia University Press is responsible for URLs that may have expired or changed since the
manuscript was prepared.

C O N T E N T S

A C K N O W L E D G M E N T S

True to its title, *On Slowness* has taken some time to reach the stage of publication. Preliminary versions of various chapters have been presented at various institutions and conferences over the last years. I am tremendously grateful to many colleagues, both in North America and in Europe, for inviting me to share some of this work and for offering incisive comments along the way. Special thanks go to the two anonymous readers for Columbia University Press, whose thoughtful observations and suggestions have greatly strengthened the arguments of this book. I am deeply indebted to both Washington University in St. Louis and Vanderbilt University. Without their generous financial support, neither the research and writing nor the publication of this book would have been possible. Thanks also go to Lydia Goehr and Gregg Horowitz for their enthusiasm about the project. Lisa Haegele has been of terrific help in getting the final manuscript ready for publication.

Preliminary versions of small portions of this book have previously appeared as articles. In all cases, however, earlier essays underwent significant rewriting and reconceptualization. For their kind permission to make selected use of published materials, I acknowledge the *Germanic Review* for "'Free Fallin': Tom Tykwer and the Aesthetics of Deceleration and Dislocation," *Germanic Review* 82, no. 1 (2007): 7–30, and "Herzog's Cave: On Cinema's Unclaimed Pasts and Forgotten Futures,"

Germanic Review 88, no. 1 (2013): 271–285; and Bloomsbury Publishing, for "0–1: Riefenstahl and the Beauty of Soccer," in *Riefenstahl Screened: An Anthology of New Criticism*, ed. Neil Christian Pages, Mary Rhiel, and Ingeborg Majer-O'Sickey (New York: Continuum, 2008), 52–70.

On Slowness

INTRODUCTION

ON SLOWNESS

It has become commonplace to say that our age of electronic networks, global transactions, and rapid transportation technologies causes many to suffer from too much speed in their lives. We cook, eat, drink, and grow up too fast, it is claimed. We have become unable to enjoy the prolonged pleasures of a good story, a thoughtful conversation, or an intricate musical composition. Sex no longer relies on artful games of erotic suspension and delayed fulfillment. Our attention spans shrink toward zero because we have to make too many decisions within ever shorter windows of time. Cell phones, handheld computers, and ubiquitous screening devices urge us to be always on and produce instantaneous responses, yet we no longer take the time to contemplate an image, develop a profound thought, traverse a gorgeous landscape, play a game, or follow the intensity of some emotion. Life is faster today than it has ever been before, it is concluded, but in accumulating ever more impressions, events, and stimulations we end up with ever less—less substance, less depth, less meaning, less freedom, less spontaneity.

Recent decades have witnessed a considerable industry trying to alleviate the pressures of compressed time and accelerated mobility.[1] Grassroots movements have organized into international networks to bring slowness to our ways of eating, whether they advocate the use of locally grown ingredients or praise the thrill of extended meal times.

Personal fitness ventures offer a wide range of meditation classes to relax the mind and unwind the body. Urban planners reroute entire roads, block off inner cities, and install speed bumps to decelerate traffic and encourage us to rediscover the joys of urban walking. Travel agencies design detailed packages for all those eager to move beyond the beaten track and avoid the latest hypes of global tourism. Pedagogues develop new methods to refocus students' attention and persuade their classrooms of the productivity of calmness and repose. And pundits, publicists, and public intellectuals fill airwaves and bookshelves with well-meaning advice about how to resist the speed of the present, ignore the relentless ticking of our clocks, and revive extended structures of temporality.

While this desire to slow down one's life might be extensive, the slowing down of the global economy in the wake of the financial crises of 2008 has done very little to correct our perception of too much speed and temporal compression. On the contrary. Slowness, as it were, has very different connotations in the realm of economic affairs than it has in the sphere of lifestyle choices. To praise slow markets and slow retail sales would border on the perverse and self-destructive. Many may fault the way in which global capitalism distributes its wealth and produces large arenas of poverty, but neither economic theorists nor populist politicians would seriously promote a decelerating of production, distribution, and consumption as a cure to the calamities of the market. Though the downturn of economic transactions initially resulted from a deliberate overheating of financial lending practices, the ensuing sluggishness of economic mobility was thus certainly not what gourmets, health professionals, traffic planners, and new age critics had in mind when applauding the pleasures of deceleration. Hardcore Marxists might see such disparities as revelatory: as indicative of the extent to which recent appreciations of slowness express the needs of those privileged to afford more wholesome ways of life precisely because they secretly, or not so secretly, profit from fast and thriving economies. Neoliberals, on the other hand, may ask whether our economic decline was triggered by a certain decrease in motivational resources of which middle-class longings for slower lives might be the most symptomatic. In both cases, however, the relation between the pace of the economy and the perceived or desired speed of everyday

life is seen as reciprocal, with one either producing or requiring the other. In both cases, slowness merely functions as a derivate, an inversion, or an ideological masking of what may propel society into the future, whereas speed continues to inhabit the normative center of what it means to envision any viable form of mobility, progress, and transformation.

On Slowness is aimed at reframing recent discourses on slowness in order to complicate its praise as much as its criticism. The focus of this book will be on recent artistic work experimenting with extended structures of temporality, with strategies of hesitation, delay, and deceleration, in an effort to make us pause and experience a passing present in all its heterogeneity and difference. None of the work under discussion will ask viewers simply to turn their backs to the exigencies of the now so as to fancy the presumed pleasures of preindustrial times and lifestyles. All of the projects discussed instead seek to gaze firmly at and into the present's velocity and temporal compression, energized by what I understand to be a quest for unconditional contemporaneity. The aim of these projects, in other words, is neither to provide redemptive meanings nor cling to nostalgic images of the past. Rather, they embrace slowness as a medium to ponder the meaning of temporality and of being present today in general, of living under conditions of accelerated temporal passage, mediation, and spatial shrinkage.

Victor Burgin has described our contemporary moment of globalized streams and fast-paced interactions as a joining of multiple histories and trajectories—"the assembly of simultaneously present events, but whose separate origins and durations are out of phase, historically overlapping."[2] Time today no longer follows one singular narrative and order, nor does it belong to specific and self-contained spaces. We instead live in multiple times and spatial orders at once, in competing temporal frameworks where time often seems to push and pull in various directions simultaneously. Time today is sensed as going forward, backward, and sidewise all in one; it might often be perceived as chronological and cosmic, geological and modern, local and global, evolutionary and ruptured in one and the same breath. Slowness, as developed in this book, emerges as a special eagerness to account for and engage with a present marked by such a seemingly overwhelming and mind-numbing sense of simultaneity. It neither hopes to press history back into

the singularity of a unified narrative, nor does it desire the end of history in order to challenge the pressures of acceleration. Rather, slowness actively reworks existing perceptions of cotemporality, of the copresence of disjunctive streams of development, in order to warrant the very possibility of experience. Far from fleeing the now, slowness asks viewers to take time and explore what our contemporary culture of speed rarely allows us to ask, namely what it means to live in a present that no longer knows one integrated dynamic, grand narrative, or stable point of observation. Slowness wants us to experience what seems to defy and deny the very possibility of experience and contemporaneousness today. It sharpens our sense for the coexistence of different and often incompatible vectors of time and, in doing so, it invites us to reflect on the impact of contemporary speed on our notions of place, subjectivity, and sociability.

Recent academic writing on the challenges of living in our accelerated now has centered around two seemingly opposed concerns. In the eyes of some critics, contemporary speed shrinks spatial relationships while at the same time resulting in a remarkable expansion of the present; it erodes our patience for the intricate work of memory and the durational.[3] The present, it is argued, greedily gobbles up the rest of time, yet in doing so dissolves the kind of historical consciousness necessary to approach and interpret the present as something meaningful. For other critics, speed's logic of ongoing displacement places enormous pressures on our sense of presentness, of presence.[4] Constantly overwhelmed and distracted by too much information, archived knowledge, and restless anticipation, we loose our receptivity toward the intensities, atmospheric values, and resonances of the moment. Slowness, as I understand it, is meant to address and mediate between these two positions. To experience the present aesthetically and in the mode of slowness is to approach this present as a site charged with multiple durations, pasts, and possible futures; it is by no means hostile toward memory and anticipation. But to go slow also means to open up to the opulence and manifoldness of the present; to unfetter this present from the burdens of mindless visions of automatic progress and nostalgic recollections of the past and to produce presence beyond existing templates of meaning. Far from bonding us to different times and places, then, slowness negotiates today's desires for both memory and presentness by allowing

us to reflect on the now in all its complexity—as receptive contemporaries of our own highly accelerated age.

Throughout the past two decades, art critics and historians have come to champion the category of the contemporary in order to address artistic work no longer associated with the modern or the postmodern.[5] Whereas modernism, in their perspective, was largely dedicated to an emphatic rhetoric of the new, the ongoing displacement of the past for the sake of the future, postmodernism understood the present as a posthistorical site of remixing history's styles, expressions, and meanings. As a tool of periodization, the contemporary followed the exhaustion of postmodernism in the course of the 1990s. It has come to describe pluralistic forms of artistic practice that are weary about any effort to label distinct movements, narratives, styles, and formal repertoires, yet are also—highly attuned to the fleetingness of the now—quite hesitant to denounce the pleasures of newness and the fundamental productivity of time.

On Slowness, in its ambition to define slowness as a strategy of the contemporary, works with a broader and theoretically more demanding concept of contemporaneity. To be contemporary, as I understand it here, does not simply result from a dual rejection of modernism and postmodernism. It instead describes a peculiar relationship to an ever changing present in which proximity and distance, immersion and critique, the sensory and the cognitive go hand in hand. Recalling the work of Friedrich Nietzsche and Osip Mandelstam, Giorgio Agamben has recently defined contemporaneousness as a special ability to be at once timely and untimely. Contemporaneousness, he explains, "is *that relationship with time that adheres to it through a disjunction and an anachronism*. Those who coincide too well with the epoch, those who are perfectly tied to it in every respect, are not contemporaries, precisely because they do not manage to see it; they are not able to firmly hold their gaze on it."[6] No present, Agamben continues, is ever transparent to itself; it is steeped in obscurity and an inevitable degree of unreadability. To be contemporary is to face this obscurity head on, to perceive and expose oneself to the darkness of the moment, yet also to recognize the light that—like the brilliance of a distant star voyaging for some time toward the earth—may be directed to or illuminate the present from either the past or the future. Contemporaneousness may

be a product of modern chronological time, but it always pushes against it, urges us to be aware of other possible orders of temporality, presses us to account for the unlived and the not-yet-and-perhaps-never-lived. It brings into play the durational qualities of memory and anticipation while drawing our attention to what is irreversible and dissipative about our course through time. To be contemporary does not simply mean to stay abreast of the flows and latest fluctuations of an ever changing now. Nor is it a quality of those able and eager to live in the zone of the moment. To be contemporary, instead, means to face and return to "a present where we have never been."[7] It manifests an ability to experience and read the now in unforeseen ways, precisely because there is always more about this present than we may perceive at face value.

Echoing Agamben's notion of contemporaneousness, this book presents slowness as the most appropriate means in order to be at once timely and untimely today. Slowness enables us to engage with today's culture of speed and radical simultaneity without submitting to or being washed over by the present's accelerated dynamics. Slowness demonstrates a special receptivity to the copresence of various memories and anticipations, narratives and untold stories, beats and rhythms in our temporally and spatially expanded moment. It not only stresses the open-ended and unpredictable but also the need to unfetter notions of mobility and movement from a peculiarly modern privileging of the temporal over the spatial. Slowness, in this expanded sense, emerges as far more than merely speed's inversion and modernity's obstinate stepchild. Contrary to both our Marxist and our neoliberal critic, but contrary also to the redemptive rhetoric of many of today's slow life missionaries, aesthetic slowness wants us to explore modes of mobility and perception that do not simply reverse—and thus surreptitiously reaffirm—what is seen as the dominant regime of speed. As one among other conceivable strategies of the contemporary, aesthetic slowness instead wants to develop and stand on its own conceptual feet: as a particular mode of reflecting on movement and temporal passage that transcends how modern Western societies have largely come to prioritize time as a realm of dynamic change over space as a domain of stasis.

Consider Olafur Eliasson's *Your Mobile Expectations: BMW H₂R Project*, first exhibited at the artist's mid-career show at SFMOMA in fall 2007 (figure 0.1). The focus of this installation was an experimental

FIGURE 0.1. Olafur Eliasson, *Your Mobile Expectations: BMW H₂R Project* (2007). BMW H2R chassis, stainless steel, stainless steel mirrors, ice, cooling unit, and monofrequency light, 145 × 525 × 255 cm. Installation view at San Francisco Museum of Modern Art, 2007. Photo by Ian Reeves, courtesy of San Francisco Museum of Modern Art. BMW Group. Copyright © 2007 Olafur Eliasson.

hydrogen racing car, stripped down to its basic drivetrain, its exterior remodeled with various netlike structures and a multitude of small mirrors. Located in a large freezing chamber, the car was then sprayed with water, which produced unpredictable formations of ice across the entire hulk. Visitors, in turn, were invited to wrap themselves into thick blankets when entering the chamber and inspecting the work up close. *Your Mobile Expectations* aspired to convert an object usually associated with swift transportation into something that made viewers pause and establish new perspectives. Due to the ice's dual power of reflection and refraction, the car's outer skin looked different from different angles; it encouraged the visitor to stroll around the installation, probe ever different points of view, and use their own bodily movements as an experimental medium of perception and experience. Made possible with the help of green geothermal energy, the fragile ephemerality of ice thus asked viewers to reconsider the way in which advertising strategies turn common visions of speed and unlimited mobility into a marketable fetish. In Eliasson's own words, "Ice is closely connected with

transience—when it melts the object is gone. It's a very fragile material; the ice can break or someone can break through it. Ice provides wonderful perceptual references to the issue of time. . . . In the message cars communicate, everything has to look and go fast, but the ice can only be thawed slowly and the water pumped away. This is truly the only 'slow' car at BMW."[8]

Eliasson's comment indicates that slowness, in *Your Mobile Expectations*, was meant to achieve much more than simply reduce the speed of modernity's foremost symbol of mobility and inspire us to think about the disastrous expenditure of natural resources today. Slowness here facilitated both a temporal and spatial intervention, driven by the hope of emancipating notions of movement and mobility from any one-sided privileging of the temporal over the spatial or of space over time. On the one hand, *Your Mobile Expectations* defined slowness as a medium to investigate modern myths of movement at the level of the sensory and behold these myths in all their relativity. The project opened up a space in which viewers could experience the copresence of various temporalities (the original car's promise of breathtaking tempo, the ice's threat of slowly melting away, the viewer's desire to stroll around while fighting the cold) and learn how to resist collapsing different trajectories into one unified and fully controllable vector of motion. On the other hand, Eliasson's project identified slowness as key to exploring the transience of spatial interrelationships. Bringing ice and temperature into the equation, *Your Mobile Expectations* provided a "responsive interface" between object and viewer,[9] the car's frozen skin and its physical environment. In doing so, the installation not only questioned the presumed power of modern technology to dominate or even annihilate the obstinacy of space through speed, it also praised slowness as a resource for adapting to and interacting with the contingencies of our surroundings. The reasons for calling Eliasson's BMW a truly slow car indeed exceeded any attempt at merely inverting what has propelled modern society. What constituted the slowness of Eliasson's project, instead, was its aesthetic invitation to transform dominant understandings of mobility: from a concept according to which motion simply signifies an unbending advancement from A to B to one in whose context physical movement unlocks unforeseen interactions and relationships; calls forth diverse memories, perceptions,

and anticipations; and allows us to experience spatial realities as being energized by various temporal trajectories and historical dynamics. Slowness, in this expanded understanding, enables us to explore spatial relationships through physical engagement and mobile interaction. It makes us pause and hesitate, not to put things to rest and to obstruct the future, but to experience the changing landscapes of the present in all their temporal multiplicity.

On Slowness follows the lead of Eliasson's reconsideration of modern mobility. The book investigates paradigmatic positions in contemporary artistic practice—photography, film, video, sound and installation art, and writing—that reframe the velocity of contemporary life and experiment with notions of slowness that go beyond a mere inversion of current speed. Contrary to long-standing suspicions about the slow as an advocate of conservative or even reactionary positions, the kind of slowness that is of interest in this book is neither driven by redemptive nor preservative impulses. It neither rallies against the proliferation of advanced tools of mediation, nor does it preach bucolic visions or revel in a new jargon of authenticity. Similar to Eliasson, the works discussed here present slowness as a medium to develop alternate notions of mobility, enrich given modes of perception, and in this way intensify what it might mean to be contemporaneous to one's present. They make us wonder about the frenzy of the moment, but they do not embrace slowness as a means to shut down mobility and the primary promise of modern life, namely the promise of contingency and indeterminism—the promise that nothing is ever absolutely necessary or impossible, the promise that everything could also be different from how it is now and has been in the past.

In order to avoid possible misunderstandings, let me clarify in a little more detail what this book should not be expected to do. First of all, *On Slowness* is not about recent artistic interventions that simply stress the durational aspects of artistic production so as to challenge the fast-paced rhythms of today's art market and thereby reclaim the sacred or the auratic, the unique here and now of aesthetic presentation. Think, for instance, of the work of Franz Gertsch, whose *Tryptichon Schwarzwasser* (1991–92) converted a single photograph over more than one year into an intricate woodcut, finally printed onto specially imported paper from Japan. Think of John Cage's *Organ2/*

ASLSP, recently installed in the German town of Halberstadt and de-signed to perform musical sounds—as slowly as possible—over no less than 633 years. While such experimental stretching of time is no doubt intriguing, the duration of a work's making or performance is by no means central to how this book defines aesthetic slowness. Dedicated to mapping the experience of contemporaneity, aesthetic slowness registers and reflects on the coexistence of multiple streams of time in our expanded present. But, with some notable exceptions addressed in chapter 2, no extended production processes or seemingly anachro-nistic modes of artistic making are required in order to articulate the principle of aesthetic slowness.

Second, *On Slowness* is not necessarily about aesthetic practices demanding that viewers reserve extraordinary periods of time to in-vestigate perceptual processes and prepare themselves for the bliss of beholding its pure passing. Readers might expect a book on slowness in contemporary visual culture to comment in further detail on Chris-tian Marclay's recent *The Clock* (2010), taking the viewer on a twenty-four-hour journey through film history while synchronizing individual representations of time on screen with the viewer's chronological ex-perience of real time; on the light installations of James Turrell, as they invite viewers over protracted periods of time to attend to the wondrous physiology of seeing; or on the films of Hungarian art house director Béla Tarr, whose slow-paced choreography of sights and sounds con-tinually probe our patience. While such work clearly seeks to suspend speed culture's dominant structures of attention, most of the works dis-cussed in the chapters to follow choose a different route toward aes-thetic slowness as they ask viewers to refract the impact of speed on our sense of time and mobility, our structures of memory and anticipation, our notion of place, subjectivity, and community. The wager of aesthetic slowness is not simply to find islands of respite, calm, and stillness some-where outside the cascades of contemporary speed culture. It is to inves-tigate what it means to experience a world of speed, acceleration, and cotemporality, experience understood—in Miriam Hansen's words—as "that which mediates individual perception with social meaning, con-scious with unconscious processes, loss of self with self-reflexivity . . . ; experience as the matrix of conflicting temporalities, of memory and hope, including the historical loss of these dimensions."[10]

Another word of warning seems necessary at this point: *On Slowness* is not designed to offer a general survey of how issues of temporality have been addressed in various media and artistic practices throughout the last two decades. Instead, the arguments of each chapter are developed through close engagement with formal aspects and thematic concerns of individual works. To be sure, some readers might want to challenge my failure to mention certain artists, writers, films, photographs, and installation pieces. All things told, however, the objects discussed in *On Slowness* have been chosen for their paradigmatic and symptomatic value. They might not always embody the most iconic work done in their respective genre or media, but they offer invaluable concentration points and force fields to think through the stakes of slowness in contemporary art and culture. Whether next generations will consider them as canonical masterpieces of our contemporary moment or not, the works gathered here are meant to serve as echo chambers of larger historical dynamics and artistic developments. And it is only by means of judicious reading—of how slow reading, seeing, and listening hones our attention for detail and suspends hasty judgment—that we can recognize the ways in which these works speak to much larger constellations and contexts and enrich our thinking about what it means to approach our accelerated present in the mode of a true contemporary.

For many critics, the rise of today's culture of speed and compulsive connectivity dramatizes how the rise of modern industrialization, urbanization, transportation, and technical reproducibility, but also of early twentieth-century modernist and avant-garde art, reshaped the itineraries of individual lives and aesthetic experience. In the first chapter of this book, I detail the extent to which aesthetic slowness today continues and recalibrates how certain modernists of the early twentieth century already questioned the dominant association of modernism with speed, acceleration, shock, and ceaseless movement. Contemporary slowness runs counter to common juxtapositions of modernism and postmodernism; it straddles the great divide of twentieth-century aesthetic culture and urges us to reconsider monolithic definitions of both the modern and the postmodern. While in the main chapters of this book the focus will mostly be on work produced during the last two decades (with some notable exceptions reaching back to the late 1970s),

the geographical range of artists, filmmakers, musicians, and writers is deliberately diverse, stretching from Canada to Australia, Germany to Japan, Iceland to Italy, the United States to Russia. This pluralism should not be mistaken as a gesture of transnational triumphalism celebrating the equivalence and compatibility of everything existing under the sun. Rather, what is at stake is to explore the present as a space in which to engage with different cultural practices, values, memories, visions, and institutional conditions as contemporaneous to each other no matter how different they may be. Echoes of Aborigine mythology in recent Australian cinema (as, for instance, discussed in chapter 4) are, in this sense, not meant to be seen as temporally antecedent to the use of high tech equipment in the work of Tom Tykwer (chapter 5), Willie Doherty (chapter 6), or Janet Cardiff (chapter 7). Rather, the central challenge is to think of the present as a space of multiple trajectories and possibilities and to resist a prevalent (and older modernist) desire to collapse spatial difference into temporal sequence and hence deny the multiplicity of the spatial as a precondition for temporality in the first place.

As a strategy of the contemporary, aesthetic slowness—true to Eliasson's deliberate use of advanced technology—cannot afford to ignore the arsenal of technological manipulation available to artists today. To go slow, in what follows, is to face contemporary art's orders of technological mediation head on. It should therefore come as no surprise that the central image that informs my understanding of aesthetic slowness in various media of contemporary artistic practice is technological in origin itself: the operation of slow-motion photography in cinema. Slow-motion photography had, of course, been available in the first decades of the twentieth century already, but it only found widespread uses in narrative cinema in the late 1960s and has become a true staple of filmmaking with the spread of digital editing and postproduction during the 1990s. Part of the inventory of cinematic special effects, slow-motion photography can be achieved by running film through a movie camera at a speed faster than normal. Once recorded, the film is then projected at standard speed such that the action on screen appears slowed down. Though slow-motion photography has the ability to intensify and stretch our perception of time and space, it cannot do without certain technologies of acceleration. It provides visions of slow-

ness, not because it simply halts the flow of time, but because it at once facilitates and reverses a stepping up of temporality.

It is this curious duality of slow-motion photography, as enabled through—and not in defiance of—advanced media technologies, that integrates the various readings of *On Slowness*. "What does a slow-motion picture of a face registering sudden terror or joy look like?" film theorist Rudolf Arnheim asked as a early as 1933, only to answer his own question by arguing that "effects would be attainable which the spectator would not take for slowed-down versions of actually faster movements but accept as 'originals' in their own right."[11] Similar to slow motion's ability to produce a different nature, in Arnheim's view, aesthetic slowness as discussed in this book doesn't simply seek to offer a slowed-down version of the real, a "thicker" version of reality in which today's media and technologies recede from the picture. Instead, slowness in the work of all artists under discussion here is an effect of a deliberate exploration of the specificity of their respective tools of mediation, and it experiments with various technologies of representation so as to unlock untapped modes of experiencing the real, of sensing our own seeing, and of developing alternate concepts of movement and mobility. Far from entertaining Luddite sentiments, aesthetic slowness takes stock of its own processes of mediation—its special effects, as it were—in order to open our senses to the multiple rhythms, stories, and durations that structure our present in all its contingency and in each and every one of its moments.

One of the central signatures of modern life, the category of contingency—the notion that everything could be different from how it was, is, or might be—has become digital culture's most enduring myth of speed and acceleration. Computing today promises the user unlimited authority over any possible movement, object, relation, distance, and intensity. The proverbial click of the mouse sends us traveling across the globe with unprecedented speed and hardly any physical activity at all. History can be recalled and redone in an instant with a few touches of the keyboard; possible futures can be invented and rejected at virtually no cost with the help of various tools of electronic mediation. Similar to the theorist of neoliberal deregulation, the dominant rhetoric of ubiquitous computing and connectivity sees our world as a playground of perfectly rational, calculating, modular, and self-sufficient

entrepreneurs whose self-interest is solely to be coordinated by the global market's invisible hand and whose strategic actions can in no way be faulted for the irrational crashes and exuberances of these markets.[12] Like neoliberalism, the rhetoric of today's culture of computing declares us as beings in full control over reality's data, movements, and speeds, and it precisely thus denies us what it might take to become a subject in the first place, namely the intricate process of negotiating what exceeds individual control; the playful encounter with what is other and incommensurable in the world as much as within ourselves; the openness to what might surpass instant understanding or mapping; the experience of conflicting temporalities, memories, and hopes.

Aesthetic slowness hangs on to the promise of contingency—freedom, indeterminism, surprise, and wonder—while challenging how today's culture of speed, ubiquitous computing, and neoliberal deregulation has appropriated contingency as one of its primary ideological building blocks, as part of a new language of inevitability. As a strategy of the contemporary, aesthetic slowness not only reminds us of the fact that everything could be different from how it is and has been. It also allows us to explore and rub against the very limits of what transcends our sense of control and strategic individualism, be it political, psychological, or perceptual in nature. Slowness approaches the present as a realm of unfulfilled pasts and unclaimed futures; it stresses the extent to which the virtual is deeply embedded in what we call and perceive as the real. A speed addict's innermost desire is to continually displace present and past in the name of the future's itinerary. He pursues eternal newness, yet precisely thus closes the space for the creativity of time, for substantial difference, change, and chance. Contemporary slowness teaches the art of simultaneously looking left and right, forward and backward, upward and downward so as to question today's rhetoric of modular self-management and envision the future as a sphere of the unpredictable. Slowness opens a space within the very heart of modern acceleration in whose context we can move notions of change, mobility, and experience beyond one-sided myths of teleological progress and goal-oriented traversal. Once denigrated as the tool of conservatives or reactionaries, slowness today serves a crucial function to challenge deterministic fantasies of mindless progression and develop concepts of meaningful progress instead.

S L O W M O D E R N I S M

1 /

In *Time and Free Will*, Henri Bergson wrote in 1889 that feelings of joy accompany our orientation toward the future, whereas sadness and sorrow result from our failure to embrace movement and overcome physical and psychic passivity.[1] Bergson's notion of joy reads like a motto for what we have come to associate with European high modernism, its departure from the dominance of tradition as much as its stress on the exhilarating effects of velocity, acceleration, shock, and ongoing mobility. According to conventional understandings, industrial modernity, as it began to sweep across the European landscapes of the nineteenth century and introduced technologies such as the steam train, the telegraph, the telephone, the cinema, and the automobile, inaugurated an age of unprecedented time-space compression.[2] Modernity brought the thrill of speed and motion to the sluggishness of preindustrial life. It provided unknown physical sensations, perceptual pleasures, and psychic agitations and, in this way, it not only reworked the entire human sensorium, but promised a future joyfully different from the past. What, in turn, defined aesthetic modernism as modernist, following this prevailing understanding, was its relentless desire to tap into modernity's valorization of speed. Modernism, it has been

concluded, surfed the waves of modern haste and rupture. In all its different manifestations, it explored the nervousness and distraction of the modern mind as a source of artistic experimentation.[3] Though not immune to the idea of a timeless masterwork, modernist artists intoxicated themselves with the thrills of accelerated movement in an effort to emancipate the work of art from static expectations, to jolt audiences away from habitual modes of perception and in so doing to situate recipients as active participants in the construction of art's future meaning.

In 1931 Aldous Huxley famously pronounced: "Speed, it seems to me, provides the one genuinely modern pleasure."[4] Speed, for Huxley, became most palpable when using his automobile at maximum velocity. The automobile's thrill, in Huxley's perspective, was thereby at least threefold. First and foremost, a car's speed allowed for an exhilarating shrinkage and annihilation of space, speed here being understood as the physical rate of movement across space, and space being understood, not as a sphere of factual relations and possible interactions, but as the mere measure of distance. Speed actively participated in how modernity reorganized everyday life and collapsed preindustrial differences between center and periphery, the near and the far. It enabled motorists to pursue nothing less than the pleasurable adventure of allowing temporality to triumph over and erase the rigidity of space. Second, unlike the primarily receptive experience of nineteenth-century train passengers, the car driver's perception of velocity was one in which a quasi-Nietzschean assertion of transformative power went hand in hand with a peculiar decentering of the driver's sense of self. In steering his car around rapidly approaching obstacles, the driver's body seemed to conquer the world of modern machines as much as it authorized these machines to recalibrate the body's perception of its own limits and extensions in space. Third, and finally, the pleasure of driving cars at high speed provided ample resources to question how nineteenth-century bourgeois culture had started to divide modern civilization into the seemingly exclusive realms of disembodied and intellectually demanding high art, on the one hand, and, on the other, of materialistic and consumer-driven mass culture. To maneuver a car at high speed, in the eyes of Huxley and others, unsettled these normative hierarchies. It allowed for a heightened sense of activity and a dramatic

sharpening of sensory perception, while it also promised to emancipate the subject from the strictures of bourgeois culture and employed modern consumer culture to explode given templates of identity.

As we will see later in this chapter, Huxley's praise of speed and car travel as modernity's principal pleasures echoed the voices of many other artists and intellectuals during the heyday of European aesthetic modernism. For now, it shall simply serve us as a paradigmatic example of how various modernisms in the first decades of the twentieth century not only valorized accelerated rates of movement as sources of aesthetic thrill and experimentation, but in so doing also articulated profound misgivings about all those unwilling to hurl themselves down the road and straight into the future. In the wake of modernism's joyful adoration of rapid motion, slowness became largely denigrated as both antiprogressive and antiaesthetic.[5] It was seen as rooting the individual in the fixity of place and as taming the energies of temporal change, subjecting the individual to the burden of tradition and containing any desire to explode the confines of bourgeois identity. To go slow was to resist modernism's categorical quest for newness, and it thus not only suspended the possibility of aesthetic experimentation, but obstructed the way in which various modernist projects sought to couple aesthetic innovation to political reform. In much of high modernist discourse, and in how later generations have come to think about it, slowness has been typecast as a sad remnant of preindustrial longings and sentiments—as something that combats the peculiarly modern sense of temporal contingency, flux, and indeterminacy; that blocks the progress of artistic and social affairs; and that quells the seeds of individual change and liberation.

Slowness, in the eyes of many a modernist in the early 1900s, not only invited space to triumph over time, but articulated a desire to turn one's back on everything that defined modernity as truly modern, including its hope to emancipate the present from the normative burdens of the past. To slow down meant to contest the joys of movement and temporal passage. It was antiprogressive and anti-Enlightenment, privileging static over dynamic interrelations, binary oppositions over dialectical energies, mindless contemplation over critical engagement, escapist flight over nonsentimental commitments, nostalgia over activism. Whereas, for the fast and furious, velocity held the promise of

unsettling traditional hierarchies and subject positions, slowness was perceived as the cultural elite's last straw to hold on to their former privileges and resist the storms industrial culture had cast over the scenes of modern life. To advocate slowness, in Huxley's modern age of speed, meant to shut out the metropolitan thrills and energizing stimulations that inspired true modernists to depart from the canon of the past. As a rhetorical figure of unbending conservatives and romantic fundamentalists, slowness wanted to recenter the subject's sensory systems, reinstate the subject as an autonomous agent of her perception, and in this way reject how modernism in its most emphatic stances translated the adventures of temporal displacement into new artistic forms.

This book pursues a categorically different framing of slowness, one whose roots can be traced back to an alternate understanding of various modernist projects and one that is far from hostile to the main elements of aesthetic modernism: sensory experimentation, ongoing movement, change, and indeterminacy. Recent scholarship has urged us to complicate seasoned notions of modernism. As a result, we have rightly come to speak of multiple modernities, alternate modernisms, and vernacular modes of modernist experience, not only in order to extend the concept of modernism to aesthetic practices, institutions, and interventions formulated outside of or in opposition to its primarily Western European (and often colonialist) model but also to overcome dominant associations of modernism with a relatively narrow historical time frame (roughly the 1880s to 1930s) and a particular class of cultural producers and consumers.[6] What this chapter, with no doubt rather bold strokes, will delineate as slow modernism participates in these recent conversations about the heterogeneity and plurality of aesthetic modernism. As I understand it here, slow modernism defined one of various folds within the fabric of high modernism. It challenged certain modernist credos of speed and ceaseless temporal displacement and it precisely thus prefigured some of the central aspects of what this book explores as today's aesthetic of slowness. My point is not to argue that aesthetic modernism as a whole was much slower than it is, in spite of all its celebration of speed and flux, shock and rupture, believed to be. What is at stake instead is to show that the normative association of Western modernism with pleasurable speed and ceaseless movement

often rested on rather lopsided definitions of the temporal as a sphere of dynamic change and of space as a dimension of static simultaneity. Such reductionist notions not only resulted in inadequate understandings of both velocity and slowness. They also had lasting effects on our ability to recognize the disruptive and transformative power of what this books identifies as a contemporary preoccupation with the slow and the durational and with space as a site of open-ended stories and vectors of change.

This introductory chapter recalls two critical moments of modernist aesthetic culture in order to develop a more nuanced understanding of modern velocity and aesthetic contemporaneity. I will first revisit the formative history of Italian Futurism between 1909 and 1913, often seen as the primary locus of modernist fantasies of speed. In an effort to complicate dominant accounts of modernist speed culture, I identify the seeds of a modernist aesthetic of slowness in the very center of some Futurist artistic practices. In a second step, I will then focus on the work of German literary critic Walter Benjamin and filmmaker Leni Riefenstahl, whose respective interventions of the 1930s urge us to distinguish between different articulations of modern slowness and thus warn us against seeing desires for slowness in modernist culture as one unified program. In discussing these two constellations of modernist culture, my aim is to reconstruct the possibility of recognizing important strains within aesthetic modernism that refused to consider slowness as antimodern, nostalgic, and antiaesthetic. Modernist slowness was far from inviting readers, viewers, and listeners to hang on to bygone traditions, rhythms, and identifications. Nor should we think of slowness simply as a corrective to the presumed modernist privileging of the temporal over the spatial, as an attempt to play out what might be homogeneous, stable, and tame about space against the rapid and discontinuous pace of modernity's clocks, vehicles, and tools of telecommunication. Modernist slowness instead defined a peculiar mode of engaging with the various temporalities and trajectories that energized the spaces of modern life, and, in so doing, it emphasized the coeval, imbricated, and indeterminate relationships of the temporal and the spatial. Slowness is what allowed modernists to register, represent, and reflect on how modern culture not only accelerated the rhythms of preindustrial life but in this way also reconfigured material relationships and immaterial interactions

across different geographies. Rather than first defining time and space as binary opposites and then presenting modernity as a period in which temporality came to triumph over the fixity of space, modernist slowness took heed of the mutual implications of the spatial and the temporal, with space being seen as a dynamic simultaneity of disparate trajectories and dissonant narratives, and time being understood as a dimension whose emphasis on change required open interactions between discrete elements and agents.[7]

Modernist slowness, then, does not figure merely as modernist speed's repressed—a forgotten orphan of how cultural critics throughout the twentieth century have come to associate high modernism with rapid change and the intensity of shock. Nor do I understand modernist slowness simply as a reactive desire seeking to reverse Huxley's velocity and hence as an attempt to reinforce the safe pleasures of distance. Instead, as it emerged within the force field of high modernism, aesthetic slowness brought into play a mode of experiencing and conceptualizing motion that was fundamentally at odds with the intoxicating visions of modernist speed addicts. Its principal aim was to emancipate the hype of modern mobility from narrow conceptions of movement as a mere traversal of space and elimination of distance and, in this way, it aspired to open the subject's senses to a much wider and temporally multivalent landscape of present experience. What I call modernist slowness fully recognized the importance of movement—including movement at accelerating rates—for any process of perceiving objects in time and space. Yet its primary ambition was to experience mobility as a force allowing us, not merely to move effectively from A to B, but to establish unpredictable connections and correspondences, to come across lateral and nonintentional perceptions, and to engage in categorically open interactions with nonidentical particulars. The point of modernist slowness, in sum, was not to abandon the speed of modern life and to bond the future back to the past. Rather, it was to define mobility as a form of communication and interrelation able to sharpen the subject's perception of the present—a present constituted by the contemporaneity of multiple pasts and futures, proximities and distances, movements and speeds.

The seminal modern theorist of the durational, Bergson saw joy in forms of movement that decidedly propelled the subject toward and

into the future. As it reads modernism's stress on movement against the grain of its speed theorists, the point of this chapter is to identify modernist experiments with slowness that prefigure—in spite of a number of fundamental historical differences—the various artistic practices discussed later in this book. In its final section, three brief theoretical readjustments become necessary to effectively set the stage for today's practitioners of aesthetic slowness. The first has to do with Bergson's work itself and its normative privileging of the temporal over the spatial. Though Bergson's interest in extended structures of temporality is of considerable importance for this project, it helped shore up binary views of space as static and time as transformative that have obstructed our full understanding of expanded concepts of mobility present in both modernist and in more contemporary aesthetic practice. The second intervention serves the purpose of reconstructing modernist discourses on medium specificity in such a way that we can accommodate how aesthetic slowness today cannot do without actively recognizing and recalibrating the temporal logic of its respective media of expression. Though aesthetic slowness today is part and parcel of what Rosalind Krauss has termed our postmedium condition,[8] it urges us to reflect on the extent to which the material bases of certain media profoundly matter in artistic strategies of meaning making. The third adjustment finally wants to reclaim the ground for a strong concept of aesthetic experience in which structures of absorption and the noninstrumental can go hand in hand with states of attentiveness and self-awareness. As an art of pursuing contemporaneity, aesthetic slowness today not only relies on the use of various technologies of reproduction; in doing so it also strives to settle the conflict modernists such as Benjamin saw between traditional art's quest for contemplation and modern media's emancipatory power of distraction.

2 /

The emergence of transportation technologies such as cars and airplanes figured as a decisive engine of how Italian Futurists shortly before the outbreak of World War I hoped to deliver artistic practice from the burdens of the past. The modern acceleration of visual, tactile, and aural

stimulations caused Futurists painters such as Giacomo Balla to rally against the representational frameworks of traditional art and explore velocity as modernity's site of the sublime.[9] For Balla, the Renaissance's perspectival system was of no more use to capture how modern speed seemed to make traversed topographies advance upon the moving subject and thus question the former role of the subject as a sovereign master of space. As a consequence, in paintings such as *Racing Automobile* (1913; figure 1.1), Balla transformed his canvas into a vortexlike structure whose frame appeared unable to contain the image's dynamic orthogonals. For writers and poets such as Filippo Tommaso Marinetti, the velocity of modern industrial culture required a new language of telegraphic immediacy that had no patience for long-winded sentences, syntactic complexities, conceptual nuances, let alone conventional punctuation.[10] Futurist language was to shortcut linguistic signification and instead grasp its objects directly and physically—like a fist hitting its target, like a torpedo striking its aim. In the realm of music, finally, Futurist speed addicts such as Luigi Russolo encouraged composers to break away from the codes of classical music because, in an age of fast-paced machinery, technological recording, and earsplitting warfare, the modern ear had lost its ability to stay tuned to the conventional arcs of melodic progression and chromatic modulation.[11]

In all of these examples, the speed of modern industrial society not only caused the artist to envision new aesthetic strategies representing what seemed to defy representation. As important, it led to calls for a radical break with how nineteenth-century society had placated the energies of aesthetic experience within the iron cage of the art museum, the reading room, and the concert hall. As embraced by Futurism, modernity's culture of velocity was welcomed as generating its own normativity. Speed justified any attempt to shatter the vessels of the past, and it sanctioned all those who had no patience for lingering in a stagnant present. Though its primary objects of fascination might strike today's historians as rather slow in motion, Western speed culture circa 1913 promoted visions of a future-oriented present as a space of Dionysian ecstasy—as a dynamic ground liberating the subject from the confines of individuation and granting the pleasures of pulsating collectivity. Or, alternatively, modern velocity demanded the advent of a new metallized body able not only to parry the shocks of accelerated

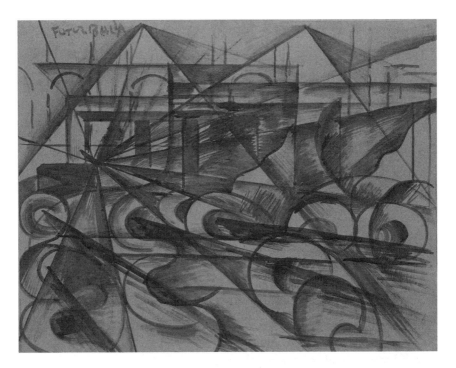

FIGURE 1.1. Giacomo Balla, *Racing Automobile* (1913). Copyright © 2013 Artists Rights Society (ARS), New York/SIAE, Rome. Image copyright © Archivio Fotografico Mart.

movement, but in so doing to learn how to fortify the body against the unsettling vagaries of difference as they may trouble the subject either from outside or from within its sensory perimeters.

Nowhere, however, did the speed of modern transportation technologies play a more decisive role than in Filippo Tommaso Marinetti's founding manifesto of Italian Futurism, first published in the French newspaper *Le Figaro* on February 20, 1909. As it praises the power of speed as a principal feature of modern life, Marinetti's manifesto instructs the reader to revere danger, ceaseless energy, and fearlessness; to carry out a feverish revolt against anything old, traditional, and static; to destroy the fossilized institutions of nineteenth-century bourgeois life—museums, libraries, academies; to embrace the beauty of struggle and the rejuvenating force of modern technological warfare; and in this way to launch "multicoloured, polyphonic tides of revolution,"[12]

sweeping away whatever may block Futurism's categorical imperative to produce futurity in each and every moment. So radical is Marinetti's attack on the sluggishness of bourgeois culture, so violent his desire to accelerate the present, that at its most extreme his manifesto declares: "Time and Space died yesterday. We already live in the absolute, because we have created eternal, omnipresent speed."[13]

Much has been written about the precarious fusion of machismo, speed, and patriotic militarism in Marinetti's work. What I therefore would like to focus on is simply the path that, in the text of his manifesto, leads him to proclaim the tenets of radical futurity: a car crash, triggered by two bicyclists whose slowness causes the intoxicated driver to spin his speedy car into a ditch. Contrary to expectation, Marinetti initially enjoys his brief sojourn in the muck. What exhilarates him even more, however, is a crowd of fishermen rigging his capsized vehicle back onto the road and allowing him finally to reimmerse himself, as if nothing could ever really thwart his route, in the pleasures of fast-forward motion. Seemingly unstoppable, Marinetti concludes: "We want to hymn the man at the wheel, who hurls the lance of his spirit across the Earth, along the circle of its orbit."[14]

Given the relentless pace of Marinetti's diction, it is easy to overlook this sentence and fail to unpack how it addresses the physical and perceptual challenges of speed. "Marinetti," writes Christine Poggi, "masters the trauma of the crash, not through a fixation on the past but through an active embrace of its destructive power, which as Jeffrey Schnapp has argued, releases new energies and drives. . . . [The text manifests] the fantasy of a metallized body resistant to threats and shocks, in the desire to dominate time and space by imagining oneself as a projectile, and in the assumption of a state of perpetual, combative 'readiness' to parry external blows."[15] Poggi's point is well taken: Marinetti wards off the dangers of moving at high speed by considering his own body as a bullet, and hence, by experiencing the car as a prosthetic extension of his moving subjectivity. Enigmatic as it may be, the concluding image, however, has more to say than this and in fact indicates the extent to which Marinetti's version of futurism, in the final analysis, tends to dodge rather than fully engage the potentiality of modern temporality, mobility, and contingency. For what is striking about Marinetti's celebration of the man at the wheel is how this

image consolidates apparent opposites into the unity of one single dynamic, suggesting effective continuities between seemingly disjunctive elements. Modern technologies of acceleration (the car) here open a window on primordial realities (the orbit); the vehicle's directional motion produces a vision of temporal circularity; material conditions give birth to hallucinatory fantasy; transportation devices give way to fierce weaponry; and, last but not least, the driver's sense of controlling the operations of motion and time yields to a galactic absence of choice, chance, and indeterminacy, namely the unbending orbit around the Earth. True to the manifesto's overall tenor, the experience of speed here surely explodes traditional templates of time and space. It generates an aesthetics of intoxicating flow meant to overcome existing spatial distances and temporal durations. As important, however, in his effort to expand the space of the present toward a rapidly approaching future, Marinetti eagerly sacrifices what is unpredictable on the altar of what is unremitting about progress and velocity itself. The contingencies of operating a vehicle at high speed in Marinetti's vision empower a mythic sense of ceaseless motion and futurity in which mechanical exigencies trump the vagaries of human will, manic repetition swallows any desire for difference. To choose modern mobility here means to forfeit our very ability to choose; to speed forward means to endorse both an eternal return of the new and a perpetual renewal of the old; to hurl oneself down the road ends up fusing the linear and the circular—planetary, technological, and subjective time—into one unified composition.

The work of Anton Giulio Bragaglia—Futurist pioneer of photography and future art administrator during the Mussolini era—effectively demonstrates the stakes of Marinetti's vision of speed. Whereas Balla had previously tried to represent the exalting pleasures of speed within the conventional frame of a painting, Bragaglia aspired to do the same with the help of his photographic still camera. Bragaglia's experiments with open shutter photography—or, as he called it, photodynamism—intended to correct the inherent dilemmas of late nineteenth-century chronophotographers such as Étienne-Jules Marey, whose analytic images—according to Bragaglia himself—had certainly been able to arrest individual aspects of specific movements, but had failed to display the true sensation of motion and speed, that is to say, the sensorial or

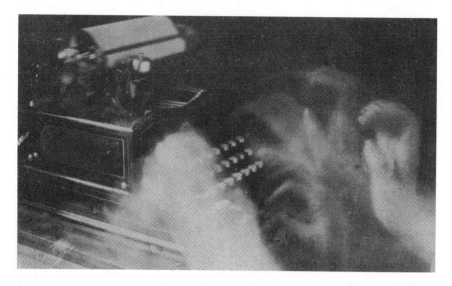

FIGURE 1.2. Giulio Bragaglia, *Dattilografa* (1913). Private collection. Copyright © 2013 Artists Rights Society (ARS), New York/SIAE, Rome. Image courtesy of Alinari/Art Resource, NY.

psychic wake observers perceive when facing continuous actions across time and space. "Chronophotography," Bragaglia argued, "could be compared with a clock on the face of which only the quarter-hours are marked, cinematography to one on which the minutes too are indicated, and Photodynamism to a third on which are marked not only the seconds, but also the *intermovemental* fractions existing in the passages between seconds. This becomes an almost infinitesimal calculation of movement."[16]

Images such as *Violinchelitsa* and *Dattilografa* of 1913 (figure 1.2) exemplify Bragaglia's quest for intensity rather than dissecting analysis, for transgressing the instantaneity of the conventional photographic image and replacing it with records tracing time itself. In these images, Bragaglia's camera captures the cellist's and the typist's accelerated activities, the interaction of body and machine, as one extended trajectory in space, as a visible wake. Yet, due to both the nature of the actions and the technological exigencies of the photographic medium, trajectorial movements here meet the viewer's eyes as strangely circular and almost illegible traces. In his effort to represent intermovemental fractions so as to achieve highest intensity, Bragaglia obliterates any

sense of sequentiality whatsoever, of where individual movements may have started and when they may have come to some kind of end. It is impossible for the viewer to determine how many keys have been pressed by the typists; impossible to ascertain what kind of notes may have been played by the cellist. True to Marinetti's vision, time and space here appear to die indeed, executed by the intensity of modern velocity.

A product of Marinetti's age of modern speed, photodynamism wanted to map fleeting movements within the simultaneity of one photographic frame, but in doing so it expunged both the distinctness of the object and the actual movement itself. Similar to Marinetti's vision of speedy cars orbiting the Earth, Bragaglia's images level the difference between the directional and the iterative; they fuse body and machine into one ecstatic image, thus depicting accelerated motion as something that surpasses the will, determination, and control of the represented subject. Like Marinetti, Bragaglia collapses subjective and machinic temporality so as to radically erase the autonomy and intractability of the human body. The pleasures of modern velocity become the modern subject's inevitable fate and destination; the Futurist rhetoric of dynamic speed invites the subject to go with the flow, to serve as a mere index of the passing of time, rather than to actively change and imprint his particular will onto the course of history. Similar to Marinetti's man on the wheel, then, photodynamism in the end leaves chance no chance. In spite of all its emphasis on innovation and departure, the futurist praise of speed projects futures that know of no alternatives and have no space for that which may exceed the authoritative templates of necessity.

3 /

Marinetti's and Bragaglia's addictions to speed, and their hope to hardwire the modern body into the trajectories of fast-moving machines, have often served as symptomatic examples of how aesthetic modernism in general, when valorizing accelerated motion over contemplative distance, has paved the way for precarious social and political agendas. But to think of both Futurism and aesthetic modernism as one unified movement would mean to view history in terms of

Marinetti's own rhetoric of speed and hence deny the possibility of alternate visions of modern mobility within Futurism and aesthetic modernism. Compare, therefore, Bragaglia's notion of the wake with what Umberto Boccioni, in his perhaps most famous 1913 sculpture *Unique Forms of Continuity in Space* (figure 1.3), set out to do in order to make the speed of modern culture representable. To be sure, a Futurist of the first hour, Boccioni's interest in motion and speed has often been directly associated with Marinetti's work, producing readings of *Unique Forms of Continuity in Space* as a cyborg *avant la lettre*: a racer whose skin has morphed into a metallic armor parrying the shocks of accelerated motion; a terminator fusing hot combustion and cold rigidity, the animate and the inanimate, into one unyielding dynamic.[17] Boccioni's work, critics have argued, is an integral part of a larger Futurist project that celebrated the infinitesimal and intermovemental aspects of accelerated motion. Like Marinetti and Bragaglia, Boccioni's sculpture—it has been concluded—embraced velocity in order to annihilate gravity and contour; to collapse multiple instants and processes onto the space of one representation; and thus to advocate a notion of movement in which the dynamic principle of time gloriously wins over the presumed stasis of the spatial.

While it would be foolish to deny crucial similarities between Boccioni's and his Futurist colleagues' thrill about modern velocity, it would be equally thoughtless not to point out critical differences about how they reflect on the impact of speed onto the registers of perception and representation. "Sculpture," Boccioni wrote in his "Technical Manifesto of Futurist Sculpture" (1912), must "make objects come to life by rendering their prolongation into space perceivable, systematic, and three-dimensional: No one can still doubt that one object leaves off where another begins and that there is nothing that surrounds our own body—bottle, automobile, house, river, tree, street—that does not cut through it and slice it into cross-sections with an arabesque of curves and straight lines."[18] *Unique Forms of Continuity in Space* is an exemplary manifestation of this program as it embraces modern velocity as a medium complicating existing notions of space and problematizing long-standing assumptions about the self-sufficiency of objects in their relatedness to other objects, including the body of the perceiver. What distinguishes Boccioni's work from that of Marinetti and Bragaglia

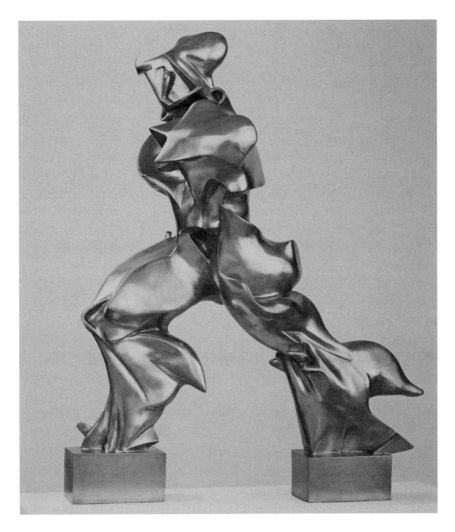

FIGURE 1.3. Umberto Boccioni, *Unique Forms of Continuity in Space* (1913; cast 1931). Bronze, 43 7/8 × 34 7/8 × 15 3/4″ (111.2 × 88.5 × 40 cm). Acquired through the Lillie P. Bliss Bequest. The Museum of Modern Art, New York. Image copyright © the Museum of Modern Art/Licensed by SCALA/Art Resource, NY.

is the fact that Boccioni's interest is neither in mapping the visible wake of accelerated motion, and thus in articulating a new myth—a determinist vision—of modern progress, nor in trying to do away with spatial and temporal extensions altogether. Rather, what drives Boccioni's sculpture is the attempt to show how modern speed and motion allow

us to perceive space as an inherently temporal and hence open and indeterminate dimension of experience. In contrast to his Futurist compatriots, Boccioni imagines movement—as Enda Duffy has put it—as "a force within a material figure,"[19] urging him to depict modern mobility as a dynamic relay station of multiple trajectories from past to future, as a meeting ground of the actual and the virtual, of factual and possible extensions in space. Whereas other Futurists represented speed as mythically fusing the linear and the circular, Boccioni encounters modern velocity as a force field defining the present as a site of uncontained potentiality and multiplicity. His figures strides forward into a future full of options, choices, and possible interactions, a future in which both the durational and the spatial exist in the plural.

In contrast to conventional perspectives, I consider Boccioni's subtle encounter with modern velocity—his reflexive distention of the spatial and the temporal—as a paradigmatic instance of modernist slowness. To go slow, in Boccioni, was to resist modernism's myth of breakneck progress in the name of modernism's own quest for expanded presence. To go slow meant to play out modernist desires for contingency and potentiality against how modernist speed addicts such as Marinetti and Bragaglia, in their efforts to eradicate space as a dimension of unpredictable connections and interactions, extinguished the very conditions of the contingent and temporally open. Later chapters will reveal the continued relevance of Boccioni's peculiar conception of mobility for understanding how artists today, with the help of various time-based media, recalibrate the speed of our techno- and mediascapes. At this juncture, however, let me turn first to the work of yet another modernist, Walter Benjamin, whose thought has often been associated with the velocity of modern industrial culture, yet whose writing offers considerable resources to expand the range of what I understand here as slowness's aesthetic pursuit of being contemporary to one's present in all its potentiality.

4 /

The figure of speed has rightly been recognized as one of the most central categories of Walter Benjamin's account of the modern and of how

industrial culture changes the modalities of sensory perception and experience. In Benjamin's view, the velocity of nineteenth-century urban traffic and transportation caused viewing subjects to abandon detached points of observation and immerse themselves in amorphous torrents of perceptual data. The accelerated rhythms of industrial machinery turned workers' bodies into prosthetic devices whose primary purpose was to serve the industry's abstract production schedules. Moreover, modern speed disintegrated the long breath of storytelling and displaced it for the flash of sensationalist news items, much as it energized the circulation of new consumer products and marketable fashions. Speed was essential to Benjamin's understanding of modernity because it confronted the individual with an unprecedented increase in experiences of contingency and hence situated the subject in a volatile dialectic of attention and distraction.

And yet, in particular in the last years of his life, Benjamin's work was quite concerned with figurations of slowness as well, part of a larger effort to counteract progressivist views of time as linear, homogeneous, circular, and thus ultimately static. While a peculiarly modern sense of velocity, shock, and fragmentation clearly structures the core of Benjamin's epistemology and prose, it is impossible to overlook the extent to which a great deal of Benjamin's later thought cannot do without deliberate gestures of deceleration, of situating the intellectual in relative distance to the velocities of the day and of endorsing memory and the durational as an antidote against modernity's logic of amnesia and catastrophe. Think, for instance, of how Benjamin, in his monumental *Arcades Project,* recalls the Parisian mid-nineteenth-century practice of walking with a turtle on a leash in order to slow down one's pace, to look intently at the urban landscape, and, of course, to transform oneself into a bohemian object of to-be-looked-at-ness. Or of how Benjamin, in the same work, reflects on boredom and waiting as existential states, not entirely ignorant of the dynamic of modern history, but situated at the doorstep of and in relation to pending transformations. To cultivate one's boredom is to orchestrate a dramatic reduction of speed. It means to take a deep breath and turn matters inside out, and to view the present as an eternal repetition of the same, before some unknown future will suddenly displace the orders of the day: "We are bored when we don't know what we are waiting for. That

we do know, or think we know, is nearly always the expression of our superficiality or inattention. Boredom is the threshold to great deeds."[20] Slowness and deceleration, in both of these examples, turn out to be peculiar products of and responses to modern speed and acceleration. Slowness needs modern speed in order to define itself and become perceptible as a relevant structure of experience. Therefore to think of slowness as nature's, spontaneity's, or tradition's outcry against the rhythms of industrial life misses the point. To live slowly requires as much deliberation and effort as a life of ceaseless tempo and ongoing dislocation. It turns speed against itself in the hope of multiplying the perceptual and experiential possibilities of modern life. Only he who is willing to face the pace of modern life, only he who dares encounter the restless flows and discontinuous shocks of urban modernity— only he will be able to recognize the true pleasures and provocations of slowness.

Nowhere does the figure of slowness in Benjamin's work become more prominent than in his final contemplation on the philosophy of history, drafted shortly before his death in 1940 and articulating an at once apocalyptic and messianic perspective on the possibility of future historical change in a time seemingly void of liberatory political energies. The central image here is, of course, that of the angel of history, Benjamin's famous reading of a painting by Paul Klee (figure 1.4). In this image, the modern conception of history as progress and rapid change is seen as a storm tossing everything at high speed into the future—a future whose principal feature is the perennial renewal and hence repetition of past and present catastrophes. In radical contradistinction to speed addicts such as Marinetti, Benjamin's angel has his back turned toward this future. Unable to close his wings, he is caught up in the breakneck tempo of historical time. Speechless about the course of history, his eye remains directed at the wreckage piling up in front of his feet: "The angel would like to stay, awaken the dead, and make whole what has been smashed."[21]

Benjamin's angel is certainly a deeply melancholic figure. He refuses to face the future so as to prevent possible blind spots of historical memory, chiasmas that deny ubiquitous suffering. His eyes staring, he rejects any understanding of history as a progressive narrative organized according to a linear, forward-moving cause-and-effect chain.

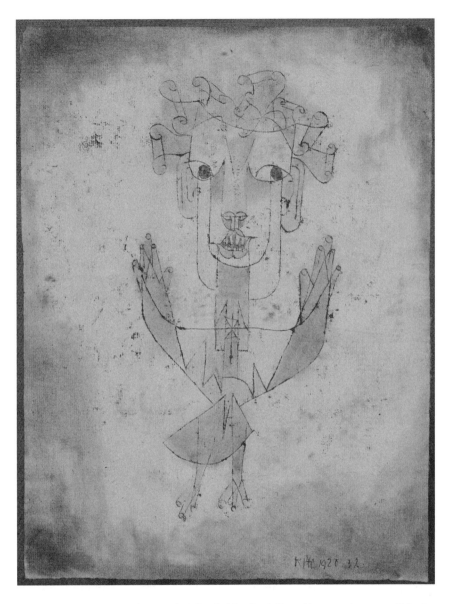

FIGURE 1.4. Paul Klee, *Angelus Novus* (1920). India ink, color chalks, and brown wash on paper. Collection of the Israel Museum, Jerusalem. Gift of Fania and Gershom Scholem, John and Paul Herring, Jo Carole and Ronald Lauder. Copyright © 2013 Artists Rights Society (ARS), New York. Image copyright © the Israel Museum, Jerusalem by Elie Posner.

And yet rather than seeing this angel's desire to slow down and halt the course of progress as a gesture renouncing modernity altogether, Benjamin's hope for redemption is deeply structured not only by the promises of modernity itself—contingency, change, and openness—but also by the kind of perceptual technologies extended by modern media society. Consider the possibility of reading Klee's angel of history as a curious embodiment of what Benjamin, beginning in his famous 1935 essay, "The Work of Art in the Age of Its Technical Reproducibility," discussed as slow-motion cinematography's ability to pierce familiar surfaces and, like surrealism, reveal forgotten constellations and surprising correspondences—a medium ideally suited to return the "Blue Flower in the land of technology."[22] Slow-motion photography, in Benjamin's understanding, represented the habitual world as one filled with wonders and the unexpected; it multiplied possible ways of reading the phenomenal world and disclosed unforeseen differences, gradations, and distinctions underneath the veneer of ordinary sights. As special effect, which, as I mentioned in the introduction to this book, relied on recording images at much higher speed than when shown during the process of projection, slow-motion photography in Benjamin's view intensified perceptions of time and movement, not because it sought to freeze the flow of time, but because it at once facilitated and reversed a stepping up of temporality.

The gesture of Klee's angel recalls what Benjamin's artwork essay described as the duality of slow-motion photography. On the one hand, the angel wants to decelerate the speed and progression of modern time; to reveal and hang on to the minute details of life lived; to find moments of forgotten meaning and mystery amid the storm of catastrophic history and pointless progress; to capture images of past and present as they had never been seen before and precisely thus redeem physical reality for its moment of resurrection at some unidentified time in the future. On the other hand, what fuels the angel's desire to slow down, what enables his strategies of deceleration, is the storm of rampant progress itself, arresting his wings such that movement and stasis become one and the same. Like a slow-motion photographer, Benjamin's angel cannot do without the stepping up of speed typical for the modern era and its technological media. His desire for slowness is an effect of his very state of acceleration, of his inability to close his

wings and step out of that storm blowing him into the future. He thus uses the one in order to produce impressions of the other. His gaze records the visible world with the help of an accelerated frame speed so as to preserve images of past and passing presents whose apparent slowness when shown at regular projection speeds express profound solidarity with the victims of history and their very state of dispersal.

Dedicated to the perceptual vortices and immersive thrills of speed, modernist writers and artists—according to Duffy—were often frustrated about possible prospects of slowness: Marlow's horror at the end of *Heart of Darkness* in no small way vents the modernist subject's dismay about thwarted or suspended movement, a profound impatience with no longer being able to venture into and traverse new dynamic spaces.[23] Benjamin's slow-motion angel has left this frustration behind. He no longer defines motion and mobility in terms of transgressing new geographies, but of revealing forgotten interactions between past and present and of illuminating hidden correspondences between dispersed elements in space. We would be gravely mistaken, however, to consider Benjamin's alternate concept of mobility, his desire to slow down the storm of progress, as intrinsically conservative or reactionary. While the angel's slow-motion photography wants to stay with the debris of history, reawaken the dead, and make whole what has been smashed, his way of seeing is clearly not one seeking to preserve present and past in their painful states of fragmentation or to subject the individual, concrete, and particular to the vision of a homogeneous and self-enclosed collectivity.

We would be equally wrong to consider Benjamin's thoughts on slow motion as a preview of what German philosopher Odo Marquard has called "compensatory slowness."[24] For Marquard, the velocity of modern society is out of step with the essential timetables dictated by our biological clocks and our inevitable human finitude. As mortal beings, we—according to Marquard—must come to realize that further acceleration cannot but lead to a fundamental denial of experience, an erasure of memory and identity, a flight from what makes humans human. Marquard's advice for us is therefore to step out of the busy tempos of the present and readopt the measures of natural and biological rhythms. Neither Benjamin's nineteenth-century flaneur nor his melancholic angel of history can be adequately described as practicing

an art of compensatory deceleration. For, rather than flee from the fast-paced pulses of modern temporality, they flee into them so as to recalibrate their energies. Rather than turning their back on modern speed altogether, they engage it so as to open up alternative spaces of experience. Compensatory slowness, as envisioned by Marquard, aims at restoring the value of tradition; preserving temporal continuity; and warranting the harmonic integration of past, present, and future. Benjamin's modernist slowness, by contrast, rests on the assumption that no future can recuperate the past without recollecting that which was never lived, seen, experienced, and actualized in the first place. Slowness here is the medium by which the present prepares itself for its discontinuous reinscription in some unknown future. It is the medium by which an accelerated present removes itself from its own closure, its vortex of vectorial movement, and exposes itself to the open vagaries of time, a heterogeneous temporality in which the future's task is to reclaim the promises and transformative energies of past generations.

5 /

As advocated by both Boccioni and Benjamin, modernist slowness resisted the desire to return to the cyclical timetables of preindustrial societies and to abandon modern technology so as to recreate the pleasures of unmediated presence and seamless duration. A deliberate reflection on modern velocity, modernist slowness instead aims at expanding the space of the present, not in order to obliterate history, but, on the contrary, to experience this present as a complex relay station of competing memories and anticipations, of stories-to-be-remembered and stories-not-yet-told. Whereas the perceptual and representational registers of speed addicts such as Marinetti and Bragaglia left no room for temporal multiplicity and openness, modernist slowness hopes to unfetter mobility from the directional and teleological determinism of speed. It maps space as a dynamic domain of mobile interactions and variable relationships and in so doing insists on the principal productivity of time, no matter whether the focus is on the future as a realm of possibility (Boccioni) or the past as a sphere of endangered meanings and memories (Benjamin). Presentness, for the mod-

ernist advocate of slowness, does therefore neither mean grace nor ec-
static fulfillment. It means to perceive the now as an ever changing
meeting ground of multiple durations and potentialities, of competing
tempos and temporalities, of dissimilar narratives and visions.

The present, when seen in the mode of modernist aesthetic slow-
ness, is therefore much more than simply a site at which past and fu-
ture shake hands and constitute durational experience. It is a site of
conflicting logics and heterogeneous flows of time; it is a site at which
space is experienced as a domain, not of fixed and immobile proper-
ties, nor as one to be traversed by a single temporal development, but
of dissonant stories and itineraries. To go slow here means to recog-
nize the contemporaneity of what resists smooth integration; it means
to behold of the old and the new, the fast and the sluggish, as constitu-
tive parts of the present moment without denying their difference; it
means to recognize the now in all its discord, multiplicity, and transi-
toriness as the only site at which we can actively negotiate meaningful
relations between past and future.

Modernist speed advocates embraced the present as a conduit pro-
pelling the subject into the future, yet in their very state of intoxication
they ended up turning temporal mobility into modernity's latest myth
and fate. Modernist slowness wants to hang on to modernity's prom-
ise of emancipating the subject from the mythic. It wants to open a
space for unconditional and unapologetic contemporaneity, i.e., for
recognizing what might be empowering and emancipatory about pur-
suing presentness. Let's make sure, however, not to confuse the speci-
ficity of this project with other articulations of slowness during the
peak years of aesthetic modernism, articulations in which aesthetic
strategies of deceleration simply invert the ephemerality of the modern
age, calm the nervousness of the modern mind, and contain emphatic
contemporaneity. Recall the famous opening of Riefenstahl's first Olym-
pia film, *Festival of the People* (1938), effortlessly trying to transport
us from the timeless image of antique Greek sculptures to the dynamic
body of a modern athlete, shown in slow-motion photography as he
hurls his discus into the Northern German sky (figure 1.5). Riefens-
tahl's film starts out with images of ancient Greek ruins, bathed in soft
morning light, the camera gently traveling along and across a field of
crumbled stones, columns, temples, and statues. Extended dissolves

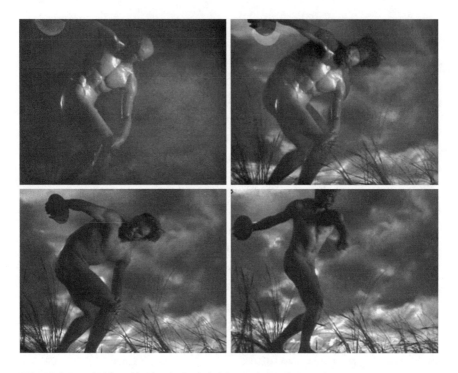

FIGURE 1.5. Leni Riefenstahl, *Olympia: Festival of the People* (1938). Screenshots.

endow these images with a sense of poetic otherworldliness. After a few minutes the camera comes to rest on a replica of Myron's *Discobulus*, a sculpture created around 450 BC and displaying the body of a discus thrower as he is about to fling his sporting equipment. First the camera smoothly circles around the sculpture's head and neck; next it slightly moves away from the statue so as to allow us a full view of how both artist and athlete manage to synthesize utter attentiveness and admirable repose; and then we witness how this image of controlled stillness dissolves into the image of a real discus thrower who will start his routine from where Myron broke off. Slow-motion images picture the athlete as he smoothly rotates his upper body twice around its vertical axis before we finally cut to a close-up of his arm as it tosses the discus forcefully into the sky.

As I have argued in greater detail elsewhere,[25] Riefenstahl's deliberate use of slow-motion photography in this scene (and most of the

following 205 minutes of screen time), on the one hand, is to demonstrate the extraordinary power of the cinematic apparatus to animate the world and shape physical reality. The dissolve from statue to athlete, from no to slow motion, stresses the apparatus's force to call things to life and control the velocity of profilmic events. By stretching time and physical movement, Riefenstahl's aim certainly was to evidence the camera's own athletic efforts of maintaining control over the athletes' and the viewers' temporal registers. On the other hand, slow-motion photography here and throughout the rest of the film celebrates profound moments of psychophysical transformation and transcendence: from a body willing to win to one whose will is to triumph over this body's physical contingencies; from the banality of an unfocused and mundane existence to the ecstasy of utter concentration and dedication. Slow motion in Riefenstahl seeks to emancipate the human body from its own temporal existence, to showcase what is universal, paradigmatic, and therefore timeless about this body. She explores some of the most advanced techniques of cinematography not only to orchestrate universal types of bodily action but also to protect our bodily existence against its very intractability, against what is erratic, coincidental, and unfinished about any form of human embodiment. Slowness in Riefenstahl thus guards the body against its own fleetingness and fragility; it shields the viewer against the very logic of temporal contingency that Riefenstahl's cinema puts to work in order to mirror an uncertain present in the stability of a timeless past.

The differences between Riefenstahl's project of slow motion and Benjamin's aesthetic of modernist slowness should be quite obvious at this juncture. Unlike Benjamin's angel of history, Riefenstahl's camera embraces slowness as a medium to map the present as a mere replay of archaic and seemingly immutable meanings. Rather than stressing the ruptures of memory and the fractured state of the durational in modernity, Riefenstahl's slowness wants to visualize the continued presence of the mythical and the timeless as they persist right underneath the veneer of modern commotion. In doing so, slowness not only reduces the present to the status of being a mere iteration of the past, but frames the modern as something whose sense of mobility has no meaning unless it can be reflected in the static paradigms of the past. Which is just another way of saying that slowness in Riefenstahl's work serves the

purpose of deflating the memory of historical alternatives while providing triumphant sites of preemptive reconciliation. Slowness in Riefenstahl maps historical time as something that neither is in need of redemption nor can be imagined as being open to acts of intervention, reconsideration, and change. In stark contrast to Benjamin's notion of slowness as a contemporaneous optic of upholding the claims of an unfulfilled past for a better future, Riefenstahl's project of slowness bonds present and future to the unbroken memory of the past and thus denies history ever to produce something new or different.

It is tempting to understand Riefenstahl's notion of slowness as an attempt to collapse the temporal onto or into the spatial, reminiscent of the function Richard Wagner's *Parsifal* ascribed to the Holy Grail, namely to transform time into space. Such a perspective, however, would not only repeat common stereotypes about the spatial as static, dead, and homogeneous; it would also overlook the extent to which Riefenstahl's peculiar vision of slowness presents the mere flip side of Marinetti's Futurist credo of speed. Both Riefenstahl and Marinetti hoped to tame modernity's logic of contingency by envisioning their notion of either slowness or speed as modernity's new myth and fate. Both aspired to contain either the temporal or the spatial in the name of the respective other, whereas the true modernist challenge would have been to recognize and explore space and time in all their mutuality and intertwinement—as dimensions of dynamic interactions, coeveal trajectories, and open relationships.

Boccioni's *Unique Forms of Continuity in Space*, much as it helped us earlier to illuminate the ideological stances of Marinetti's and Bragaglia's theology of modern speed, is helpful also in identifying a compelling modernist alternative to Riefenstahl's antimodernist conception of slowness. For, unlike Riefenstahl's athlete, the body of Boccioni's sculpture is one in which the past has its place in the present without reducing this present to the status of a mere afterimage of a timeless past. Though meant to capture the perceptual effects and thrills of modern speed, Boccioni's work translates the full potential of slow-motion photography in Benjamin's modernist sense into the medium of sculpture, namely to stretch temporal processes to such a degree that we become able to perceive a passing present in all its complexity and recognize it as a site at which multiple logics of movement may inter-

sect without being fused into one unified form and meaning. Whereas Riefenstahl hoped to slow down the present so as to allow the modern subject to find its grounding in a static past, Boccioni's work represents a modernist aesthetics of slowness whose primary aim is to invite reflection about the principal openness of time and space amid the very speed of modern life. Whereas, for Riefenstahl, to go slow meant to return the present to an unchanging past, Boccioni invites us to contemplate—attentively and hence slowly—the fundamental instability of the present as a site of various durations that are never fully determined by the pathways of the past nor by the goals set for the future.

6 /

In mathematics and physics, deceleration is considered as a mere inversion of the process of acceleration: a negative rise of the rate of movement requiring as much force and energy as its counterpart. Riefenstahl's desire to slow down the pace of modern history, in this sense, may reverse modernist fantasies of ever increasing speed, but it remains wedded to similar concepts of expenditure, motion, and mobility, of space as a static container of action and time as the privileged domain of change. What I call the aesthetics of modernist slowness, by contrast, explores registers of perception and representation that move beyond the matrix surreptitiously shared by early twentieth-century speed addicts such as Marinetti and Bragaglia and slowness fetishists such as Riefenstahl. Modernist slowness opens our senses and minds to experiences of space as more than merely a container for movement and of time as a dimension that exceeds the opposition of teleological progress and circular repetition. Modernist slowness expands the space of the present, not simply in order to make us hesitate and become contemporaneous with various speeds and temporalities, but in so doing to reflect on alternate models of mobility and uphold visions of indeterminacy, newness, and aesthetic playfulness.

It has become commonplace to resort either to Albert Einstein's relativity theory or to Ernst Bloch's notion of noncontemporaneity to account for modernist attempts of mapping the present as a site of temporal multiplicity. Modernist slowness at once echoes and transcends

the implications of such references. As a medium of facing a passing present in all its relativity and obscurity, modernist slowness clearly recalls what was at the core of Einstein's groundbreaking work: a stress on how observational positions define variable frames of knowledge, including our knowledge of an object's motion in and through time. Yet in contrast to Einstein's relativity theory, whose considerable level of abstraction prompted many modernist writers and artists to develop primarily metaphorical appropriations, my concept of modernist slowness wants to stress the phenomenological dimension of experiencing time in industrial modernity. While the theoretical revolution of modern physics indeed resulted in new theoretical conceptions of space-time, modernist slowness aspired to register certain material transformations and temporal contractions in modernity at the level of the senses. Similarly, Bloch's notion of noncontemporaneity and asynchronicity, coined in the 1930s,[26] was meant to refer to the coexistence of phenomena that belonged, properly speaking, to different historical areas or stages of social development. Yet whereas Bloch sought to conceptualize such states of cotemporality in terms of dialectics, as transformative oppositions between old and new, the utopian and the actual, modernist slowness—as suggested here—did not seek to force the present in all its multiplicity into the straightjacket of historical dialectics. To go slow and practice what Siegfried Kracauer, in the early 1920s, called "hesitant openness" instead meant nothing less than to encounter the present as a space charged with the virtuality of various possible futures and the durations of multiple pasts, remembered and forgotten.[27] Rather than seeing the present as a dialectical stage of asynchronous oppositions and negativity, modernist slowness approached the now—without necessarily abiding critical awareness—as an open meeting ground of various streams of time, a space too complex in its temporal layering simply to be negated as whole, a site at which neither past nor future existed in the singular and a traditional dialectician's concept of totality no longer appeared quite applicable.

On Slowness rests on the assumption that recent artistic work in various time-based media such as photography, film, video, installation art, and writing remains deeply indebted to the legacy of modernist slowness. To be sure, little is left of what caused modernists of the early twentieth century to marvel or moan about the modern wonders

of speed and acceleration. The velocity of a Ford T1 or a roaring steam train appears quaint from today's perspective. More important, the political, economic, technological, and cultural transformations associated with recent processes of globalization have often been seen as changes toward a society, not of breakneck speed and acceleration, but of radical instantaneity and homogenized simultaneity—a society in which advances in telecommunication urge us to always be "on" and invite us to connect to different realities and temporalities with the proverbial click of the mouse. Under such conditions, it has been suggested by critics such as Paul Virilio and Fredric Jameson,[28] neither speed nor acceleration is really an issue anymore because both, in order to be measurable or be experienced as intensities, require some sense of both spatial distance and temporal extension. Unlike the modernist imaginary, which hoped to accelerate time by shrinking space, postmodern technocultures of globalization have flattened both time and space into synchronic depthlessness, thus erasing whatever may allow us to identify speed as speedy to begin with, including its putative adversary, namely deliberate acts of slowness. Today, everything appears to be in frantic motion, it is concluded, yet space no longer offers room for any acts of traversal; time is on the fly, yet the present is at a standstill, expanding into the past and future without allowing for the possibility of future progress or regress. If speed today, according to these arguments, is literally suicidal because it devours its own resources, why— we must ask ourselves at the outset of this study—do we need to talk about slowness at all? If contemporary culture's logic of compulsive connectivity wants to emancipate us from the materiality of space and the stickiness of place altogether, how can aesthetic slowness serve as a challenge to the perceived rush of time?

In Virilio's and, in particular, in Jameson's reading, our present is one that has lost its ability to sense true temporality and the durational, precisely because this present has erased the specificity of local meanings and historical nuances. We all now live in one single time, one that knows of no alternatives, of no holdovers from the past, of no disruptive memories or unsettling anticipations—so much so that the very notion of the contemporaneous has lost its traction and we find ourselves in an age of the postcontemporaneity. As Jameson writes, "We no longer are encumbered with the embarrassment of non-simultaneities

and non-synchronicities. Everything has reached the same hour on the great clock of development or rationalization (at least from the perspective of the 'West')."[29] This is not the place to discuss in detail Jameson's notion of the present as a space of postcontemporaneity and of globalization as a triumph of homogenized instantaneity in theoretical terms. Doreen Massey has done so persuasively in her 2005 *For Space*, stressing the extent to which Jameson's notion of the global present as a single integrated moment not only reiterates narrow concepts of space as a static slice through time, but in so doing, at a conceptual level, prevents us from the possibility of thinking temporality and history in the first place. According to Massey, Jameson's notion of postcontemporaneity—his lament about the twentieth-century's move from the modernist story of progress to the postmodern vision of synchronic superficiality—throws out the historical baby with the theoretical bathwater: "Any assumption of a closed instantaneity not only denies space the essential character of itself constantly becoming, it also denies time its own possibility of complexity/multiplicity. To read interconnectivity as the instantaneity of a closed surface (the prison house of synchrony) is precisely to ignore the possibility of a multiplicity of trajectories / temporalities."[30] To think of the present as a fully integrated and horizontally homogenized moment, in Massey's perspective, continues to rely on the same conceptual matrix that encouraged modernist speed addicts to play out the temporal as a dimension of progressive change against the spatial as a sphere of retardation. To understand the present as a space of postcontemporaneity is to underestimate one of the crucial insights of what I have earlier called modernist slowness: namely that space too is inherently dynamic, a realm of potentiality and unfulfilled memory, a sphere of difference and interaction that we can neither conceptually nor experientially reduce to one singular realm of motionless representation. Modernity's arrow of time never follows merely along one unified axis or vector, nor can we reconstruct or predict its course with the help of one integrated story or in one image casting dynamic flux into stable spatial form. The reign of instantaneity, therefore, is never as closed a system as today's theorists of postcontemporaneity and posttemporality want it to be. History happens, not only— as Jameson tends to argue—when in the name of a better future we mobilize what is nonsynchronic against the homogeneous space of the

present but also—as slow modernists such as Boccioni and Benjamin have taught us—when we learn how to face the synchronicity of various durations and spatiotemporal dynamics that continue to define our present even under the conditions of advanced globalization and technological connectivity.

Aesthetic slowness today, as will be discussed in the chapters to come, may no longer serve as an artistic intervention to reflect on the mythologies of running athletes or Ford Ts as they move at their respective top speeds. In their efforts to engage with the frantic mobility of the present, however, the artists of this book remain dedicated to what also defined the heart of Boccioni's and Benjamin's enterprises: to express in sensory form that neither time nor space are ever as homogeneous as contemporary discourses of speed and instantaneity proclaim them to be. Aesthetic slowness today continues to pursue the art of being contemporaneous, of encountering the present in all its contingency and multiplicity, of gazing straight into the face of the present while nevertheless seeking to account for all that has never been and all that might never be lived. Slowness asks viewers, listeners, and readers to hesitate, not in order to step out of history, but to enable the possibility of simultaneously looking left and right, forward and backward, up and down; slowness diverts directional movement so as to reveal the different stories, durations, movements, and speeds that energize the present, including this present's notions of discontinuity and rupture, of promise and loss.

A spatial as much as a temporal project, aesthetic slowness is much less about simply trying to decelerate the ticking of our clocks and exchange the exigencies of urban life for the sluggish paces of the rural than it is about holding our gaze at our own age and reflecting about competing visions of time, movement, progress, and change. We therefore should not be surprised to find instances of aesthetic slowness where today's self-help manuals and new age sages might expect them the least: on speed trains and high-flying airplanes, vis-à-vis the nervous pace of action films and the beats of experimental music, in creative practices that employ today's entire arsenal of advanced computing and image-sound manipulation. Neither pre- nor postcontemporary, aesthetic slowness today invites viewers, readers, and listeners to absorb themselves into their present while at the same time allowing them to

maintain some kind of reflective distance. Aesthetic slowness is thus far from merely reactive, let alone reactionary; it wants us to belong to our time by exploring the now as a conduit of many different temporalities and durations that never join into the unity of one dynamic. In the following chapters we will thus find aesthetic slowness at work whenever photographers use their medium, not to present their viewers with seemingly static slices through time, but to reflect on the temporal diversity of modern space and the spatial substrates of temporal durations (chapters 2 and 3). We will encounter aesthetic strategies of slowness in the work of film directors who use their cameras to capture forms of mobility that exceed our desire merely to move from one point to another and thus to collapse or tame the tenacity and unpredictability of extended geographies (chapters 4 and 5). We will come across aesthetic slowness in contemporary video art as a powerful means to remember and rework traumatic residues and reanimate painful histories seemingly frozen in the past (chapter 6). We will face aesthetic slowness when sound and walking artists, with the help of advanced editing devices, layer multiple strata of visual and acoustic representations on top of each other and thus encourage the listening walker to get lost amid a plurality of different narratives and perceptions (chapter 7). And we will encounter what I call slowness here when writers use their privileged medium of the word to reflect on today's meshing of technologically mediated and human time, at once pulling toward and pushing away from the way in which much of today's slowness discourse edges toward new forms of religiosity that precariously collapse any remaining distinction between the particular and the universal, the passing and the eternal (chapter 8).

Only a generation or two ago, critics still sought to ban slowness from the repertoire of critical practice and analysis. In this study, by contrast, slowness is discussed as a critical intervention whenever it will go to the roots of how we perceive and misperceive the temporal regimes of our present and whenever it will urge us to resist the facile description of this present as a frantic realm of homogenized instantaneity, synchronic depthlessness, and undifferentiated closure. Boccioni's use of the medium of sculpture or Benjamin's praise of (silent) filmmaking may no longer suffice for today's artists to hold their gaze—slowly, steadily, creatively, and imaginatively—on the commotion of our

present. As we will see in a moment, newer and technologically more developed media are of critical importance in most of the projects under discussion here. However, similar to how Boccioni's and Benjamin's slowness ran counter to dominant conceptualizations of aesthetic modernism and its association with modern velocity and progress, so do the kind of projects discussed here problematize what it might mean to talk about artistic progress in the first place. True to and yet different from the interventions of Boccioni and Benjamin, aesthetic slowness today hopes to open a space within the very heart of our age's obsession with the speed of electronic flows at which we can reflect about the meaning of memory and change, probe different ideas of progress, develop alternate visions of future mobility, and precisely thus can become and be contemporaries.

7 /

Three more things need to be said for the more theoretically minded before we set course to survey what in contemporary artistic practice wants us to question the concept of following a straight course along a unified axis. First of all, even though *On Slowness* investigates how different artists today experiment with different forms of duration, one should not mistake the following arguments as a simplistic attempt to map the thought of modernism's prime theorist of the durational, Henri Bergson, onto contemporary scenes of artistic practice. To be sure, aesthetic slowness as a mode of contemporaneity shares Bergson's discontent with mechanistic notions of time as measurable, divisible, and automatized—i.e., with modern clock time. Similar to Bergson, slowness urges viewers and listeners to hesitate and pause in order to behold time as an overlapping and indivisible dimension of flow and becoming; it asks us to investigate the peculiarly modern pleasures and fears of contingency. Unlike the early Bergson, however, the projects discussed here do not seek to pit the temporal as a (good) dimension of heterogeneous multiplicity and creative synthesis against the one of space as the (evil) realm of distinct homogeneity and reifying representation whose principal logic is to block the possibility of true experience. On the contrary, many of the aesthetic interventions of contemporary

slowness take direct aim at Bergson's biased privileging of the temporal over the spatial as they seek to explore space as what Massey calls "the dimension of multiple trajectories, a simultaneity of stories-so-far."[31] Post-Bergsonian slowness, as I understand it here, allows me to perceive the space of my desk as a meeting ground of heterogeneous temporalities: a site at which the assertive modernity of my desk lamp is synchronous with the aging surface of the wooden table top; a realm in which my laptop's relentless processing speed is copresent with my writerly indecisiveness, my acts of adding and erasing words as I go along. As important, however, slowness also allows me to recognize that spatial constellations and relationships play an active role in constituting the kind of stories told by various objects in the first place. It reminds me of the fact that the durational—pace Bergson—is more than merely a singular feature of my consciousness, that it adheres to external things and their relations as well, and that only thus can it provide alternatives to what is deterministic about the visions of modern and post-contemporary speed addicts.

Secondly, as an aesthetic of radical contemporaneity, the art of slowness of this book simultaneously draws on and reframes modernist discourses on medium specificity. J. M. Bernstein has recently argued that the idea of the medium in various modernist accounts serves both as an embodiment and a corrective to the rule of modern disenchanting rationality. Modernity might result in a progressive dematerialization of nature and human experience. But no matter how much modernist aesthetic practice participates in this process of abstraction, it is by addressing the nature of their respective mediums—understood as an art form's material-specific potential for sense making—that modernist art also sought to suspend, negate, or recalibrate what modernity is doing to nature. Mediums are part of the world of human consciousness: a set of practices, ideas, and institutions by which artists structure their material and subsume their expressive visions to larger conceptual or discursive schemata. But mediums are also part of the world of nature; they are matter themselves (think of the materiality of the brush stroke, the mechanics of the photographic camera, the scratches on the vinyl record), not only providing embodied forms of engaging with inner and outer nature but also offering counterfactual models of how to reconcile the discursive or conceptual demands of

artistic technique with what is incommensurable and hence nondiscursive about human intuition, spontaneity, and sensory experience. Modernist art employed mediums as effigies holding up the claims of subjectivity and sensory experience in spite of their factual dematerialization; it is by reflecting on the materiality of the medium itself, in all its historical constitution, that modernism sought "to rescue from cognitive and rational oblivion our embodied experience and the standing of unique, particular things as the proper objects of such experience, albeit only in the form of a reminder or promise."[32]

For most of the projects discussed in the following chapters, a particular medium's materiality continues to matter as both a source of meaning making and as a conduit of exploring the viability of sensory perception and embodied experience. To formulate this more strongly, in its very effort to challenge dominant modes of movement and experiment with alternate modes of mobility, our contemporary aesthetic slowness considers artistic mediums as material means of encouraging subjects how to think, not only with their brains, but with their entire mobile bodies. This art explores certain mediums in all their materiality as models of how to relate to the world, experience the present's multiplicity of durations, and produce knowledge through physical and sensory engagements. Contrary to many practitioners and theorists of high modernism, however, the projects of this book are no longer guided by the idea of a particular medium's purity and autonomy. Time and again, we will encounter strategies pushing artistic representation toward or beyond the limits once associated with a specific medium: we witness photographers seeking to visualize the flow of time and filmmakers trying to emulate the photographic, we come across audio artists surreptitiously engaging the visual and video filmmakers relying on quasi-literary and cinematic narrative voice-overs. Slowness as an art of contemporaneity recognizes our inability today to resort to some idealized notion of medium specificity and autonomy. It runs up and rubs against the conventions historically associated with particular mediums, not in order to declare a medium's materiality as irrelevant for artistic practice, but on the contrary to warrant the possibility of sensory encounters and the nonintentional within an age in which the convergence and crossover of electronic media has become the order of the day.

Third, and finally, the readings of *On Slowness* participate in what I perceive as the critical rediscovery of aesthetic experience over the last decade. Some of the most innovative contributions to these conversations have been made by scholars addressing the way in which digital screens and installation spaces today have a unique ability to produce new forms of embodiment, help us explore the mechanisms of sensory perception, and, in so doing, offer new types of aesthetic experience.[33] This more recent writing on new media art and culture, on the one hand, refreshes certain phenomenological traditions, theorizing our encounter with digital interfaces as an incentive to experience our bodies as the primary medium and interface, as a mobile framing device enabling somatic interactions and mediating ever shifting perspectives on the world. While the days of more contemplative forms of viewership might be counted indeed, the interactive possibilities of digital media, it is argued, have the capacity to reveal how our seeing is grounded in our experiential modalities of kinesthesia (the sensation of body movement), of proprioception (the awareness of our body's position and boundaries in space), and of touch (the sensation of physical contact with objects other than our body), all three of which comprise what some critics call "tactility," and others the "haptic body." On the other hand, in accord with the growing interest of image theorists in cognitive sciences and advanced brain research, new media critics now also seek to stress the unprecedented capabilities of digital media to map the viewer's mental activities and thus render visible what makes aesthetic sensation neurologically possible in the first place.[34] Electronic media, they argue, play a privileged role in helping new media artists to reveal the material operations of the brain—the firing of neurons, the distinctive linkage of neurological patterns and networks, the peculiar binding of perception and consciousness—and in this way electronic media help these artists to simulate, playfully engage, and critically investigate what is key in our efforts to grapple with aesthetic objects and align certain impressions with prior associations. New media culture, recent phenomenologists and neuroaestheticians therefore tend to conclude, by no means results in the vanishing of materiality, the sensory, and hence the aesthetic. The mobile screens of digital culture may no longer allow for fully concentrated forms of looking. But, far from obliterating the aesthetic altogether, new media in this understanding teach the user

how to play again as much as they urge us to consider the materiality of the body and the brain as irreducible engines of affect, attention, and nonintentionality.

On Slowness continues some of these arguments, but also responds to what I consider some of their limitations, in particular their tendency to reduce aesthetic experience either to mere sensory play or to cognitive observation. Aesthetic experience, I suggest, emerges in-between positions of immersive absorption and disembodied cognition; it transpires whenever we oscillate between states of ecstatic self-displacement and seemingly detached judgment. To experience objects aesthetically, in other words, involves our ability to actively register a partial loss or a rapturous expansion of sensory perception as much as to investigate the feel of pushing against the way in which works of art pull us into seeing the world through different eyes. Rather than to describe a state of harmonious equilibrium, then, aesthetic experience ensues from extended moments of rupture, indecision, and instability. It relies on how certain viewing arrangements allow the subject to probe different models of seeing the world and explore the tensions between sensing oneself as other and sensing the other as other, between diluting and validating our sense of self-awareness. In contrast to Benjamin, for whom modern culture purged contemplative forms of spectatorship and inaugurated an age of critical, albeit fundamentally distracted, modes of looking, aesthetic experience cannot do without certain structures of awe and absorption and a mimetic blurring of the boundaries between viewer and viewed. It cannot do without relinquishing the contours of modern sovereign subjectivity. Understood in this sense, aesthetic experience requires uncertainty and flux, and it calls for recipients who welcome a certain lack of control and clear orientation as an opportunity rather than a threat.

Huxley considered speed to be the twentieth century's only new pleasure, but the following readings will make us wonder whether modernism's quest for speed was as aesthetic as it often believed itself to be. *On Slowness* rests on the assumption that aesthetic experience cannot do without our wavering between competing states of absorption and self-awareness. Aesthetic slowness today urges us to take time probing different modalities of sensory perception and precisely thus warrant the viability of aesthetic experience. To go slow, in what follows,

intends to explore heterogeneous modalities of perceiving time and space without being pressed for acts of seamless reconciliation; it approaches the zone of indeterminacy between self and other as a zone, not only of the unexpected, but of bliss, shudder, and rapture. It is now time to move on and see how artists in the last decades, with various media and at various locations, have explored slowness as a viable gateway, not only to sensory pleasure, but to aesthetic experience in this more rigorous sense.

TWO

OPEN SHUTTER
PHOTOGRAPHY AND THE ART
OF SLOW SEEING

1 /

Toward the end of his life, Henri Cartier-Bresson—the master of twentieth-century street photography—turned away from the camera so as to revive his earlier passion for painting and drawing. Having dedicated major portions of his career to the art of rapid seeing, of fixing time in the singularity of an instant, around 1970 he suddenly felt a profound urge for slowing down and cultivating modes of seeing guided by the tranquillity of a painter's continuous brushstroke. In the foreword to his 1952 portfolio, *The Decisive Moment*, Cartier-Bresson had summarized his photographic project as such: "To me, photography is the simultaneous recognition, in a fraction of a second, of the significance of an event as well as of a precise organization of forms that give that event its proper expression."[1] Accordingly, photography's task was not simply to slice individual moments out of the continuum of time and embalm them for future generations. It was to capture critical contractions of temporality: instants pregnant with historical energies and meaning, sudden events rupturing the ordinary flow of time, extraordinary folds within the fabric of the everyday that had the power to speak for larger personal or political reconfigurations. When Cartier-Bresson, around 1970, abandoned the camera, he did so because he was

no longer willing to remain in step with the logic and pace of decisive moments. For Cartier-Bresson, to paint rather than release the shutter meant to forsake his earlier conception of time as a dialectic of the continuous and the discontinuous, the mundane and the unexpected, determination and contingency, *chronos* and *kairos*—a conception according to which reality was at its most real whenever it approximated the logic of photographic exposure itself, suspended the rule of linear time, and crystallized into an image of dynamic forces at a standstill.

Similar to the course of modern industrial society, the history of photography is one of ever increasing speed and acceleration. Long exposure times, during the first decades of photographic reproduction, compelled photographers and their subjects alike to remain still for minutes, that is, simulate death in front of the camera so at to allow future viewers to experience a ghostlike entry of the past into their present. The introduction of celluloid film base in 1887 and Kodak's first box camera in 1888 not only democratized photography but also enabled nonprofessional users to capture snapshots whenever they seemed apposite. The development of lightweight cameras in the mid-1920s increased the speed and flexibility of taking pictures, while the arrival of Polaroid cameras in the late 1940s dramatically decreased the time between the moment of exposure and the viewing of developed images. The advent of digital photography in the mid-1990s, finally, completely erased the time between the act of taking a picture and the one of seeing it, no matter whether or not we rework certain images at a later moment on our computers.

The critical writing on photography has largely followed this trajectory of acceleration inasmuch as it has come to consider the shutter's increasing speed as an effective tool to cut distinct slices through time and redeem passing moments from the forces of forgetting. According to this dominant tradition of thought, in its technologically mature form, photography administers sudden shocks to the linear progress of time; it makes use of the camera's speed to disrupt the continuum of history and fix individual moments for eternity; it participates in and outflanks the modern compression and acceleration of time by capturing decisive moments and extending traumatic violence to the transient flow of history. Photography, in the texts of its seminal theorists such as Walter Benjamin, Roland Barthes, and Susan Sontag, is pri-

marily presented as an art of fast seeing, a technology that enables us to wrest unique instants away from the current of history and preserve these for the future. It may unlock what has never been seen before, introduce us to the optical unconscious, bless us with epiphanic insight, and serve as uncanny memory prosthesis. Yet it can only do so because photographers understand how to use their camera's speed as a medium to encounter and withstand the otherwise unstoppable rush of time. Photography, in this understanding, punctures the linear and ultimately meaningless stream of the ephemeral for the sake of infusing meaning into the historical process. It pictures the present's transience from a standpoint in whose perspective the extraordinary and singular alone do matter, that is, kairos reigns over chronos, catastrophe and crisis annul entropy and mere flow.

Cartier-Bresson's renunciation of photography wanted to break with this critical writing on photography and the conception of the camera as a tool of fast seeing. To take up painting, for him, meant to redeem himself from the dominant understanding of the photographic image as a slice through time and as a redemption, and embalming, of the at once singular and paradigmatic. Exhausted from hunting after sudden contractions of historical temporality, he was now ready to favor the continuous over the discontinuous, linear over catastrophic time, flow over rupture, extended duration over traumatic caesura and, in order to achieve this, he could not but exchange the newer medium of the camera for the older one of the paintbrush and draftsman's pen. Or so, at least, it appeared to him—and falsely so, as I would like to argue in this chapter. For Cartier-Bresson's turning away from photography not only failed to consider the possibility of viable strategies of photographic slowness, it continued to rest on and thus reinscribed that very reductive juxtaposition of linear and catastrophic time, flow and interruption, dynamic temporality and static space that had given birth to the privileging of photography as an art of rapid seeing in the first place. In his flight away from photography, Cartier-Bresson hoped to escape the camera's presumed complicity with modern acceleration, speed, and transitoriness, whereas the true challenge would have been to break away from a thinking about both modern temporality and the art of photographic seeing that cannot but envision slowness as merely a leftover from the past amid the velocity of modern culture.

Cartier-Bresson saluted the art of the older medium of painting as slow and redemptive because he considered it to be modern speed's repressed. To slow down, for him, meant to turn his back on twentieth-century acceleration, the century's dedication to trauma, shock, catastrophe, and crisis. Yet in so doing he secretly confirmed the conception of modern culture as one whose notion of time and history is profoundly shaped by the understanding of photography to begin with. And he failed to explore alternate concepts of both the modern and the logic of the camera that might recognize the layering of different durations, the simultaneous copresence of dissimilar temporalities, as one of the key features of what defines modernity as modern.

In 1936 former Bauhaus member László Moholy-Nagy identified as one among eight varieties of photographic vision the option of "slow seeing by means of the fixation of movements spread over a period of time: e.g., the luminous tracks made by the headlights of motor cars passing along a road at night: prolonged time exposures."[2] Himself an ardent apologist of modern tempo,[3] Moholy-Nagy didn't really expand on how photographers could practice this art of slow seeing and thus break the spell of the modern discourse on photography, the dominant doctrine of the decisive moment. But in advocating the use of long time exposures, the capturing of motion across extended durations, Moholy-Nagy—unlike Cartier-Bresson—emancipated the photographic image from the understanding of modern history as a dialectic of the linear and the catastrophic, as much as he indicated the possibility of embracing slowness as a legitimate element of modernist aesthetic practice itself. Slow seeing, as presented in Moholy-Nagy's example, is exercised in an encounter with what chapter 1 discussed as the arguably most emblematic sign of modern mobility and speed: a car. And the traces thus captured by the photographic image—this layering of polyrhythmic itineraries, striated velocities, and differential speeds within one and the same picture—are made possible by nothing other than the equally important emblem of modern life: electric light. Although Moholy-Nagy in his 1936 remark leaves many questions unanswered, he certainly suggests that even photographers can go slow without violating the logic of their medium or withdrawing from the defining features of industrial existence. To slow down, here, is an effect of situating oneself in a certain way within the streams and flows

that mark modern life; to face rather than turn away from what, in modern times, seems to cause everything solid to melt into thin air.[4]

This chapter probes Moholy-Nagy's notion of slow seeing by exploring the work of two contemporary photographers whose images not only rely on prolonged exposure times but seek to capture—from a postindustrial vista indeed—central elements of industrialism's culture of transport, speed, mobility, and light. The focus will be on Hiroshi Sugimoto's so-called theater series, begun in the 1970s and continuing into the 1990s, and Michael Wesely's images of German and European train stations of the 1990s. In the work of both photographers, the calculated use of open shutter techniques—of exposure times ranging from minutes to several years—raises fundamental questions about our modes of prosthetic looking, the nature of photography, the limits of photographic authorship, and the articulation of movement, space, and time within the photographic image. Though dedicated to capture different material objects and human constellations, both photographers put to work the indexical nature of photography in such a way that we come to witness not only things no human eye could ever see, but the transformation of photography into an art of mapping different temporal logics and ambivalent durational experiences. Rather than reducing photography to a medium of rapid seeing, Sugimoto and Wesely revision modern culture as a site of pluralistic, frequently illegible, and often incompatible trajectories of change. There is not one time that is at play in modern culture but a whole panoply of different temporalities. And to slow down is, not to abandon the modern all together, but to behold and probe the overlapping durations that structure modern time; not to hunt for the fraction of the second, but to gaze head-on at the differential paces of objects, architectural configurations, technologies, modes of transport, tools of entertainment, human bodies, and forms of sensory perceptions that might meet at one and the same place.

2 /

Aside from factory whistles and assembly line production, cinema and train travel may very well stand out as the most important agents in

the standardization of temporal experience during the last hundred and fifty years. The proliferation of railway lines in the second half of the nineteenth century in Europe and North America produced enormous pressures to do away with local time zones and to see one's own location within the frame of reliable timetables and synchronized clocks.[5] Nothing in the technological makeup of motion pictures around 1900 stipulated that film would necessarily turn into what it came to mean to audiences within a few decades; early projection conditions had been quite aleatory—a hodgepodge of different film genres, film speeds, and film lengths. And yet, by the time synchronized sound conquered movie theaters in the late 1920s, film institutionalized itself as something that should last roughly between ninety and hundred and twenty minutes and should be projected at one standardized frame speed. Cinema, as Jean-Luc Godard once famously put it, is truth twenty-four times per second. It was able to entertain, distract, reveal, redeem, and produce insight, not least of all because cinema's images and sounds come to viewers in calculable and, in this respect, streamlined temporal forms.

A certain sense of calculability and standardization also seems to be what has driven Japanese photographer Hiroshi Sugimoto to photograph the interior of movie theaters since the mid-1970s in different international locations (figures 2.1 and 2.2). All these images are energized by one and the same concept: to picture a theater's screen during the duration of an entire movie or, to be more precise, to picture the entire duration of a movie, thus producing images in which the theater's screen—due to the ongoing reflection of different intensities of light—will turn out to be entirely white. Blank, albeit mysteriously glowing. Vacated and yet articulating a sense of "too much." Void of all that which normally matters to us when going to the movies. A bright hole in the middle of a moderately lit auditorium. Whether shot in Los Angeles, New York, or Tokyo, the vast majority of Sugimoto's theater shots are taken in lavish theater palaces of the 1920s and 1930s: architectural remnants of the classical period of film consumption when film moved from silent to sound and the act of going to the movies still had the thrill of encountering the wonder of mechanically reproduced images. All shots are taken from a central point of view, often from the rear of the auditorium and, when possible, an elevated vista such as a

FIGURE 2.1. Hiroshi Sugimoto, *U.A. Walker, New York* (1978). Copyright © Hiroshi Sugimoto, courtesy of Fraenkel Gallery, San Francisco. Image courtesy of Fraenkel Gallery, San Francisco.

balcony or grand tier. With a few exceptions, in the vast majority of photographs the screen's luminous square takes up no more than a fifth or sixth of the image space; in this way we can also peruse the theater's interior architecture, these palaces' lush ornamentation often seemingly reflecting the screen's white light, yet at the same time serving as a frame for and hence enabling the emanation of this light in the first place. In none of these images do we detect the presence of any spectator, of audiences entranced by the most entrancing window of the modern distraction industry.

"What we can see in the sunlight," Charles Baudelaire noted around 1860, "is always less interesting than what transpires behind the panes of a window. In that dark or luminous hole, life lives, life dreams, life suffers."[6] Baudelaire understood windows as screens of imaginary transport. Rather than merely framing the real, windows energize the

imagination. They stimulate the mind's eye to make up stories and tell legends about the world. As important, windows invite the observer to live, rejoice, and suffer in others, to feel for and feel with those on the other side of the pane. Cinema, as it came to celebrate itself in the 1920s and 1930s as the primary medium of modern entertainment, embraced one half of Baudelaire's fenestral thrill at the cost of subduing the other.[7] In those sumptuous movie places pictured by Sugimoto, classical narrative cinema appealed to the viewer as a seemingly transparent window allowing us to live the lives of others, to be and become other, to dream of alternate realities and suffer with the fate of our heroes. Yet it did so by seeking to absorb the audience's temporal experience into a film's efficiently organized narrative drive, by reconstituting our sense of time within the cause-and-effect chains of character-centered stories that left little or no space to make up our own stories, imagine different narrative twists, or simply enjoy the sight of the accidental and incommensurable. Whereas Baudelaire's praise of the window emphasized the adventure of vacillating between looking at and looking through the window's frame, the window of classical narrative cinema wanted spectators to forget that they were facing a screen in the first place. It eliminated Baudelaire's dual and ambivalent pleasure by drawing the viewer through the screen's frame into the trajectory of a decisively forward-moving story whose ending was designed to resolve all open questions.

Sugimoto always leaves us in the dark about the kind of films his camera transforms into mysteriously glowing rectangles, screens frustrating our desire to see other lives live, dream, and suffer. Nor does he ever picture theaters packed with viewers, their gaze directed at the screen's window, their bodies transfixed in their chairs, their appearance serving as our perceptual proxy, our avatar, within the frame of the image. Moreover, it will remain Sugimoto's secret whether differences in the illumination of his auditoriums resulted from varying the settings of his aperture or from different durations of certain films pictured and hence from different sum totals of the projected light during the time of exposure. What is clear, however, in spite of all the mysteries that come with Sugimoto's theater series, is the fact that these images engage their viewers in startling negotiations between different temporalities and durational extensions and that, in doing so, in not

FIGURE 2.2. Hiroshi Sugimoto, *Radio City Music Hall* (1977). Copyright © Hiroshi Sugimoto, courtesy of Fraenkel Gallery, San Francisco. Image courtesy of Fraenkel Gallery, San Francisco.

allowing us to subject our dreams and desires to the narrative drive depicted on screen, they recuperate some of the pleasures Baudelaire experienced vis-à-vis urban windowpanes long before the advent of cinematic entertainment. Sugimoto's images are sites of stunning perceptual reversal and transposition, of ironic juxtaposition and irresolvable multiplicity. In each of these images, the screen's aura—the astonishing here and now of its luminosity—is a product of Sugimoto's utterly proficient technological manipulation and his attempt to overturn Cartier-Bresson's dedication to the unique and decisive moment. And whatever, in this series of images, at first might appear as hermetic and inexplicable is unthinkable without the conceptual impetus, the analytical rigor and precision, of Sugimoto's work. As in the grail of Wagner's *Parsifal*, time here seems to turn into space, yet nothing should make us think that we could ever possess spatialized time like

an object, stick it into our pocket so as to carry it home like a trophy. Space here is and remains as intractable as the flux of time.

"Elegant *surface splendor*," wrote Siegfried Kracauer in 1926 about the kind of cinemas to which Sugimoto's photographs return our longing, "is the hallmark of these mass theaters. Like hotel lobbies, they are shrines to the cultivation of pleasure; their glamour aims at edification."[8] Yet precisely in elevating modern pleasure to the level of a cult and fetish, dominant commercial cinema—as Kracauer continues to argue—tends to rob modern distraction of its meaning and potential, namely to make spectators recognize their own sense of alienation and fragmentation in an age of secularization. For Kracauer, the classical movie palace, instead of allowing the viewer to recognize the essentially decentered nature of modern life, serves as a site for the deceitful temporal compression and phantasmagorical totalization of what is separated. Movie palaces endow with ritual meaning and spiritual transcendence what has obliterated the sacred and exchange contemplative attitudes with nervous diversions. In the eyes of Kracauer, these highly stylized interiors function like shrines; they invite pilgrimages to the modern fetish of entertainment, to how the twentieth-century culture industry trades in images of fulfilled self-presence and promises to redeem us from the entropy of ordinary life.

Photography, Christian Metz argued in the early 1980s, is better fit than film to work as a fetish, that is, to proliferate objects that seem to own magical qualities, demand our unconditional devotion, and thus involve the viewer in a beguiling process of displacement and substitution.[9] The reasons for this, according to Metz, are threefold. First, due to its relative smallness and the absence of predetermined durations of reception, photographic images invite viewers to cast a lingering gaze, one that potentially situates spectators as masters of the look and hence—unlike the imposed viewing time of film—allows them to absorb and be absorbed by isolated details. Second, whereas film immerses the viewer in movement, the representational logic of photography is essentially tied to immobility and silence, to paired down perceptions of timelessness that are comparable to the work of the unconscious and memory. Third, and finally, photography defines the boundaries between on-frame and off-frame space fundamentally different from how film relates the visible and the unseen. Whereas the filmic off-frame is sub-

stantial, i.e., has a certain presence and structures our knowledge and identification, the photographic off-frame is subtle, refuses ever to enter the frame, and will always remain unheard. As a series of successive frames and camera movements, film invites us to see the visible world as one of ongoing connections, stories, and transformations. Photography, on the other hand, because it cannot supersede the initial exclusion of off-frame space in the course of time, pictures the presence of the past as if trying to maintain the memory of the dead as being dead. Precisely because the photographic image is resilient to change and strategies of reframing, we tend to treasure it like a repository of magical powers, a supernatural object that supplants our ordinary mechanisms of perception and recollection.

Sugimoto's theater pictures suspend the viewer somewhere in between photography's immobility and melancholic fixation and film's emphasis on livingness and transformation, and, in so doing, these images make us rethink the link between mechanical reproduction and the fetish. Though highly attentive to issues of framing, Sugimoto's long exposure times cause the viewer to reconsider the power of the screen's frame as it dominates the very center of his photographs. Whereas the logic of photography, according to Metz, relies on an unbending juxtaposition of on- and off-screen space, the luminous whiteness of Sugimoto's screens is, of course, nothing other than the product of the camera recording a continued process of ongoing reframing, of inscribing film's substantial space in the middle of photography's subtle space. Photography is thus emancipated from merely remembering what is dead as being dead, just as much as film emerges as a medium not exclusively held to absorb each and every detail within a forward drive of a self-contained narrative. Sugimoto's slow frames are closed and open at the same time. Photography here absorbs film just as much as film seems to help drive photography beyond its own representational logic. As a result, these images fundamentally rework the differential times of reception and reading associated with the medium of photography and film respectively. Indexing the duration of an entire film within the space of a seemingly immobile image, Sugimoto's images allow us to break away from any desire to see photography or film as being structured by one single temporal logic in the first place. Photography here maps film as a medium of elusive intensities and

mysterious transcendence, whereas film energizes the photographic image in such a way that it transcends its own tendencies to become and be a fetish. If the tense of mainstream photography is the past perfect, insisting on the completion of some action in the past itself; and if the tense of narrative filmmaking is the present perfect, situating the past as something that actively reaches into our own present; then Sugimoto's theater pictures layer different temporal trajectories and materialities such that we cannot but fail to assign one single tense to what they show and how we see it in the first place. Rather than exploring a world over and done with, or one propelling us impatiently into the future, Sugimoto pictures the presence of the past as one extended now in whose space we can enjoy the pleasures of losing our normal temporal bearing. Whereas Bragaglia, in his open shutter images of typists and cello players of the 1910s (figure 1.2), erased the present in the name of a speedy future, Sugimoto slows down the workings of chronological time for the sake of illuminating the various durations and directions that meet in what we call the present and what may serve us as the ground for defining us as contemporaries.

Sugimoto's theater images recall the shrines of modern distraction, not as something dedicated to photography's emphasis on catastrophic rupture and singularity, nor as something structured by film's stress on forward-moving and teleological narrative. Instead, these images picture the movie palaces of the early twentieth century as sites transporting contemporary viewers through different times and relating us to dissimilar durations within one and the same space—as sites at which neither the modernist logic of the traumatic point nor the one of linear progress can claim exclusive dominance. Exasperated by the traumatic course of modern history—the way in which modern history seemed to follow the temporal logic of photography and film simultaneously— Walter Benjamin noted, toward the end of his life, "Marx says that revolutions are the locomotives of world history. But perhaps it is quite otherwise. Perhaps revolutions are an attempt by the passengers on this train—namely, the human race—to activate the emergency brake."[10] In Sugimoto's remapping of modern cinematic entertainment, history has no need for revolutionary ruptures nor for sudden acts of pulling the emergency brake. For history, as seen through the open shutter of Sugimoto's camera, always unfolds in the plural and approaches us as

a site of multiplicity and coevalness. To stay within Benjamin's image, there is always more than one train that traverses the present at any one given moment in time. And even though cinema, from its very inception, was marked by a special kinship with the locomotive and the experience of railway travel,[11] nothing could be more mistaken in the eyes of Sugimoto than to think of history as a film carrying us like a train track, and therefore in a linear fashion, from one point to another. History and historical memory, for Sugimoto, can neither be reduced to the logic of a photographic snapshot nor to that of narrative filmmaking. It neither unfolds as a series of discontinuous crystallizations nor as linear narrative. Instead, history emerges in the hybrid space between the filmic and the photographic, the sudden and the durational. It is neither a rushing train nor an immobile compartment seat, but both at once: a site for the experience of differential speeds and durations whose multiplicity cannot be contained or halted with a simple pull of the emergency brake.

3 /

In our age of TGVs, ICEs, Eurostars, and Acelas, the speed of early trains would surely bore us to death. Yet, in the eyes of nineteenth-century passengers, train travel resulted in a profound destabilization of perception, an at once seductive and catastrophic shrinkage of space and time that overwhelmed the traveler's perception with an overload of discontinuous stimuli.[12] Here's what German poet Heinrich Heine wrote about a train ride he took from Paris to Rouen and Orleans in 1843:

> What changes must now occur, in our way of looking at things, in our notions! Even the elementary concepts of time and space have begun to vacillate. Space is killed by the railway, and we are left with time alone. . . . Now you can travel to Orleans in four and a half hours, and it takes no longer to get to Rouen. Just imagine what will happen when the lines to Belgium and Germany are completed and connected up with their railways! I feel as if the mountains and forests of all countries were advancing on Paris. Even now, I can smell the German linden trees: the North Sea's breakers are rolling against my door.[13]

The speed of train travel, for Heine and many of his contemporaries, led to an unsettling annihilation of space, a compression of spatial extensions that invalidated customary modes of mapping and inhabiting the world. Yet even the survival of time after the sudden death of space had little consolation to offer. For once the waves of faraway oceans were able to knock directly on the doors of Paris apartments; time was no longer experienced as the unfolding of certified meanings along an integrated steady continuum, but as a series of discontinuous shocks and potentially traumatic displacements. To be left with time alone meant to experience temporality as a sequence of nonsequential contractions, a string of sudden events that knew of no durational integrity. Shrinking space and pulverizing temporal extensions, the velocity of trains in this understanding did to early travelers what that other great innovation of the 1830s, photography, following dominant discourse, did to our experience of time and space, namely reduce spatial spread to a static and framed slice while redefining the temporal as an ever accelerating succession of memorable and decisive, albeit inherently catastrophic, moments.

Trains and photographic images, if we are to tag along a prevalent reading of nineteenth- to twenty-first-century modernization, meant to industrialist society what the fast-paced streams of commodities, investments, technologies, and electronic entertainments mean to our own age of post–cold war globalization. All of them, it is said, shrink space and lead to a fragmentation or compression of time. All of them make us traverse, immerse ourselves into, or consume various topographies without recognizing the boundaries of local contexts as defining limits. Some critics might argue that photographs and trains, just like networks of digital communication and trade in our own age, might primarily erase the materiality of space and thus turn us into permanent nomads and exiles, into addicts of the virtual. Others might interpret the link between early industrial and our own culture of unbound capitalism as one defined by the weakening of temporal boundaries and a concomitant evaporation of the present in the name of past and future. What critics commonly share, however, is the assumption that the perceptual settings of trains and photographic cameras erase durational experience and, similar to today's circuits of globalized trade

and ever increasing bandwidths of communication, favor the instanta-
neous over the extended, Cartier-Bresson's decisive moment over the
labyrinth of memory, the slice, point, and click over the durational. What
all might agree upon is the fact that in order to become citizens of the
epoch of railway transport and photography as much as the post–cold
war age of global interchange, people had to part from former templates
of linear time and continuous space; that, in order to navigate the con-
dition of early industrial as much as of triumphant global capitalism,
we needed to reset our clocks and compasses and learn how to exist in
various spaces and histories at once.

Enter German photographer Michael Wesely, born in 1963, educated
at the Academy of Fine Arts in Munich, and ever eager, by retooling
the photographic apparatus and training his modified cameras for
extended periods onto the architectures of post–cold war life, to make
us rethink our relation to the passing of time and the geographies of
our present. Wesely's work includes slit-lens photographs of palaces in
Rome (1995) and of East German landscapes (2002–2004) that turn
natural and man-made environments into abstract horizontal and ver-
tical bands of color; portraits of famous twentieth-century architects
shown in front of their structures or at work in their offices in pictures
that, due to extended exposure times, often do not allow us to discern
the sitters exact bodily features; pictures of architectural projects such
as the massive rebuilding of Potsdamer Platz in Berlin during the 1990s
and the remaking of the Museum of Modern Art in New York between
2001 and 2004, projects that Wesely captured with his camera shutter
open for several years so as to create a perplexing layering of the old
and the new, the static and the dynamic; and images of German, Euro-
pean, and South American soccer stadiums (2005) exposed during the
period of an entire game and thus showing given architectural struc-
tures in sharp focus and fans on the stands as blurred fields of color
while the players on the pitch—because of their ongoing movement—
vanish from sight altogether.

And then there is Wesely's conceptually perhaps most compelling
work of the early 1990s: a series of open shutter photographs taken in
German, Austrian, and Eastern European train stations (figures 2.3
and 2.4). The basic concept of Wesely's series is relatively simple; its

FIGURE 2.3. Michael Wesely, *Praha 15.10 – Linz 20.22* (1992). Copyright © 2013 Artists Rights Society (ARS), New York/VG Bild-Kunst, Bonn.

phenomenological, aesthetic, and political implications are however stunningly complex. In each of these images the camera is positioned on a different station's platform (Prague, Berlin, Munich, Hamburg, Hanover), its lens aimed at a departing train like the eyes of a person bidding farewell to a friend in one of the cars. Yet, instead of isolating the decisive moment of departure, the shutter of Wesely's camera will remain open until the train arrives in its scheduled destination, be it Budapest, Linz, or Munich—be it five, seven, or ten hours later. The consequences of Wesely's prolonged exposure times are stunning and often uncanny. We see and see through the spectral contours of travelers in the foreground, the faint traces of their waiting layered over the clearly discernible sight of a bench underneath them. We see blurred bands of light and shadow to the left and right, left by numerous passing trains during the time of exposure. We see station clocks, their numbers shown in perfect focus, their hands completely invisible due to their ongoing

motion; we see stationary arrival signs pronouncing the photographer's location and movable departure signs not showing any destination at all because they never displayed long enough to impact the silver halide salts of Wesely's slow negative film. We see the impressive structures of Prague's, Hamburg's, and, to a lesser extent, Berlin's train stations in great detail, monuments to how high industrialism employed the man-made materials of glass and iron to accommodate the itineraries of a modern age of ongoing mobility and flux. Yet what we, in spite of, better, because of these images' long exposure times, do not see is any visible difference between night and day, dawn or dusk. No matter whether our departing train traveled through the night or into the day, Wesely's train stations are bathed in the always same light, a diffuse, nameless, utterly even illumination.

And what we, aside from all this, do not see at all in Wesely's images is the sight of the train itself whose departure had triggered the shutter release and whose itinerary lent each of these images its name and co-ordinates. Though hubs of movement and transaction, of ongoing arrival and departure, of painful longing and joyous reunion, Wesely's train stations resemble ghost towns, largely emptied of what invigorates them when seeing them, not with the camera's prosthetic eye, but the nervous visual organ of the traveler. Wesely's platforms emerge as strangely forgotten places, as spooky and extraterrestrial. Open shutter photography, precisely by layering different movements and durations within the frame of one and the same image, thus emerges as an art of subtraction. In some sense, it could be seen as deducting the fast and furious from the slow and sluggish. It might be more accurate to say, however, that it folds the accelerated rhythms of today's traffic and connectivity into the fabric of what is lasting and more permanent, not in order to underwrite the latter and simply tuck away the earlier, but in order to sharpen our awareness for the differential speeds and temporalities that structure the unbound landscapes after the end of the Iron Curtain. While open shutter photography—as we had seen with Braga-glia's photodynamism of the 1910s—can no doubt tend toward abstraction, toward eliminating signs of contingency and flux in the name of the unchanging and archetypal, in the case of Wesely's station pictures it exposes the uncanny simultaneity of past, present, and future, of here and there, effected by the very historical transformation that redefined

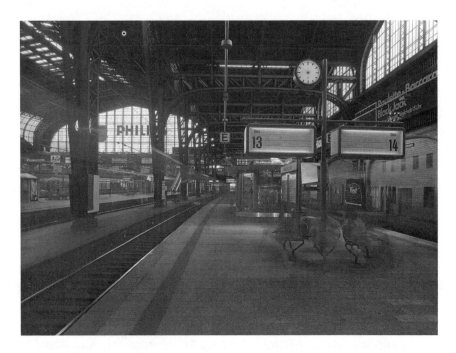

FIGURE 2.4. Michael Wesely, *Hamburg 9:07–Munich 18:06* (1992). Copyright © 2013 Artists Rights Society (ARS), New York/VG Bild-Kunst, Bonn.

cities such as Berlin, Prague, Budapest, and Munich as part of a new network of material and symbolic exchanges. The seeming absence of temporal specificity is these images' precise temporal and historical index. The clock's missing hands (figure 2.5) are the sundials of a history in whose wake neither the industrial city nor the nation nor the political blocs of the cold war offer defining limits and may anchor the itineraries of everyday life within the topographies of the present. All numbers, and yet unable to tell us the time, Wesely's uncanny clocks are witness to a historical moment in which insular notions of the local—of unified identities, demarcated territories, and distinct presences—no longer appeared viable because, after the collapse of the Soviet Empire, the open and fast-paced form of the network emerged as the perhaps dominant structure of communication, collaboration, and cultural production.

According to Norbert Elias, the proliferation of human networks in modernity has a direct impact on our experience of social tempos and

FIGURE 2.5. Michael Wesely, *Hamburg 9:07–Munich 18:06* (1992). Detail. Copyright © 2013 Artists Rights Society (ARS), New York/VG Bild-Kunst, Bonn.

processes of acceleration.[14] The denser the network, that is to say, the higher the number of routes intersecting at each of a network's nodes, the larger the pressure to make selections in ever shorter time and hence the greater a particular node's perception of social speed. Networks provide scattered structures of interaction and cooperation whose routes are fluid, dispersed, multiple, and often unpredictable. Contrary to earlier modes of organizing connections and collaborative relationships, networks today are the organizational form of societies in which the exchange of immaterial goods—of information, knowledge, and ideas—has become dominant. Though networks are certainly not free of asymmetrical distributions of power, they comprise openwork fabrics in which channels of communication cross at regular or irregular intervals. Rather than disseminating and dispersing immaterial goods from one central location, networks process information simultaneously and often along random pathways. They might predetermine some of the ways in which people can exchange thoughts, images, and sounds, but in making use of networks to transfer immaterial goods we constantly create and recreate them in the first place. While we might speak of a network's identity or meaning, each of its nodes will always preserve

its singularity and difference, defined not by what it is in and of itself, but by its peculiar set of connections to other surrounding nodes: its specific location within the overall net; its various options to receive, route, manage, or store changing data; and its ability to establish new links and passages to other elements—new or old—within the network.[15]

Contemporary social theory often suggests that the pressure of acceleration as produced by the post–cold war rise of global networks cannot but result in a pathological desynchronization of temporal experience.[16] Overwhelmed by ever more intense flows of information, and the demand to make more decisions in ever shorter periods of time, we are no longer able, so the argument goes, to coordinate the three constitutive dimensions of social acceleration in a networked society, namely the increasing speed of technological innovation, transport, and communication; the intensifying velocity of larger social transformations as they recalibrate the relevant relations of past, present, and future; and, finally, the escalating tempo of our individual life trajectories and everyday calendars. Acceleration may produce its own jinks, jams, and blockages. As important, however, it leads to a painful disintegration of life time and world time, of being able to see and experience the different dimensions of acceleration as some kind of meaningful totality.

Michael Wesely's open shutter images of the early 1990s explore contemporary processes of desynchronization, not as signs of fundamental pathologies, but as catalysts of aesthetic experience and formal experimentation. Rather than entirely denying the breathless speed of compulsive connectivity today, Wesely's photographs encourage viewers simultaneously to absorb and being absorbed by the streams of global deterritorialization. Desynchronization here becomes an aesthetic strategy to reveal the vibrant copresence of multiple speeds, durations, and temporalities; as much as to push the medium of photography toward and perhaps even beyond its limit. The present of Wesely's images is a profoundly expanded one, yet one emancipated from the drive of defining mobility merely in terms of linear movement. What makes these images tick is the fact that they probe the extent to which motion and acts of ongoing displacement constitute our understanding of place and location; that the near cannot be thought without the far; that any present is a future's past even though—or precisely because—neither past, present, nor future ever come merely in the singular. Wesely's images

track space as an open-ended dynamic of departures, traversal, and arrivals. Hamburg is as much in Munich as Munich's potentiality since we cannot think of any specific moment as being autonomous from various trajectories and itineraries that cut through it, as being a self-contained and hence a frozen slice though time. Wesely thus presents us space as a heterogeneity of different movements and processes, a dynamic topography structured by untidy beginnings, uncontained ends, and ongoing stories. Contrary to the ideologies of the cold war, space here can never be owned by means of defining territorial boundaries and bounded national narratives. It no longer forms a completed simultaneity in which all relations and connections have been defined and established while unforeseen links, loose threads, and surprising transgressions—a fizzling out of certain knots in the fabric—are being excluded. In Wesely's open shutter photography, space instead emerges, in Doreen Massey's words, as a "dynamic simultaneity, constantly disconnected by new arrivals, constantly waiting to be determined (and therefore always underdetermined) by the construction of new relations. It is always being made and always, therefore, in a sense, unfinished (except that 'finishing' is not on the agenda)."[17]

Somewhat reminiscent of the critical role of blur in the photo-paintings of Gerhard Richter,[18] the partial fuzziness of Wesely's photographic work sharpens our attention for that which escapes our sight. It slows down our seeing and thus expands our present, not out of some nostalgic longing for a past of strong local identifications and sluggish timetables, nor for the sake of decoupling body and world and taking us on a ride that displaces the body's materiality and sensory experience. Rather, to practice the art of slowness in a world of unbound connectivity, here means to recognize that the perceiving body has some originary technical base already; that cameras, instead of elevating the phenomenal body to the level of the apparatical or rendering the apparatical natural, can help expand human experience by enabling new couplings between the organism and its spatiotemporal environments; and that therefore the virtuality of an expanded present amid our age of quick-change and informational acceleration isn't merely the product of a special effect, but can become visible solely because acts of virtualization are part and parcel of our bodily experience to begin with, our motion through and being in time.[19] Wesely's images succeed in expanding the

space of the present, not because they exchange the human for an automaton's eye, but, on the contrary, because they rely on the fact that human embodiment cannot do without, secretly or outspokenly, being familiar with the intractability of time and the folds of virtualization within the very fabric of the present. Without the fact that we are never entirely at home in a static present and could own our bodies like objects. The fact that we are mere custodians of our phenomenal bodies and hence need to consider our sensory location in time as merely a crossroad, a medium, of multiple temporal experiences.[20]

4 /

In a famous passage of his *Phenomenology of Perception*, Maurice Merleau-Ponty writes:

> How can anything ever present itself truly to us since its synthesis is never completed? How could I gain experience of the world, as I would of an individual actuating his own existence, since none of the views or perceptions I have of it can exhaust it and the horizons remain forever open? . . . The belief in things and in the world can only express the assumption of a complete synthesis. Its completion, however, is made impossible by the very nature of the perspectives to be connected, since each of them sends back to other perspectives through its own horizons. . . . The contradiction which we feel exists between the ubiquity of consciousness and its commitment to a field of presence. This ambiguousness does not represent an imperfection in the nature of existence or in that of consciousness; it is its very definition. . . . Consciousness, which is commonly taken as an extremely enlightened region, is, on the contrary, the very region of indetermination.[21]

In its dominant modernist understanding, photography has often been reduced to a medium, not only mimicking the operations of human memory and consciousness, but achieving a heightened sense of presence, closure, and en-light-en-ment. Seen as being deeply implicated in the modern drive toward speed and acceleration, photography was

hailed as the ideal tool to express the fragmentation of modern tempo-
rality, the way in which modernity emphasized discontinuity, rupture,
and shock and considered history as a progressive tale of nonsequen-
tial departures, breaks, and traumatic interruptions. Photography, he-
roically, as it were, synthesized what resisted synthesis in modernity. It
captured the shrunken spaces and times of modern life as fields of ful-
filled presence, as contractions of historical temporality pregnant with
explosive meanings and energies, but also with ghostlike emanations
of unfulfilled pasts.[22] On some level, modernist aesthetic practice was
eager to abandon the idea of reaching some sense of final closure and
completion; it privileged contingency over tradition, crisis and catas-
trophe over the timeless and preordained. On a different level, how-
ever, it also pressed the photographer's camera to picture things as if
they had achieved some sense of final completion after all and thus
to identify what Baudelaire wanted modern art to find in general: the
eternal at the very heart of the ever changing, timeless meaning in the
very midst of ongoing flux and transformation, unadulterated pres-
ence and epiphany amid the most mundane and ephemeral progress of
time.[23]

Both Hiroshi Sugimoto and Michael Wesely break with this under-
standing of photography and modern temporality. As their images return
us to some of the key sites of modern industrial culture and mobility—
the classical movie theater, the railway station—these two photogra-
phers produce pictures in which no one could ever perceive oneself as
entirely present, as being able to achieve complete perceptual synthe-
sis. Instead of picturing modern temporality solely as one privileging
kairos over chronos and short bursts of attention over prolonged at-
tentiveness, Sugimoto and Wesely map modern time as an inconclusive
array of different durations and stories to be told. Not one perception,
not one single point of view, not one pregnant slice through time, could
ever exhaust all that could be seen and experienced. While their images
expose the copresence of different temporal layers and trajectories, their
peculiar techniques of open shutter photography defines this present
as something whose horizons cannot but remain forever open and whose
multiplicity resists any (photographic) grasp for closure and synthesis.
The slowness of open shutter photography in this way allows us to

relinquish any one-sided understanding of modern temporality as a regime of decisive moments, heightened presence, and catastrophic singularity. It enables the viewer to see the differential speeds and durational extensions that drive modern culture underneath its veneer of progress, directional haste, and traumatic discontinuity. To go slow, in Sugimoto and Wesely's perspective, means to encounter the sites of modern speed and acceleration with our shutters wide open. Slow seeing resists the hubris of trying to achieve complete perceptual interpretation, and it recognizes the inconclusiveness, the necessary blind spots, delays, and openness of perception and artistic representation. At once a product and response to our speedy times, slow seeing embraces our failure of ever attaining complete synthesis as modernity's greatest opportunity and triumph—as the only viable ground to become contemporary to our own times and better understand that no present can ever be fully transparent to itself.

Which leaves us with the one open question as to the status of the human body and its agency in both Sugimoto's and Wesely's image series. At first sight, both Sugimoto's and Wesely's technique of open shutter photography tends to favor what is lasting—the architectural and the immobile—over what is moving and in flux—the embodied and the variable, resulting in the seeming erasure of the human subject from the visual field. Don't both photographers, by subtracting the contingency of human embodiment from the visible space, ultimately collaborate with the reifying politics of industrial and postindustrial capital, namely its tendency to present architectural structures as breathtaking spectacles while at the same time obliterating the contingencies of human inhabitation, dwelling, and usage?[24] If reification under the sign of twentieth-century consumer capitalism, as Theodor W. Adorno already claimed in the 1940s, is nothing other than a process of forgetting,[25] aren't Sugimoto's and Wesely's images actively participating in this process by venerating the splendor—the objecthood—of material form and forgetting about the human subjects that maneuver these spaces? Does contemporary slowness, all told, make us thus complicit with the reifying tendency of the modern culture industry and the postmodern society of the spectacle?

Nothing, I would like to argue with regard to Sugimoto's and Wesely's work, would be more wrong than to associate their aesthetic of slowness

with spectacular capitalism's forces of reification and forgetting. Sugimoto's and Wesely's art of slow seeing may indeed often lead to a rendering invisible of the contours of the traditional humanist subject. A product of deliberate technological manipulations and conceptual interventions, their work aims at enhancing or recalibrating certain operations of the phenomenal body with prosthetic extensions that allow us to perceive things no eye could ever see as such. But precisely in presenting special effects as tools that have the capacity to retrain our human sensorium and augment new forms of phenomenological experience, Sugimoto's and Wesely's aesthetic of slowness opens a window for richer and more differential sensory encounters with the visible and invisible world around us. Slowness, as pursued in their work, emancipates the viewer from any one-dimensional drive toward progress and synthesis and instead helps us to explore the open and often ambivalent durations of perceptual experience that structure our view of the present. Far from obliterating human embodiment from the picture and hence replicating the reifying tendencies of late capitalism, slowness provides an opening, a fold within the fabrics of reification, in which we can experience the now in the mode of true contemporaries, namely as something whose inherent obscurity, multiplicity, and uncontainability invites us to recognize perceptual indetermination as an engine of particularity and freedom.

In *Still Moving: Between Cinema and Photography*, Karen Beckman and Jean Ma write: "The uncanny rhythms of hesitation, interruption, delay, and return released by photographic technologies undoubtedly contribute to the disintegration of organic constructs of memory and temporality, to the attenuation of older modes of historicism; at the same time, however, they open onto new capacities for action and reflection in the interstitial zones of private and public remembrance between individual subjectivity and a publics sphere of collective memory."[26] As practiced by Sugimoto and Wesely, open shutter photography is surely able to incite new ways of reflecting on what it means to occupy the folds between the private and public in our present. Their work engages with the monuments of modern(ist) culture without prompting viewers to cling to or to erase the remnants of the past. Though no longer chasing after decisive moments, Sugimoto's and Wesely's techniques of slow seeing no doubt result in a further disintegration of organic forms

of memory. At the same time, however, their work invites us to gaze straight into the face of our own open present, and it encourages viewers to actively ask themselves—with some sense of hesitation and deliberation—what kind of past we might want to carry with us into the future and what kind of history we are happy to leave behind.

THREE

GLACIAL VISIONS,
GEOLOGICAL TIME

1 /

Whenever, finally, all doors are locked and armed for departure, all seat belts are tightly buckled, and today's myriad of mobile communication devices have been powered down, it is time to enter what even most seasoned aviators continue to experience as a perplexing alternate order of time, space, and duration. At thirty thousand feet above the ground, even advanced flight information systems cannot but fail to persuade frequent flyers to perceive a plane's speed as a feature of their own bodies. Locked into their chairs, most passengers come to consider airplane time as dead time, a time void of becoming and surprise, a time as close to the essence of boredom as it might ever get, a time so far from meaning and motion that we happily indulge in viewing films whose dullness would otherwise bore us to death. While tremendous stretches of land or water pass by underneath us in the blink of an eye, we—as if paralyzed by the tenacious thickness of aviation time—tend to shut down our perception altogether, virtually untroubled by the distracting absence of visual distractions. Spending the flight's shapeless hours in drowsing, we might try to adjust our watches to the succession of different time zones, yet little do our bodies know what such adjustments really mean until—after

landing—we find ourselves waking up at the most inhospitable hour of the night.

A perhaps more fortunate variety of airline travelers, on the other hand, understands how to embrace the plane's suspension of ordinary time as deeply relaxing and refreshing. Viewed as a self-enclosed system of reference, the plane's speed and spatial progress, for this second type of traveler, provides a temporary niche to unwind from the rhythms of business and compulsive connectivity; to move along the edge of boredom so as to rediscover a sense of passing time in the first place. Unlike the first species of passengers, this other one experiences the plane's lack of temporal structure—the seemingly complete unmooring of temporality from spatial grounding—as something exhilarating, perhaps even truly intoxicating. Whether they enclose their perception with noise-reducing earphones, indefatigably turn the pages of their crime novels, or simply stare at never-ending sunsets: for this second set of flyers, airplane time gives cause to ponder the past, mull over the future, and engage in time travel of all kinds. It miraculously allows for the individual to travel with, in, through, against, and beyond the progress of time without much physical activity whatsoever.

Early writing on aviation saw little room for such wondrous acts of time shifting, nor was it able to envision boredom as a possible effect of air travel. Italian Futurists such as Filippo Tommaso Marinetti hailed aviation as a riveting spectacle of motion and speed, transporting the subject beyond the monotonous templates of bourgeois life while radically reducing the messy complexity of modern existence. "I feel my breast open like a great hole," Marinetti wrote in his 1912 prose poem, *The Pope's Monoplane*, "and all the azure of the sky, smooth, cool, and torrential, / pours joyously in. / I am an open window, in love with the sun / and flying toward it! / Who can stop / the windows now, hungry for clouds, / and the drunken balconies / tearing off the old house walls tonight / to spring into space?"[1] Aviation, for Marinetti as for many other speed addicts of the early twentieth century, freed the individual from the sluggish timetables of preindustrial society. It fueled simultaneously aristocratic and Dionysian visions of self-transcendence and renewal. Like a powerful drug, the plane's speed was deeply rhapsodic in nature. It intoxicated the subject with feelings of overwhelming power, carrying the body beyond itself.

It transformed the subject into a perception machine, one that would not hesitate to experience its own death as a source of exhilarating stimulation—as in the last scene of *The Pope's Monoplane*, when pilot and plane deliberately crash into Mount Etna in the hope of unifying with the primordial force, the volcanic violence, of Mother Earth.

And yet there is a strain of modernist writing on aviation in which the plane's velocity and altitude, rather than obliterating space and temporality altogether, intensifies the bodily aspects of perception so as to produce at once richer and strangely abstracted images of passing landscapes. Consider Gertrude Stein's famous remarks about aerial vision in which she juxtaposed the way we see the earth from an airplane to the way in which it may look to car or train passengers: "When I was in America I for the first time traveled pretty much all the time in an airplane and when I looked at the earth I saw all the lines of cubism, made at a time when not any painter had ever gone up in an airplane. I saw there on the earth the mingling of lines of Picasso, coming and going, developing and destroying themselves."[2] Aviation, for Stein, was neither about intoxicating the self with feelings of speed and visual mastery, nor about the engineering of posthuman technosubjects eager to find primordial forms of pleasure in the self's very disappearance. Instead, to be on and to look out from a plane caused Stein to see the natural world according to how cubist painters broke down spatial illusion, violated the defining power of the frame, and sought to inscribe the process of perception onto the canvas itself. Pablo Picasso or Georges Braque may have never flown on an airplane before painting their first cubist works, but in Stein's view the syntax of their paintings—the analytical reduction of depth and detail; the use of simplified forms, geometrical abstraction, and conflicting point of views; the emphasis on the temporality and heterogeneity of perception—correlated to a plane passenger's view right down onto the ground. Aviation here produced expanded forms of vision that did not reduce space to a mere image of frozen time. On the contrary, from Stein's elevated viewpoint spatial extensions emerged as a ground of dynamic lines, forms, trajectories, and temporalities; an energetic force field joining geographic features and human motion into a complex and multilayered assembly. Unlike the futurist aficionados of aviation, for whom the airplane's speed helped obliterate the messiness of modern existence and reduced space

to the unity of a singular trajectory, Stein welcomed airplane travel as a technology of vision whose very velocity enabled what this book considers to be the most profound phenomenological bliss of slowness: intensified experiences of both time and space as untidy, heterogeneous, layered, and mutually interrelated. The spatial, as seen from Stein's airplane, wasn't just about distance and traversal. Nor did it merely, like a photograph, arrest time, negate process, and hence fixate meaning. Space instead here was experienced as a site at which previously unrelated temporalities can meet each other, enter a dynamic and transitory configuration, and in so doing define a ground for the production of nothing less than novelty.

Almost a century after Stein, Berlin-based artist Olafur Eliasson and Japanese photographer Hiroyuki Masuyama repeatedly entered various airplanes to photograph, not the geometric spread of Midwestern farmland, but the pathway of various glaciers and rivers in Iceland (Eliasson) and the vast expanses of seemingly unbound continental passages (Masuyama). The resulting work—Eliasson's *The Glacier Series* (1999) and *The Jökla Series* (2004); Masuyama's light boxes such as *Tokyo-London* (2002), *Miami-Anchorage* (2004), *Flight Mont Blanc* (2006), and *Himalaya Flight* (2007)—continues Stein's venture of the 1910s as both artists embrace aerial vision as a means not only to complicate our sense of temporality, but in so doing redefine what we understand as a map, as strategies of mapping. Though both artists put to work very different artistic strategies indeed, Eliasson's and Masuyama's aerial photographs capture the overt or hidden timetables of the natural world as they become visible to observers who are themselves in motion. Similar to the open shutter work of Sugimoto and Wesely, yet relying on fundamentally different photographic techniques (seriality, digital manipulation), they picture space as a combination of multiple trajectories and temporalities, some of which are subjective while others are objective in nature. When looking at nature, Eliasson writes, "I don't find anything out there . . . I find my own relation to the spaces, or aspects of my relation to them. We see nature with our cultivated eyes. Again, there is no truthful nature, there is only your and my construct of such."[3] Eliasson's as much as Masuyma's cartographic efforts portray the natural world as an open-ended series of human perspectives; a

transitory product of cultural technologies such as the camera and the moving airplane; a shifting construct that displays its own rhetoric. And yet we shouldn't think that Eliasson's or Masuyama's stress on the temporary and fabricated truths of the natural world endows the viewer with imperial power over the field of vision. On the contrary, what is most striking about the work of both artists is the fact that they, in recalibrating the Romantic tradition of the sublime, allow us to witness a curious act of observational self-limitation and modesty: a sense of phenomenological humility produced by the remarkable meeting of aerial speed and the extended temporality of the earth's geology, of colossal glaciers and mountainscapes.

2 /

What we see are forty-two color prints of different glacial formations, each mounted on board and arranged in a neatly organized grid of six rows and seven columns, the total of which covers a wall space of about ninety by one hundred and fifty inches (figure 3.1). As if trying to fit its subject matter, the series's display is monumental indeed, an at first daunting spread of visual texture and detail. All images of this series are shot from above, although we do not see any trace of what allowed the photographer to assume this stunning bird-eye's perspective—no accidental glimpse of the tip of a wing, no sign of iridescence or refraction as produced by the aircraft's window pane. It is impossible to say whether at least some of these pictures have been shot with the help of wide-angle lenses because the camera's unsteady viewing angle here in and of itself elicits the impression of curved and canted space. What all of these images share, however, is the fact that they, in spite of their display of towering mountainscapes and breathtaking ridges, allow the viewer to see a narrow band of sky above the horizon line, at times filled with gray clouds, at times gleaming in metallic blue. The camera's gaze, so much is clear upon our first approach to Eliasson's immense grid, isn't that of a scientific cartographer trying to convert three-dimensional shapes and elevations into flat surfaces. Rather, Eliasson's camera projects horizontal and vertical looking onto one dynamic

picture plane, one that puts the viewer in the shoes of a pilot who, due to unfriendly weather conditions, is unable to tell the proper course of his flight without the help of a horizon meter.

But then again, is there really any reason to feel overwhelmed by the scale of this photographic installation? Is *The Glacier Series* really designed such that it dwarfs the viewer?

Once we step nearer and peruse the work image by image, we quickly come to realize that Eliasson's work follows a strictly topological and typological pattern organized around the display of different glacial formations such as glacial ice caps, accumulation areas, cirque glaciers, ablation areas, and glacier snouts. Though neighboring images tend to show similar geographical features, there is no reason for us to assume that what we see is simply one and the same area of a specific glacier being shot from different viewing angles. I will have more to say in a moment about how Eliasson's series at once engages and disrupts the idea of a path, a closed narrative of departure, passage, and arrival. For now it is simply important to note that Eliasson's arrangement relies as much on scientific categorization as it seeks to establish certain visual rhymes and aesthetic variations across the frames of individual images— echoes and repetitions that situate the viewer as a discriminating reader of visual detail, eager to explore the concrete gestalt of individual land- scapes while at the same time trying to scout for larger formal patterns. Nothing, then, would be more wrong than to consider installations such as *The Glacier Series*, in spite of their daunting size, as an attempt to crush the viewer's sensual perception similar to the way in which a glacier's flow grinds down the countryside and accumulates debris along its relentless path. Far from subjecting the viewer to the authoritative syntax of his work, Eliasson invites us to become at once a mindful explorer and an attentive beholder: an observer for whom the sensual and the cognitive registers of experience go hand in hand.

Glaciers are highly complex and fundamentally unstable systems. About 10 percent of the land surface of the Earth is still covered by glacial ice covers, though in recent decades rising global temperatures have placed remaining glacial formations under great duress. Glaciers

FIGURE 3.1. Olafur Eliasson, *The Glacier Series* (1999). Forty-two c-prints. Photo by Jens Ziehe, courtesy of Collection Tony Podesta. Copyright © 1999 Olafur Eliasson.

form from the slow transformation of snow into ice, caused by the accumulation of several years' worth of precipitation and the kind of pressure higher layers place on lower ones. Once the ice is thick and compact enough, its own gravity will make the glacier flow, whereby the speed of movement not only differs along the glacier's path but also across its width and depths due to different temperatures, forces of resistance, and basal conditions. A glacier's visible structure of crevasses, folds, ripples, furrows, faults, thrusts, and sedimentary stratifications reflects the work of competing forces of flow and hence of different rates of movement within the mass of accumulated ice. Far from representing a unified geological configuration, a glacier is a highly dynamic force field whose individual vectors themselves undergo constant motion and transformation. "As the glacier moves downhill the layers deform gently, because ice is approximately plastic and moves faster in the middle of the glacier than at the margins. A period of excessive ablation may remove and truncate many of the layers, so that when new layers accumulate a marked discontinuity, called an unconformity, is apparent."[4] It is a glacier's categorical unconformity—its articulation of multifarious forces and timetables—that turns any attempt to predict its kinetic activity into an extremely taxing undertaking. No individual glacier really behaves and transforms like another one. Not one particular section within one and the same glacier follows the same logic of change as a second one within the same formation. Flow is what glaciers are all about. Or to be more precise: what glaciers bring to light is a simultaneity of different forms of flow, at times steady or seemingly stagnant, at times accelerating or slowing down, in each case producing a rich maze of folds and crevasses. And it is this commanding reality of uneven flow and flux, however slow it may be, to which we must attune our perception if we do not want to fall prey to a common (mis)understanding of glaciers as seemingly static and contained images of the temporal.

Though glaciers, due to their dramatic shrinking and disappearance, have received considerable attention in recent decades, their actual rise to iconic prominence dates back to the nineteenth century, a century when explorers, scientists, artists, and tourists alike suddenly revealed deep-seated desires to encounter the deep time of the Earth's geological formations, the *longue durée* of natural history. As eager as ever to

expose the follies of his contemporaries, Mark Twain after visiting the Swiss Alps in 1878 related the following anecdote about his—a tourist's— experience of a glacier's at once slow and heterogeneous flux:

> I marched the Expedition down the steep and tedious mule-path and took up as good a position as I could upon the middle of the glacier—because Baedeker said the middle part travels the fastest. As a measure of economy, however, I put some of the heavier baggage on the shoreward parts, to go slow freight. I waited and waited, but the glacier did not move. Night was coming on, the darkness began to gather—still we did not budge. It occurred to me then, that there might be a time-table in Baedeker; it would be well to find out the hours of starting. I soon found a sentence which drew a dazzling light upon the matter. It said, "The Gorner Glacier travels and average rate of little less than an inch a day." I have seldom felt so out-raged. I have seldom had my confidence so wantonly betrayed. I made a small calculation: One inch a day, say thirty feet a year; estimated distance to Zermatt, three and one-eighteenth miles. Time required to go by glacier, a little over five hundred years! The passenger part of this glacier—the central part—the lightning-express part, so to speak—was not due in Zermatt till the summer of 2378, and that the baggage, coming along the slow edge, would not arrive until some generations later. . . . As a means of passenger transportation, I consider the glacier a failure.[5]

Unlike Twain himself, many of Twain's contemporaries saw glaciers as unified streams of time, as memory banks transporting the past into the future. At the same time, they were encountered as rather static books of nature, paradoxically preserving earlier ages as fixed images for future readers and onlookers. In this wonderful anecdote, Twain's satiric gaze was less directed at how nineteenth-century scientists and travelers started to explore the extended historicity of natural wonders than at how his contemporaries expected nature to act according to the templates of industrial civilization. Glaciers fail as human transporta-tion systems, not because their dynamic of flow and stasis is simply too complex, but because it is foolish to render it commensurable with the travel patterns of contemporary railway users in the first place. Glaciers might resemble images of frozen time, but in the end they resist to

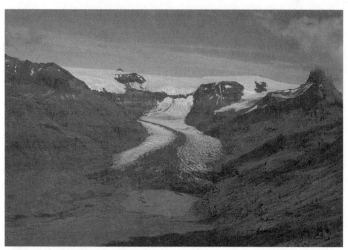

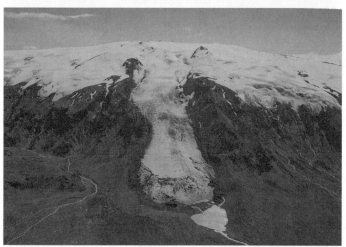

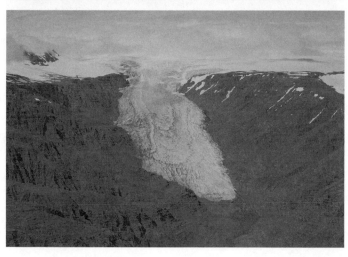

accommodate our human needs precisely because they don't behave like images, because their uneven movements resist the power we extend whenever framing objects into self-contained images, because the very nature of their flux remains something that neither Baedeker nor advanced scientists can entirely rationalize and subject to human will.

It is one of the principal achievements of Eliasson's photographic installation that it invites the viewer to adjust her vision to this incommensurable facticity of glacial flow. Though Eliasson's camera allows us to hover majestically over various glacial formations, it systematically undercuts any desire for imperial mastery. As captured on and across his photographic grid, the aerial sight of glacial foliation by far exceeds the nineteenth-century view of glaciers as frozen representations of time. What Eliasson's series proposes instead is a type of glaciology in which maps are able to chart the constitutive openness and contingency of glacial time, but also a photographic practice that emancipates photography from the medium's proverbial association with standstill, mortification, timelessness, and death. *The Glacier Series* defines glacier and camera as each other's allegory, as elective affinities manifesting the innermost truth of human perception, namely its inexorable processurality, its embeddedness in time and flow. Nature, as Eliasson points out, might be nothing other than a mere construct. It is a product of our cultivated modes of looking, not any kind of primordial reality. But in his very deliberate exploration of glacial flux, Eliasson at the same time leaves no doubt that his constructivist stance does not necessarily posit the subject as a sovereign ruler over the phenomenal world. On the contrary. Presupposing embodied viewers whose kinetic dispositions are as heightened as their sense of vision, *The Glacier Series* gives cause to experience the human and the nonhuman, the subjective and the objective, perception and the material world as mutually dependent. One sheds light on the meanings and operations of the other; neither can do without the other. Unlike Marinetti, Eliasson thus embraces aerial vision, not in order to intoxicate himself and his viewers with superhuman feelings of power and velocity, but to sharpen our view for the multiplicity of speeds and temporalities that structure our relation to the world

FIGURE 3.2. Olafur Eliasson, *The Glacier Series* (1999). Detail. Forty-two c-prints. Photo by Jens Ziehe, courtesy of Collection Tony Podesta. Copyright © 1999 Olafur Eliasson.

and hence to what is messy, ephemeral, and necessarily limited about the work of sensory perception. Whereas Marinetti's worship of flight, speed, and power culminated in a spectacular union with volcanic nature, Eliasson uses the airplane as a technology of seeing that allows us to explore certain correspondences between the operations of embodied sight and photographic recording on the one hand and, on the other, a glacier's mysterious temporality and slowness.

3 /

Glaciers, ice formations, and (ant)arctic landscapes have taken on a prominent role in recent artistic practice and installation art, less perhaps though to address environmental calamities than to probe the limits of certain media and to challenge the drive of art after postmodernism toward either lavish spectacle or deep spirituality. With projects such as *Arctic Circles* (1998) and the long-term *Vatnasafn/Library of Water*, American artist Roni Horn has sought to explore the anormal and divergent in dominant weather patterns, turning Iceland into the very medium of aesthetic sensibilities and quests. In montage and essay films such as *Landscapes with Ice and Snow* (2010; figure 3.3), German filmmaker Alexander Kluge—following a suggested project of his former teacher Theodor W. Adorno—aspires not simply to contemplate the function of coldness in modern culture as an engine of disaffection and self-objectification, but to bring coldness to the consciousness of itself, to make it gaze right into its own eyes, and precisely thus allow it and us to better understand its structural conditions, including its role in the world of art and contemporary media culture itself. And French artists Pierre Huyghe, in work such as *A Journey That Wasn't* (2005) approaches arctic landscapes to investigate the relation of fiction and reality in art today and deconstruct the kind of exoticism—the fetishizing of the other—that energizes much of modern travel art and writing. Huyghe's work, as Mark Godfrey has argued, "takes the very structure of the spectacle (fiction creating reality) as a format but forges completely new effects with this structure."[6]

In *A Voyage on the North Sea,* Rosalind Krauss has used the work of Marcel Broodthaers in order to investigate how postmodernism

moves art beyond modernism's understanding of medium purity and into what she identifies as our millennial postmedium condition.[7] Let me compare, for a moment, Eliasson's approach to Icelandic glaciers instead with the role of floating icebergs and glacial formations in the images of two other artists, Ilana Halperin and Nina Subin, not only in order to set the stage for an argument about the continued importance of medium specificity in contemporary art but also to indicate the extent to which medium reflexivity matters to what this book identifies as contemporary art's aesthetic of slowness. The work of both Halperin and Subin is driven by the impulse to supplant aerial views of arctic ice with more grounded and horizontal perspectives: images captured from boats or from the position of an observer traversing inhospitable icy landscapes by foot. "Greenland," writes Halperin, "was a place to pass over. Between Glasgow and New York. A commuter route. The magnificent occasion of air travel reduced to what you do to go between one place and another. Passing over Greenland as often as I did, I began to feel that I knew it all too well. Within a few hours after departure from either side of the Atlantic the air would become choppy. Turbulence was always expected and would usually last until we crossed the southern coast of the impenetrable landmass."[8] Both Subin's and Halperin's images of Greenland, of floating icebergs, glacial front sections, and blinding ice caps, aspire to correct what both consider the sensory abstraction of aerial looking and speedy passage and instead, through physical proximity and a slowing down of the observer's position, produce what Halperin, when visiting Eliasson's native Iceland and its curious mix of volcanic and glacial landscapes, considered "carnal knowledge of a landmass. So beautiful, you break open and melt in. The leap into the volcano."

Gathering work from a 2006 ship voyage to the northeast coast of Greenland, Halperin's *Towards Heilprin Land* (figure 3.4) seeks to generate and document such carnal knowledge through a wide array of representational strategies and media: hand-drawn charts, photographic images, digital film clips, historical texts and documents, entries from Halperin's own logbook during the journey, entries from earlier explorers' logbooks, water color paintings, etc. Not one medium, so our first impression, seems to suffice to capture the rich experience of direct physical engagement. Not one representational register by itself

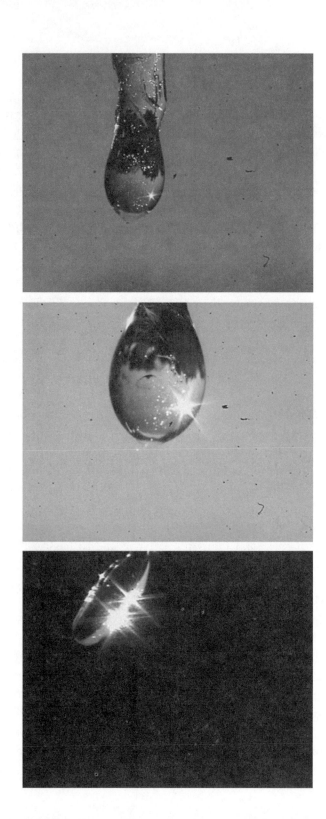

appears able to communicate the manifold perceptions produced by slow proximity and sensory presence. The juxtaposition of static photographs and moving images here complement each others' unique documentary power, much as the copresence of drawings of distant icebergs and extreme close-up paintings of rock and ice structures, of historical diaries and present-day logbook entries, of poetic evocations and sober scientific descriptions, of highly controlled or composed images and seemingly wild and boundless visual representations. What you get when leaving the airplane and situating the body amidst Greenland's icy land- and waterscapes is an uncontained overload of possible perspectives and impressions, a multiplicity of viewpoints calling for varied forms of mediation and presentation. "The New Red Mountains," the Scottish artist notes at some point, "were originally located at the equator. A desert terrain drifted north into a frozen place. East Greenland and Scotland formed during Caledonian Orogeny (when mountains smash together and join into one). Then they split. Is this why I feel so at home here? One day we visited a glacial moraine. In this particular place, there was not a single sign of life. No tiny roots, no cracked bones. The longer we remained there the more terrified I became. It was not a place for life as there was not a trace of death. Only high pitched time. Time which carves mountains. Time devoid of life." Halperin's multiple and heterogeneous registers of representation hope at once to map and to inhabit a landscape in which neither signs of life nor signs of death seem to offer points of human contact and inhabitation. As if trying to overcome what Halperin once struck with terror, *Towards Heilprin Land* in fact seeks nothing less than to define a perceptual human framework able to account for and endure Greenland's uncanny landscapes of multilayered, albeit lifeless and displaced, time. Similar to the work of a film camera patiently traveling in ever shifting angles across a photographic image, Halperin's stress on the slowness of physical proximity wants to unearth the flow of time hidden beneath what for human observers and aviators alike appears lifeless, abstract, and void of any human measure. Rather than allowing herself to be overwhelmed by what she considers the arctic's high

FIGURE 3.3. Alexander Kluge, *Landscapes with Ice and Snow* (2010). Screenshots.

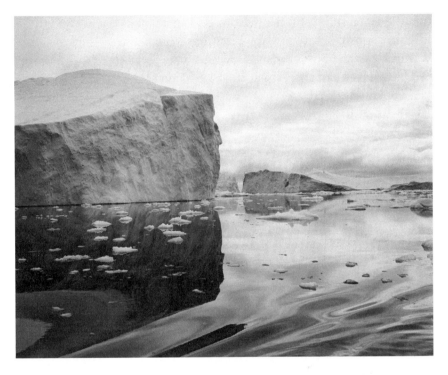
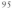

FIGURE 3.5. Nina Subin, *Greenland* (no year). Copyright © Nina Subin. Image courtesy of the artist.

pitched time, her project hopes to absorb the forbidding temporality of Greenland's geology so as to render it commensurate with a more human scale of time, motion, and flow.

In Subin's images, by contrast, Greenland's icebergs and glacial snouts emerge as sublime shapes and transcendental miracles exceeding reliable human scale and measurement (figure 3.5). Shot in black and white, these photographs in fact transform the presence of massive ice formations into at once timeless and highly abstract configurations. Though some images show traces of human presence in the foreground (the ripples of a boat's wake, a wooden house as seen against the backdrop of towering rock and ice structures), Subin's camera presents arctic landscapes as self-contained and of stunning beauty: a world void

FIGURE 3.4. Ilana Halperin, *Towards Heilprin Land* (2006). Copyright © Ilana Halperin. Image courtesy of the artist.

of haste and motion; a universe strangely ignorant of history and trans-
formative powers; a topography that has become image long before it
was met by the photographer's eye and that, precisely for this reason,
produces feelings of contemplative stillness and calm in the viewer. Subin
pictures arctic ice as a quasi-extraterritorial presence, a landscape so
distant and foreign that we may venerate its compositional power with
awe, but can only fail to grasp or connect to its essential strangeness.
Time is extraneous to what constitutes the beauty of Subin's ice forma-
tions. The ice may flow or float at differential speeds; towers of hard-
ened snow may rise like cathedrals and eventually crash into the Arctic
Sea; dispersed clouds may cast variable shadows over the land's glar-
ing whiteness. Yet, all things told and seen, what energizes the formal
beauty of Subin's images is the extent to which her framing and image
processing do not simply subtract temporality from these natural won-
ders, but rather present icebergs and glacial arrangements as landscapes
in which time has been entirely absorbed by the spatial distribution of
awe-inspiring shapes and forms. Glaciers and icebergs, like photographic
images in one dominant sense, here present time as space. The arctic,
in Subin's work, appears as a past powerful enough to outlast any future;
as a timeless present existing in a state of suspension. Contrary to Twain's
nineteenth-century tourists, Subin's hope is not to subject natural spaces
to the itineraries and temporal demands of modern civilization, but
instead to allow the frozen world of the arctic to teach the viewer how
to pause, to suspend our ordinary haste, to become a pensive spectator
vis-à-vis these photographs' privileging of space over time. The predom-
inance of the horizontal and the frontal in Subin's Greenland images is
key to this project. Its function is to open a transparent window onto
the profound alterity of these landscapes of the arctic, thus helping to
absorb the viewer's time into the presumed timelessness—the pure and
self-contained spatiality—of Greenland's icebergs and glacial end points.

In a 1984 essay, Peter Wollen has famously used the metaphors of fire
and ice in order to describe the respective logics of film and photogra-
phy. "Film is all light and shadow, incessant motion, transience, flicker,
a source of Bachelardian reverie like the flames in the grate. Photography
is motionless and frozen, it has the cryogenic power to preserve objects
through time without decay. Fire will melt ice, but then the melted ice

will put out the fire."[9] Though it would be inadequate to call Halperin's *Towards Heilprin Land* cinematic, her hybrid multimedia installation clearly seeks both to expose and stir up the fire hidden underneath the appearance—the photographic stillness—of arctic ice and glacial formations, whereas Subin's project is to mimic and double the seemingly photographic surface of Greenland's landscape with the medium of photography itself, that is to say, engage the viewer in a double process of cryogenic suspension. If Halperin seeks to melt the ice by infusing glacial time with more human and quite diverse forms of temporality, Subin puts out the ice's secret fire and motion by picturing the arctic as if it was some strange and unaccommodating picture in the first place—a space of pure forms and timeless shapes. Cinematic elements, in Halperin, redeem arctic ice from what, at first sight, appears all too photographic about them; photography, in Subin, pictures arctic landscapes as the camera's ideal soulmate and hence as a topography redeeming the viewer from the flux and cinematic substructure of ordinary life.

The work of both Halperin and Subin each illuminates one central aspect of what Robert Macfarlane calls the dual nature of glacial formations: "They seem static, frozen like a photograph by the cold and the thin, transparent air. Eighteenth-century travelers regularly compared them to deserts. But like deserts, glaciers open themselves up to you when you look closely at them. You can never step into the same river twice, said Heraclitus. Had he traveled a few latitudes further north, he would have said the same for glaciers. The ice is in that old paradox—a permanent state of flux."[10] It is by using the verticality of aerial perspectives and by choosing the series format that Eliasson, in his own work on glaciers, seeks to untie the Gordian knot of this paradox: to find the most adequate strategies of representing the glacier as a permanent state of flux as much as a permanence in flux. Like Halperin, his work wants to bring fire to and visualize the invisible motion of the glacier; like Subin, he is eager not to subject the glacier's void of human time to his own sovereign gaze and temporality. What allows Eliasson to succeed in this endeavor is not only the fact that, in his images, the abstraction of aerial vision is by no means antithetical to a quest for embodied carnal knowledge but also that his peculiar use of

the series and the grid format moves the viewer beyond what is, in the final analysis, quite reductive about any binary opposition of the photographic and the cinematic. Glaciers, for Eliasson, are both fire and ice, flux and stasis, motion pictures and pictures of differential motion. His choice of aerial perspective and the typological grid aspires not simply to do justice to the curious slowness of geological time but also to show that its principal duality is perhaps less paradoxical than we may think. For, similar to the way in which we may understand the glacier as both fire and ice, Eliasson draws our attention to the fact that the cinematic incorporates the photographic just as much as photography entails its curious sibling, the cinematic, as its potentiality. Slowness is what emerges, neither when photography turns cinematic nor when cinema becomes merely photographic, but when both media join forces to establish a third space; when both registers of representation—like a glacier's different layers—fold themselves into each other, without moving into a seemingly boundless space of postmediality and postcontemporaneity.

4 /

Over the past two decades, Olafur Eliasson has pursued a myriad of projects that were very much dedicated to what has always been at the very center of the aesthetic: the exploration of the process of sensory perception, of how we see and how we can render visible our own seeing, our sensing of the phenomenal world. Eliasson's interventions are indebted to the research of nineteenth-century physiologists and psychologists such as Gustav Fechner, Hermann von Helmholtz, and Wilhelm Wundt; they draw on Henri Bergson's philosophy of memory and Maurice Merleau-Ponty's phenomenology in order to probe the ineluctable temporality of human perception; and, last but not least, they are in conversation with the writings of contemporary critics such as Jonathan Crary and Paul Virilio, scholars who are devoted to complicating our thinking about social space and strive to challenge the way in which modern consumer cultures have drowned the individual with mind-numbing spectacles. Yet, no matter how conceptual in nature, Eliasson's work has, at the same time, sought to engage with the

particularity of local contexts and geographical locations. As if following Goethe's famous axiom, his work has investigated the extent to which theory, rather than opposed to or merely projected onto, can emerge from our very experience of the phenomenal world.

In Eliasson's substantial photographic work, seriality has served as one of the most important methods to mediate between science and art, the conceptual and the aesthetic. Serial photography, as practiced by Eliasson, opens a performative space in which the subjective and objective, aesthetic sensibility and conceptual rigor, poetic intuition and rational understanding penetrate each other without aiming for final synthesis. It aims at something that cannot be granted by the individual photograph and its mummification of singular instants, but it also transcend film's temporalization of the spatial, the suturing of individual images into one continuous stream. Seriality, in Eliasson's work, pursues meanings and truths that emerge from the empty, uncharted, and temporally undetermined spaces between individual images. It develops and unfolds its particular subject matter by putting to work what is nonsystematic and nonlinear about the peculiar movement with which camera and viewer alike travel from one image to another.

Eliasson's *The Glacier Series* and *The Jökla Series* (figure 3.6) are deeply dedicated to this idea of a dynamic unfolding of visual truth in the interstices between individual images and to thus developing structures of representation that at once hybridize and transcend the normal operations of still photography and film. Seriality here situates the viewer as an active observer whose aesthetic experience, by traversing images as well as the gaps between individual images, reworks the mechanization of vision inherent in any form of technical reproduction. As we contemplate visual rhymes and kinetic echoes, as our eyes engage with shifting aerial view points and different glacial patterns, as we try to follow Eliasson's own flight path through Icelandic airspace, we cannot but fail to fill the temporal and spatial void between individual images with unambiguous content and stability. No way to determine how much time may have passed, how much landmass had been crossed, between the taking of one shot and the next one. No way in fact to determine whether adjacent images were actually shot in greater temporal and spatial proximity to each other than images that are hung farther apart within the space of the installation. Time—the slow time

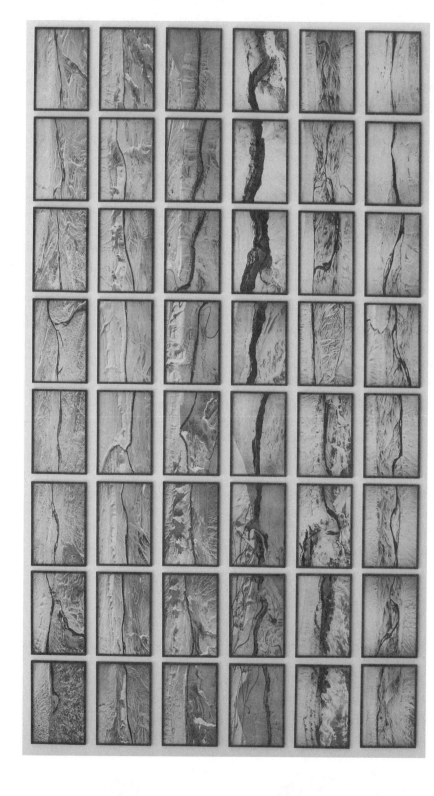

of glacial movement, the accelerated time of aerial travel, the unpredictable time of a viewer's reception—thus emerges, not as a mere sequence of coordinates along a continuous arch, not as something that could be broken up into discrete units and then recomposed to produce seamless impressions of motion, but as a form of energy whose various flows and patterns resist a chart's objectifying fixity. Eliasson's use of seriality encourages a mutual penetration of the seemingly invisible time of glacial movement and of our own unpredictable acts of viewing. What we see is not a mere chart of motion made visible and hence more human because it has been sliced into discrete moments. What we instead experience is a slow unfolding of our own perceptual time in the face of a glacier's dynamic multiplicity of flow and stasis—an unscripted and unmethodical approximation of the subjective and the objective facilitated by the speed and spatial distance of aerial vision.

And yet doesn't Eliasson's use of the grid contain and eradicate seriality's stress on the subjective, on the indeterminacy of aesthetic experience, on the heterogeneity of flow and rupture? Doesn't the rationalist form of the grid reobjectify the curious meeting of intuition and conceptual understanding, the open-ended unfolding of visual truth, built into the photographic series?

Grids, it is often assumed, map the visible world according to a predictable system of vertical and horizontal lines.[11] They structure the world as if it entirely corresponded to geometric principles and allowed us to assign exact coordinates to every element of the visual field. Grids dissect, frame, and reconstitute the phenomenal world for us. They catalyze sensations of control, power, and omnipotence as much as they might bestow feelings of closure, of abstraction, of unbearable rationalization. A world engendered or represented as a grid gives the impression of being entirely knowable and calculable. It has nothing to hide; it contains no dark secrets; it impedes our desire for and our fear of getting lost. Though often seen as essentially modern in nature,

FIGURE 3.6. Olafur Eliasson, *The Jökla Series (1999)*. Detail. Forty-eight c-prints, 268.8 × 474.4 cm (each 37.8 × 55.8 cm). Installation at the Light Setup, Lunds Konsthall, Sweden, 2005. Photo by Terje Östling, 2005, courtesy of the artist; neugerriemschneider, Berlin; and Tanya Bonakdar Gallery, New York. Copyright © 2004 Olafur Eliasson.

grids ultimately present the world as something that is void of time and change, void of history.

Rosalind Krauss has importantly argued that, in modernist art, grids play a decisive role in the artistic endeavor to convert three-dimensional extensions into two-dimensional flatness and thus to focus one's attention on the pure materiality of the canvas.[12] But, as Krauss added, the function of the grid in the work of such artists as Piet Mondrian is by no means unified. It is, in fact, quite ambivalent, providing a structure open to multiple readings and appropriations. On the one hand, modernist grids present the image as a self-enclosed mapping of space onto itself, thereby defending the purity and autonomy of the image against the intrusion of the ordinary world. On the other hand, artist such as Mondrian often present their images not as something entirely coextensive with the grid, but, on the contrary, as ones that acknowledge the world beyond the frame. The image here imposes no logical boundaries on the lattice that structures the canvas. As such it defines the space of representation as merely a fragment of a much larger spread of similar elements and constellations. At once shutting out and acknowledging the world beyond the frame, at once imposing impressions of self-enclosed autonomy and of infinite iteration, modernist grids are puzzlingly schizophrenic in nature. Instead of visualizing a complete triumph of modern rationality, the modernist grid at once points our attention inward and outward; it suspends our perception and stirs our appetite for more. Whatever appears to be a product of the grid's unyielding structure surreptitiously speaks of that which may exceed the grid's rational order and control.

It is more than tempting to read Eliasson's combination of the grid and of serial photography, his effort simultaneously to provide a poetic typology of glacial formations and track the differential speeds of a glacier's flow and its airborne observer's passage, as a late-modernist exercise in such schizophrenia. Similar to the way in which the slowness of a glacier itself bears two faces (flow and stasis), so does the grid in Eliasson's work serve as a means to bring together seemingly incompatible forces, temporalities, and perceptual approaches. The grid here simultaneously frames what seems to resist the power of framing as it questions the ability of any frame to contain what is

centrifugal, dispersed, and multiple. Eliasson's grid provides a rational form delineating the extent to which we cannot but fail to assimilate a glacier's movements and an observer's passage to the exigencies of abstract rationalism. While each of the forty-two images seems to arrest the vagaries of human perception and geological time, the lattice as whole as well as the gaps in between each and every image point our attention beyond frame and grid—toward aesthetic experiences of mobility and slow deliberation that exceed fantasies of control and containment.

5 /

I will now move on to discuss a number of photographic light box installations by Hiroyuki Masuyama, a Japanese photographer of Eliasson's generation whose highly composed aerial images of large continental landmasses and towering mountainscapes add an interesting dimension to the dynamic mapping of slow geological time that we have seen at work in Eliasson. Like Eliasson, Masuyama has repeatedly used an airplane's passage as a prosthetic tool of embodied vision, rendering visible what is imperceptible about the slowness of natural history and geological motion. And similar to Eliasson's choice of expansive formats, Masuyama's preference, too, is for large commanding scales, ranging from little more than a meter to up to seventeen meters in width. Unlike the work of his Danish-Icelandic contemporary, however, Masuyama's images are far less driven by conceptual impulses and a philosophically informed investigation of sensory perception. And unlike Eliasson, Masuyama, in his breathtaking images of snow-capped mountain ranges such as the Rocky Mountains, the European Alps, and the Himalayas, has little ambition to employ the modernist grid as a means to explore some third space between the photographic and the cinematic. And yet, as we will see in a moment, Masuyama's light boxes pursue a project quite comparable to Eliasson's photographic installation, namely to reveal the slow time of geological formations, not by turning one's back to modern technology and accelerated modes of transport, but by deliberately embracing them and thus allowing

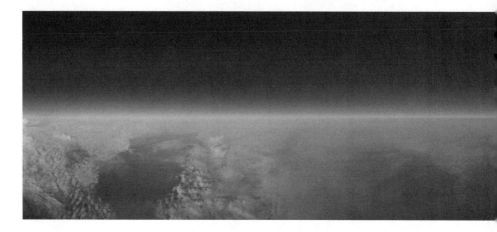

FIGURE 3.7. Hiroyuki Masuyama, *Journey Around the World* (2003). Copyright © Hiroyuki Masuyama. Image courtesy of the artist.

human speed and technological mediation to disclose the hidden and slow itineraries of natural history.

Here's how Masuyama himself describes his technique of aerial image production: "During these flights, I took one photo of the Earth through the window every 20 seconds. Due to the plane's motion, the camera 'travelled' a couple of kilometers between each snap shot. I later aligned the photographs on the computer, showing a panorama of the total distance of the journey."[13] Fusing several hundreds of images into one (seemingly) seamless horizontal spread, Masuyama's flight and time images offer visions—an extended presence in both temporal and spatial terms—no human eye or body could ever see as such. In *Journey Around the World* (2003; figure 3.7), the artist combined no less than seventeen hundred individual shots taken during a two-week trip around the globe, forty-two hours of which were spent on various planes flying from Frankfurt via Bangkok, Tokyo, Honolulu, Los Angeles, New York back to Frankfurt. Because of the often prolonged durations of Masuyama's flights, individual images tend to "traverse" wide stretches of nighttime darkness, some of them starting and ending in the dark, with the glare of urban lights set against a black background on both the left and right sides of the frame. In *Journey Around the World* Masuyama's camera leads the viewer three times through

the night, entertaining our gaze with the sight of multiple sunrises and sunsets. What strikes the viewer's eye most in all of Masuyama's light boxes, however, is the sight of various mountain ranges, as they emerge from the vast flatness of their respective continental plates and reach into the stark blue of the sky. Whether draped in pristine snow and ice or not, mountains populate Masuyama's light boxes like uncanny giants, banishing every trace of life from the visible world. They are irresistible in attracting the viewer's attention, and yet at first they encounter our gaze as something strange and unfathomable, as intruders from a space and time seemingly foreign to and annihilating our own.

Similar to Eliasson's focus on ice and glacial movement, Masuyama's fascination with imposing mountainscapes follows the footsteps of the nineteenth century, that is, the at once enlightened and romantic obsession with the deep time of geological formation.[14] It was during the nineteenth century, in the wake of the writings of scientists and explorers such as Charles Lyell, Georges Cuvier, Richard Owen, Ebenezer Brewer, Horace-Bénédict de Saussure, and James David Forbes, that a larger public preoccupied itself with the hidden past and long historical formation of planet Earth, and the "common imagination began to respond to the aesthetics of inordinate slowness; to gradual changes wrought over epochs."[15] Once limited by religious dogma to an existence of a few thousand years only, the earth's time now was radically

extended, geology and mineralogy serving as powerful telescopes into remote pasts and as measuring sticks to assess the gradual formation of the present. Whereas in the realms of philosophy and historiography dominant paradigms of historicism paid tribute to the specificity of different historical epochs, nineteenth-century naturalists and geologists read rocks, minerals, fossils, and mountain ranges as archives of a long-forgotten past touching upon the present. Since the mid-nineteenth century, tourists and serious mountaineers alike flocked in ever greater numbers to the Swiss, Austrian, and Italian Alps so as to participate in this encounter with geological deep time. And rather than serving them as a merely Romantic *chiffre* of civilizational discontent and outdoor escapism, critics and aesthetic theorists thought hard in order to describe and classify the poetic qualities and aesthetic symbolism of different geological sites. In particular John Ruskin's 1856 *Of Mountain Beauty* set mountainous standards for the encounter with the earth's monumental sites, emphasizing the extent to which geological formations become aesthetic whenever visual artists or poets could reveal the dynamic process continually at work in their making (and unmaking). "Mountains are the beginning and end of all natural scenery,"[16] he proclaimed in his treatise, trying to remind artists and audiences alike not only of the fact that mountains and rocks were part of an ongoing story of becoming rather than of static being but also that this story was often far from peaceful and harmonious—that the deep time of nature must be seen as a battleground of conflicting forces, dialectical energies, and at once productive and destructive powers.

Due to the parameters of Masuyama's photographic projects, the left and right edges of his images are typically taken up by flat metropolitan areas—by sites able to support the launch of large continental or transcontinental airplanes. In any literal sense, mountains thus form neither the beginning nor the end of Masuyama's immense horizontal light boxes. And yet, as a result of the extreme horizontality of Masuyama's picture planes and the curious curvature of the horizon as seen from high altitudes, photographs such as *Journey Around the World*, *Flight Mont Blanc*, or *Himalaya Flight* present extended mountain ranges as geological features at once framing and dramatically animating their surrounds—as primary sights of attraction causing the

viewer to step up and scrutinize the image in all its rich detail. Whereas the lowlands and oceans, in the perspective of Masuyama's camera, offer little to capture and energize the onlooker's eye, it is the mountains' verticality that structures the visible field and provides points of orientation. It would be wrong, however, to consider the unyielding verticality of Masuyama's mountains as a sign of their presumed fixity and sublime annihilation of everything temporal—of a total triumph of space over time. On the contrary, like the roaming travelers, scientists, and mountaineers of the nineteenth century, Masuyama's flight light boxes too present commanding mountainscapes as vibrant texts of sublime becoming, as dynamic archives containing a multiplicity of ongoing stories. The key to how Masuyama seeks to render visible the deep time of geological formation, however, is less in how he fuses hundreds of different images and hence moments in time within the frame of one and the same picture, but in how his reliance on aerial speed and passage brings into the play the perceptual power of parallax and its curious potential of defining space as a dynamic of subject and object, the phenomenal and the material, mind and matter.

Parallax, let us recall, is the apparent displacement or alteration of an object caused by an observer's motion through space. The parallax produced by different lines of sight plays a critical role in determining spatial distance, whereby objects in close proximity have a larger parallax than those far from the observer, meaning that slight changes in our perceptual position cause tremendous changes in the appearance of nearby objects and nearly no changes in remote objects such as, for instance, distant stars or star systems. In our post-Einsteinian and post-Heisenbergian world, visual parallax often serves as an important measure to point at the interrelatedness of observer and observed, perceptual reference and scientific fact—the situatedness of the subject in the world of the object as much as the subjective interrelation of the object with the observer's changing point of view. As Slavoj Žižek has reminded us recently,

> The philosophical twist to be added (to parallax), of course, is that the observed distance is not simply subjective, since the same object which exists "out there" is seen from two different stances, or points of view. It is rather that, as Hegel would have put it, subject and object are inher-

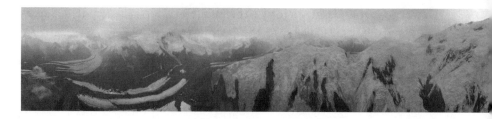

FIGURE 3.8. Hiroyuki Masuyama, *McKinley Flight No. 2* (2006). Copyright © Hiroyuki Masuyama. Image courtesy of the artist.

ently mediated so that an "epistemological" shift in the subject's point of view always reflects an ontological shift in the object itself. Or—to put it in Lacanese—the subject's gaze is always-already inscribed into the perceived object itself, in the guise of its "blind spot," that which is "in the object more than object itself," the point from which the object itself returns the gaze. Sure the picture is in my eye, but I am also in the picture.[17]

Masuyama's flight images constitute ongoing formal engagements with the challenges of parallax viewing. Though his camera, in its passage through aerial space, assumes slightly different angles of vision every twenty seconds, Masuyama's final images at first give the impression that what we are seeing is one (impossible) stationary shot of one stationary and contiguous reality. Digital mediation and editing here produce a view seemingly so distant that observer and observed could never inhabit the same image space and touch upon each other. Like God, the assumed monarch-of-all-I-survey gaze of Masuyama, one might conclude, manages to elide the dynamic of parallax vision precisely because—like God—it transcends the confines of space and the irreversibility of time. And yet the closer we study Masuyama's images—the curved recession of Masuyama's flat horizon; the at times curiously warped verticality of his mountains; the simultaneous push and pull that the bowed shape of glaciers, cliffs, and valleys extent to the viewer—the more we come to realize that these images, even in their final form, are far from emancipating the human eye from the laws of parallax. Parallax remains at work and structures the appearance of Masuyama's land- and mountainscapes even when technologi-

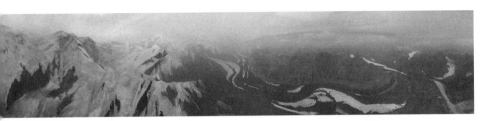

cal mediation toys with the idea of superseding the limitations of human vision. Witness how, in images such as *McKinley Flight No. 2* (2006; figure 3.8), the entire mountain seem to wrap itself around the position of the (virtual) camera, in spite of the relative evenness of the horizon line. Witness how everything that is perpendicular to our implied line of sight appears strangely bent, its sides pointing toward the viewer rather than to the edges of the image. Witness how certain segments appear as if shot with a tremendous fish-eye lens, even though the image does not repeat a fish-eye's familiar mimicking of the Earth's curvature. Witness, in one word, how in this image the curved and the linear go hand in hand and thus produce a line of sight our eye cannot possibly accept as being the result of one static act of distant looking even if this eye at first might not know how to make sense of what it sees otherwise.

It would be quite erroneous, then, to follow our first impulse and read Masuyama's flight images as delivering the human eye from the laws of parallax by elevating it to the transcendent, disembodied, timeless, and hence divine view point of technological vision. Any closer look at how these images warp spatial extensions and perspectival lines in fact will lead to quite contrary results, namely that Masuyama's flight images stage nothing other than the impossibility of emancipating the human eye and its technological prostheses from the materiality of time, motion, and embodiment. Instead of celebrating the camera as a tool moving the viewer beyond known orders of space and time, Masuyama's flight images in the end visualize the extent to which neither the human eye nor technological mediation can ever successfully repress, contain, or erase the dynamic of parallax viewing. While aviators might often desire nothing so much than to leave the limitations of embodied vision behind, Masuyama's images suggest that even the

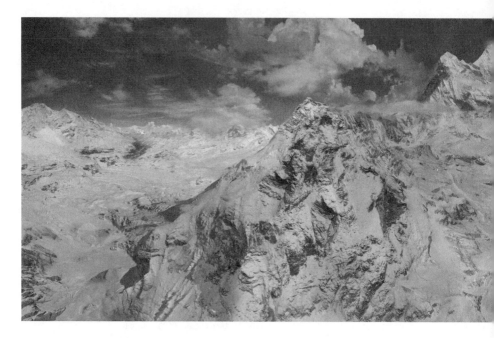

FIGURE 3.9. Hiroyuki Masuyama, *Matterhorn* (2004). Copyright © Hiroyuki Masuyama. Image courtesy of the artist.

most distant view cannot escape the gravity of the body and its movements. True to Žižek's recent ruminations, the copresence of the linear and the curved in Masuyama's flight images does not simply reveal the ineluctable structure of parallax, it also—as important—situates observer and observed, in spite of all their difference of scale and temporality, in one and the same image space. Masuyama's images display the viewer's gaze as being inscribed in the very object of observation—the sight of towering mountains—as much as these images present mountains as objects that cast their gaze back at us. We are in the image as much as the image, the mountain of the image, is in us. The mountainscape's seemingly inhuman being and becoming in time thus enters and reshapes our temporality as viewers as much as the camera's airborne trajectory mediates that what seems to exceed a human's eyes receptiveness to the deep history of geological formations.

It is worth comparing the stress on movement, slow becoming, and perceptual reciprocity in Masuyama's flight images with how the same

photographer, in a different series of photographic images, has (re)constructed specific Alpine landscapes as either imaginary or archetypical mountain sceneries. In order to produce images such as *Matterhorn* (2004; figure 3.9), *Alps 1* and *Alps 2* (2002), and *Jungfrau* (2004), Masuyama rented a helicopter, took hundreds of individual images of various areas in the Swiss Alps, and then composed these individual shots into what he considered desirable, characteristic and aesthetically pleasing visions of the Alps. In all these images the horizon line is considerably higher than in the flight images, mountain peaks and ridges now clearly overpowering the camera's sight line rather than being spread out underneath our (virtual) gaze. As important, unlike the flight series, the images of the mountain series tend to situate their primary object iconically in the very center of the frame: as triangular shapes whose geometry stands out dramatically from any surroundings and thus best represent the very idea of the mountain. The emphasis is thus no longer on the expansive spread of certain mountainscapes as visualized by a moving camera, but on the sublime singularity of the ideal-typical mountain, on the timeless sight and self-sufficiency of Alpine mountains as it

had informed the visual compositions of Romantic painters and as it continues to be seen in uncountable picture postcards. Any trace of parallax viewing and perceptual displacement here is being elided, while the rules of central perspective, the grammar of static and detached observation, and the rhetoric of the monumental and eternal reign triumphant. Neither are we invited to enter the picture, nor do these imaginary, albeit ageless, mountains have the power to touch upon our lives and itineraries. The deep time of geological transformations instead remains utterly foreign and undisclosed to the viewer. In recomposing the real into some kind of archetype, Masuyama in fact strips history away from geology and thus denies the viewer that curious kind of aesthetic pleasure so central to witnessing his flight images.

Masuyama's mountain images, in their very abstraction, stasis, and painterly composition, want to carry the viewer beyond any topography of time, flux, and becoming, whereas the ambition of his flight images was to mediate between the deep time of geology and the accelerated tempo of contemporary civilization. If, in other words, Masuyama's mountain series proposes the radical alterity of geological formations so as to extract the place of the observer from the observed, Masuyama's flight series, in its effort to explore a certain commensurability between viewer and viewed, presents human temporality and geological time as interrelated and coconstitutive. As they place the diverse movements of viewers and mountains within one and the same space, images such as *Journey Around the World*, *Flight Mont Blanc*, and *Himalaya Flight*— in stark contrast to the mountain series—not only depict nature as a historical being while sharpening our awareness for the imperceptible rhythms of the nonhuman world. As important, in their very engagement with the logic of parallax viewing, these flight images also hope to slow down our perception and recalibrate the speed of aerial passage to which they owe their very existence.

6 /

It seems quite plausible to argue not only that the relation of Eliasson's glacier series to Masuyama's flight images restages the differences between the work of nineteenth-century chronophotographers Eadweard

Muybridge and Étienne-Jules Marey but also that both artists—similar to their nineteenth-century predecessors—push photography into the realm of the cinematic to explore what is protocinematic about photography. Like Muybridge, Eliasson seems to isolate and stop imperceptible intervals of motion. He charts the interplay of space and time by first dissecting certain actions or transformations into individual images and by then assembling these individual movement images within the rationalist form of the grid—a form whose rigorous geometry indicates calculability and invites scientific scrutiny. And, as if trying to follow in the footsteps of Marey, one could continue this argument, Masuyama seeks to spatialize durations by mapping out distinct stages of certain movements within the frame of one and the same image and thus displaying, somewhat paradoxical as it were, the indivisible nature of what is transitory and in motion. In their common, albeit quite different, efforts of stopping temporal flow, of charting coordinates of movement across space, and finally of reanimating these coordinates in time through different display strategies, both Eliasson and Masuyama—one might want to conclude—revive the way in which both Muybridge and Marey, a few years before the advent of cinema, had run up against the medium of photography and thus had presumably prepared the ground for how film, after 1895, captivated viewers with temporalized images of space.

The preceding pages provide good arguments against this kind of reasoning. It in fact has been one of the principal contentions of this chapter that we fail to understand both Eliasson's and Masuyama's respective contribution to an aesthetic of slowness if we—as suggested by the above reasoning—see their work as merely an engagement with the alleged protocinematic character of photography, that is to say, as artistic interventions seeking either to arrest cinematic flow or, conversely, animate photographic stillness. What is slow about both Eliasson's glaciers and Masuyama's mountains is neither the result of artistic practices trying to halt the speed of film and cinematic flow nor of strategies seeking to turn photography into film and thus bring measured motion to individual images. Slowness, in Eliasson, emerges from the unchartable and hence noncalculable cracks, folds, and fissures between the images of the grid, whereas Masuyama's flight images define the slow as a result of a deliberate digital synthesis of spatial displacement that

no human eye could ever see as such. As should have become clear in the preceding discussions, neither of these two strategies of aesthetic deceleration can be reduced to a mere attempt to render photography cinematic or to arrest cinematic flow with photographical means. Nor can we, for that reason, see both artists' work and their respective aesthetics of slowness as interventions aspiring, in one way or another, to activate or reverse a presumed narrative of paternity that led straight from the discrete stillness of photography to the animated flow of the cinematic. Instead, we must think of both Eliasson's and Masuyama's work on glaciers and mountains, on the meeting of aerial speed and deep geological time, as two different attempts to define a third space somewhere in between, but also categorically different from, the photographic and the cinematic—as a space of mediation in which different rates of change can as much coexist as scientific rationality and aesthetic pleasure, understanding and intuition, the objective and the subjective.[18]

Similar to the way in which mountains and glaciers are both flow and stasis, present and past, becoming and being, so do grid and digital montage in the aerial visions of Eliasson and Masuyama embody something that is both photography and film at once—a third and hybrid mode of mediation that can neither be reduced to the logic of one medium alone nor situate both media as dialectically struggling over the most appropriate way of representing the passage of time. And, similar to how recent entertainment technologies encourage viewers to watch films at their own pace—to freeze frames, reverse scenes, play favorite sequences in slow motion, jump forward or backward in narrative time—and thus suspend the forward drive of narrative cinema,[19] so does the third space of mediation in Eliasson and Masuyama appeal to spectators eager to complicate, decelerate, and reflect on the itineraries of ordinary (media) time, to spectators eager to contemplate the temporal nature of their own seeing and explore new forms of viewing in time.

In an intriguing discussion about the paradoxical representation of photographic still images in narrative cinema—of filmic scenes in which cinematic time, for a moment, seems to freeze vis-à-vis the frozen time of a photograph—Raymond Ballour once envisioned the desirability of a pensive spectator: a viewer no longer fully absorbed into

a film's unrelentless temporal drive, a viewer able, not simply to look at the film, but to allow the image to look back at him. "The photo thus becomes a stop within a stop, a freeze-frame within a freeze-frame; between it and the film from which it emerges, two kinds of time blend together, always and inextricable, but without becoming confused. In this, the photograph enjoys a privilege over all other effects that make the spectator of cinema, this hurried spectator, a pensive one as well."[20] As they picture the slowness of glacial and geological becoming from the window of a flying airplane, both Eliasson and Masuyama open a space for such pensive acts of viewing. Though, in both of their works, different times and temporalities blend together, they do not attain seamless totality and integration but instead remain visible in their difference and otherness. It is the apparent stop within the stop that allows the spectator, in both works, to contemplate and set into motion different orders of time and movement—orders neither dictated by photography's speedy logic of the decisive moment nor of cinema's linear pull into the future. It is to the question of how both art cinema and popular filmmaking themselves can engage such strategies of deceleration and pensiveness that I turn in the next two chapters.

F O U R

D R E A M T I M E
C I N E M A

1 /

Early film theory was often quite torn about the meaning of slow-motion photography. Some theorists such as Rudolf Arnheim and Walter Benjamin applauded a cinematic decelerating of movement as a means not simply to display a slower version of existing realities but to reconstruct our notion of the physical world. Quoting the work of Arnheim, Benjamin described slow-motion photography in the 1930s as a quasi-scientific instrument of representing unfamiliar aspects of ordinary kinetic processes. As it revealed reality's optical unconscious, slow-motion photography's biggest promise was to allow "another nature" to speak to the human observer.[1] Other critics such as Béla Bálazs, by contrast, were eager to emphasize slow motion's ability to serve as a stand-in for the potentials of aesthetic perception, expression, and transfiguration, for visualizing sensory and mental operations—subjective states and perspectives—that transcended mere scientific impulses. The optical tricks of slow motion, Balázs argued as early as in the mid-1920s, "show not just the object but also its transformation in our mind. Not just what happens to the object but also what happens simultaneously in us."[2]

The often aleatory conditions of early film recording and projection left little room for developing a coherent language of slow-motion photography. As we have seen in chapter 1, in the late 1930s Leni Riefenstahl sought to define slow-motion photography as a standard for projecting the seemingly timeless and archetypical, but it was only after the demise of classical narrative cinema in the 1950s and during the emergence of young cinemas in the second half of the 1960s that slow-motion photography gained critical prominence on film screens worldwide. Contrary to Riefenstahl's single-minded ambitions, however, slow motion around 1970 came to carry out a whole number of different expressive functions: to suggest the dreamlike quality of certain experiences, to signify supernatural power or extraordinary violence, to emphasize the lyrical quality of particular story elements. Rather than to display the present as a mere replay of a timeless past, the use of slow-motion photography around 1970 aspired to temporarily suspend the drive of narrative progress for the sake of intensifying visual perception and complicating spectatorial identification. As if fusing the scientific and the aesthetic ambitions of early film theorists, slow motion thus often intended both at once: to reveal aspects of physical movements and processes unseen by the human eye and to explore a new grammar of cinematic representation allegorizing the work of aesthetic perception itself. The films of Sam Peckinpah played perhaps the single most important role in this recodification of slow-motion photography. Contrary to common wisdom, Peckinpah's use of slow motion was not to celebrate the violence of intense action at all costs, but to explore temporal stretching and stylization as means of questioning the violent undercurrents of his contemporary society. Whether Peckinpah's moral and political agendas with films such as *The Wild Bunch* (1969) and *Straw Dogs* (1971) really bore fruit is not for me to answer in this context. What is noteworthy, however, is that Peckinpah's use of slow motion was especially compelling when its purpose was to signify a character's loss of physical volition, that is, to express, as Stephen Prince has argued, "the metaphysical paradox of the body's continued animate reactions during a moment of diminished or extinguished consciousness."[3] Slow motion, in this sense, was not designed to celebrate mythic figures of finality and closure

(as it was in Riefenstahl). It instead intended to stretch out the abrupt cessation of human intentionality as caused by the speed of violent mutilations of the body. Slow motion's task was to represent the unrepresentable—sudden death triggered by modern instruments of destruction—and, in so doing, it promoted the camera's aesthetic transformation of the physical world as an antidote to the brutality of the real.

During the last four decades, and particularly since the global proliferation of East Asian martial arts films in the 1990s, slow-motion photography has become an omnipresent staple of narrative filmmaking. Extreme high-speed cameras and digital postproduction facilities today provide relatively easy means of stretching cinematic temporality for various expressive purposes. I will explore the recent popularity of slow-motion techniques in commercial cinema in chapter 5, focusing on the work of German director Tom Tykwer and how his films rework the prominence of slow-motion photography and high-frequency editing in contemporary action filmmaking. This chapter, by contrast, will deal with two complementary allegorizations of aesthetic slowness within the domain of international art house filmmaking, both of which largely eschew the use of slow-motion photography itself and instead engage the viewer in a complex project of media archeology. The focus will be on Peter Weir's disturbing *The Last Wave* (1977) and on Werner Herzog's more recent 3-D essay film, *Cave of Forgotten Dreams* (2010). The two films could not be more different in style and purpose, and yet what they both share is an interest in caves as sites inviting us to envision alternate forms of cinematic time, representation, and pleasure and in dreams as mediums (and media) facilitating intricate temporal transactions between past, present, and future, the durational and the contemporary. An amalgam of Weir's and Herzog's interventions, what this chapter calls Dream|Time cinema not only rubs against dominant notions of rectangular enframing so as to stress the importance of our sense of touch, of embodiment and physical motion, to our act of beholding cinematic images. Dream|Time cinema also hopes to suspend the way in which narrative filmmaking has largely tended to collapse the different dimensions of cinematic time into each other and erased any sense of presentness and cotemporality, of being contemporaneous with various streams and rhythms of time.

Most prominently defined by Erkki Huhtamo, the academic field of media archeology today is concerned with reading media history against the grain. Media archeologists, according to Huhtamo and Jussi Parikka, "construct alternate histories of suppressed, neglected, and forgotten media that do not point teleologically to the present media-cultural condition as their 'perfection.' Dead ends, losers, and inventions that never made it into a material product have important stories to tell."[4] Both Weir and Herzog, as they explore the dreams and caves of seemingly distant times, aspire to construct an alternate history of cinema, one able to bring cinema's historically suppressed and neglected potentiality to live again. To be sure, their interest is not in simply idolizing the dead bodies of the past and heroizing the losers of media history. Instead, what is at the center of their inquiry is to explore alternate possibilities of what film audiences encounter as a screen. By exploding the quadrilateral flatness of the cinematic image, Dream|Time cinema wants us to see with our senses and to sense our seeing. It invites viewers to experience cinema as the site of sensuous transactions and physical voyages and in so doing to rework the dominant shapes of cinematic time. Media archeology here serves the purpose of reading cinematic temporality against its grain to play out forgotten possibilities against cinema's iron regime of arrowlike time and to expand cinema by activating the protocinematic aspects of dreams and parietal art.

In Peter Weir's Australian film, media archeology engages the Aboriginal notion of dreamtime—its mysterious blending of the spiritual and the sensory, the supernatural and the material, of past, present, and future—as a valuable medium for slowing down dominant systems of cinematic time. In contradistinction to the Freudian or Lacanian tradition of reading dreams as highly compressed dramas of repression and displacement, Weir's actualization of dreamtime mythology identifies art cinema as a site asking viewers to slow down their viewing processes so as to sense hidden meanings and durations behind the facades of the real. Similar to the slow time of dreamtime mythology, Weir's film situates cinema as a sensory relay station emplacing audiences in multiple temporalities and asking them to experience the phenomenal world as a secret text in which even seemingly trite objects may have alternate meanings, multiple existences, and extended durations.

Though Herzog's filmography includes a feature on Aboriginal life too (*Where the Green Ants Dream*, 1984), this chapter's focus is on his much more recent attempt to translate the experience of Paleolithic cave art into a compelling 3-D extravaganza. *In Cave of Forgotten Dreams* Herzog approaches the drawings of the Chauvet Cave in Southern France as a means to reconsider the ontology of the cinematic medium, but also to ponder about certain ruptures and continuities between the earliest signs of human artistic production and our own present. Similar to the way in which the rock artists of thirty thousand years ago must have considered wall surfaces not simply as support for their markings but as membranes from which to release animated images, Herzog presents 3-D cinematography as a medium of heightened attentiveness that has the potential to move viewers beyond the confines of the conventional screenic frame. Parietal art, in Herzog's trenchant perspective, can teach contemporary and future film audiences a lesson or two about the art of embodied looking; it embodies a temporality of beholding that repudiates the restless rhythms of today's visual culture.

It is tempting, of course, to think of Weir's foray into Aboriginal mythology and Herzog's descent into Paleolithic darkness as a neo-Riefenstahlian embrace of the archetypical: a decisive turn away from the present into some prehistoric past and otherness. Yet the wager of this chapter is to present Weir's and Herzog's Dream|Time cinema as a cinema of contemporaneity, not simply because it—like the prominent role of Aboriginal art on the global art market since the 1970s[5]—actively participates in a contemporary creation of value, but first and foremost because it explores the contours of what contemporaneity after modernism and postmodernism is all about: to recognize the co-existence of various temporalities (whether modern, premodern, or protomodern) within the space of our (globalized) present; to assess the role of numerous discourses on time and of experiences of temporal passage to contribute to the kind of conversations that in today's world form various possible futures.[6]

Though films such as *The Last Wave* might in crucial moments—like Peckinpah—rely on slow-motion techniques, this chapter develops a much broader sense of how to think about slowness in contemporary filmmaking. Dream|Time cinema's contribution to a contemporary aesthetic of slowness is in how Weir and Herzog explore the temporality

of dreams and cave art as media that embody cinema before and out-
side of film as we know it—a cinema of phenomenological attractions
in which vision exceeds the optical and viewers are not subjected to the
linear drive of narrative progress. Dream|Time cinema is dedicated to
expanding our perception, our corporeal knowing of things, thus recall-
ing the dual vision of slow motion developed by modernist theorists
such as Arnheim, Benjamin, and Balázs. It helps stretch bodies and
minds across temporal and spatial divides and thus invites viewers to
encounter their present, not as a rapid succession of highly fragmented
images, but as a meeting ground for open-ended meanings and extended
durations. At once recalling and reworking the legacy of surrealist film-
making of the 1920s, Dream|Time cinema resists linear stories and spatial
trajectories so as to rework our bodily relation to the cinematic image
and its inherent temporality—to redefine the screen as a threshold or
door rather than an ocular viewing device. It asks us to take time, to
behold of multiple times at once, for the sake of modifying our phenom-
enological construction of the (filmic) world, decelerating our perceptual
processes, and attending to aesthetic experiences of flux, cotemporality,
and durational overlay.

2 /

Peter Weir's *The Last Wave* tells the story of a white taxation lawyer
drawn into a puzzling case of tribal murder. Though Aborigine tribes
are said to be no longer in existence in Sydney, David Burton (Richard
Chamberlain) reveals the covert work of tribal justice behind the kill-
ing in an effort to protect the accused from the ordinary legal system.
Contrary to the persecution's line of reasoning, Burton insists that the
victim's death did not result from an act of intoxicated murder, but
constituted a punishment for the violation of tribal law, namely the theft
of a number of ritual objects from a sacred cave way below the city's
topography. More important than the film's nod to the courtroom and
thriller genre, however, is its exploration of Burton's troubled self, his
interaction with the clan members, and his fateful descent into a world
in which dreams provide visions of a catastrophic future while stable
lines between the oneiric and the real can no longer be drawn. The film

starts out with images of a freak hailstorm in the outback and then moves on to show us Sydney being inundated by unusual rainfalls and massive floods. Though the narrative introduces Burton as a well-to-do head of an orderly middle-class family, the routines of his day life and the world of his dreams will soon be affected by the violent frenzy of nature. The more water floods his suburban house, the more Burton feels estranged from his family and delves into the mysterious temporality of Aborigine thought such that in the end of the film we not only witness Burton entering the forbidden cave and murdering one of the clan's spiritual elders but also foretelling the arrival of a giant wave that, in the film's last images, seems to consume the entire city of Sydney.

Haunted by excruciating nightmares, Burton at one point proclaims: "We've lost our dreams. Then they come back and we don't know what they mean." Desperately, he turns to one of his clients, the Aborigine Chris Lee, in order to sort out his predicament, but Chris's response only intensifies the lawyer's existential crisis. "A dream," Chris ponders while the camera first captures his inscrutable gaze and then closes in on his thumb as it pinches his arm, "like . . . seeing . . . hearing . . . talking. The way of knowing things. . . . If my family is in trouble, in dream, they send me a message. . . . And through my body. Part of my body will move . . . if my brother calls me. . . . Dream is a shadow of something real." For Chris, dreams do not operate as Freudian mechanisms of displaced wish fulfillment, nor do they merely regurgitate daytime events or provide imaginary solutions to pressing problems. On the contrary, true to the beliefs of Australian Aborigines, Chris understands dreams as media of sensory experience and transport. They link dreaming subjects to the ancestral past, bond them to other clan members who are scattered across geographical divides, and offer premonitory signs. To dream, for Chris, is to expand the real, to perceive it as being structured by the long, slow-moving, and often secret duration of clan history and mythology. Dreams here work like magical and somatic switchboards. They connect the near and far, past and present. They mediate mythical laws through historical subjects and warn about possible transgressions of shared rules and legislations. As a shadow of something real, the dream gives contour to reality, renders it legible and hence meaningful. As important, it enlarges the individual's percep-

tion and knowledge in bodily form. Far from merely offering a cerebral imaginary, dreams transport and imprint physical impulses across space and time. Their language is haptic and tactile, enabling the dreamer to receive signals directly with his senses and to open up his sensory organs to other times and places.

Already troubled by premonitory visions as a child, Burton's principal dilemma is that he, like his Aborigine clients, comes to experience dreams as a slowing down of time revealing shadows of the real, yet he lacks the cultural resources to make sense of what he sees, hears, and senses. Unable to heed what, for the Aborigine Chris, are clear signs of warning, Burton's curiosity drives the lawyer to behold that which Aborigines law defines as secret and off-limits; he desires to enter the fabric of Aborigine life without realizing that, in doing so, he cannot but violate the very system of meaning he tries to attain. Weir makes use of a number of aesthetic strategies other than merely the use of slow-motion photography in order to communicate Burton's confusion about his place in space and time. Repeatedly, it is only in retrospect that we come to realize that certain scenes captured the interiority of dream visions. Moments of terrified awakening puncture the flow of the narrative as much as images that seem to duplicate what we have seen before. However, what is perhaps most striking about Weir's cinematography is the extent to which *The Last Wave* associates the world of Burton's dreams with the help of numerous internal framing devices such as windowpanes and doorframes. Chris, for instance, appears to Burton for the first time in the form of a disturbing dream image, framed initially by the pane of his home's window and then by the verticality of the doorposts of his study (figure 4.1). A later daydream of Sydney street life as a creepy underwater scenario is introduced to the viewer through the windshield of Burton's Volvo, its windshield wipers haplessly trying to hold the flood at bay. While in both scenes Weir's cinematography situates Burton like a movie spectator in front of projected images, rumbling noises on the sound track mark these scenes as at once terrifying and uncanny. Similar to the Aboriginal notion of dreamtime, the act of dreaming here literally pushes against the frames of the real. It displaces or engulfs the everyday with an immersive and sensually compelling, albeit highly disturbing, theater of the mind.

FIGURE 4.1. Peter Weir, *The Last Wave* (1977). Screenshots.

A far from perfect translation of what different Aboriginal tribes and languages call "ngakumal," "kadurer," or "altjiranga ngambakla,"[7] the English term *dreamtime* describes a sacred period of creation that reaches into the present of social and historical time with the help of an intricate array of totemistic objects and sites, a texture of material references that Aborigines call dreamings. The function of the concept of dreamtime is to designate the principal duality of reality, it being at once visible and invisible, tangible and metaphysical, social and religious. As important, it is to render transparent that—like the cosmos of our dreams—the extrahistorical period of creation isn't understood as a former golden age, a time of unhampered plenitude, harmony, and authenticity. On the contrary, Aborigine legends often recall the heroic creators of life and landscape as highly ambivalent figures whose all-too-human errors and desires by no means provide splendid models of moral integrity. Within the thought systems of most Aboriginal tribes, the aim of interconnecting the principal duality of life through certain ritualistic practices, and in this way of accessing the timeless domain of the dreamtime, is neither utopian nor nostalgic or entelechial in nature. Whether it depicts certain animals, artifacts, or geographical features as interfaces to the sacred time of creation, Aborigine thought urges clan members to reconnect to their mythic past, not in order to flee their present altogether, but to ascertain a compass able to map their positions in historical time.

The opening credit sequence of Weir's *The Last Wave* starts with the image of a man sitting in a cavelike opening while painting enigmatic figures and ornaments—a spiraling circle, a shape possibly representing an animal—on the surface of the rock above his head (figure 4.2). In the film's very first frame, the cave's opening and our painter are shown in profile from a medium distance, the rock shrouding more than half the screen in darkness, the painter's arm stretched out in such a way that his body connects the cave's bottom and ceiling. In this first shot, body and rock seem to exist in a symbiotic relationship, one extending the other, one needing the other in order to achieve compositional completion. No matter whether we consider the painter's presence as a force at once humanizing and buttressing the architecture of rock or the rock's daunting overhang as a power simultaneously petrifying and incorporating the human body: Weir's first shot defines

FIGURE 4.2. Peter Weir, *The Last Wave* (1977). Screenshots.

the living and the nonliving as elements of one and the same semiotic order, a structure in which different temporalities—the rock's apparent timelessness, the painter's deliberate movements, the lyricism of the dawning or setting sun in the background—coexist in dynamic interaction.

Inanimate objects, covered with painted emblems and hence human marks, play an essential role in *The Last Wave* to communicate the tribe's secret knowledge and propel the film hero's increasing disorientation. We'd be mistaken, however, to consider these objects as part of a primitive aesthetic. Rather than capture realistic views of nature, painted objects in *The Last Wave*—as much of Aboriginal art in general—instead provide enigmatic representations of former instances of dreaming. Their task is to offer conceptual maps of at once spiritual and material landscapes, of geographies that are experienced as maps—as sites of past inscription, marking, and signification—in the first place. However, what concerns us most about the opening shot of Weir's film is not the painter's act of cognitive mapping itself, but the way in which the contact between the corporeal and the inanimate here form a second screen within the screen, a jagged window onto a distant landscape that defies the symmetry of the ordinary cinematic frame. The intricate composition of this first shot is as allegorical as the subject matter of most Aborigine art production itself. It defines dreamtime art and mythology as protocinematic so as to evoke the possibility of an alternate order of cinematic representation, framing the real, and understanding the screen as a map of our dreaming. Far from fueling Luddite fantasies, this first shot reveals the medial and technological character of dreamtime myth as much as it envisions forms of cinematic representation in which the perceptual structures of Aborigine dreamtime help counteract the dominant codes of narrative time and cinema and their manipulation of the viewer's conscious and unconscious.

3 /

The exploration of other states of consciousness—dreams, visions, hallucinations—has been at the heart of Werner Herzog's work as a

film director ever since the late 1960s as well.[8] Think of Herzog's use of hypnosis in *Heart of Glass* (1976) and the depiction of colonial madness in *Aguirre, the Wrath of God* (1972) or the delusions, deliriums, megalomanias, and prophetic stances of Herzog's protagonists in later feature films such as *Fitzcarraldo* (1982), *Cobra Verde* (1987), and *The Wild Blue Yonder* (2005) and in documentaries such as *Bells from the Deep* (1993), *Gesualdo: Death for Five Voices* (1995), and *Grizzly Man* (2005). In his 3-D essay film, *Cave of Forgotten Dreams*, Herzog's quest for moments of transcendence and the spiritual, for what Brad Prager has called Herzog's pursuit of aesthetic ecstasy and truth,[9] takes on a new dimension as we follow the director into the Chauvet Cave in Southern France and ruminate over the origins of human art and spiritualism around thirty thousand years ago. Discovered in 1994, Chauvet contains by far the oldest cave paintings and carvings known today. It was shut to the public soon after its discovery for reasons of preservation. Ever since, only highly select teams of scientists and humanists have been granted access to the site to research the cave's extraordinary rock art and bring light to the mysteries surrounding its coming into being.[10] In all likelihood, Herzog's cinematic descent into the cave will remain the only extended filmic document of the cave's parietal art for some time to come: a film capturing the past in all its obscurity for an unknown future. Yet, shot at the height of the commercial 3-D craze in international film culture, Herzog's *Cave of Forgotten Dreams* at the same time may also come to stand as a curious witness to alternate uses of the most advanced film technology today, a veteran auteur's effort to read our own moment against the grain of its technological triumphalism. Like Wim Wenders's *Pina* of the same year, *Cave of Forgotten Dreams* engages the spectacular aspects of 3-D, not in order to bury the legacy of postwar art cinema, but to invite the viewer to do what modernist art cinema has done all along, namely reflect about the potential, appropriateness, and limitation of certain media—their codes, their material logics, their structures of support—in depicting specific subject matters.

The Chauvet Cave, Herzog ponders early in the film, "is like a frozen flash of time;" it presents "a perfect time capsule." But from the film's very first shots, gathered by a camera that strangely—as if partly liberated from the laws of gravity—hovers through a vineyard and up

along a cliff, it is clear that Herzog's trip to southern France is not simply about showcasing a remote past for modern eyes of consumption. Instead, *Cave of Forgotten Dreams* wants to be both a meditation about the prehistorical and spiritual origins of image production and an attempt to explore past artistic practices as a resource to expand cinema beyond its historically developed language and templates of looking. Herzog's quest, in other words, is to tap into the *longue durée* of forgotten pasts so as to complicate what we today should consider an image in the first place. It explores cinema as medium to generate time-images, in Deleuze's sense, as much as it wants to locate cinema's ability to capture the dynamics of time far beyond a specific historical era. To be sure, scholars of cave art have still not found one conclusive answer about why people about thirty thousand years ago descended into the darkness of interior spaces in order to engrave, scratch, paint, and draw images on rock walls. Dominant accounts refer to shamanism, to apotropaic visualization, and to quasi-genetic needs for aesthetic self-expression in order to explain what inspired acts of prehistoric image making in the flickering light of torches.[11] But there is little agreement about the exact psychological and social function of early cave art, let alone whether we should consider Paleolithic markings as art in the first place. Herzog's film asks a handful of scholars to articulate their positions regarding this matter, but in the end he neither seeks to take sides in current scholarly debates nor to come down with one coherent view of what caused Paleolithic people to engage in image making. His most important aim lies somewhere else: to explore prehistoric caves as (forgotten) media whose images can move viewers beyond dominant forms of cinematic projection and whose dreams question how commercial cinema has made us understand time as a linear, teleological, and tightly integrated progression from A to Z.

Not long into the film, Herzog allows us for the first time to behold of Chauvet's perhaps most iconic images, a panel depicting the heads of four horses, their eyes all directed to the left, their shapes neatly set against each other in such a way that we cannot escape the impression of forward movement (figure 4.3). As in various later encounters, Herzog's camera here already seeks to accentuate the images' stunning efforts to represent motion. He captures the deliberate flickering of artificial illumination and tenderly pans across the walls so as to imprint

FIGURE 4.3. Werner Herzog, *Cave of Forgotten Dreams* (2010). Screenshots.

the animals' intimated dash onto the viewer's perceptual registers. "For these Paleolithic painters," we hear Herzog's voice-over right before his camera begins to travel over a pair of bison fighting with each other, "the play of light and shadows from their torches could possibly have looked something like this. For them, the animals perhaps appeared moving, living." Herzog's voice at once speaks propaedeutically and deictically in this moment. It precedes, points at, and in this way virtually summons what it then wants to show and prove to our eyes. It asks advanced 3-D technology to learn from the past and invites us to see our own seeing as part of a much older practice of enchanted looking.

Only seconds later, Herzog's camera will identify the image of a single bison, its body painted with eight legs as if to embody—as Herzog himself is eager to point out—"almost a form of protocinema." Paleolithic painters, we are to conclude, as they allowed the trembling light of their torches to energize their imagination, foreshadowed what scholars of our own times have often canonized as one of the crucial origins of cinema: Étienne-Jules Marey's late nineteenth-century desire to arrest individual aspects of specific movements within the unity of one and the same image. Herzog's painters thus speak to us across funda-

mental divisions of time. Their dreams and visions not only anticipate our own aspirations and technologies. They also have the power to deliver whatever appears past and frozen from the medusan logic of deep time—to display the *longue durée* of human history as something dynamic, as something that resonates through our own present and might open the door to alternate and unclaimed futures.

Like the flickering of early film projectors, prehistoric cave painting in Herzog's view drew makers and viewers alike into hallucinatory experiences of dynamic motion. Nowhere does this analogy become more explicit than when Herzog, while urging one of the Chauvet researchers to reflect on the interplay of light, shadow, and bodily presence in early cave art, suddenly cuts to the "Bojangles of Harlem" sequence of George Stevens's *Swing Time* (1936). The scene shows Fred Astaire tap dancing in black face on stage, his back mostly to the audience, his face and body primarily directed toward his own shadow as it is being cast threefold on a giant screen at the back of the stage (figure 4.4). In the course of Astaire's original number, the dancer's shadows gain increasing independence from the actual body on stage. They continue or supplement moves Astaire himself does not carry out on stage, thus not only multiplying the choreography's complexity but also identifying the speed and virtuosity of Astaire's steps as media of intoxication, of out-of-body experiences, of a temporary suspension and transcendence of the real.

At once meant as a replay and a fast-forward, Herzog's use of "Bojangles of Harlem" and its splitting of identity is quite programmatic. It defines the protocinematic aspects of cave art in terms much more expansive than the way we have come to accept cinema as a vehicle of realist illusion and integrated narrative time. As they allowed the flickering play of light and shadow to intoxicate their own senses, Paleolithic painters anticipated a cinema well able to transport mind and body into the unknown, to challenge the parameters of the real and invite the fantastic to enter its scenes, to provide sensory experiences—not just consumable images—powerful enough to be and become other. Astaire's dance intoxicates itself with its own representation and precisely thus allows representation to gain material presence and animated life in its own right. Cave artist dreamed such dreams long before cameras, projectors, and screens were able to call still images to life, much as they

FIGURE 4.4. Werner Herzog, *Cave of Forgotten Dreams* (2010). Screenshots.

FIGURE 4.5. Werner Herzog, *Cave of Forgotten Dreams* (2010). Screenshots.

remind us of bodily pleasures that—like Astaire's—move us far beyond the kind of thrills commercial cinema has largely come to offer its viewers since its emergence. In Herzog's cave cinema, the making and beholding of images fuses into one single dynamic and space, yet not— as Astaire's example indicates—in order to fancy states of absolute self-presence, but to play with the possibility of living and encountering multiple rhythms, speeds, and temporalities at once.

Asked by Herzog toward the end of the film what might constitute humanness, French archeologist Jean-Michel Geneste reflects about our species' ability to inscribe memory and communicate it, through mythology and music, across history. To be human, in his view, is to resist the entropy of time and be able to trace and read layered traces of lived life against the stream of linear chronology. Figurative images

must be seen as humanity's perhaps most effective tool of allowing pasts to communicate with their futures, and—as Geneste is eager to conclude, pointing his finger directly at the camera—cameras like Herzog's clearly continue this mnemonic mission. At which point Herzog cuts to an aerial shot of the banks of the Ardèche River, right next to the entrance of the cave (figure 4.5). We can identify three men standing next to the water, their faces directed at the camera. One of them is Herzog, another holds a bulky remote control in his hands. The camera moves smoothly toward the group, yet before reaching them turns halfway around and catches a glimpse of the river and the majestic arc dominating the valley. Meanwhile, the soft humming of an electric rotor emanates from the sound track. The camera's eye then turns back to the group again, approaches the open hands of the man in the middle, and ends its approach in the dark cave of its catcher's grasp, with nothing to show and nothing for us to see anymore. The shot's self-reflexivity could hardly be trumped. What it reveals to the viewer is the work of a small helicopter camera, taking pictures of its director as well as of its operator, laying bare what made many earlier images of the film possible in the first place. And yet, as the helicopter's image fades into cavernous black, it also seems to return the viewer across the banks of time to the Upper Paleolithic—or rather to define prehistoric cave painters and advanced cinematographers as contemporaries, as being able to communicate through visionary images across the abysses of history. Like Astaire, Herzog's film here turns on itself to show and celebrate what the magic of human image making, according to Geneste, is all about: to complicate our maps of progress, uncover history's unconscious, and thereby reveal the dynamic cotemporality of media past and present.

4 /

Time to recall, at this point, that one of the most influential Western conceptions of perception, truth, and the duality of body and mind, namely Plato's simile of the cave, not only shares its location with crucial sections of Weir's *The Last Wave* and Herzog's *Cave of Forgotten Dreams*, but has inspired generations of film theorists to conceptualize

cinema as a powerful machine of fantasy production. For Plato, the world was separated into the realm of ephemeral appearances and sensual perceptions, on the one hand, and, on the other, the timeless sphere of abstract ideas, whereby the first merely provided an alluring, albeit quite inferior, representation—a flickering image, a feeble projection—of the second. Chained and immobilized, the inhabitants of Plato's cave were constrained in their perception to the play of mere shadows cast on a wall in front of them. Privy to the power of illusion, they were unable to grasp the true nature of things and hence enter the realm of eternal forms and unchangeable ideas. In the work of apparatus theorists of the 1970s such as Jean-Louis Baudry,[12] Plato's cave foreshadowed the perceptual conditions of cinematic experience: the way in which both the womblike darkness of the auditorium and the mechanical time of cinematic projection immobilize spectators so as to entertain them with captivating illusion—the way in which the dream screen of filmic representation, rather than merely helping to disseminate certain ideological perspectives, is ideological in its very institutional nature as it simultaneously exploits and reinscribes the Western duality of mind and body, the real and the imaginary. As summarized by Thomas Elsaesser and Malte Hagener, in Baudry's rather tragic and highly deterministic view of the cinematic situation, "the specific set-up of projection, screen and audience, together with the 'centering' effects of optical perspective and the focalizing strategies of filmic narration, all ensure or conspire to transfix but also to transpose the spectator into a trance-like state in which it becomes difficult to distinguish between the 'out-there' and the 'in here.'"[13] Replaying Plato's allegory, cinema's architecture of the gaze in Baudry's view renders reality checks impossible. It at once requires and produces spectatorial immobility in order to rework the viewer's psyche and make us complacent with the protocols of consumer capitalism.

At first, traditional Aborigine mythology and religion might seem to echo some of the basic tenets of Platonic thought.[14] Just like Plato's cave serves the purpose of separating the realm of timeless forms from the transience of sensual perception, so does the Aboriginal concept of dreamtime distinguish between the spiritual and the material, the supernatural and the natural, the eternal and the historical. And yet, what makes the Aborigine concept of dreamtime so puzzling is the fact that

its stress on topography and site specificity revokes the very dichotomy it seems to set up in the first place. Many Aboriginal myths tell tales of travel in which ancestors move across expansive territories to relive the founding dramas of their tribes. Ongoing physical mobility here provides the base for reconnecting with the past, for both revealing and actualizing the power of ancestral dreaming. In these stories the features of the physical world figure as something neither to be subjected to human activity nor to be denied and overcome by inert spirituality. Instead of offering frozen images of the past, the physical landscape describes a crossroads for overlapping narratives and ongoing existential trajectories. It offers "concentration points for intense religious, political, familial and personal emotions" and must be read with the body's entire sensory system.[15] Contrary to Platonic thought, then, traditional Aborigine myths do not consider the body of the perceiving subject as being chained, immobilized, and fooled by transient illusions. They instead press the subject to open its senses to the indexical, albeit riddle-like, inscriptions—the dreams—of the foundational past and thus to establish dynamic relationships to the physical world. It is through one's corporeal engagement with the materiality of certain topographical features alone that one can partake of the timeless forms and sacred meanings of the dreamtime. It is only by means of various strategies of mobility that one can literally get in touch with the unconscious other of historical time, the long duration of that which transcends one's own horizon. Whoever wants to tap into the spiritual world of the dreamtime needs to move slowly and deliberately into time, not beyond it.

Though worlds seem to separate the foundational dreams of Australian Aborigines and the cave paintings of the Upper Paleolithic Age, quite similar claims can be made about the way in which Herzog approaches prehistoric caves as sites embodying the potential of an alternate history of filmic representation and cinematic time. For Herzog, the lessons to be learned from parietal art production are far too rich to reduce cinema—like Baudry—to primarily an optical and physically stagnant experience. In *The Mind in the Cave*, David Lewis-Williams speculates about why people used sites of apparent sensory deprivation to produce, store, and communicate symbols as follows: "In their various stages of altered states, questers sought, by sight and touch, in

the folds and cracks of the rock face, visions of powerful animals. It is as if the rock were a living membrane between those who ventured in and one of the lowest levels of the tiered cosmos; behind the membrane lay a realm inhabited by spirit animals and spirits themselves, and the passages and chambers of the caves penetrated deep into that realm."[16] Lewis-Williams's notion of cave and rock as membranes is useful for emphasizing the crucial difference between Herzog's and Baudry's appropriation of cavernous spaces as allegories of cinema. Whereas, for Baudry, the cave primarily figured as a model of how cinema's structures of looking suture viewers into the regimes of both disembodied Renaissance perspective and passive consumption, for Herzog prehistoric caves foreshadow the possibility of thinking and embracing cinema as a membrane: a skin or revolving door of manifold sensory and nonsensory transactions. Unlike Baudry, Herzog doesn't approach Chauvet's cave paintings as if they were mere visual projections onto fixed screens. Though the visible flickering of light and shadow clearly matters for our understanding of the act of making and beholding parietal art, cave painting for Herzog is deeply haptic and somatic in nature. It reveals, through the medium of touch, what is considered within or behind the surface of the rock and it invites the beholder to what media scholar Laura Marks has called in a different context a sensuous response without abstraction, that is, a "mimetic relationship between the perceiver and a sensuous object . . . [which] does not require an initial separation between perceiver and object that is mediated by representation."[17]

It doesn't take much to notice that *Cave of Forgotten Dreams* abounds with references to all kinds of senses—touch, hearing, smell— in order to explore the possibilities of a (past and future) cinema whose sensuous transactions have the ability to move us beyond Baudry's rather restricted notion of the perceptual immobility of both cave and cinema. As modeled on the Chauvet Cave, Herzog's expanded cinema is one in which screens function like skin,[18] the flatness of projection is replaced by deep tactile space, Renaissance perspective no longer defines our entry point into what we experience as image, and perceiver and perceived—like rock and rock artist—can entertain mimetic relationships that liquefy hardened boundaries between subject and object. Herzog's repeated focus on a handprint found in various locations of

the Chauvet Cave and left, as scientific analysis has shown, by a singular individual, communicates this modeling of somatic, nonrepresentational forms of cinematic perception. Contrary to initial assumptions, Herzog's thrill about this handprint is not about his desire to identify a prehistoric prototype of bourgeois art's cult of the signature, but rather about documenting a long-forgotten index of the symbiotic relationship between flesh and rock, the human and the nonhuman, subject and object, materiality and spirituality. The meaning of the hand's imprint on the wall, for Herzog, functions like a promissory note foretelling a yet-to-be realized cinema in which dominant notions of making and consuming, activity and passivity, proximity and distance no longer hold because film will define sight, touch, and movement as mutually imbricated. As it unsettles the integrity of the conventional cinematic frame, 3-D projection is as close as one might get to this expanded cinema at this point. But, all things told, the viewer's 3-D experience remains only an allegorical abbreviation of what is protocinematic and, as it turns out, anti-Platonic about the art of the Chauvet Cave: the promise of a promise.

Which returns us to the opening shot of Weir's *The Last Wave* (figure 4.2). In depicting not only an Aboriginal artist whose hands simultaneously map and mark the physical landscape, but one whose body comes to embody the perimeter of an asymmetrical screen within the screen, Weir's film too—like Herzog's—urges us to rethink the much theorized role of film as a Platonic mechanism. Alluding to the curious mingling of the real and the imaginary in the Aborigine conception of the dreamtime, Weir's shot envisions forms of cinematic representation able to situate film and audience in reciprocal sensory relationships. The materiality of the cinematic image, according to this conception, has the power to absorb the viewer into the world it presents as much as the viewer is enabled to immerse the film into his own body and sensuality. The border between frame and image here is as permeable as the one between the act of viewing and the act of representation, of image production. One simultaneously needs and produces the other. One relies on the other's very materiality and presence, not merely in order to engineer acts of psychic identification, but to establish stunningly physical and physiological bonds between screen and spectator.

As envisioned, then, by both Weir and Herzog, Dream|Time cinema explores caves not simply as sites of cinema before film, but as models to expand cinema beyond its historical evolution. Mingling the material with altered states of consciousness, Dream|Time cinema invokes structures of viewing in which the cinematic image, instead of simply suturing the viewer's mind and desire into seamless narrative constructs, operates as a prosthetic limb allowing us to touch upon topographies, objects, and histories not of our own making. Dream|Time cinema is a cinema of embodiment and perceptual movement, a cinema offering sensory maps of the world. To capture and behold of an image, in this conception of the cinematic process, is to sharpen our attention for various temporal trajectories that may define presentness in the first place. Rather than draw the viewer into the streamlined and restless time of narrative progression, Weir's and Herzog's membrane-like cinema wants to open our senses to the irresolvable overlay of different times and spaces that make up the present. And rather than shove the viewer forward along a relentless chain of events, Dream|Time cinema functions as a somatic relay station shaping our awareness for the unframed and inexpressible, the strange and other in ourselves as much as in the world around us.[19] Images in Dream|Time cinema aren't just something putting a stable frame around our vision and thus converting the world into a surface of visibility. The skinlike, multidimensional screens of Dream|Time cinema instead serve as a concentration point of various intensities and temporalities, as enchanting interfaces fusing the visual and the haptic so as to resurrect our desire to be and become other and to literally touch upon and be transformed by a dramatically expanded reality.

At once myth and medium, Dream|Time cinema promotes an inspiring return of conventional cinema's repressed: a meeting of different rhythms and intensities in whose context psychic activity isn't purchased through physical immobilization and sensory anesthetization, but goes hand in hand with experiences of embodiment and our sense of bodily motion. In contrast to dominant forms of spectatorship, in particular the one conceptualized by apparatus theory, Dream|Time cinema addresses the eye, not as a transparent window to the soul and the viewer's desire, but as a physical organ, as part of a body for which experiences of touch and physical motion are integral to the efficacy of

seeing. Images here aren't external to the body, and they reveal to us that we have no absolute authority over our own bodies—their senses, their temporal and spatial extensions, the images we receive and produce alike—nor that we can employ these bodies and their images to claim authority over the perceptual field, over inner and outer nature.

The body of Dream|Time cinema, as we encounter it in Weir and Herzog, is unstable and defies decisive limits. This body is something we can never entirely master and dominate, it is something we merely borrow from time.

5 /

We may find ourselves kicking and screaming when waking up after a terrifying nightmare, but most of our nighttime dreams—known to last a few seconds only—seem to evolve without any sounds whatsoever. Classical Hollywood cinema may have embraced diegetic dream sequences as opportunities to experiment with jarring melodic progressions and modernist dissonance, yet most of the critical and analytical writing on our dreaming rightly considers it as an exclusively visual event, a silent film of the mind. It is one of the remarkable features of what I understand here as the slowness of Dream|Time cinema that acoustic experiences and expressions play a role of nearly equal importance to that of seeing and the visual. Sound, in fact, in how Weir's and Herzog's media archaeologies approach the dynamic contemporaneity of past and present, has agentive and creative powers. Rather than merely representing a by-product of the emergence of living things and artistic expressions, it energizes their very coming into being, the quasi-mythical transformation from the inanimate to the animate.

In many creation myths of the Australian Aborigines, sound often serves as a powerful tool of creation, best exemplified by various totemistic beings wandering across the surface of the earth and singing animals, plants, geographical features, rocks, and humans literally into existence. In these myths, sound builds a bridge from the spiritual to the material, the timeless and shapeless to the sensory. It engenders temporal forms and bodies, brings to light and life what had been

slumbering beneath the earth's crust, and thus sets up topographies of meaning and human interaction. By singing the world into existence, as Bruce Chatwin has reminded us, ancestral beings assumed the role of poets in the original Greek sense of the word *poesis:* they engaged in the business of creation.[20] Yet sound and song, in dreamtime mythology, do not only have the ability to call forth the living and perceptible, they also enable the individual to reconnect to her ancestral past and thus touch upon the mythical period of the dreamtime. Known as the practice of walkabout (and most memorably screened in Nicolas Roeg's eponymous film of 1971), tribal Aborigines up until today suddenly begin to wander across vast spatial expanses in an effort to map through song and movement the secret meaning—the dreaming, the sacred map—of their territories. What to the unknowing eye may appear like a chaotic zigzagging across inhospitable geographies often turns out to be a very deliberate tracing of the so-called songlines: an attempt to immerse the body in an intricate system of paths that is made up of songs telling the creation of the land.

Songlines can thread their way through various language barriers and territorial divides. To follow their tracks is not only to follow a trail of materialized music, a spatialization of a musical score. It is to tap through one's own song, listening, and motion into a network of connections and interactions. Music and matrix alike, the idea of the Aboriginal songline brings into play a tactile production of spatial and temporal relations through physical motion and mobilized perception. Place and space, the concrete and the abstract, the territorial and the conceptual, here are interrelated, one embedded within and energizing the other, one cotemporal and contemporaneous with the other. To follow the invisible tracks of the songlines is to become responsible for the past, not in order to halt historical time, but to experience the present as a crossroads of open-ended stories, loose ends, and possible connections that still need to be made.[21]

How does Dream|Time cinema translate the at once dynamic and hallucinatory acoustics of the songlines into a viable cinematic aesthetic of slowness? How does Weir convert the slow acoustics of the walkabout, its mingling of the sensory and spiritual, of motion and temporal diffusion, into a viable strategy to expand cinema beyond its current forms and modes of beholding?

FIGURE 4.6. Werner Herzog, *Where the Green Ants Dream* (1984). Screenshots.

It should come as no real surprise that most filmmakers have stayed away from picturing the songlines' metaphysical idea and ethics of slowness and instead deliver images and tales of obstructed or misconceived Aboriginal dreaming, of blocked or unsettled connectivity. Consider Herzog's *Where the Green Ants Dream* (figure 4.6), where white landowners and mining company officials, by turning a seemingly dreary countryside into a site of exploration and exploitation, end up blocking, destroying, and rendering silent existing Aborigine dreamtracks. In one of the film's most stunning scenes, we witness a group of Aborigines protesting against this destruction of their territories. Energized by the sounds of a didgeridoo player, they perform a ritual dance in front of a mighty bulldozer, not simply in order to halt the machine's destructive path, but to embody relations to the land that are in stark contrasts to the mining company's instrumental reason. Consider Nick Parsons's 1996 *Dead Heart,* in which we meet the figure of a well-meaning anthropologist, Charlie (John Jarrat), trying to record Aboriginal music and map out their dreaming tracks. After the death of one of the members of the local tribe, we see our anthropologist lying on the ground amidst the chanting mourners (figure 4.7). His tape recorder in hand, he is clearly out of place here, presented as both a violent and ridiculous intruder whose work is driven by a hubristic desire

FIGURE 4.7. Nick Parsons, *Dead Heart* (1996). Screenshots.

to capture the nonreprensentable. When the village's relationships between white and black populations take a turn for the worse, Charlie will rip his map of Aboriginal songlines from the wall of his house, only to then allow it to be blown away by the wind into the desert—as if to acknowledge the inevitable failure of any effort to cast the metaphysics of Aboriginal mythology into a stable, two-dimensional, abstract representation.

Instead of simply picturing the destruction or conceited framing of Aboriginal songlines through white Australia, Weir's *The Last Wave* goes a long way to encode the frame-breaking power of dreamtime song within the frame of his film itself. Repeatedly, Weir's sound track layers barely perceptible and at times even imperceptible acoustic

elements on top of each other in an effort to mediate the acoustics of dreaming without inviting the viewer to primitivist identifications. Employed already in his breakthrough success *Picnic at Hanging Rock* (1975), these acoustic strategies are described by Weir himself as follows: "With the soundtrack I used white noise, or sounds that were inaudible to the human ear, but were constantly there on the track. I've used earthquakes a lot, for example, slowed down or sometimes mixed with something else. I've had comments from people on both Picnic and Last Wave saying that these were odd moments during the film when they felt a strange disassociation from time and place. Those technical tricks contributed to that."[22]

Though slow-motion photography has become a major stylistic signature of mainstream filmmaking since the 1970s, few filmmakers today really explore the potentialities of decelerated sound recording. We are perfectly used to seeing violent action on a screen shown in extreme slow motion while a film's sound track inundates us at the same time with the fast and relentless beats of techno music.[23] Weir's use of white noise and slowed-down sound occupies this lacuna so as to unsettle our relation to what we see on screen. Rather than bond the viewer's emotions to what is spectacular or redemptive about the cinematic image, the layering of decelerated sounds in Weir's work produces strange experiences of dislocation. It yanks viewers out of their habitual viewing position, not simply because we can't figure out what we are hearing, but because it redefines what sound and hearing might mean and do in the first place.

By sampling, stretching, and superimposing different acoustic properties, Weir's sound track has the ability to open up the cinematic frame and—due to the enigmas thus produced—lodge itself in the interiority of the viewer's sensory perception. To listen, here, doesn't simply mean to become enveloped by prepackaged sonic stimulation and thus be sutured into a film's spatial order and speed. It instead means to experience the corporeality of one's own listening as an instrument of framing and reframing the physical world, of actively producing temporal and spatial relationships in the first place. Puzzled by Weir's assemblage of different sounds, we cannot but question the integrity of the film's frame of representation and consequently feel urged to rebuild the world—similar to the wanderer along the Aboriginal songlines—

through and within our mimetic faculty. In Weir's *The Last Wave*, slow sound serves the purpose of marking the extent to which we cannot think of this reality as being independent of our own acts of perception: the extent to which our sensory organs create the perceptual field as a field of possible perceptions to begin with and hence the extent to which we—in Henri Bergson's famous words—must consider our own bodies as one of the images in whose affective presences we find ourselves all the time.[24]

6 /

David Lewis-Williams has made a strong case to make us think of Paleolithic cave art as something in whose context sound and acoustic experience take on similar functions to what we have just discussed with regard to the slow aesthetic of the Aboriginal songlines. While Socrates' simile of the cave, in its foreshadowing of the standard cinematic situation, largely described a silent theater of vision, the production of early cave art has often been associated with the presence of low-frequency drumbeats, their ability to induce trancelike states and enable out-of-body experiences. Findings suggest, Lewis-Williams explains, that resonant areas in caves such as the one at Chauvet "are more likely to have images than non-resonant ones. The implication is that people performed rituals involving drumming and chanting in the acoustically best areas and then followed up these activities by making images."[25] Lewis-Williams is rightly skeptical about the grounds and ramifications of such scientific speculation, but he nevertheless sees good reasons to believe that acoustic properties added important aspects to how cave artists produced and received rock images in the flickering light of the cave. The effects of rhythmic drumming, the echoes of invisible animal sounds, and the resonance of inexplicable topographical and geological noises—all, in his view, contributed to setting a multisensory stage for altered states of consciousness. As Lewis-Williams concludes, "The factors that governed the placing of images were far more complex than resonance alone, and included the way in which the topography of a cave was conceived and the locations where specific kinds of spiritual experiences were encouraged. Still, we need not

doubt that resonance and echoes added to the effect of subterranean Upper Palaeolithic rituals. The caves, if not the hills, were *alive* with the sound of music."[26]

How does Herzog translate the hallucinatory energy of cave art into Dream|Time cinema? How does his version of expanded cinema turn the sound of (cave) music into a formula of aesthetic slowness?

Well known for his work with opera, for his use of ethnic music as much as for his enveloping Wagnerian soundscapes, Herzog is of course no stranger to experiments with acoustic properties and challenging sound-image relations.[27] It therefore should barely come as a surprise that Herzog took great care with the design of the musical sound track for *Cave of Forgotten Dreams*, engaging Dutch avant-garde composer and cellist Ernst Reijseger to provide a mix of atonal and choral, rhythmic and postrhythmic, melodic and strangely hovering musical sounds in order to flesh out the film's cavernous images. Reijseger had worked with Herzog before, on films such as *The White Diamond* (2004) and *The Wild Blue Yonder* (2005), and, similar to these earlier projects, in *Cave of Forgotten Dreams* Reijseger does everything at his disposal to surround the viewer with sounds at once alluring and utterly uncanny, curiously familiar and perplexingly foreign—sounds at once extraterrestrial and as if echoing from the deepest recesses of the human soul and body.

But *Cave of Forgotten Dreams* resounds with abundant acoustic references even beyond the work of Reijseger's sound track. Halfway through the film, Herzog leads the viewer once again to the iconic horse panel in order to ruminate about the horses' open mouths, depicted as if being caught in the act of whinnying. These images—Herzog speculates—are quite audible to the viewer. They tell stories whose sounds we can almost hear. As the camera moves on to capture the paintings of other animals, Herzog then, inspired by what he sees, reflects about a lion's growl and a bison's clapping hooves, as if such acoustic impression were as present and material as the physical markings on the wall. At other moments in the film, Herzog draws our attention to the gurgling of subterranean springs, and how their sounds may have impacted the drawing of certain images, and—in a rather lengthy and at times almost comical aside—to the role of (flute) music in Paleolithic societies. In all of this the focus is on sound, not simply as a means of

accompanying the visual, but as a force generating the world and ener-gizing visual perception. Sound here bespeaks and complicates the mo-bility of what can be seen. It situates Dream|Time cinema as a cinema of synesthetic intensities, as a cinema in which different sensory registers can interact with, cross, and mutually enrich each other.

Yet nowhere does sound play a more important role in exploring the sensory aspects of expanded cinema, and in slowing down the me-chanical time of the apparatus, than about twenty minutes into the film when Herzog asks scientists and film crew to rest in silence and listen to the utter absence of external sounds amid the darkness of the Chauvet Cave. For several minutes the camera will glide over the faces and bodies of Herzog's cave explorers, calmly traverse various wall panels and drawings, show scientists holding up scientific sketches of certain cave paintings, and capture the sight of bones spread across the ground (figure 4.8). Science couldn't be further removed from ordinary science during this sequence, for Herzog pictures his collaborators in what appears to be a state of trance, deep absorption, and compulsive attention—of aesthetic suspension and displacement. As if washed over by the bliss of wonder, their faces show no more traces of science's call for relentless progress and methodical care for detail. Herzog's editing amplifies our impression of trance, our own trancelike sense of absorption during this sequence of silence, by allowing the rhythmic pounding of a heartbeat eventually resound from the sound track and, intermixed with the haunting sounds of Reijseger cello, envelop our visual perception. After some more time, Herzog's voice concludes this scene of reverie by ruminating from the extradiegetic: "These images are memories of long forgotten dreams. Is it their heartbeat or ours? Will we ever be able understand the vision of the artists across such an abyss of time?"

The heartbeat's sounds, to say the least, are at first thoroughly unnerv-ing, though for some they might succeed in drawing the viewer into a state of suspension and intoxication, of sensing a pause in the relent-less drive of linear and teleological time, of experiencing a pocket of slowness amid the rush of modern temporality. Michel Chion's famous distinction between different orders of cinematic sounds is useful here for conceptualizing this unsettling rhetoric of both embodiment and deceleration.[28] Acousmatic sounds, for Chion, are sounds whose sources

FIGURE 4.8. Werner Herzog, *Cave of Forgotten Dreams* (2010). Screenshots.

are hidden from the viewer's view. They can reside in or emanate from what lies beyond the frame of the image or they can resound from nondiegetic spaces, a film's musical sound track and the voice-over of a disembodied filmic narrator being the most common examples. In Chion's view, the use of film sound is at its most productive when sounds begin to shift their status, in particular when they undergo what he calls a process of deacousmatization, that is to say, when invisible sounds suddenly wander across and pierce the frame of the image and thereby redefine our point of view and reshape our understanding of and relationship to the integrity of the cinematic frame. It is tempting to describe Herzog's heartbeat as acousmatic: a sound whose source remains invisible to the eye of the viewer. But a more careful consideration must call

this into question and come to the conclusion that Herzog's project, in this sequence, is to rub against and suspend the very distinction between the acousmatic and the nonacousmatic. While the heart's sounds, technically speaking, of course belong to both the acousmatic and the nondiegetic, Herzog's aim in this sequence is for us to hear them as indexical signs of the viewer's own heartbeat within the diegetic space or, more precisely, to define the camera as a tool inviting us to listen to our own bodies and experience our bodies' sounds as echoes of other times and places.

7 /

In the late 1950s and early 1960s, American minimalist composers began to layer different rhythmical features in such a way that accelerated beats could create impressions of nonnarrative stasis: a hallucinatory sense of pause and standstill not unlike the experience of being on drugs, a Zen-like transcendence of linear time, progression, and sovereign subjectivity.[29] In the work of Terry Riley and Steve Reich a certain speeding up of musical rhythms was meant to draw listeners into states of trance, daze, and intoxication—of aesthetic slowness. Their slow music repeated, recombined, and remixed, not in order to freeze any sense of development, nor simply to level out the exigencies of our everyday, but to open a sonic space for reflection and calm, a space in which listeners were invited to explore different levels and structures of attention, of literally and metaphorically being in touch with the copresence of dissimilar rhythms, beats, pulses, and temporalities.

Dream|Time cinema's experiments with sound are quite reminiscent of the way in which American minimalism pursued experiences of temporal delay and dislocated subjectivity. As developed in Weir's and Herzog's respective projects, Dream|Time cinema envisions a viewing subject categorically different from the unified and critically distanced subject of both transcendental philosophy and modern critical theory. Dream|Time cinema redefines cinema as a Benjaminian "room-for-play": it wants to allow human beings, in Miriam Hansen's words, "to appropriate technology in the mode of play, that is, in a sensory-somatic and nondestructive form."[30] Dream|Time cinema aims to situate the

viewer's body as a mechanism actively generating audiovisual experience within its own physiological and affective indeterminacy. It enables viewers to establish sensory connections to images and sounds whose origins lie less in the framed space of the screen than in the viewers' bodily innervations, their ability to assimilate to, incorporate, build, and rebuild the world within their own senses. Neither sound nor image merely serves the purpose of representing the world, i.e., to contain it within the bounds of a reliable frame. On the contrary, Dream|Time cinema encourages noninstrumental relationships between percept and perceiving body based, not on desires to control, contain, and frame, but on our yearning to learn how to listen and let go, to open ourselves up to what is contingent and beyond our control. Instead of trying to force a relentless narrative and perceptual trajectory onto the viewer, Dream|Time cinema allows the viewer to let go and slow down, the art of slowness here being understood as our ability to suspend linear temporal and spatial orders and—like a dreamer—experience the world of our perception as something beautifully ambivalent, enigmatic, in flux, unassimilable, and unpredictable.

8 /

When it entered the scenes of everyday life around 1900, cinema had fostered a concept of life as movement, change, chance, and process, and it promised to make this peculiarly modern concept of life, in all its contingencies, representable, reproducible, and hence legible.[31] Such promises, however, were accompanied by considerable fears as well, anxieties about the unmooring of reliable temporal and spatial templates. The rise of narrative cinema in the first two decades of the twentieth century was part of an effort to alleviate such fears with the help of commercially viable structures. Star-centered narratives, teleological and psychologically motivated storylines, cross cutting and parallel editing—all served the purpose of channeling what had been paradoxical and disquieting about cinema's production of modern time into more manageable and predictable forms.

At various junctures throughout the twentieth century, avant-garde movements and countercinemas—including the ones that helped trig-

ger the wider dissemination of slow-motion techniques around 1970—have sought to rally against commercial filmmaking's standardization of cinematic time. Though it would be irresponsible to reduce experimental and independent filmmakers to one singular model, it is not much of an exaggeration to say that avant-garde practice and criticism have largely been driven by the vision of a critical and distant spectator eager to produce autonomous images, meanings, and stories with the help of reflexive forms of iconoclasm. As a consequence, criticality at the movies has been mostly associated with a viewer's ability to run up against Hollywood idolatry, to actively explore each of the three orders of temporality in cinema in its own terms and rights, and precisely thus to replace the culture industry's exploitation of affect and mimetic desire with emancipatory agency and self-determination.

The slowness of Weir's and Herzog's Dream|Time cinema formulates an alternative challenge to mainstream cinema. There is certainly nothing iconoclastic about how Aboriginal mythology, in Weir's film, helps illuminate the copresence of different temporalities in the present, including the three dimensions of cinematic time. Nor does Weir's experimental use of slow-motion photography or Herzog's strategies of ongoing reframing, even when probing the differential between the three orders of cinematic temporality, envision viewers who remain skeptically at bay of what is shown in the film, privileging cognitive distance over affective engagement, criticality over absorption. Following a critical matrix suggested by W. J. T. Mitchell, I instead suggest understanding the slowness of Weir's and Herzog's Dream|Time cinema as a mechanism of presenting the cinematic image, neither as an idol nor as a fetish, but as a totem; and our relation to the images and sounds on screen as a form of critical idolatry, a project reminiscent of how totemism seeks to reframe the unabashed power of the idol.

"Totemism," Mitchell has argued, "is the historical successor of idolatry and fetishism as a way of naming the hypervalued image of the Other. It also names a revaluation of the fetish and idol. If the idol is or represents a god, and the fetish is a 'made thing' with a spirit or demon in it, the totem is 'a relative of mine,' its literal meaning in the Ojibway language."[32] Unlike the idol, whose surplus meaning requires absolute submission to some ultimate value, and unlike the fetish, which makes us as fragmented individuals—somewhat perversely—obsess about

material objects as if they were not of our own making, the totem is associated with the negotiation and regulation of community bonds, with how meanings and identities are transmitted from past to the present, and with how certain populations may reproduce themselves to warrant their futures.

As it presents film as a sensory relay station of multiple durations and open-ended stories, Dream|Time cinema values cinematic slowness as a modern heir to the archaic role of the totem. It reminds us not only of the fact that even in our totally enlightened world we often encounter images as if they wanted something from us. It also, and as importantly, sways us to acknowledge that such a seemingly archaic overvaluation of certain objects does not necessarily force us into positions of submissive repetition à la Riefenstahl. Weir's and Herzog's art of cinematic slowness proffers images and sounds that are meant to be transformative in nature. They may not expect viewers to become iconoclastic avant-gardists eager to destroy or disfigure the idols of cinematic representation, but they provide powerful "echo chambers" for human thought, deliberation, memory, and anticipation.[33] Similar to totemism, Dream|Time cinema treats cinematic images and sounds as if they were relatives of ours—as if they encountered us as both challenging other and sensorially familiar. This cinema hopes to slow down our perception so as to enable viewers to let go of the idols and fetishes of mainstream entertainment and recall film's original promise of contingency and indeterminism as key features of modern life. And it probes the different registers of filmic temporality so as to sharpen our sense for the various meanings of mobility that may delineate the contours for future communities. Both strategies recall and recalibrate what totemism was (and is) all about: to make us recognize our engagements with and obligations to others in all their flux and indetermination. As a form of totemism in a reflective key, Dream|Time cinema's aesthetic of slowness produces presence as a plurality of relationships, perceptions, and vectors of motion. And, precisely in doing so, Weir's and Herzog's slowness asks its viewers to approach their respective present, neither from the standpoint of an unchangeable past nor that of an entirely discontinuous future, but from the one of unconstrained contemporaneity, the cotemporality of different durations, of forgotten pasts and unclaimed futures.

F I V E

F R E E F A L L

1 /

It is difficult not to think of the dramatic shrinkage of average shot lengths (ASL) in mainstream cinema over the last four decades as a sign and symptom of larger cultural transformations, i.e., as part of a general reorganization of attention spans in postindustrial societies. Before the 1960s, ASL rates for commercial films typically ranged between 8 and 11 seconds, whereas the average rate today has decreased to 4 to 6 seconds, with action films such as *Skyfall* (2012, dir. Sam Mendes) and *World War Z* (2013, dir. Marc Foster) clocking in at 3.3 and 2.5 seconds respectively.[1] If regular feature films once consisted of a few hundred shots only, today they easily extend beyond the 1,000 mark, resulting in an acceleration of narrative speed amplified by the use of cuts in the middle of movement, of cutaway tracking shots, of hectic rack zooms and jerky reframings, and of unfocused whiplash pans. In much of mainstream filmmaking today, nervous editing and rickety camera moves impart a general sense of speed, energy, and arousal, but particularly in action cinema they often do so at the calculated cost of legibility. Exposed to a frenetic burst of images and sounds, we often no longer are able to determine spatial and temporal relationships between individual shots and understand how one

movement might lead to another. Much of what we see in crucial action sequences does not only remain out of focus, it also emancipates the viewer from any sense of meaningful continuity and causation. Yet contrary to the hopes of the former avant-gardes, this intensification of narrative pace is far from situating the viewer as an active or critical observer. Its point is primarily to produce a general feeling of dynamic thrill and mobility and precisely thus seize the viewer's attention. As David Bordwell has summarized, "The rapid cutting, constant camera movement, and dramatic music and sound effects must labor to generate an excitement that is not primed by the concrete event taking place before the lens."[2]

It is perhaps no coincidence that the acceleration of ASL rates in particular since the 1990s has gone hand in hand with the proliferation of viewing technologies allowing spectators to assume more control about both the process and the location of visual consumption. On the one hand, the spread first of DVD players and, more recently, of handheld digital viewing devices has provided viewers with ample opportunities to watch films on their own temporal terms: to pause, fast-forward, replay, or skip particular images or entire sequences at their own will and thus reauthor the narrative speed delivered to them by filmmakers. According to Laura Mulvey, these newer technologies have the potential to transform the viewer into a participatory and sovereign time shifter: "[These technologies] work on the body of film as mechanisms of delay, delaying the forward movement of the medium itself, fragmenting the forward movement of narrative and taking the spectator into the past. Whatever its drive or desire, this look transforms perception of cinema just as the camera had transformed the human eye's perception of the world."[3] On the other hand, ever more effective compression formats, successful hardware miniaturization, and full-blown wireless connectivity now allow us to watch films wherever and whenever we are in need of quick diversion, whether we stream them through the ether to our cell phone screens or download them to our tablet computers. Rather than go to the movies, we ask motion pictures to come to us and assimilate to our own physical motion. We watch them on the fly, consume moving images on the move and ever more in broad daylight,[4] and thus seem to achieve unprece-

dented command over the spatial context in which we allow images and sounds to address us as beholders.

There is no need to be a nostalgic cinephile in order to be troubled by this constellation, fearing that the curious seesaw of contemporary film consumption—the duality of accelerated speed and participatory technologies of time shifting—doesn't really add up to what it might promise: what one hand gives, the other takes. Haunted by both overwhelmed and technologically empowered spectators, visual pleasure today—some have argued—might either derive merely from the isolated fragment or it may no longer respond to the filmic text at all but instead solely register the viewer's own narcissistic gratification of shaping the flow of images.[5] Today's mobile digital aesthetic, others have added, is antiaesthetic: better not watch *Citizen Kane* or *Apocalypse Now* at all than to watch it on your iPhone or your airplane's entertainment center, i.e., on mobile display devices that no longer show moving images as they were meant to be seen and—due to their diminutive size and decentered presence—are unable to hold our perceptual attention.[6] The partnership of shrinking shot lengths and mobile viewing devices, one might thus conclude, privileges the excitement of intentional consumption over the bliss of nonintentionality, feelings of control and imperial sovereignty over those of awe and absorption. In this way it transforms us into utterly distracted spectators who have no tolerance for succumbing our perceptual authority to the splendor of traditional film projection, hence for exploring what is constitutive of the aesthetic—its yielding to the unexpected, the uncertain, and the indeterminate; its unsettling reframing of the sensory and sensible.

The recent return of neoformalist art house movements such as the so-called Berlin School seems to add fuel to such critical assumptions.[7] The films of this rather heterogeneous group of filmmakers, of which the work of Christian Petzold (*Die innere Sicherheit* [2000], *Gespenster* [2005], *Yella* [2007], and *Jerichow* [2008]) is often seen as a flagship, are typified by their discreet camera work and their resistance against rapid cutting and reframing, against special effects and digital image manipulation. Berlin School films extol their own slowness and smallness, their lack of spectacle and affect, their patience in registering the mere passing of unstructured time. As if trying to roll back

today's frenetic editing and mobile watching, Berlin School films eagerly seek to preserve the integrity of each cinematic frame and savor the continuity of represented action. They offer extended and highly legible flows of images that ask viewers to behold things from a distance so as to slowly peruse minute gestures and movements. Petzold's films in particular engage a pondering aesthetic of long takes and minutely choreographed frames, rigorously exploring what often turns out to be the absence of rigor and transformative energy in the lives of his antiheroes. The durational thickness and deliberate inertness of his shots is meant to restore what cinema, in the age of its digital mobility, acceleration, and ubiquity, has putatively lost: the quest for aesthetic experience, understood as our ability to calmly probe the rupture between different orders of sensory perception and representation, to explore zones of indeterminacy between self and other, and to hover somewhere in between states of absorption and our need for interpretation.

A neo-Bazinian exploration of what global economies today are doing to the fabrics of the real, the Berlin School's brooding long takes and steadfast frames embody one possible strategy of pitting the aesthetic against the joint venture of velocity and technological self-determination in contemporary culture. "Aesthetic experience," writes Jacques Rancière, "has a political effect to the extent that the loss of destination it presupposes disrupts the way in which bodies fit their functions and destinations. What it produces is not rhetorical persuasion about what must be done. Nor is it the framing of a collective body. It is a multiplication of connections and disconnections that reframe the relation between bodies, the world they live in and the way in which they are 'equipped' to adapt to it. It is a multiplicity of folds and gaps in the fabric of common experience that change the cartography of the perceptible, the thinkable and the feasible."[8] In the films of the Berlin School, the formalism of the long take and the steady frame indeed serves the purpose of displaying bodies that no longer fit their presumed functions—outsiders, the unemployed, drifters, failed entrepreneurs, people aspiring but never succeeding in taking their lives into their own hands. As it radically reduces the pace of how commercial cinema today aims at mobilizing its viewers, this new art cinema seeks to derail the viewer's modes of sensory perception and anticipation, to frustrate what makes us move toward presumed destinations, and in

this way to redraw the map of what can be seen, thought, and done. True to Rancière's views about the politics of art, this cinema wants to take on a political mission, not by actively envisioning a new collective and suggesting that formal aesthetic interventions themselves could provide direct causes for desired political effects, but instead by suspending the very relationship between cause and effect, movement and destination. It makes us ponder and grow pensive, not because pondering itself is a desired goal and desired destination, but because pondering can reveal the cracks and folds within the everyday from which we may be able to envision new connections and develop alternate orders of experience.

It is tempting to explore the politics of the long take in recent formalist film practice such as that of the Berlin School, or in the work of international art house directors such as Michael Haneke, Tsai Mingliang, and Béla Tarr, in greater detail here. In line with the argument of the other inquiries of this book, however, this chapter will probe the possibilities of aesthetic slowness in contemporary filmmaking at a different location: not where filmmakers radically turn us away from the speeds and rhythms of hypermobility, but where they seek to face these head-on and hold their gaze directly on cinema's dual dream of unbound speed and technological self-emancipation. The focus of this chapter will therefore be on the work of German director Tom Tykwer, a perhaps unlikely candidate at first for thinking about slowness in contemporary film practice, but, as I will suggest, a filmmaker whose work—in particular prior to his more international engagements since the mid-2000s—consistently seeks to recalibrate the temporal exigencies of his heroes' (and spectators') lives and whose films—not so different from the ones of his art house colleagues such as Petzold—are dedicated to multiplying the connections and disconnections of bodies in space and to reframing how these bodies may relate to each other sensorially in and across time.

Tykwer's films may often proceed as if on speed, yet they are certainly not designed for uninhibited speed addicts. On the contrary. Tykwer's work not only abounds with prolonged sequences shot in slow motion; it also returns time and again to one aesthetic figure: the image of heroes in states of free fall, seemingly bound toward one destination and yet at the same time strangely released from both the burdens of

gravity and the teleological drive of narrative progress. Tykwer's images of free fall, so my argument, open folds and gaps of aesthetic slowness amid the fabrics of contemporary speed and purposive mobility. They produce spaces in the very heart of highly accelerated actions that invite heroes and viewers alike to pause, to suspend the relentless logics of cause and effect, to recognize and yield to the copresence of different dynamics of moving through time—and precisely thus to do what aesthetic slowness as an art of radical contemporaneity is all about, namely to derail deterministic notions of movement and sovereignty and reframe what is perceptible, thinkable, and feasible today.

2 /

Tom Tykwer's films, including his more recent forays into international coproductions, are known for their highly kinetic style and their narratives of restless activity. Clocks tick ruthlessly in Tykwer's soundtracks, not only to indicate the inexorable dearth of human time, but to rush characters into action and overwhelm the viewer's attention with a general sense of urgency. Techno music emulates the accelerated body functions of Tykwer's protagonists while impressing sensations of speed and rhythm directly onto the senses of the spectator. Jump cuts, rack zooms, unexpected camera motions, and abrupt reframing strategies prevent our eyes from lingering on certain details; they yank us from one sight to another and disrupt any sense of permanence and stability, of temporal and spatial continuity. Tykwer's use of animated material, of different film stock and recording equipment, and of imaginative special effects celebrates cinema's constitutive ability to put images in motion as much as it tends to mobilize the viewer's emotions. Constantly on the run, Tykwer's heroes never cease to struggle against the finitude of their existence. They experience the present as being haunted by painful pasts or they hurl themselves into the future in the hope of recuperating the possibility of a meaningful present. Though all films provide narrative resolution, their endings rarely produce a sense of closure and repose, be it that we finish with the sight of protagonists who move on into unknown tomorrows or simply

vanish from the screen, with cameras that almost endlessly pull back from the last scene of action so as to suspend the viewer's gaze or with final sounds whose relentless beats suggest everything but tranquillity and rest.

While postmodern criticism has turned our attention to the production of human geographies and the way in which hybrid subjects actively situate themselves in the fractured spaces of their present, Tykwer at first sight seems to hang onto a more modernist privileging of the temporal over the spatial, to a view of time as the primary source of life, motion, conflict, and change. Speed, flux, and ongoing transformation describe the very heart of Tykwer's cinematic aesthetic. Like Lola, the heroine of Tykwer's most celebrated film *Lola rennt* (*Run, Lola, Run*, 1998), the viewer encounters Tykwer's films as an unending series of audiovisual trials and visceral astonishments (figure 5.1). Breathlessly, we dash from one narrative event and stylistic repertoire to another, always on guard, never able to relax our attention, in constant anticipation of yet another change in how the film might organize its images, sounds, and narrative elements. Few filmmakers, one might conclude, have ever granted the present—the protagonists' as well as the viewers'—as little autonomy as Tom Tykwer. From *Die tödliche Maria* (*The Deadly Maria*, 1993) to *Heaven* (2002) and even to *The International* (2009), no identifiable "now" seems to exist that doesn't instantaneously evaporate in the face of our heroes' need to escape trouble, parry sudden challenges, and fix unsettling pasts. Any wish to hesitate or lag behind, to stop running or reduce one's pace, carries the threat of failure. Of disaster. Of death.

But then, again, isn't there more to Tykwer's aesthetic than just speed and kinetic attraction? Don't we see even Lola in moments of repose in between her three runs, as if recharging her batteries and recuperating the power of speech amid the frenzy of restless action? Tykwer's films, at both the narrative and formal levels, can be seen as being all about the tempo of living in an age of global connectivity and virtualization, but in all his films viewers also encounter curious moments of both temporal and spatial standstill, moments in which cinematic time and motion are decelerated to such an extent that human bodies and symbolic objects seem to hover in midair or transcend the

FIGURE 5.1. Tom Tykwer, *Run, Lola, Run* (1998). Screenshots.

FIGURE 5.2. Tom Tykwer, *The Deadly Maria* (1994), *Winter Sleepers* (1997), *Heaven* (2002), *The Princess and the Warrior* (2000) (clockwise). Screenshots.

parameters of Euclidian space altogether. Think of Maria jumping out of the window of her claustrophobic apartment in the last sequence of *The Deadly Maria*, of Marco's twirling dive into the abyss at the end of *Winterschläfer* (*Winter Sleepers*, 1997), the recurrent image of the red telephone flying majestically through the air in *Run, Lola, Run*, the sight of Sissi and Bodo jumping off the hospital roof in *Der Krieger und die Kaiserin* (*The Princess and the Warrior*, 2000), and the final ascendance—an inverted fall, as it were—of Philippa and Filippo in *Heaven* (figure 5.2). While Tykwer, in all these scenes, makes proficient use of slow-motion photography to intensify our perception, what his camera captures are moments in which objects and bodies themselves already seem to slow down, not by fleeing from their accelerated lives and unstable spatial positions, but by fleeing into them. What we observe here are moments in which speed outspeeds itself and in which a sudden intensification of velocity provides a ground not only for discontinuous experiences of deceleration and respite, but for a momentous reorientation of Tykwer's protagonists and his viewers within the fleeting landscapes of the present.

As discussed in the introduction, discourses of slowness continue to be seen as belonging to the political right: a rhetorical weapon of

unbending conservatives, romantics, and fundamentalists who are eager to stop the decentering speed of modernity and preserve the homogeneity of local identities. Tykwer's aesthetics of occasional standstill and deceleration is indicative of a substantial change in the form and function of slowness in contemporary art and culture. Tykwer's art of slowness—amid all his breathtaking kineticism—goes hand in hand with a rethinking of dominant notions of mobility and a concomitant refusal to favor either the temporal over the spatial or space over time. To overturn speed here is no longer coded as a romantic protest against the abstract and inauthentic rhythms of the present. Instead, Tykwer's films encourage us to think of slowness as both a product of and a reflective and refractive view onto the speed of our age, as a special effect that cannot do without the very force it seems to challenge or suspend, yet whose aim is to disperse, reroute, or even derail what is oppressively directional and teleological about contemporary experiences of speed. Rather than merely reading these moments as a retrograde yearning for extended structures of temporality, Tykwer's aesthetics of free fall serves the purpose of exploring new forms of localization and the durational, not in opposition to, but by actively engaging with today's logic of temporal and spatial shrinkage.

"A still life," writes Kathleen Stewart in *Ordinary Affects*, "is a static state filled with vibratory motion, or resonance. A quivering in the stability of a category or a trajectory. It gives the ordinary the charge of an unfolding."[9] With its repeated images of free fall and seemingly arrested motion, Tykwer's aesthetic of deceleration reveals what is vibrant and unfolding about our human geographies amid a life seemingly frozen in all its restless dedication to speed and forward motion. His project is not simply to challenge, but to shift the very foundation of what causes contemporary critics such as Paul Virilio and Fredric Jameson to call our present one of frantic standstill and flat postcontemporaneity,[10] namely their continued conceptualization of time as the sole dimension of change and space as a mere sphere of stasis and fixity. Far from simply seeking to halt speed and step out of our totally mediated world, Tykwer's instants of free fall showcase a continued need and possibility for acts of individual and collective localization, but also for experiencing space as a dynamic crossroads. Whenever

Tykwer's protagonists fall and, in spite of all motion, seem to assume the appearance of a still life in midair, we come to be witnesses to a cinematic vision according to which people can play many roles at once and occupy multiple homes and histories within one and the same space. Whenever we see Tykwer's heroes fall in slow motion, we see them trying to beat the acceleration of global culture at its own game with the intention of producing contemporaneous spaces and times of their own, inhabiting temporary nodes of meaning amid our pulsating networks of flow and interdependency, and thus recharging the ordinary with the transformative energy of memory and the vibrancy of unpredictable unfolding.

3 /

In the early seventeenth century, Galileo devised an ingenious device to measure time and motion. First, he built a ramp allowing a ball to roll downward while picking up speed along the way. Second, he marked numerous points on this sloping board that were all of equal distance to each other. Finally, he constructed a curious time meter, capable of measuring the ball's velocity as it rolled from various resting points along the incline through the marked distances. Galileo described this time meter in 1638: "For the measurement of time, we employed a large vessel of water placed in an elevated position; to the bottom of this vessel was soldered a pipe of small diameter giving a thin jet of water, which we collected in a small glass during the time of each descent, on a very accurate balance; the differences and ratios of these weights gave us the differences and ratios of the times, and this with such accuracy that although the operation was repeated many, many times, there was no appreciable discrepancy in the results."[11]

In the absence of reliable stopwatches, Galileo's water clock converted time into a distinct and measurable object, namely the weight of water as it gathered during a certain period of movement in different glasses. Aside from proving some of Aristotle's assumptions about moving bodies wrong, the effect of Galileo's intervention was twofold. On the one hand, it greatly advanced early modern efforts to quantify temporality

and subject the passing of time to foolproof procedures of measurement. Galileo thus helped inaugurate the modern understanding of time as something entirely calculable—a consistent and uniform structure of how we can assess physical movement across (fixed) space. On the other hand, Galileo's experiments played no small role in the emerging differentiation of the domains of physical and natural time from those of human and historical time, whereby the former was seen as well ordered, transparent, and expectable and the latter as potentially messy, mysterious, and resistant to comprehensive knowledge and enlightenment.[12]

In spite of their many ticking clocks and abundant various time meters, Tykwer's films drastically depart from how Galileo sought to make motion and change quantifiable. Though rigid rhythms energize Tykwer's narratives and protagonists, time never merely denotes an abstract container of human perception. Nor can we speak of natural time in Tykwer as something void of mysteries and ambiguities, as something whose forces might successfully be subjected to the grids of instrumental reasons and the ticking of clocks. In Tykwer, time itself is on the run. It escapes clear delineation and specificity, not least of all because Tykwer's narratives tend to collapse the modern differentiation between human and natural temporality as much as they, in various ways, deny clear distinctions between the spatial and the temporal. Time here often appears as space becoming legible in the form of topographical inscriptions and geographical extensions. The seeming stability of spatial configurations, by contrast, regularly trembles under the impact of different strategies of temporalization, be they affected by a protagonist's desire to transgress existing confinements or simply by the mobility of Tykwer's camera. Most important, however, both human and physical time in Tykwer completely circumvent the modern privileging of linearity and progress over the recursive, the circular, and the multiple. Temporality in Tykwer's films can move protagonists simultaneously forward and backward. The drive of narrative time here pushes and pulls, mobilizes and freezes the subject in one and the same breath. It situates the viewer in parallel worlds of experience, each of which structures the relationship between past, present, and future differently, yet all of which provide an essentially anti-Galilean view of time as a domain of second chances, random opportunities, and unpredictable alternate outcomes.

Consider, first, the use of aerial photography in *Winter Sleepers* capturing the sublime sight of Alpine mountainscapes from varying angles and distances (figure 5.3). Majestically, the camera glides over summits, rock faces, ridges, glacial valleys, and fractured snowfields as if the recording apparatus were emancipated from the laws of gravity. Though shot from a passing helicopter, what we see in this thirty-second segment appears void of tempo and haste. Canted frames and slow-motion photography decelerate our perception as much as the use of Arvo Pärt's celestial music on the soundtrack. Motion and stasis here appear folded into one dynamic. The camera hurls the viewer through barren and forsaken spaces, at the same time extending the impression of contemplative standstill, of auratic suspension, of moving through speed and accelerated temporality beyond them. Reminiscent of the photographic projects of Olafur Eliasson and Hiroyuki Masuyama discussed in chapter 3, Tykwer's mountainscape thus strikes the viewer as eerily subjective and uncannily alive. Its creases and folds recall images of the human brain, of our cerebral lobes and their winding fissures. Its extended snowfields fill the viewer with wonder about what might be hidden from sight, and what might become visible during other times of the year. Nature here seems endowed with an optical unconscious, with the presence of long-forgotten pasts buried under the cover of imposing surfaces. And the camera's unstable perspective and its final tilt upward encourage us to see things as if we were witnessing this landscape without the mediation of cameras, helicopters, and projectors whatsoever—as if seeing would mean to touch upon the visible as much as it would mean to be touched by the elements of the visual field. The narrative function of this aerial shot might be entirely expressive; it is not authorized by the perception of any of the film's protagonists. But in its apparent weightlessness, its denial of localization and velocity, the shot succeeds in imbuing even most hostile territories with traces of time and history, with a sense of being and nonbeing, with the human dynamic of ambition, anticipation, forgetting, and failure. Being looked at from an elusive point of view, Tykwer's landscape looks back at us. However otherworldly, it echoes and transforms the viewer's timetables.

Tykwer's shot of Alpine landscapes immediately follows a sequence in which we see, first, René (Ulrich Matthes) unsuccessfully trying to

FIGURE 5.3. Tom Tykwer, *Winter Sleepers* (1997). Screenshots.

overcome his short-term memory loss with the help of photographic images and his scratch book and, second, Theo (Josef Bierbichler) as he painstakingly, albeit fruitlessly, seeks to translate flashes of traumatic memory into meaningful representations. At first, Tykwer's shot of jagged ridges, peaks, and snowfields merely seems to cast René's and Theo's respective quests for the past into allegorical form. Charged with the vibrancy of the unseen and hidden, Tykwer's mountains, one might argue, serve as a symbolic externalization of what torments our two protagonists and undermines their search for extended structures of temporal experience. Such a view, however, would severely underestimate the extent to which Tykwer's camera, here and elsewhere, shows natural and urban landscapes as being animated by intrinsic and often contradictory temporalities, as sites of haunting pasts and repositories of alternate futures. Whether he allows his camera to float weightlessly over rugged summits or over urban rooftops (as in *Run, Lola, Run, Heaven,* and *The International*), Tykwer's topographies are clockworks whose balance springs run at different speeds than those of Tykwer's protagonists and viewers. In contrast to a long tradition of modern Western thought, Tykwer presents space as an inextricably temporal dimension of experience: as a cache of history, at times seemingly frozen and void of motion, at times persistently haunting viewers and protagonists with unexpected recollections. In the face

of Tykwer's landscapes and urban topographies, Galileo's hope of rendering the time of nature and the physical world entirely calculable cannot but melt into thin air. The itineraries of natural phenomena and material objects are just as messy and mysterious as the twisted calendars of human beings.

Consider, second, the opening image of *Run, Lola, Run*, a slow-motion shot showing a grotesque pendulum as it swings from one side of the frame to the other and, in so doing, conjures and erases some of the film's production credits (figure 5.4). The appearance of the pendulum is preceded by the sound of a clockwork whose precise ticking will create a stark contrast to the archaic swoosh that Tykwer uses to underscore the movement of the lever. After a few swings, the pendulum comes to a sudden standstill, as if arrested by forces whose power we are unable to comprehend. Techno beats set in while the camera first zooms in on the monstrous face depicted on the pendulum and then moves up along the bar that connects the lever to the clock's main body. Set against a black background, this clock is no less menacing then the lever, not only because its face and hands are surrounded by mythological snakes and beasts but also because the camera first approaches the clock from an eerily low angle, subsequently hovers across its face, and finally tilts into a horizontal position and then approaches—and in fact vanishes into—the opening mouth of a gargoyle located above the clock's hands. This extended shot is structured by dissimilar and competing temporalities: the clock's rather old-fashioned Roman numbers stand in stark contrast to the accelerated pace of its hands; the camera's floating and subjective movements counter the ravenous haste suggested by both the film's soundtrack and the horrific beasts on display. Yet time here does not simply appear emancipated from the measures of everyday life and transformed into an autonomous and antagonistic menace. It also strikes us as being freed from the burdens of space and territorialization, the black background against which we see our clock defining a kind of black hole, a fold in the Euclidian organization of space, a dreamlike nonspace in which anything might be possible, but no compass exists to guide our way and indicate our position.

Tykwer's films are replete with cinematic allusions and textual cross-references. They evoke the past of cinema, as if film history knew of no

FIGURE 5.4. Tom Tykwer, *Run, Lola, Run* (1998). Screenshots.

potential aging or forgetting. When seeing the opening shot of *Run, Lola, Run*, it is impossible not to be reminded of the abstract factory clocks as well as the image of Moloch in Fritz Lang's 1927 *Metropolis*. Unlike Lang, however, Tykwer asks us to witness, not the destruction of meaningful places and corporeal experience at the hands of fully industrialized time, but the birth of space out of the contingencies of the temporal. It is the camera's movement into the gargoyle's mouth and down the throat of time that leads to a gradual concretization of space and kicks off the film's narrative. Time itself is thus presented as a monster: it consumes the viewer, but it also provides the grid—the *monstrum*—that structures the film's events, relationships, and sites. Whereas the role of aerial shots such as the ones in *Winter Sleepers*, then, was to picture spatial configurations as eerily charged with slow and layered time, in the opening scene of *Run, Lola, Run* our meta-phorical and quite physical descent into the abyss of time serves as a mechanism inaugurating the subsequent conjuration of narrative space. Once again, however, this view of temporality is fundamentally differ-ent from Galileo's notion of time as an accurate measure of motion. Far from merely quantifying change and velocity, time in Tykwer pro-duces the two at the start. Time in Tykwer is never, or never remains, a

merely abstract and universal yardstick for motion. For what makes Tykwer's film tick is the temporality of the medium of film and its history itself, the shaping of temporal experience as we encounter it through our media of representation, storage, and fantasy. What makes Tykwer's film tick is not Galileo's hope for exact knowledge, but the rhythms, beats, and tempos that have driven the most effective machine of twentieth-century fantasy production, namely cinema. Lola's run, in the final analysis, is a run up, against, and down the hallways of cinema itself. To run, here, doesn't simply mean to move effectively from one point to another. It instead means to reveal the flexible and deeply temporal nature of space and, in so doing, to probe notions of mobility commensurate with this book's aesthetic of slowness—notions that seek to release our experience of movement from teleological and quantifiable conceptions of time as much as from any concept of space as a mere container of physical passage.

4 /

Though Tykwer relies heavily on state-of-the-art technologies, it is one of the puzzling aspects of his work, at least prior to *The International* and *3* (2010), that his narratives completely shun the kind of mobile and wireless communication devices that have fundamentally transformed human interaction for the last two decades. Digital video, computer-generated special effects, and electronic sound production are essential to Tykwer's style. His characters, however, seem to live as if the digital revolutions have simply passed them by—as if they knew nothing about the speed of ubiquitous computing or mobile telecommunication. Rather than utilizing sleek cell phones and the networked ether to connect, Tykwer's contemporary heroes are stuck with clunky telephone receivers and pedestrian landlines.[13] Instead of coordinating their itineraries with the help of e-mail and text messaging, their preferred medium of bridging distant spaces is the handwritten word and the traditional letter. So striking is this absence of contemporary communications technology that we must think of it as systematic, an element of narrative emplotment. Imagine Lola connecting to Manni via a cell phone to coordinate their meeting, Sissi firing text messages to

Bodo to enable a reunion, René using a handheld GPS system to track his own position in time and space, or Philippa triggering her bomb with a smarter remote control: in all these examples the use of computerized telecommunication would clearly aid our heroes' quest, but at the same time it would undermine these films' entire narrative architecture.

And yet, should we therefore really think of Tykwer's heroes as strange relics from the past who cling to outmoded technologies in hopes of steering clear of how mobile telecommunication today seemingly emancipate us from the strictures of place, space, and locality? Should we really understand Tykwer's films as hi-tech vehicles remedying and hence celebrating the slowness of older media of human connectivity? As retro through and through? As a rebuttal of our era of wireless mobility?

Certainly not.

When networks go wireless, William J. Mitchell has argued, they destabilize sedentary structures and mobilize practices formerly bound to fixed locations: cafés become libraries, subway cars become moving film theaters, the home becomes a travel agent's office. As it encourages both ongoing mobility and unprecedented decentralization, the networked city fundamentally transforms the rhythms and patterns according to which human bodies navigate their surroundings and appropriate architectural structures for unanticipated purposes. "In traditional nomadic societies, regularly rekindled campfires provided mobile focal points for social life. With urbanization, social life became more commonly focused by fixed attractions—village wells, domestic hearths, and computer network drops. In the mobile wireless era, a third alternative has emerged; we can use our portable communication devices to construct meeting points and gathering places on the fly—places that may only be known within particular, electronically linked groups, and which may only play such roles for fleeting moments."[14] In the wireless city, the locations and paths of human interaction are fundamentally in flux. Place remains essential for carrying out certain acts of communication, but we cannot think of spatial perimeters as stable, solid, and unyielding. To go wireless is therefore not simply to inhabit and traverse multiple spaces at once. It is to recognize the existence of parallel modes of inhabitation and vehicular transport, of

what material spaces and social geographies mean for our identities in the first place.

Tykwer's heroes are no doubt experts at living their lives in the plural. What drives their itineraries is the hope of constructing provisional meeting points along the way. What fuels their desire is to be at different sites at one and the same time. What energizes their existence is their ability to transgress solid geographies and linear temporalities, to emancipate themselves from sedentary structures and take second chances. In spite of their failure to utilize the latest gadgets of telecommunications, we might therefore consider Tykwer's heroes to be deeply familiar with the logic and speed of wireless networking. As they struggle with the randomness of fate and the contingencies of their urban existence, they—like the subject of portable telecommunications—come to realize that space no longer is destiny and that no meaningful boundary can be defined between the sedentary and the vehicular. Tykwer's protagonists are neither distracted drifters nor immobile dwellers. What typifies their existences is the fact that they, in likeness to the wireless self, understand how to define their positions in time and space beyond traditional juxtapositions of the nomadic and the stationary, the static and the mobile.

It is interesting to note that in Tykwer's films the iconic appearance of older technologies of telecommunication often serves nothing other than the purpose of exploring this unsettled ontology of the wireless era. Rather than ground speakers in and interconnect them across distant territories, Tykwer's phones mobilize and temporalize space like cell phones, yet in dispersing the location of the individual in the topography of their present they create all kinds of open questions and narrative challenges. Snail mail letters link different people instantaneously like e-mail and—as if sent via WLAN and Wi-Fi networks—at decentered sites, yet nevertheless fail in establishing urgent contact or piercing the confines of certain characters. Time and again, Tykwer presents newer forms of telecommunication in the guise of older ones, thus probing the channels of our highly mobilized, albeit cellular, era of compulsive connectivity. Time and again, he entertains his viewers with images of a not-so-distant past, not in order to produce nostalgic sentiments, but to make us think about how our accelerated present

FIGURE 5.5. Tom Tykwer, *The Princess and the Warrior* (2000). Screenshots.

constantly produces new pasts, yet cannot fully contain the vibrant copresence of nonsynchronous temporalities.

Recall the opening sequence of *The Princess and the Warrior* (figure 5.5). The film starts with the image of a woman writing a letter in front of a panorama window that opens on a gorgeous, and gorgeously remote, coastal landscape. Once finished, our woman walks up a long driveway toward a small village and throws her letter into a mailbox. We cut inside the mailbox and witness this letter, in two shots captured in slow motion, gliding to the bottom of the mailbox. After then seeing the film's title card, we witness a series of close-ups showing an electronic mail sorting and routing machine, the rhythm of the sound track picking up speed as we observe ever more letters passing the eye of the camera. Next we cut harshly to a bird's-eye view of a German mailman delivering our letter to the address that attentive eyes were

able to detect already in the earlier mailbox shot, namely the Klinikum Birkenhof, a psychiatric ward, located in the city of Wuppertal (Tykwer's hometown). This opening of *The Princess and the Warrior* clearly reworks the first sequence of Krzysztof Kieślowski's *Red* (1994) in which special effects and time-lapse photography allow us to follow the path of a telephone signal from Great Britain to Geneva. Yet whereas Kieślowski's passage ends in a busy signal and the image of an electronic light flashing red, Tykwer's letter does actually arrive at its addressee, Sissi Schmidt (Franka Potente), even though it will take her several hours to open and read it and her act of reading will tell us little about the link between the two characters.

What drives most of Tykwer's heroes is a basic desire for contact and embodied communication: an urgent need to experience a quasi-mystical fusion with other souls, a yearning to remove any degree of separation between them and literally to get in touch with one another. In pursuing this hope, however, Tykwer's protagonists do not simply have to overcome existing spatial obstructions and learn how to synchronize their own movements with those of other protagonists, but they also displace the ordinary templates of space and motion altogether. Unlike religious pilgrims in search of eternal redemption, Tykwer's heroes do not flee out of conventional time and space, they flee into them so as to temporarily transcend from within blocked conduits of communication and probe new connections and disjunctions. And, unlike devoted wayfarers, they know all too well that whatever may allow them to achieve precious contact and salvation will also, and almost simultaneously, take them away again. Tykwer's obsession with older technologies of communication is thus part of an effort to probe one of the principal ideologies of our era of ubiquitous wireless exchange. In his films older modes of communication behave like more advanced mobile devices to show that neither the instantaneous speed nor the decentered flexibility of today's tools of interaction per se increases the chances of unbound reciprocity. Similar to the nomadic subject of the wireless era, Tykwer's heroes might be able to communicate on the fly, but this ability by itself means little for seeing their innermost hopes fulfilled. The basic form of life in Tykwer's film is cellular, whether or not Tykwer's protagonists use cell phones in order to reach out to others or not. The experience of touching another

person's life remains the absolute exception—a miracle. What truly matters is, not merely to surround oneself with ever more gadgets of instantaneous and mobile contact, but to explore what is transitory and unsettled as the ground for a new ethics of breaching the cellular forms of contemporary subjectivity, a relational ethics of care that need neither be strictly localized nor energized by an essentialist logic of physical proximity.[15]

"Every man belongs to two eras," Paul Valéry noted in 1935, namely the slow, continuous time of the past and the discontinuous, hectic, and unpredictable time of twentieth-century modernity.[16] Tykwer's heroes clearly no longer enjoy the simplicity of Valéry's model. Deeply structured by various technologies of communication and transport, their lives take place at various times and in various spaces at once. Like the wireless subjects of our digital age, they live in flux, not in order to escape their own existence, but to find a hole in their current present that would allow them to move on to yet another parallel present, another version of their selves, another fate and destiny. Their world is one of dazzling multiplicity. It is driven by the pace of dissimilar rhythms and temporalities. Discontinuities here can produce lasting impressions as much as linear time can contain unforeseen ruptures and sudden surprises. The hope of Tykwer's heroes for contact and communication is nothing other than a hope for briefly experiencing one's own lives as a temporal unit, for finding momentary rest and respite amid a present that ever more forcefully expands into, reframes, and gobbles up the rest of the time, including Valéry's dialectic of the slow and the fast, the continuous and the discontinuous.

5 /

Tykwer's images of free fall, I have argued, outspeed the speed of contemporary culture and film in order to explore the promise of alternate notions of mobility. Of making new connections across space and time. Of breaking the logic of measurability and calculability, of mapping time merely as spatial passage. And hence of achieving true contemporaneity, understood as an ability to be timely and untimely, absorbed and distant at once. Let us now turn in greater detail to Tykwer's

frequent use of slow-motion photography and how it relates to the accelerated narratives of commercial cinema today.

The shrinkage of average shot lengths in commercial cinema today strangely—and paradoxically, as it may appear at first—coincides with an increasing use of slow-motion photography, often directly intercut with images shot at regular speed, often even reviewing one and the same train of action from various angles and perspectives. Editors nervously step up the pace of narrative progression, but, at the same time, they also, and amid of all this, provide us with images that invite us to pause, to get delirious about a certain suspension of temporality, causation, and gravity. Think of the famous shoot-out sequence in *The Matrix* (1999, dir. Andy and Larry Wachowski), having Neo face his adversaries on the rooftop of a skyscraper and escape their bullets by skillfully manipulating the dimensions of time and space (figure 5.6). Shot from various angles and in extreme slow motion, this climactic sequence is acoustically driven by rigorous techno rhythms. The film's otherwise frantic editing, however, here doesn't keep its directors from entertaining viewers with a sense of suspension, a curious triumph of style and self-control over the stubbornness of linear temporality and Euclidian space. As we slowly and repeatedly observe the path of the bullet approaching Neo's body, and as we then observe Neo literally bending the coordinates of the existing space-time continuum so as to dodge the attack, slow-motion photography thus celebrates the rewards of achieving utter focus and attention, of utterly absorbed and yet completely controlled intentionality, of surpassing the kind of illegibility and unintelligibility that structures the representation of movement and action in our era of rapid cutting and editing. As a consequence, the shoot-out scene not only illustrates Neo's phenomenal skills of self-determination and self-transcendence, it also celebrates contemporary cinema's ability to manipulate the parameters of time and space themselves and by doing so—reminiscent of very early film projection indeed[17]—to astonish viewers with the temporal miracle that is cinema. Like Neo, cinema here displays its inherent power to move time and control motion in space; to replay, accelerate, and delay action; and to reverse the entropy of things in the name of individual survival and redemption.

The stylized use of slow-motion photography in this and so many other sequences of contemporary cinema displaces the logic of physical

FIGURE 5.6. Andy and Larry Wachowski, *The Matrix* (1999). Screenshots.

and scientific laws, but its inherent stress on voluntary control and temporal reversibility should makes us wonder whether it really opens a door to the indeterminacy of aesthetic experience. Advocates of the new sciences, i.e., of scientific views according to which instability, disequilibrium, chaos, and entropy are the norm rather than the exception, Ilya Prigogine and Isabelle Stengers have argued that "irreversibility plays an essential role in nature and lies at the origin of most processes of self-organization. We find ourselves in a world in which reversibility and determinism apply only to limiting, simple cases, while irreversibility and randomness are the rules."[18] While the rhetoric of slow motion in much of contemporary (action) cinema often seems to defy the basic tenets of classical physics, we shouldn't think that its use—including in *The Matrix*—will automatically cause heroes, filmmakers, and viewers to side with the views of new scientists such as Prigogine and Stengers. Quite the contrary, the inflationary presence of slow-motion photography today, understood as a companion of the nervous pace of editing operations, often serves as a medium to parade a hero's (and a camera's) seamless authority over the parameters of time and space. It envisions alternate universes in whose context individual goal orientedness and sovereignty may triumph over the vagaries of entropic time and contain whatever may destabilize or decenter one's trajectory. Contrary to its use around the 1970s, slow motion today has largely come to encode and celebrate a world and cinematic

enterprise in which neither the random nor the irreversible may ever thwart a hero's intentional actions. It wants to function as a sign of liberating empowerment, of a hero's and the camera's ability to flee the iron cage of modern rationality and oppressive biopolitics, but it often does so at the cost of eliminating what its stylized language evokes: the aesthetic. Allegorized by the camera's use of slow motion, Neo might be able to bend himself beyond the Matrix's hegemonic organization of space-time. His skillful and sovereign interventions, however, remain entirely bound to what aesthetic experience in any rigorous sense would seek to disrupt, namely a logic that directly associates certain interventions with certain effects, skills with predictable outcomes, physical movements with desired destinations.

Compare what Neo and the Wachowski brothers are doing to the space-time continuum to Tykwer's frequent images of free fall shot in slow motion. Instead of merely emulating the uses of slow motion in contemporary action cinema, Tykwer tends to infuse this special effect with a different meaning, one simultaneously recalling what chapter 1 discussed as the mnemonic politics of Walter Benjamin's angel of history and its efforts to read historical progress against the grain and Umberto Boccioni's view of the modern body as a body of indeterminate potentiality. Slow-motion photography, in Tykwer, is repeatedly employed to represent a rerouting or suspension of traumatic histories. It situates protagonists and viewers in alternate frames of reference and allows for a derailing of catastrophic time, achieved not through gestures of hypertrophic willpower and self-determination à la Neo, but—reminiscent of Benjamin's angel—through a certain yielding and adaptation to what cannot but exceed human control. At the same time, slow motion in Tykwer, when capturing his heroes in states of free fall, is meant to picture the movement of particular bodies as being emancipated from a pressing logic directly relating causes to desired effects, movements to anticipated destinations. Like Boccioni's runner, Tykwer's heroes and viewers, in moments of free fall, experience the present as a dynamic relay station of multiple and ambivalent trajectories from past to future, as a meeting ground of the actual and the virtual, and hence as a site of aesthetic rupture at which neither causes nor movements can ever be seen as producing predictable outcomes and unambiguous effects.

Consider the following examples (figure 5.2).

Pushed to the brink of what a person can tolerate, the title character of *The Deadly Maria* (Nina Petri) decides to escape her lifelong confinement and lets herself drop out of her apartment window. The camera tracks her fall in slow motion, producing the impression of our lead character gliding almost peacefully—her legs and arms outstretched, her back facing the viewer—down along the wall and the windows of her tenement building. The film's final shot shows Maria lying on top of her secret next-door lover Dieter (Joachim Król), both most likely crushed to death, but both also finally liberated from what had turned their lives into an ongoing nightmare, an extension of hell on earth.

Finding himself trapped by a chain of unfortunate events and misunderstandings, Marco (Heino Ferch), in *Winter Sleepers*, puts on his skis and dashes down a steep slope. The camera cuts back and forth between the image of Marco coasting down the mountain and that of his girlfriend Rebecca smoking a cigarette while looking out of her window, both images once again captured in slow motion. Soon Marco's appearance will be shrouded by clouds and fog, as if produced by the smoke Rebecca exhales against the window pane. Next we cut to a dizzying upside-down shot. It shows the rugged edge of a cliff set against a startling metallic blue sky. Within a second, Marco's skis and body enter the frame, seen from below, as they shoot over the cliff. Then the camera moves first to a horizontal and later to an overhead position to show us Marco's plunge into a giant abyss. Initially we see him paddling his arms as if he were trying to fly and thus avoid his fall. But soon we witness his body yielding to the forces of speed and gravity, his body resembling the sight of a parachutist who glides sublimely through the air. We cut to Rebecca as she—presumably after Marco's death—leaves town by train, but then return once more to the image of Marco as he approaches the bottom of the abyss, his body becoming a minuscule dot in front of the colossal white snowfield and finally moving out of sight. What Tykwer spares us is the image of a final crash. Like Marco himself, we remain suspended in midair, unable to decide whether Marco's leap was accidental, an allegorical killing, or an act of liberation—or all of the above.

In *The Princess and the Warrior*, with no more places to hide in or go to, Sissi and Bodo, opt for jumping off the roof of the film's psychi-

atric ward. In a two-shot, we see both characters nodding at each other, set against a black night sky. Slow-motion photography captures the sight of the two as they run hand in hand first toward, then away from the camera to the edge of the roof. Due to a brief temporal over-lap and duplication, we can see the couple's actual jump twice, once from behind, once from the side, separated by a shot of three police officers helplessly trying to halt the lovers' action. Once again, the camera tracks their fall in slow motion from various angles and points of view, their bodies—like Maria's and Marco's—at once struggling with and embracing their downward motion. It is only during the last phase of their fall that the film's viewers—and so, in all probability, Bodo and Sissi—will realize that our protagonists, rather than falling to their certain death, will land in a muddy pool located in front of the ward: a landing documented with the help of decelerated underwater cine-matography. Whether Sissi and Bodo anticipated this miraculous turn of events here is a question as pointless to ask as the question whether Marco's jump is unintentional or suicidal or whether Maria drops out of the window in order to end her life or to be united with Dieter's body. For what's at stake in this scene is to show that our lovers' resolve to jump itself is the miracle—that what they experience as love sus-pends the ordinary templates of space and time and ushers them into a parallel universe in which their desires are neither hampered by the gravity of place nor the finitude of time.

When an entire police squad in *Heaven* has cut off any likely path of escape, the fugitives Philippa and Filippo hijack a police helicopter and do what in the beginning of the film was said to be impossible: ascend in a vertical direction until their vehicle—like Marco's body—vanishes from sight. Similar to Wim Wenders's *Der Himmel über Ber-lin* (*Wings of Desire*, 1987), Tykwer's adaptation of Kieślowski's script here plays with the dual meaning of *Himmel*, "sky" and "heaven," leaving it up to the viewer to decide exactly where to locate the film's protagonist after the end of the narrative. Tykwer once again resorts to slow motion in order to capture the helicopter's astounding departure and disappearance, freely mixing objective with more subjective point-of-view shots. Though bullets fly left and right at Filippo and Philippa, Tykwer in this sequence situates the film's protagonists in an imper-meable, albeit mobile, refuge. At no point does the viewer get the

impression that the police's massive ammunition can really reach our heroes. Slowness is their ticket to beat the speed of violence at its own game. Slowness is what allows them to leap like a tiger out of the existing order of time and space and into an alternate frame of reference.

Caught up in the breakneck storms of historical progress, Benjamin's angel of history (figure 1.4) found himself unable to close his wings: he yielded to the very force that propelled him into the future so as to prevent present and past from the forces of forgetting. Whatever made Benjamin's angel speed into the future allowed him simultaneously to slow down, that is, to distance himself from and disrupt the hellish logic of modern progress, to recall the forgotten and repressed in the name of a different future organization of human relationships. Tykwer's heroes typically have little concern for achieving widespread salvation and social reform. And, yet, whenever we witness Tykwer's protagonists flying in slow motion through the air, their posture resembles that of Benjamin's angel. They jump, fall, or fly, not in order simply to escape the catastrophes of their lives, but—like Benjamin's angel, like the special effect of slow-motion photography—to climb on the ladder of their own velocity in order to transcend it, to overcome linear conceptions of historical time so as to experience their own live as meaningful, to find a temporary place of their own amid, and in active use of, ongoing processes of dislocation and spatial shrinkage. Tykwer's slow-motion images of free fall thus index what was and remains at the heart of the modern project: the promise of indeterminacy and contingency. They cause protagonists and viewers alike to experience the present—aesthetically, as it were—as a site of a disjunction that suspends any direct relationship between certain actions and their desired effects, between intentional movements and anticipated destinations. They invite us to hesitate, to slow down, and to view the passing of time—like Boccioni's runner—as a zone of possibility and virtuality, a zone producing futurity without denying the ambivalence, multiplicity, and unpredictability of bodies in motion.

Nothing would be more wrong therefore than to consider Tykwer's slow-motion images of bodies in free fall merely as products of idiosyncratic exercises in style; nor to see them as replicating how contemporary action filmmaking uses the special effect of slow motion in order to suggest authoritative triumphs of individualized time shifting amid

the frenzy of rapid cutting. Instead, the use of slow motion in Tykwer's scenes of free fall embodies these scene's inherent aesthetic logic and message. What is at stake in these images is to envision a world in which we understand, mimetically and effortlessly, as it were, how to convert the present's speed into a source of calmly empathizing with the past and serenely traveling into the future. What is at stake is to embrace the special effect that is cinema as a lens not only allowing us to see the world differently, but restitching the fabrics of what can be thought and done. What is at stake is to explore the indeterminacy of aesthetic experience as an effigy holding up the claims of subjectivity and sensory experience in spite of their ever increasing dematerialization. Rather than lionize heroic self-determination while at the same time overpowering the spectator, then, slow motion in Tykwer invites protagonists and viewers alike to probe the promises of a world in which we can safely and playfully yield to what exceeds our control. It wrests some other time and space away from any singular logic of progress and movement and it envisions alternate mobile futures in which we may freely be able to reframe our perceptions, affects, and actions without returning to the seasoned image of absolute and sovereign subjectivity.

6 /

But what about Tykwer's images of seemingly mindless collectivity? Of crowds driven by laws and logics that seem to close down the future because they appear to replay a wretched past?

It is tempting to see the opening sequence of *Run, Lola, Run*—and, more precisely, the overhead shot in which a diverse crowd seems to unify in order to forms letters spelling out the film's title—as a tasteless reinscription of such a dreadful legacy. For decades postwar German cinema had shied away from grand panoramic vistas fusing individual bodies into neatly choreographed mass ornaments. To assume authoritative points of view and show integrated crowds after Riefenstahl was considered barbaric. To use the cinematic frame as a mechanism reducing social differences into one identity after *Triumph of the Will* smacked of turning art once again into a direct expression of totalitarian power. Tykwer's extravagant bird's-eye perspective at the beginning of his

most celebrated film seems to draw on a highly problematic cinematic language indeed. Did his film, in mimicking Riefenstahl's imposing gestures, allow for an uncanny return of German postwar cinema's repressed? Did Tykwer, in capturing this emblematic image of a mass ornament, proclaim the end of a postwar taboo and in this way call for a new and more relaxed engagement with the national after German unification?

While Tykwer's films have no doubt energized German filmmaking after the Wall,[19] any reading of the opening images of *Run, Lola, Run* as both a postmodern reinscription of the Nazi mass ornament and a concomitant reassertion of national cinema cannot but miss the point. Tykwer's cellular heroes are no longer heroes of an age in which unified national identities provide operative structures of collective belonging and political sovereignty. Though Tykwer's films do not shun images of collectivity altogether, traditional concepts of political philosophy such as the one of the crowd, the masses, the class, the mob, and the nation have simply lost their capacity to describe what defines the common ground of Tykwer's collectives. Instead, Tykwer's protagonists are representatives of a period in which highly flexible and geographically unbound networks define the principle form of how people cooperate, establish communicative relationships, understand the world, and map their own place within it. What we learn from the opening of *Run, Lola, Run,* is not only that this new collective form of the network can unsettle the very space from which both Riefenstahl's image of the mass ornament and the idea of the coherent and self-enclosed nation had once emerged. What we also learn is that its logic of dispersal and swarmlike mobility can provide the conditions for a possible reorganization of individual and collective perception, for an unprecedented temporary association of fragmented and multiple temporalities, and hence for the reflexive recognition of spatial heterogeneity and temporal plurality that this book calls our contemporary aesthetic of slowness.

Let's take one more look in order to better understand what I consider the political implication of Tykwer's aesthetic of slowness.

The camera moves rather erratically and at chest or below-chest level through an amorphous crowd. Everybody seems to be on the move, yet nobody appears to follow a predetermined path. Their heads mostly directed at the ground, the members of the crowd take no no-

tice of each other. Each is on his own, even though all of them seem to be searching for something similar. In spite of the density and indifference of moving bodies, no one ever touches, let alone bumps into, anyone else. A series of slow dissolves produces layered images that emphasize the crowd's ongoing motion and dispersed concentration. Digitally reworked, the shot's colors are desaturated, its texture exceptionally grainy. In this way the camera presents the bodies on-screen as something spectral, as phantomlike. As silhouettes in search of whatever might provide them with more complete materiality. As undead, craving life. Repeatedly, the camera slows down its own movements, singles out individual members of the crowd from low-angle perspectives, and invites them to gaze back at the recording apparatus as much as at us. More fully saturated colors emphasize their singularity and present these individuals as privileged subjects able to rise above their spectral immateriality so as to arrive in the real. Any viewer familiar with the film's narrative will of course recognize these individuals as characters whose lives will be affected by Lola's triple run, their various futures in each episode indicated to us in fast-paced series of photographic snapshots. Though none of these figures will play essential roles in the film as a whole, all of them—through Tykwer's later fast-forward montage sequences—will be shown as characters embodying contingent and divergent temporalities, as characters whose lives will continue to move on in various directions even after the narrative's actual ending.

The last person to be captured and isolated from the crowd in the opening sequence is a private security guard, dressed in black leather clothes, a relaxed smile on his face. After the film's sound track up to this point had entertained us already with some pop-philosophical ruminations about the meaning of life, the guard now, too, addresses us directly. First we hear him quote some famous lines by legendary soccer coach Sepp Herberger. Then we see him shoot a soccer ball way up in the air—with the help of a powerful kick that urges the camera to take on a sublime bird's-eye point of view and thus allows us to witness how the dispersed members of the crowd slowly but deliberately arrange their bodies into one larger body spelling out the film's title: "LOLA RENNT" (figure 5.7).

In *Multitude*, their 2004 follow-up study to *Empire*, Michael Hardt and Antonio Negri drew our attention to new forms of collectivity

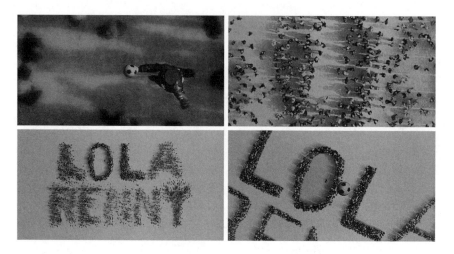

FIGURE 5.7. Tom Tykwer, *Run, Lola, Run* (1998). Screenshots.

characteristic for our age of globalized economies, ceaseless war, and networked relationships. In their work Hardt and Negri engage notions such "the multitude" and what they call "the common" in order to conceptualize these new modes of counterhegemonic association. The multitude, they suggest, is a plural collective composed of irreducible singularities, that is, a social subject whose interior differences cannot be reduced to some coherent idea of identity or sameness: "The multitude designates an active social subject, which acts on the basis of what the singularities share in common. The multitude is an internally different, multiple social subject whose constitution and action is based not on identity or unity (or, much less, indifference) but on what it has in common."[20] In the past, notions of operative collectivity essentially relied on visions of teleological closure or a rhetoric of recuperated origins. Whatever brought people together was thought of as furthering or fulfilling an inert program of history. Whatever caused individuals to merge into a mob was seen as replaying a mythical and hence timeless desire for overcoming one's own singularity. Hardt and Negri's concepts of the multitude and the common want to overcome this tradition of political thought. Their eye on the global formation of antiglobal and antiwar protests after 2000, Hardt and Negri explore forms of association in which the key characteristics of our networked

age of immaterial labor, namely the production of deterritorialized communication and cooperation challenging the biopolitical order of the day. Hardt and Negri's multitude represents an era in which social labor is structured around the production of mobile and flexible forms of knowledge, information, and exchange. The common does not simply allow irreducible singularities to communicate with each other, but produces their network of communication in the first place. The common defines the space of interaction as a topography void of unifying boundaries and synchronized temporalities.

Hardt and Negri's concept of the multitude is certainly as dazzling as it is problematic. After all, it is difficult, if not impossible, to imagine how to build any concrete politics on the base of what is inherently fuzzy about the notion of the multitude. In the final analysis, Hardt and Negri's concept might be suitable to theorize a prepolitical longing for new forms of operative communality, a resisting against former principles of social integration, much more so than it offers an effective blueprint for political reform. Yet it is precisely when uncoupled from Hardt and Negri's more explicit political agendas, when seen as a term primarily mapping the emergence of new forms of association under the sign of omnipresent networking, that the concept of multitude is quite useful for illuminating the negotiation of the cellular and the communal in films such as *Run, Lola, Run*. Tykwer's assembly of searchers in the opening of *Run, Lola, Run* is obviously not one congregating around an explicit political agenda, let alone protesting the effects of globalization. And yet what we see here is a gathering for which neither the concepts of the mass and the mob nor the notion of the people appear suitable and for which Hardt and Negri's conception of the multitude organizing around a common might fit much better. What is clear from the beginning of the scene is that each member of this gathering owns her or his irreducibly singular temporality; whatever brings them together—unlike Riefenstahl's mass ornament—does not efface this singularity and sacrifice difference on the altar of some higher kind and idealized form of unity. At the same time, let us note that the assembly of bodies in this scene is not shown as the realization of a timeless or ahistorical identity, but clearly marked as a temporary and ephemeral, albeit not indifferent, aggregation. "The ball is round," our security guards cites Herberger's legendary line before kicking the

soccer ball up in the air and thus triggering the searchers formation of a collective. "The game lasts 90 minutes. That's a fact. Everything else is pure theory. Here we go!"

Though able to write in common what individual members of the crowd are unable to read, Tykwer's multitude has no inert unity, nor does it stage collectivity as the actualization of some preexisting or teleological identity. Whatever brings people together will also separate them again. Collectivity is and cannot be other than performative, a temporary, and provisional production of something common as common. While we are rightly hesitant to see this multitude as embodying any kind of specific political agenda, we can certainly see it as a symbolic embodiment of a new form of politics itself that—unlike former concepts of the political and the collective—is willing to reckon with the contingent and the finite, the ephemeral and the instable. A politics that, in the name of difference and singularity, shuns both nostalgia for lost origins and teleological visions of future final fulfillment. A politics drawing on the transformation of temporal and spatial experience under the conditions of digital culture, not in order to accelerate the homogenizing strategies of globalized capitalism, but to enable provisional networks of communication and to mobilize what they share in common against the at once unifying and isolating force of global capital. A politics of slowness that explores the copresence of different temporalities as an opportunity to uphold the often forgotten claims of modern contingency and nondetermination and that envisions future forms of belonging without either idolizing the specters of sovereign subjectivity or simply erasing the grounds of subjectivity altogether.

7 /

Sepp Herberger was certainly right to emphasize the finitude of the match. After all, who knows what might happen after ninety minutes, that is, after the end of the game? But Herberger was also shrewd enough to add that the closing of one game inaugurated our anticipation of the next one and that, in this sense, the game would therefore never end. Alternating between the thrill of fast-paced action and momentous visions of slowness, Tykwer's choreography of time nego-

tiates this apparent paradox. Highly kinetic, and yet deeply associated with the aesthetics of slowness discussed in these pages, Tykwer's films share in common the ambition to explore how contemporary culture may enable us to live in and across various layers of time, to recognize the dynamic copresence of various rhythms, speeds, and temporalities. To be modern and contemporaneous, in Tykwer's cinema, means to engage with this fragmentation and multiplication of time head-on, not in order to overcome it, but—like a soccer player—to adjust our actions and thoughts flexibly in response to evolving situations on the entire field. Tykwer's films might have little in order to be seen as political in terms of traditional notions of political art, but in their effort to reframe the viewer's perception and temporal registers, in recalibrating the dynamic textures of how we may connect to others across space and time, and in suspending the kind of logic that associates reliable outcomes with certain intentions—anticipated goals with sovereign actions, desired destinations with directional motions—Tykwer's films indeed, in Rancière's words, "open up new passages towards new forms of political subjectivation."[21]

How theory—pace Herberger—may be of help in elucidating the way that contemporary video art, by slowing down the viewer's perceptual mechanisms, can reframe the traumatic fragmentation of modern memory and thus, too, reopen passages to different futures, will be the focus of the next chapter.

SIX

VIDEO AND THE SLOW ART OF INTERLACING TIME

1 /

Dominant models of modernist film theory, in their endorsement of moving image technology as the twentieth century's most significant art form, considered the cut as the primary site of cinematic meaning. For critics such as Walter Benjamin and Sergei Eisenstein, cutting and editing defined film as film. They served as formal means to rupture lethargic desires for continuity, to interrupt standardized processes of perception, to shock our eyes and minds with incommensurable sights. Cutting and editing dislodged what appeared static about the representational registers of bourgeois art. The more frequent, disruptive, or violent an editor's interventions, the more active and dynamic the viewer's response and hence the faster the experience of a film's temporality. Cutting and editing, in this sense, rushed spectators into unknown futures and alternate realities, liberating them from the sluggishness of time as much as the gravity of place. Instead of situating the viewer as a passive voyeur, cutting and editing invited—perhaps even forced—the spectator to go traveling across remote landscapes. Cuts defined the new medium of film as an ideal training ground for the inherently traumatic structure of modern life in general—the violent and overwhelming onslaught of discontinuous and fast-paced vi-

sual stimuli. Film at its best, for modernist montage theorists, prepared viewers for and helped them work through the shocks and discontinuities of modernity.

When video filmmaking entered the arena of artistic production in the late 1960s, the new technology promised a very different mode of encoding time and memory, of shaping perception, experience, attention, and temporal passage within the realm of time-based art. As they invisibly refreshed themselves dozens of times a second across the space of the screen, video's scan lines defined the new medium as one favoring an aesthetic of flow and perceptual continuity, of observational attentiveness and durational extension. Contrary to film's language of rupture, fragmentation, and displacement, video's initial promise was therefore to allow filmmakers to capture ephemeral images of mere life and time passing by—to provide a medium whose artistic potential rested precisely on its seemingly unaesthetic or aesthetically reduced formal operations. With its ability to offer direct visual feedback, video not only encouraged experimental applications. In so doing, it also moved the language of moving images beyond the grammar of montage and fragmentation so prevalent in modernist film theory. Though early video artists did not shy away from capturing harrowing experiences, their medium necessitated a new way of thinking about the relationship between form and content and hence about how moving images could and should communicate the substance of traumatic histories. The advent of more elaborate technologies of video editing, be they magnetic or, later, digital, did not fundamentally change this. In contrast to the beliefs and practices of many modernist filmmakers, video no longer automatically associated the cut with both accelerated and shocking structures of temporality. The rigor of form no longer carried predictable content; the cut lost its formerly privileged status as a means of grafting the conditions of modern life quasi-directly onto the physiological receptors of the viewer. Video, in this sense, provided a primary avenue toward an aesthetic of slowness: a means enabling the filmmaker to absorb and reflect on modern temporality without being blinded by its speed and drive, a means to visualize the dynamic of modern time and experience without necessarily getting caught up in its reliance on both trauma and teleological directionality.

Nowhere does this difference between film and video, between the earlier medium's dual stress on rupture and speed and the later one's on temporal reflexivity and slowness, become more obvious than in the work of video artists such as Tacita Dean, Douglas Gordon, Sam Taylor-Wood, and Bill Viola. In the various projects of these artists, video's particular ability to decelerate perceptual processes and images of physical motion enables a continued probing of the body's location in space and time, the physiology and metaphysics of perception, the workings of memory and affect, and of course the role of the camera itself in capturing images of passing realities. Whether we think of Viola's *The Reflecting Pool* (1977–79), Gordon's 24 *Hour Psycho* (1993), Taylor-Wood's *Brontosaurus* (1995), Dean's *Fernsehturm* (2001, TV-Tower), or Gordon's revised version of his 1993 Hitchcock film, 24 *Hour Psycho Back and Forth and to and Fro* (2008), slow-motion images here serve the purpose of intensifying the viewer's viewing, not simply in the sense of sharpening our awareness for things normally left unnoticed, but of allowing us to explore the indeterminate space between represented time and the real time of our viewing.

For the purpose of this chapter's argument, however, the extensive use of slow-motion photography in recent video art appears quite too literal and transparent to unfold the full possibilities of slowness in contemporary aesthetic production. I will therefore direct my attention at work instead whose slowness is constituted by techniques other than a mere slowing down of recording or projection speeds. While I have more to say about the work of Douglas Gordon toward the end of this chapter as well as in chapter 8, its initial focus will be on Willie Doherty's *Ghost Story*, a fifteen-minute video installation that represented Northern Ireland at the Venice Biennale in 2007. Doherty was born, lives, and works in (London)Derry, Northern Ireland, in close proximity to the border of the Republic of Ireland. Ever since the 1980s, his photographic and video work has explored the challenges of living in a community haunted by past and present violence, by trauma and division, by the fear, oppression, and despair associated with the Troubles. *Ghost Story* continues this line of inquiry. Though Doherty's video avoids any explicit use of slow-motion photography, the piece's measured pace and lingering images not only ask tough questions about

how to represent haunting memories of the past in the present. In doing so, the work also offers intriguing perspectives on how video can address trauma and violence beyond the modernist (cinematic) aesthetic of rupture, shock, and speed. It is *Ghost Story*'s extraordinary effort in contemplating the difficult relationship of past and present, arrest and motion, the traumatic and the durational that marks Doherty's particular contribution to a contemporary aesthetic of slowness. Far from merely taking the speed out of dominant editorial strategies of representing violence and traumatic memory, *Ghost Story* allows the viewer to contemplate the space of the present as one embedding numerous conflicting and unresolved memories, narratives, and perceptions—as one in which aesthetic slowness channels our need to learn how to move with the remnants of violent pasts in order to move beyond them.

2 /

The camera travels slowly but steadily along an empty country road, a dilapidated barbed wire fence with a needle forest on the right, shrubs and jumbled foliage on the left (figure 6.1). It must have rained recently. Gray and blue tones dominate the landscape. Barely visible between the top of the trees, the sky appears indistinct, as deserted from points of orientation and markers of time as the landscape itself. It might be fall. Or winter. Or spring. Or simply one of those summers that never develop their full promise. The dirt road in front of our eyes runs toward the horizon in a straight line, our point of view being that of a walker strolling down the alley with the unsettling exception that the use of Steadicam technology restrains any visible impressions of the act of stepping. No shaking, no trembling, no bumping disturbs the gaze of the camera. It simply seems to glide or float down the road as if emancipated from its own materiality. Like an angel. Or a ghost, for that matter. After less than a minute, our gaze will suddenly turn to the right, a hard cut rather than a soft pan redirecting our attention. A lake's or river's surface—as gray and inarticulate as the sky above—becomes visible behind the trees and the wires of the fence, but once again we cannot but fail in our effort to detect some human presence, some sign locating us firmly

in space. We keep walking straight ahead toward the horizon, the viewer's body feeling physically pulled by the forward motion of the camera, and yet it is difficult to imagine not feeling lost on this abandoned country road, in this nowhere land, moving along some border or edge whose precise nature remains unknown to us. As evocative as it is unsettling, the landscape around and in front of us reveals as much as it hides. Something unrepresentable and invisible haunts the visible.

Faint noises of passing cars eventually seem to identify this space on the outskirts of some larger urban area as a hybrid space between the natural and the man-made, stuck or boxed in between two competing options and thus, once again, void of any clear profile or location or identity. After about four minutes, the scenery will drastically change, even though the camera will continue its disquieting drift through what we see. We travel down a narrow asphalt road, flanked by stone and concrete walls on either side, some hills and houses, or mounds of trash, toward the horizon. As the camera approaches a bend in the road and thus engages our curiosity about new things to come, we cut back to the initial alley again, thrown back to some point along the path we must already have passed before. Later on the camera will cut to a sinister highway underpass at nighttime, barely illuminated by neon light, a male person leaning and waiting against the wall without acknowledging the arrival of the camera. And, after one more cut back to the alley road, we end up on a huge deserted parking lot during twilight hours. A car rolls into the picture from the left and comes to a halt in mid-frame as the camera continues to approach the vehicle and allows us to make out the silhouette of the driver. Instead of zooming in on the figure in the car, however, the camera returns us once again to the alley road, to the sidelong glance of shot 2 showing fence, trees, and river. It now holds this perspective for much longer than in the video's initial vision. In fact, the camera asks us to stare to the right for much more than a minute before it will slowly veer forward again, as if our imagined walker in the film turned his head away from the thicket and focused on the road ahead again, perhaps captivated by the fact that

FIGURE 6.1. Willie Doherty, *Ghost Story* (2007). Fifteen minutes, color, sound, single screen installation. Dimensions variable. Image courtesy Alexander and Bonin, New York.

the trees and brushes on the left are much more transparent now than in any previous shot. We roll on for a few dozen meters before the video comes to an end. Or, better, loops back again to its beginning and replays what we have just witnessed.

Any retelling of Doherty's *Ghost Story* will remain incomplete, of course, without mentioning, on the one hand, the repeated use of brief insert shots, showing in extreme close-up a women's and then a man's eye eerily glancing past the camera and the haunting voice-over spoken by actor Stephen Rea, his seemingly flat and toneless, emotionally restrained retelling of fragmented memories and visions, stories and perceptions, narrative glimpses of past and present, while constantly and bewilderingly switching tenses. "I found myself walking along a deserted path," Rea's voice starts out as we see the alleyway on-screen. It continues, time and again suspending the progress of the act of speaking, and hence our curiosity, with the help of deliberate pauses: "Through the trees on one side I could faintly make out a river in the distance. / On the other side I could hear the faint rumble of faraway traffic. / The scene is unfamiliar to me. / I looked over my shoulder and saw that the trees behind me were filled with shadowlike figures. / Looks of terror and bewilderment filled their eyes and they silently screamed, as if already aware of their fate. / The scene reminded me of the faces in a running crowd that I had once seen on a bright but cold January afternoon." What in the beginning of Rea's voice-over might sound as if, over time, it could add up to one coherent story about a violent historical moment, most probably the events of Bloody Sunday of January 30, 1972, will never gain narrative integration. Similar to the haunting voice of Canadian walking audio artist Janet Cardiff (discussed in the next chapter), Rea's evocative intonation—his performative modulation of speaking with a Northern Irish accent—seems to get underneath our skin, speaking to me as if I was the only viewer and listener ever intended to witness *Ghost Story*. But the content of his speaking will never allow us to be pulled or sutured into one connected story arc. What we witness instead is a seemingly aimless amble through the tormented mindscape of the speaking I, which results in a disparate collection of memories, dreamlike images, perceptions, and speculations.

Slowness, some might find, is a medium to buffer the pressing immediacy of making decisions, particularly in our contemporary moment of incessant temporal shrinkage and ever expanding connectivity. We desire to slow down and stretch out time, it is said, so as to be able to contemplate different options, evade the brunt of what occurs to us as inevitable and/or unstoppable, look left and right before moving forward, and thus (hopefully) make wiser and more autonomous choices. In Doherty's *Ghost Story*, however, both the camera's and the narrator's slowness is not about enabling better decisions. Rather, it is about allowing an amorphous and seemingly traceless past to bubble up to the surface of consciousness, not in order to integrate it firmly into the demands of the day, but in order to invite the silent and static elements of the repressed and unspeakable, of the forgotten and incommensurable, to find some voice in the first place and thus somehow bring it into motion again. Slowness, in Doherty, in other words, is meant to endow the surface of the visible with words, to allow language emerge from the cracks and fissures of the visual field. Consequently, we hear the narrator speak about troops violently chasing an urban crowd with their rifles; about this narrator's inability to find traces of the massacre at some later point; about the odors and viscous shapes of a landscape of invisible memories; about the narrator making out some human figure, but being unable ever to get any closer to what strikes him as a "further incursion of unreality"; about him seeing the silhouette of a car as it had swerved and was then abandoned in some shallow ditch; about detailed memories of various photographs showing blindfolded men, their hands cuffed, as they were taken away; of barking dogs and piled up bodies, exploded cars, and a family shown as scared witnesses of violence. And, as the video's image track nears the end of its loop, Rea's voice concludes with a series of reflections on the spectral qualities of life and landscape in the aftermath of forgotten or not fully remembered trauma: "The wraith is usually a vision of someone who is in another place at the time of the appearance. / It manifests itself during the hours of daylight in a place where the living person could not possible be. / A wraith can assume the likeness of a close friend or relative or even appear as the viewer's own image. / The appearance of a friend or relative usually means that

the person is already dead or in great danger. / To see one's own image is a warning of one's death within a year."

What is quite remarkable about the narrator's voice-over is how Rea's intonation—his performance of nonperformativity—lends some vague and confusing sense of continuity to this collection of utterly disparate memories and premonitions. The narrator clearly makes no effort to order these elements, to make sense out of them. He allows aspects of past and present to speak to him, whether they are filtered through mediated images or are part of his own recollection and perception. Remarks about the spectral and abstract nature of the landscape stand next to detailed descriptions of blood and gore, of horrific experiences whose visceral power is not softened for the listener through metaphor or simile. And yet, as a result of Rea's hauntingly intimate voice, the incommensurable and discordant here appears as if strung up like beads on one and the same string, separated by pauses and spaces, but not by ruptures or radical discontinuities. As if each and every element was of the same perceptual, existential, and ontological valence. As if the lingering violence of the past had obliterated any clear distinction between interior and exterior landscapes, between dream, recollection, perception, and description, between ghostlike abstraction and bloody concreteness. The deliberate slowness of both Doherty's passing imagery and Rea's voice is what enables the disparate and inexplicable to appear in nonhierarchical simultaneity, to be situated in close proximity without being pushed through the ordering filters of consciousness, rationality, and meaning making. Slowness permits copresence to what refused to be present or was hidden behind the visible. Slowness allows images and words to complement each other without turning into each other's interpretative keys and explicators.

3 /

Video, Yvonne Spielmann has argued, is essentially defined by its structural indeterminacy and hence its resistance to being understood in essentialist notions of media specificity. Video, according to Spielmann, is all about process and transformation due to the medium's funda-

mentally open structure, its absence of preexisting aesthetic determination.[1] An artistic medium whose advent in the late 1960s was not burdened by preexisting codes and expectations, video—according to Spielmann—liberates artistic production from narrow discourses of a medium's inherent logic because (1) video signals can be produced in various ways (depending on whether one uses a camera, a synthesizer, a scan processor, a field switcher, etc.); (2) audio and visual sources can be mixed freely and unexpectedly; (3) video art may not necessarily result in recorded works but can instead merely involve closed-circuit and feedback loops; (4) the fleeting scan lines of video display defy any sense of visual closure and homogeneity; and (5) video works are not bound to one form of presentation or projection alone.

Video, for Spielmann, lacks any sense of stability, both in terms of its institutional existence and its ontological definition. Unlike film, video capture and projection relies on the constant interlacing of different scan lines, never allowing us to isolate what could be called the materiality of a single image or shot in the first place, always splicing parts of what is to come into what is and what has been before. Though a camera's or a player's pause button might give us the illusion that video relies on a train of isolated images fused into perceptions of seamless movement, in actual fact video knows of no such stable, identifiable, basic entity. Everything is in flux, everything open to ongoing transformation. Every image (and sound) contains past, present, and future at the same time or, more precisely, relies on different moments layered into one impression of ongoing and open-ended presence. While video, of course, can employ complex strategies of cutting, the medium's principal avenue of making meaning lies in its ability to engage its own technological and temporal malleability, its absence of one coherent program, its stress on open simultaneity rather than film's (modernist) logic of sequentiality and rupture, of narrative development, montage, and the shock of formal juxtaposition. Borrowing from Roland Barthes, we might say that, as medium and compared to film, video is weak in meaning. But it is this weakness—the relative absence of ontological predetermination, the fundamental instability of its interlaced images and sounds—that constitutes video's strength as a key player in contemporary efforts to decelerate time so as to map the multitude of temporal layers that energize perceptual and experiential space.

In Doherty's *Ghost Story*, video's interlacing of images and sounds does not simply operate as a mechanism to capture painful memories, but allegorizes the very way in which the past of the Troubles has come to structure perceptions even of seemingly innocuous sights in the present. Doherty's landscapes—the pathway, the underpass, the parking lot—confront the viewer with utterly concrete and unmetaphoric spaces, much as they, due to the work of the voice-over, emerge as part of a haunting landscape of the mind. Like video itself, *Ghost Story* defines the present as a site at once revealing and concealing various streams of history and memory, all somehow woven into each other, yet no one offering itself to provide some sense of unity or totality, of coherent meaning and stability. Doherty's work literally interlaces fragmented recollections of past violence, of things witnessed here or elsewhere, of personal or mediated traumas, with quite tangible perceptions of surrounding space, not in order to depict the present as the location of a dreary replay of the past, but to define presence as an unstable relay station that eludes comprehensive definition: a place in which the past doesn't want to go away, even in the absence of visible traces of historical violence; a site indeterminately mixing interior and exterior, psychological and physical qualities; a geography whose invisible stories and spectral elements undercut any attempt at orientation and localization.

Troubled by inconclusive and unaccountable story fragments of the past, then, Doherty's landscape is one in which neither a clock nor a compass would be of much use to tell us anything about our location. As it interlaces past and present, the dead and the undead, this landscape instead appears to the viewer as a tormenting twilight zone. The longer we watch, the more questions seem to pop up: Wouldn't it be much better simply to step up one's speed so as to leave this ghostly territory behind and find sure footing somewhere else? Doesn't Doherty's interlacing of past and present enslave the present to the past and thus prevent the victims of history from ever coming to terms with their trauma? And doesn't Doherty's slowness thus precisely reinscribe the very problematic that had haunted the work of modernist speed enthusiasts as well?

4 /

Speed, in modernist culture, was often seen as a catalyst of desensitiza-
tion. As we have seen in chapter 1, for speed addicts such as Marinetti
traveling at high speed harnessed the body against the unwanted leg-
acy of nineteenth-century bourgeois culture—its cult of interiority, its
stress on sensitivity, its ethics of compassions and empathy. Modernist
speed may have triggered new passions, but its central achievement
was to eliminate bourgeois pathos, that is to say, the individual's capa-
bility to feel for and with others, but also his ability to experience and
allow for affect in face of his own suffering. Speed caused the modern-
ist body's sensory organs to shut out unwanted stimulations and meet
the world with what Ernst Jünger theorized as a cold or second con-
sciousness, a mental state oblivious to pain while eager to register—
photographically, as it were—the perceptual field with precise, albeit
highly distanced, objectivity.[2]

At first, pathos and affect appear equally absent from the world of
Doherty's *Ghost Story*, as if Doherty intentionally sought to show that
complete reversals of modernist speed could produce states of disaffec-
tion as well. While Doherty's camera eye moves along the alley with-
out ever responding to particular elements of the visual field, Rea's
voice-over narrates even most horrific recollections as if nothing could
ever really affect the speaker: no apparent empathy with the victims of
the past, no seeming irritation about the shadows of the undead lurk-
ing behind the trees. Like Jünger's or Marinetti's voyages across the
battlefields of modern culture, Doherty's video, one might thus argue,
moves the viewer through the landscapes of the Troubles as if camera
and narrator had been deadened by the traumas of the past—as if the
traumas of the past had initiated the rise of a second consciousness,
immunizing us against any future trouble.

Contrary to one's first impression, however, nothing would be more
mistaken than to follow this line of reasoning and hence equate mod-
ernism's anaesthetic understanding of speed with the role of slowness
in Doherty's video. The most obvious difference, of course, is this:
whereas the perceptual apparatus of the Futurist adherent of speed
was primarily projectile, shutting out lateral distractions so as to clear
the path into the distance, Doherty's video suggests perceptual motions

in which the lateral and the trajectorial, sideways and forward glances, go hand in hand, not in order to screen out what possibly might diminish one's attention, but to allow the unanticipated and forgotten, the invisible and unspoken to (re)enter the frame of attention. Unlike the second consciousness of the speedy modernist, slowness in Doherty is far from reducing attention to the perception of one single point. On the contrary, the slowness of both the camera and Rea's voice-over in *Ghost Story* is to decenter the frame of perception—to pierce the confines of projectile attention—to such an extent that the unaccounted and unaccountable can enter the traveler's consciousness and gain renewed presence in the present.

It is worthwhile at this juncture to discuss in greater detail how Doherty's camera seems to emulate the moving perspective of a pedestrian. Or more precisely: how Doherty's camera seems to embody the perspective of a perambulator inviting the viewer to identify or empathize with the steady movement of the camera itself; how this camera encourages us to see its work as our own bodies' extension in the filmic space and hence draws us into the video's diegetic world; and how *Ghost Story*, in so doing, embraces film's kinesthetic qualities for the sake of fooling the viewer's proprioceptive compass, of making us lose our sense for the exact location and limits of our own bodies as viewers. The experience might strike the viewer as somewhat familiar, either from classical horror film conventions in which unsteady POV shots create utter tension (and perverse pleasure) or from first-person shooter games that ask the player to navigate challenging spaces with the help of a diegetic avatar. And, yet, the visceral pull of Doherty's camera is quite different from these experiences, not merely because no challenge, adventure, or visual horror will ever materialize within the visual field, but first and foremost because the camera, upon a closer look, *performs* the operations of subjective perception more than it tries to simply mimic or replace them. Whereas Doherty's Steadicam removes even the slightest hobbling from the image when looking forward and in this way invites the viewer to float rather than step through the space in front of us, the camera's sideways glances on fences, trees, and lakes are far too fixed in angle and direction to really impersonate the lateral gazes of a moving subject. In the next chapter, when discussing the work of

Janet Cardiff, I will devote much more attention to the role of walking in the aesthetic of slowness in contemporary artistic practice. At this point what I would simply like to explore more closely are the perceptual and aesthetic effects of how *Ghost Story*, in spite of its restraint and sobriety, presents the camera's phenomenology of vision and movement, of peripatetic perception, as deeply theatrical and how, in performing, somewhat abstractedly, the motions of a human walker, Doherty's camera hopes to return some minimal, albeit liberating, sense of pathos to the frozen landscape of violence after all, the video's slowness injecting a rudimentary dose of (e)motion into how the traumas of the Troubles have numbed people's senses.

Perception, argues French neuroscientist Alain Berthoz, is simulated action, meaning that vision is only able to perceive objects in space because our brain knows how to employ a multitude of perceptual schemata to associate certain future actions with these objects—actions that involve other perceptual registers, in particular the one of touch. In this respect, the brain operates like a flight simulator, constantly anticipating possible patterns of action and playing through alternative ways of navigating space.[3] Coordinating the movements of the perceiving body, the motion of head and eyes, and the shifting locations of object in space, our general sense of movement relies on how our neurological system is able to anticipate what it would take to physically connect to visible objects—to invent and continually revise models of the world and its relationships around us. In this process, tactile information is of central importance in counteracting certain limitations of the vestibular system, in particular the visual receptor's inability to distinguish between accelerations of head movements in one direction and decelerations of the body's speed in the other direction. Visual perception and cognition, in sum, is not only essentially predictive (and creative) as it builds on our brain's ability to project physical activity into the space of the future, it also cannot do without relentlessly trying to make proprioceptive and kinesthetic information cohere and thus maintain balance between different sensory input and neurological operations.

Cognitive neuroscience, at least in the perspective of this author, is rarely of much use in exploring the specificity of modern aesthetic experience and how artworks in various media seek to develop new ways

of seeing the world and relating different sensory registers. In the particular case of Doherty's *Ghost Story*, however, Berthoz's insistence on both the anticipatory and the tactile aspects of visual perception is helpful to better define the unsettling ways in which the movement of Doherty's camera disturbs the operation of normal vision and its orchestration of internal models of physical reality and how, in so doing, the video's slowness opens up a mode of aesthetic experience in whose context the viewer can reevaluate not simply the relationship between the kinesthetic and the proprioceptive, sight and touch, but, as important, between present, past, and future, between projective and mnemonic activities, and thus also between motion and emotion.

In its consistent refusal to ever respond to even the smallest stimulus of the visual field, Doherty's camera work radically minimizes the way in which "normal visual perception" relies on the anticipatory invention of models of physical reality as much as on the constant (re)calibration of different internal and external vectors of motion. Seemingly untouched by what it sees, Doherty's moving camera maps passing realities as if the perceiving mind was no longer able to project future models of physical relationships and as if the observer had lost her capacity to coordinate the motion of head, eye, body, and things in space. The resulting impression for the viewer at first might be that of a seeming—and, if you wish, pathological—disconnect between sight and touch, precept and anticipation, motion and image. But, given that we are perfectly aware of the fact that we are not dealing with a scientific explanation of perceptual processes, the viewer is likely not only to interpret this disconnect as primarily haunting instead of merely dysfunctional but also to experience it aesthetically as an incentive to bring into play our own processes of projection, anticipation, and creative model building. The video's perceptual lack, its seemingly dehumanized restraint and traumatized inertia, serves as an open invitation to the viewer to inject motion into Doherty's at once moving and arrested images and consequently encounter the depicted space as a space of possible future action and physical engagement again.

Nowhere, perhaps, does this become more palpable than when the camera drifts across the empty parking lot, at once aware and yet seemingly oblivious to the car entering the frame from the left and then coming to a standstill in the middle of the frame. Whereas the camera

will steadily continue its approach as if the diegetic observer's visual receptors had no interaction with the brain's system of tactile projection and hence failed to produce any form of anxiety about a possible collision of the two kinetic trajectories, the viewer—subliminally coupling sight and touch—cannot but feel unsettled by the action on-screen and project some form of affect and pathos into the whole situation, be it angst, fear, concern, dismay, or dread. Whereas the camera's disembodied motion—call it ghostlike or angelic—seems to exclude any present or future contact with physical reality, the viewer's affective response in this and most of the other scenes, our pathos, results from the fact that structures of embodiment, our sense of tactility and proprioception, are critical for any process of mobile vision and vision of mobility.

Pathos, Robert Buch explains, recalling the term's original semantics, emerges from a fundamental conflict "between the effects and experience of de-humanization and the countervailing tendency, the reclamation of the very humanity that seemed to be forfeited. On the one hand, pathos is the name of unsalvageable pain and misfortune, radically immanent, that is to say, irredeemable creaturely suffering. . . . But then, on the other hand, pathos is also the name of compassion. It is the means by which we relate to another's pain and by which suffering is recognized and affirmed as human, precisely at the point of radical crisis."[4] In *Ghost* Story the tension between the camera's seemingly dehumanized and disembodied slowness, on the one hand, and, on the other, the viewer's efforts to project touch, motion, and affect into the images on-screen recall the conflict between irredeemable pain and rehumanizing empathy that is at the core of what Buch calls pathos. Whereas the camera appears untouched by what enters the visual field, the viewer—being at once unsettled and literally moved by the haunting disconnect of vision and tactility on-screen—cannot resist the pull of (re)charging Doherty's images with some sense of emotion and affect, understood here as our ability to be moved by and to move the pain of others, by a rudimentary sense of compassion recognizing and in recognizing trying to reframe the anguish on screen. Because it is primarily being played out in the realm of perceptual processes, this resulting rehumanization might be extremely basic and formal, void of any ethical determination or ideological impulse. But, in situating the

figure of pathos at the very center of his video, in urging the viewer to bring (e)motion to the camera's images of dehumanized movement, Doherty's exercise in slowness provides a model of coping with the lingering residues of violence that differs critically from dominant psychoanalytic paradigms of "working through" traumatic incidents. Doherty's alternate model instead is homeopathic. It requires subjects to take in controlled doses of what afflicted their bodies in the first place, to ingest the past into the present, so as to learn how to move beyond pain by learning how to move with it into the future.[5]

Like the shocks theorized by modernist advocates of cinematic montage, trauma has often been understood as a rupture of continuity so violent in nature that the event in question is not really experienced and hence properly remembered by the subject in the first place. Informed by various psychoanalytic models, cultural and literary critics in turn have come to favor modernist strategies of disruption and discontinuity as the most adequate means of representing what is unrepresentable about traumatic memories and in this way to overcome the past's spell over the present. The role of aesthetic slowness in Doherty is clearly at variance with such a favoring of modernist disruption as a means of articulating traumatic residues in the present, similar to how video's logic of interlaced temporality differs from the dominant (modernist) concept of disjunctive cinematic time. As it explores pathos's tension between dehumanization and rehumanization, the point of Doherty's slowness is not to foster the illusion that one could ever master the torment of the past, fill the void, bridge the rupture, and compensate for losses so as to operate "normally" again. In evoking and reintroducing the power of (e)motion, the pathos of aesthetic slowness in Doherty's video instead allows the past in all its irredeemable roughness to gain dispersed presence again without defining the present as a sole afterimage of the past. Doherty's aim in *Ghost Story* is not to master the unmasterable through affective distance and cognitive reflexivity, but to expose our senses to what overtly or secretly continues to trouble the mind and causes extreme feelings of displeasure. No one here talks of a redemptive victory over the scars left by history. The blood of Bloody Sunday has been shed, the dead are really dead, and the losses of the past cannot be salvaged. To learn how to endure the specters of the past— to live and keep moving in the face of the ubiq-

uity of past disaster—is all Doherty's aesthetic of slowness can offer. Which might not sound like all too much, but is perhaps more than many were once able to hope for and few may be prepared to accomplish today.

5 /

Though it defies one singular logic, video's single most important prerogative has often been seen in its unique ability to modulate the temporal, to contract or expand, to crystallize or stretch our perception of time. Consider the writing of art theorist and philosopher Maurizio Lazzarato.[6] For Lazzarato, video's most original contribution to the history of art is its power to explore the complexity of temporal experience and duration. Video art is essentially time art, an art of capturing and shaping the temporal in its most emphatic form. It allows artists and viewers alike to rework, transform, condense, unfold, and converse about the flow of time and thus open a pocket of nonlinear, subjective temporal experience amid the modern dominance of objective chronological time. Contrary to its very name, video is less about mere acts of seeing and reframing the world as it is about extracting us from the structured itineraries of the everyday and encouraging us to explore the richness, the unpredictability, and the intensity of being and becoming, memory and anticipation, contingency and chance. Video's primary task is to suspend the chronological regimes of Fordist modernity in the hope of opening a window onto a different order of time, one that allows viewers to become active producers of what they consider time and its manifestations in space in the first place.

Though not much really happens and no overt special effects are used to modulate the passing of time in *Ghost Story*, Doherty's video illustrates of how video art, in its unique ability to both reflect on and shape the temporality of perception, may function as a principal conduit of aesthetic slowness. True to Lazzarato's ruminations, Doherty runs up against chronological time in an effort to explore the folds and fissures, the loops and blockages, but also the transformative potentials of the now. A disturbing blend of subjective and objective time, *Ghost Story* might allude to the most worn trope of linear and forward-moving

time, namely the path as it cuts its way toward a distant horizon. But the video's sound and image tracks, as they plunge us ever deeper into the narrator's mindscape, persistently decenter this trope even before it may take hold of the viewer's imagination. In Doherty's land of ghosts, every itinerary is necessarily forked and leads in multiple directions at once; every step evokes different memories of the past, perceptions of the present, and anticipations of the future and causes them to appear in uneasy copresence. There is no need in this video installation for elaborate slow-motion sequences to make the viewer slow down, to look hard and listen carefully, to rehearse perceptual patience and dispense with the pressing timetables of the everyday, to linger and drift along. There is no need to decelerate the speed of moving images here at all to make us practice the slow art of endurance and nonintentionality and thus follow the lead of the images of the female and male eye, their radical calmness and openness, as edited into Doherty's passage of images at rather unpredictable intervals.

Recent self-help discourse regularly tends to embrace slowness as a panacea for the world's ills of acceleration and forgetting: slowness appeases the mind and calms the soul; slowness reduces stress and opens our heart to the beauty of our surrounds; slowness allows us to reprioritize things that really matter and in the process find harmony and accord amid the hassles of the contemporary world.[7] Slowness, in this no doubt caricatured and exaggerated perspective, reduces complexity and eases the tensions of decision-making processes. It resynchronizes our personal itineraries, bring things down to a human scale, and in so doing situates us more firmly in the topography of our present. Slowness, in other words, is discursively constructed as a remedy putting us in touch with our own selves again by producing a heightened and unified sense of presence. It is to fortify our experience of identity by streamlining and integrating the relationships of past, present, and future.

None of this can be identified at the heart of Doherty's aesthetic of contemporary slowness. Though slowness here too is of critical importance for incorporating the past into the present, it doesn't do so in order to placate the mind and recenter our emotions. On the contrary. Slowness, as pursued by Doherty, complexifies what we call present from the start. It helps recognize the unredeemed and unsalvageable

horrors of the past as they continue to structure the experience of the present. Slowness, in fact, in Doherty, far from resynchronizing memory, perception, and anticipation, far from reducing public to personal time, explores the present in all its dissonant and jarring incommensurability. Nothing here wants to add up to a whole. Different layers of temporality, landscape and mindscape, appear in uneasy constellations. Presence emerges as a site we could hardly ever embrace as a location of identity and fulfillment. To put it emphatically, then, contemporary slowness—as exemplified in Doherty's *Ghost Story*—offers a catalyst of desynchronization: it puts the viewer beside herself and enables us to encounter the space of the present as one marked and marred by unmasterable temporal inscriptions. Slowness puts the walking and viewing subject in touch with what is other and unintentional about herself and her location in time and space. It helps explore the present as a place one cannot but fail ever to fully inhabit. Instead of serving as a great harmonizer, slowness plays an important function in revealing and commemorating the anguish of history. It excavates the sediments of grief that constitute even seemingly innocuous landscapes and, in doing so, it visualizes the trajectories of conflict, antagonism, and loss that haunt each and every historical moment. Rather than firmly situate the subject in a centered sense of place and self-presence, slowness here denies our desire ever to be in full command over our movements through and meanings of time.

Extrapolating from the particular stakes of Doherty's work on the Troubles, we might then want to define contemporary slowness as a peculiar ambition seeking to arrive in the present while being very well aware of the fact that such an arrival will always be hampered by the burdens of the past. What I call slowness, here and in the other chapters of this study, explores the present as a heterogeneous space of becoming and transformation, of ongoing flow and motion, but it also does not fail to take heed of the blockages and gaps, the fissures and loops that prevent any enthusiastic notion of fulfilled self-presence and integration. Slowness as an art of radical contemporaneity urges us to connect to the present even when we know all too well about the ultimate futility of this urge, our inability simply to leave the past's ghosts entirely behind. In this respect, contemporary slowness describes an aspiration that includes the recognition of its own failure. In contrast

to the self-absorbed advocate of mere stress relief, contemporary slowness cannot do without a certain strain of melancholia, of restraint, of mourning. As illustrated by *Ghost Story*, it is driven by the insight that we cannot fix the ruptures of the past or plaster over the cracks of the present. To redeem the past in spite of all its negativity is as little an option as redeeming ourselves from the present. To go slow, instead, is to behold—intensely, with endurance and pathos—the topography of the present as one of lack and loss, fragmentation and conflict, frustrated anticipation and painful recollection. It is to recognize the progress of time as a troubling dynamic of failure and futility, yet to insist, at the same time, that we need to keep moving and keep the ball rolling so as to avoid paralysis and prevent the past from taking over the present. Slowness, in sum, invites the viewer to look at the world like a video camera, continuously interlacing different perceptions into ever moving, unabashedly heterogeneous images of passing time and space in motion.

6 /

Which returns us to the work of Douglas Gordon, celebrated for its daring use of extreme slow-motion photography over the past decade and a half, but only in rare cases approximating the intricate dimensions of contemporary slowness I have discussed in Doherty's *Ghost Story*. However, one recent project of Gordon deserves mentioning in further detail here, as it—precisely by shunning Gordon's signature technique of slow-motion photography—pursues an aesthetic of slowness surprisingly corresponding with Doherty's work even though these projects could not be more different in subject matter and artistic strategy. The work I am thinking of, *Zidane: A 21st Century Portrait* (figure 6.2), takes us away from the painful legacy of Northern Ireland's Troubles to the contemporary world of spectator sports, resulting from a collaboration between Gordon and French artist Philippe Parreno as well as numerous highly trained cinematographers making unusual use of their high-tech equipment. Released a year prior to the first exhibition of *Ghost Story*, *Zidane* does not only have something

FIGURE 6.2. Douglas Gordon and Philippe Parreno, *Zidane: A 21st Century Portrait* (2006). Screenshots.

quite spectral about the way it organizes images and sounds. In spite of their focus on intense physicality, Gordon and Parreno—like Doherty— also do everything at their disposal to picture the now in the mode of aesthetic slowness as a site of both ongoing becoming and failure, of dispersed flow and unattainable control, of conflict and antagonism, of endurance and unredeemability.

Let's take a closer look, though, before jumping to conclusions. Or better: let's pick up the ball we dropped at the end of the last chapter, dribble with it for a little while, and see how Gordon's work can add to Doherty's notion of aesthetic slowness as an art of probing a fractured present.

During the last few decades, not one player on the international stage has arguably manifested a better sense for the unpredictable dynamic of modern soccer than Zinedine Zidane. In his role as an offensive midfielder, Zidane's virtuosity was in serving as a creative relay station—in

quickly scanning and anticipating the distribution of players on the pitch; in opening up unforeseen spaces, enabling unpredictable collaborations, and being intuitively at the right spot at exactly the right moment. Though Zidane's technical skills in controlling the ball were marvelous, what he will be remembered for is his unconditional sense of concentration and absorption: that utterly rigorous look in his eyes, never tired of envisioning possible holes in the opponents' defense that could become key for his own team's success.

On April 24, 2005, Gordon and Parreno trained seventeen cameras on Zidane during a regular La Liga match between Real Madrid and Villareal CF at Bernabéu Stadium. The parameters of Gordon and Parreno's project were simultaneously simple and utterly complex: to record Zidane's actions and interventions throughout one entire game from seventeen different angles and then retell the match's ninety minutes in real time, solely focusing on Zidane's position within and contribution to that match. Some of the most advanced camera technologies were put to work to capture desired close-ups of Zidane: his feet tipping and dragging across the grass during empty moments, profuse sweat on his neck and forehead, and, of course, Zidane's relentless stare. Some of the most accomplished cinematographers were hired to generate footage that tracked Zidane's ceaseless trajectories across the pitch, yet also—through sudden shifts in focus and imaginative pans—explore perceptual and physical interactions between player and crowd, player and teammates.

Premiered out of competition at the Cannes Film Festival in May 2006, *Zidane: A 21st Century Portrait* is likely to frustrate mainstream soccer fans, eager to learn more about their star's life and to be presented with a montage of spectacular athletic accomplishments. Not one shot in this entire film tells us anything about the star's private life or public career beyond the limits of this particular game. Gordon and Parreno's seventeen cameras frame Zidane's body so tightly that they at first seem to subtract Zidane from the game, eject him from its spatial dynamic, show him as an isolated specter on the field. But the longer we stay with the film and allow ourselves to sink into Zidane's motions, the more we come to realize that something quite different is at stake, namely the artists' effort to offer an intriguing phenomenology of what it means to participate in the spatiotemporal dynamic of

team sports such as soccer to begin with.[8] Precisely by seemingly extracting Zidane from the game, Gordon and Parreno's project emulates and illuminates soccer's inherent logic, which I—as we will see in a moment—understand to be a logic of slowness, a logic that in all its unpredictability appears quite illogical and only very infrequently produces what we all of course desire most—a goal.

As presented in Gordon and Parreno's film, the real time of soccer emerges as inherently fragmentary and multiple. Though teams can only succeed if they somehow manage to synchronize their players' path through time, each player operates according to his own clock, and each clock turns in different directions at once. *Zidane: A 21st Century Portrait* communicates this dispersed sense of temporality by completely suspending the audience's ordinary perception of play time and instead drawing us into the hero's fragmented perception. With the exception of a few shots rapidly panning across the stadium's display screens and thus giving us a glimpse of the actual clock time of the game, there is nothing in this film allowing the audience to locate the action securely within the game's prescribed ninety minutes. We see ongoing movement, but it seems strangely emancipated from how fans normally measure each action against the running down of the game clock. In Gordon and Parreno's film, time is neither a mere container of motion, nor will it ever add up to a unified whole. It instead is constituted through and energized by Zidane's own internal and multitemporal game clock, his ongoing efforts to insert himself into the game and relay the ball in ever unexpected ways. Real time here is shown not as a time of prolonged authenticity that makes us stop our breath and indulge in experiences of triumphant presence. Rather, the real time of soccer is utterly fractured, kaleidoscopic, and ultimately quite hallucinatory, something we can never measure from an external standpoint, something that could never coalesce into a singular event void of any past or future.

One of the central agendas of Gordon and Parreno's project is to picture the messiness and apparent uneventfulness of soccer as the game's most fascinating aspect. Unlike most of conventional sports coverage, which pictures the space of the field as merely a neutral frame for ceaseless motion and spectacular exertion, Gordon and Parreno explore the extent to which Zidane's shifting positions on the field, his focused

observation, his moments of hesitation, his resolute insertion into the action, as well as his effective relaying of the ball constitute what we have to consider the game's spatiality in the first place. Space here is a fickle product and process, it is not shown as something that precedes the efforts of athletic bodies, that should simply be traversed with stunning movements, and that could ever be mastered by brilliant athletes. On the contrary, space is captured as something inevitably temporal, something that compresses or expands according to how individual nodes within the network of relays interact with other nodes and become active agents of exchange and transaction. Space here is nothing one could ever own, traverse, fill, block, map, dominate, or master. Nor can we think of it in the singular, as a unified and homogenous meeting ground for twenty two players eager to secure zones of control and opportunity. The space of the game instead is shown as fractured and aggregate: a disparate array of ever changing connections that can be reconfigured through physical action and collaboration, but that no player can ever succeed in fully inhabiting and occupying.

According to Gordon and Parreno, Zidane's greatness resulted from the extent to which he was able to turn the game's logic of failure and futility into an engine of ongoing movement and action. But the film's cameras are far from picturing this greatness—Zidane's pathos, as it were, his ability to look straight into the eyes of the game's unmasterability and suffering—as a source of heroic success and personal fulfillment in front of the crowd. On the contrary, in Gordon and Parreno's relentless perspective, Zidane emerges as a player whose absorption in the game doesn't really allow us to think of him as a self-contained subject in the first place, a unified entity eager to connect with other entities on the field and enjoy such conjunctive moments with some ecstatic pleasure.[9] Repeatedly, we witness the film's cameras as they first deliberately focus in on Zidane's body, or parts thereof, and then shift their focus to the crowd in the background or the grouping of other players in Zidane's vicinity. Because of the cameras' considerable zoom and limited focal depth, this alternation of focus, on the one hand, has the tendency to picture the space of the pitch as an aggregate of virtually disconnected planes of action. On the other hand, such calculated cinematographic maneuvers tend to infuse Zidane's presence on the field with spectral qualities. Though the object of passionate identification,

Zidane's body appears elusive, in flux, constituted and dismantled in the very process of his own movements as much as the cameras' and our own acts of looking. While his face, eyes, torso, hands, knees, and feet are literally all over the screen, Zidane barely ever really seems to achieve unified bodily form. He is shown as both a fascinating presence and a phantom, as unmatched athlete and uncanny apparition. Whatever allows Zidane to absorb himself into the game at the same time also causes him to transcend, or undercut, the game's goal-oriented nature. He is constantly in search of making new connections and reshuffling the spatial distribution of his own team, but he is not shown as doing this from the position of a commanding individual, an autonomous, self-determined, and singular subject. As seen through the relentless eyes of Gordon and Parreno, the game's space of communality will never provide a home, not only because it is comprised of heterogeneous temporalities and aggregate planes of action but also because it is populated by subjects who are other to themselves and therefore forfeit whatever would allow us to see them as sovereign subjects.

Aesthetic slowness, I have argued when discussing Doherty's *Ghost Story*, reveals, recognizes, and reframes the haunting presence of the past in the hopes, not of salvaging the victims of history, but of illuminating the extent to which the space of the present is one structured by antagonism and conflict. There is certainly no lack of conflict and antagonism at work in *Zidane: A 21st Century Portrait* as well. The pitch of Bernabéu Stadium, as maneuvered by Zidane, is not a space of intentional *egos* seeking to merge with other *egos* into an ecstatic experience of community, but one of dispersed *Is* driven by their own otherness and bound to the inevitability of failure. As seen through the eyes of Gordon and Parreno, soccer at its best—like video art—emphatically pursues the art of interlacing different flows without ever seeking to achieve harmony or closure. Conflict and struggle in fact are the stuff soccer is made of. Brief moments of successful interaction and cooperation here always alternate with long periods of direct physical rivalry and intense athletic opposition, whereby Zidane's gaze constantly scopes the field to protect or expand temporary zones of dominance on the pitch. Zidane's sense of utter absorption is at once product and medium of the game's logic of adversary and unpredictability. His stare not only seeks to anticipate sudden twists of events, but is constantly engaged

in mapping out possible new constellations and coalitions amid the game's normality of disconnect and blockage. To be absorbed, for him, does not mean simply to go with the flow and therefore contemplate the game from some inner distance. Rather, it means simultaneously to read, embrace, and intensify the game's antagonist structure so as to rearticulate the relations between different nodes of action on the pitch.

If Doherty's contemplative gaze is one mapping the way in which past antagonisms and conflicts have decentered the space of the present into a haunted landscape, Zidane's absorbed stare charts the antagonism of the present in order to find footholds for future interaction that may briefly, albeit decisively, prevail over the game's overall sense of futility. Regardless of their differences, however, what both gazes share is the extent to which they offer complex reflections on time, embodiment, and movement while depicting the present as being moved by conflicting forces that resist any attempt to be cast into the unity of one single dynamic. What both share is the fact that, instead of showing the moving subject as being in full control over his action, motions, and perceptions, they explore how subjects may perceive and traverse the visual field in adverse conditions in the first place. No matter all the differences between both projects, *Ghost Story* and *Zidane* both dramatize the act of looking as a mode of facing and enduring head-on a present deeply hostile to acts of intense, hard, and prolonged looking. Interlacing attentive perceptions of space and time, both projects seek to beat the catastrophic rush of modern time at its own game and precisely thus inject what I call aesthetic slowness in this book into the very heart of what it means to be present today.

7 /

It is difficult to ignore that the speed of today's global information highways has led to a political culture ruled by the survival of the fastest.[10] The demand for and reality of instant connectivity has dramatically shrunken the space of political decision making while a virtual overflow of dispersed input is raising the frequency of and pressure on making choices by the minute, whereby possible side effects become

less and less calculable. Instant grassroots networks using communication and social network tools such as text messaging, Twitter, and Facebook have been able to mobilize mass protest within ever shorter periods of time, but the extraordinary success of such acts of mobilization in various contested parts of the world is simply also the recto to the verso of a new and extremely fickle economy of attention, one in whose context political legitimacy no longer emerges as the result of extended processes of public deliberation, but is simply measured by the rate and speed of distributed output, of speedy feedback, of Web page hits and cell phone traffic. The increased velocity of globalized politics—similar to the addictive logic of technological innovation—energizes ever more urgent calls for instant change; legitimate hopes for rapid transformations in the distribution of power, influence, and wealth have become the order of the day. Yet, as appealing and seductive as our expectations for political quick change might be, in eagerly following the accelerated streams of political, social, and economic developments across the global stage we not only often take no notice of the most pressing demands in front of our doorsteps, we also help produce a culture of forgetting, swiftly dismissing even yesterday's losses and today's failures in our anxious run for decisive newness. The space for learning from disappointment and traumatic blockage, thwarted liberation and unsuccessful change, has never been smaller and short-lived than amid our contemporary information highways. Who wants to linger with the painful defeats of the past and present if the promise of a different future, of a redemptive turn of events, baits our attention with each and every click of our computer's proverbial mouse?

Both Doherty and Gordon/Parreno define and pursue slowness as an aesthetic strategy challenging such a shrinking of temporal and spatial horizons in our contemporary lifeworlds. Their hope is not to turn our backs on the present, but, on the contrary, to inhabit it more emphatically and intensely: to recognize the present as a space of antagonism and conflict whose effects we cannot afford to ignore. Aesthetic slowness, in their perspective, is what allows the subject to face ongoing struggles without being paralyzed by these struggles' physical, psychological, or perceptual challenges. To go slow here means to explore and experience the present in all its violent or fierce multiplicity, neither

believing that any subject or action could ever really master the dispersed motions of time nor that any future present would ever be able to salvage the traumatic losses and failures of the past.

As exemplified in the video work of both Doherty and Gordon/ Parreno, aesthetic slowness must therefore be understood as something that can do much more than merely revealing hidden aspects of a perpetually changing present. As a quest for intensified contemporaneity, slowness instead pursues what is at the core of the medium of video, namely to interlace the passing of time in all its volatility into fundamentally unfixed images that invite the viewer to look hard, enduringly, with pathos and hence without desiring the future solely for the sake of annulling the present. "Presentness is grace," Michael Fried claimed in the late 1960s in his polemical critique of the theatrical elements of minimalist and conceptual art and their hostility toward objecthood.[11] More than forty years later, it appears as if the grace of becoming and being present can no longer do without a certain sense of performativity, of playfulness, of staging the self in all its fragmentation; and that, in their very effort to reevaluate the durational against the pressures of instantaneity and to reclaim sensuous encounters amid an increasingly abstract world, contemporary artists often cannot but understand this present as one populated by various ghosts and specters, by many things unseen and various narratives unheard. As it shifts our attention from video to sound art, yet expands this chapter's focus on the nexus between the slowness of walking and the operations of sight, the following chapter will provide further evidence of this.

S E V E N

T H E A R T O F
T A K I N G A S T R O L L

1 /

In one of the fragments of his *Arcades Project*, as noted in the first chapter of the present work, Walter Benjamin famously describes the habit of walking turtles on a leash as a mid-nineteenth-century method of slowing down one's pace, looking intently at urban landscapes, and presenting oneself to the gaze of others. To stroll with a turtle, around 1850, was to counteract the force of industrial speed and traffic; it was to traverse and map the modern city, not according to the abstract and accelerated tempos of urban transportation systems, but the sluggish rhythms of the human body. Turtles reminded urban subjects to use their bodies and senses as the principal measure of things. They deflected the way in which modern machines and technologies of reproduction increasingly detached human perception from the vagaries of individual embodiment, and, in so doing, these creatures reminded urban subjects to experience their own bodies—their eyes, skins, olfactory perceptions, and acoustic membranes—as the primary medium of worldly contact. Whereas the speed of urban life and capitalist modernization, in Benjamin's perspective, led to a progressive expansion of the limits of corporeality and perception, the turtle's slowness served

as a curious reminder to preserve the grounding of experience in the materiality of the human body.

Benjamin's focus on urban walking reflected a considerable interest of modernist writers and artists in strolling the city, seeking to transform the buzz of metropolitan streets into playgrounds of the imagination and relearn the art of getting lost—of productive disorientation—amid the increasing rationality and tempo of industrial modernity.[1] In his desire to wander along the boulevards of modern life, Benjamin found comrades in action among 1920s modernists such as Franz Hessel, Siegfried Kracauer, Christoph Isherwood, and Louis Aragon, but he could also look back to nineteenth-century flaneurs such as Charles Baudelaire and their hopes to extract emphatic moments of aesthetic experience from the fleeting movements of urban crowds. Reminiscent of a skillful fencer, Baudelaire embraced the art of walking as a measure to outwit the visual shocks of urban traffic and dramatically intensify his perceptual awareness; the rambler's slowness here served the purpose of anticipating and thus cushioning the distractions of metropolitan civilization. His eyes eagerly awaiting all kinds of chance encounters, Baudelaire endorsed the art of walking as a tool to remake his own body into what he, in different contexts, denigrated most polemically: a photographic camera wresting fascinating sights away from the rush of modern temporality.

Yet walking, of course, was not the exclusive invention or discovery of aesthetic modernism. It may have offered modernist artists certain subversive tactics of maneuvering industrialized space, but it certainly had a history much older and widespread than the one predominantly associated with the figure of the urban flaneur. Friedrich Nietzsche, for instance, found great recreational pleasure in carrying out solitary walks, turning the rhythms of his steps into powerful engines of his poetic and polemical mind. Immanuel Kant was known to stride rigorously through the streets of Königsberg, not in order to indulge himself with visual distractions, but to strengthen his body for the demanding strictness of his intellectual life. Last but not least, Jean-Jacques Rousseau sought to walk whenever possible, emphasizing the interconnectedness of thinking and walking, of developing complex ideas and traversing natural landscapes. "Never did I think so much," he wrote in his *Confessions,*

exist so vividly, and experience so much, never have I have been so much myself—if I may use that expression—as in journeys I have taken alone and on foot. There is something about walking which stimulates and enlivens my thought. . . . The sight of the countryside, the succession of pleasant views, the open air, a sound appetite, and the good health I gain by walking, the easy atmosphere of an inn, the absence of everything that makes me feel my dependence, of everything that recalls me to my situation—all these serve to free my spirit, to lend greater boldness to my thinking, so that I can combine them, select them, and make them mine as I will, without fear or restraint.[2]

Whereas modernists such as Baudelaire and Benjamin stressed the urban walker's ability to collect fragmented impressions from the disruptive spaces of industrial society, for Rousseau the slow art of walking endows the walking subject with a sense of spatial and temporal continuity—a sense of perceptual coherence amid ever changing sceneries, which in Rousseau's view at once defines the ground and allegorizes the process of thinking. Walking provides the royal road to thought and reflection. Its deliberate, measured, and unhurried pace emplaces the body in its physical surrounding as much as it situates mental activities within their corporeal base. Walking integrates into the unity of one single dynamic what Cartesian philosophy sought to separate: mind and matter. I walk and therefore I think and am, Rousseau seems to say in order to correct Descartes's infamous dictum and in this way also to reveal the apparent differences between his preindustrial and Benjamin's industrial pleasures of walking. For, contrary to the later generation of urban flaneurs and their distracted ecstasy, Rousseau considers walking a practice not only defining thought and perception as deeply embodied, but situating the human sensorium as a reliable compass for the relationships of space and time. To go slow, for Rousseau, meant to locate one's own self strongly and reliably in the geography of time, whereas urban strollers such as Baudelaire and Benjamin endorsed slow walking as a means to launch the modern disintegration of place and tradition against the confines of the bourgeois subject itself—against the vision of the sovereign individual as the cognitive and sensorial center of the world. Walking, in Rousseau (and Nietzsche and Kant), triggered and energized thinking. In Baudelaire

and Benjamin, by contrast, the act of walking helped to unthink the foundation of bourgeois society, playing out moments of nonidentity and nonbeing against the modern demands of steadfast identity, teleological becoming, and instrumental rationality—I walk and therefore I no longer am.

And, yet, wouldn't it be foolish to dismiss Rousseau's advocacy of walking as a typical expression of romantic antimodernism, a retrograde form of fundamentalism anticipating nothing less than the agendas of contemporary hardcore back-to-nature ecologists? Walking, according to Rousseau, emboldens his thought and therefore his notion of self because it emancipates the walker from "everything that recalls me to my situation."[3] But what exactly does this mean? And how does it communicate with Benjamin's later thoughts on walking and the rather diminished status of walking in our own hypermobile society of global connections and virtualized transport?

Rousseau's walking, as Rebecca Solnit has written, offers a means of productively modulating one's sense of alienation. To walk means to extend mind and body through slow physical movement beyond its given limits. It displaces the fixity of things and, in a controlled manner, relinquishes some control over one's perceptions, sensations, and thoughts. "A solitary walker," Solnit suggests, "however short his or her route, is unsettled, between places, drawn forth into action by desire and lack, having the detachment of the traveler rather than the tires of the worker, the dweller, the member of a group."[4] Whenever we walk we engage in an ongoing process of defining some meaningful, albeit highly unstable, sense of here amid the impressions of continually passing theres. Rather than cultivate intensified forms of forward, frontal, and primarily anticipatory visuality, walkers are free to develop what I would like to call lateral modes of embodied looking. Their act of mobile viewing can stretch out sideways or even backward as much as it, by necessity, is held to look onward. No need to focus one's eyes solely on what challenge to master next. No need to fret about how each step effectively prolongs the last one into the future. The walker's eyes might often dash ahead to some goal in the far distance, but the physical aspects of mobility constantly also remind the observer of the complex spatial and temporal relationships that make perception possible in the first place. As a wanderer between places,

the walker experiences the walk as an ongoing questioning of what phenomenologists call proprioception (the awareness of our body's position and boundaries in space) due to the power of kinesthetic transformation (the sensation of body movement). While the walker's delight in the impression of an ever changing world might be a sole result of his own bodily movement, the act of walking nevertheless asks us constantly to test the extensions of our sensory organs in relationship to the world—to project ourselves step by step, yet ever differently, into space (forward, sideways, or backward) so as to produce virtual body images that enable us to map the world around us and traverse its geography. Walkers dwell in mobile gestures of nondwelling. They probe the fixity of both their environments and the limits of their own bodies, thus distancing themselves from what Rousseau considered the stultifying burdens of his "situation." To walk is to quest for structures of detachment without detaching vision from the materiality, motion, and measures of the body. It is to transform the moving body into a vibrant medium of perception; to expose oneself to some form of self-alienation, of unsettledness, in the hope of intensifying one's experience and recuperating forgotten relays between sight and the other senses. Strolling defines walkers as strangers to themselves. It slows down the pace of life, allowing us to explore what restricts and dissolves our authority over not only the perceptual field but our own bodies.

Rousseau, then, is certainly not a Baudelaire or Benjamin. But in his desire to detach himself from his "situation," in his aspiration to expand the perceptual field and indulge in lateral, mobile, and embodied views, he clearly anticipates the flaneurs' urban aesthetics of slowness. To go slow, for all three of these poetic philosophers, is to suspend modernity's dual regime of linear, teleological, goal oriented time and of perspectival, framed, abstract space. It situates the perceiving body, in all its flux and fickleness, within an unstable field of perceptions, thereby allowing the walking subject to probe the very limits of her sensory systems—the way in which our various organs interface with their surrounds—and to perceive the world as one structured by open-ended potentialities and principally unpredictable relationships. Walking, for them, produces impressions of space that are specially sensitive to the unsynchronized transformations and actions that may unfold within it. Space, in these walker's ever shifting perspectives, is no longer

to be considered as fixed and homogeneous—as a possible container for abstract grids and geometric divisions, as a void of time, narrative, and memory. Walking instead reveals what is animated and temporal about space in the first place. It enables the strolling subject to experience space, in Elizabeth Grosz's words, as "emergence and eruption, oriented not to the ordered, the controlled, the static, but to the event, to movement or action."[5] Rousseau may have scolded at the artificial pleasures of metropolitan life, but what he shares with Baudelaire's and Benjamin's vision of nineteenth- and twentieth-century flanerie is nothing other than the desire to slow down one's step because, in so doing, one may be able to encounter spatial surrounds as sources of potential shudder, surprise, and rapture—of aesthetic experience in its most emphatic sense.

In this chapter I explore certain continuities and discontinuities between the romantic and modernist art of taking a slow stroll, on the one hand, and, on the other, the curious prominence of pedestrian mobility in twenty-first century aesthetic practice. To be sure, nothing today seems to be more outlandish than the idea of taking a walk. While, day by day, hoards of power walkers fill the streets or suburban shopping malls during early morning hours, and while huge industries devote considerable effort to sell high-tech walking gear, it is difficult to make out those leisurely subjects, those slow gatherers of fleeting impressions, that occupied Rousseau's, Baudelaire's, and Benjamin's imagination. Though cities and museums worldwide today offer ever more guided walking tours and park management departments divest considerable energy to carve out pockets for pleasurable ambling, walking at its best may count as the province either of the educated elite eager to indulge in temporarily relinquishing their access to advanced transportation technologies or of exasperated office workers who are in dire need of a good, albeit not too strenuous, cardiovascular workout. At its worst, urban or suburban walking figures as the primary realm of the impoverished, disadvantaged, and the oddballs, with private safety guards kicking into action once unidentifiable subjects trespass gated grounds. Walking today, in most of its instantiations, has little to do with practices of drift and getting lost. Instead, it has assumed the very instrumentality and goal orientedness, the very privileging of trajectory over

chance, the forward over the lateral, the structured over the open, so loathed by earlier generations of walking poets and philosophers. For most people in the postindustrial West, to walk means to reckon with the fact that we have increasingly managed to eliminate undefined spaces of play, potentiality, and ambivalence. Rather than detaching us from our "situation," walking today often entices the walker to carry her situation along, be it in form of mobile communication and entertainment devices, be it in form of the ticking of our watches that remind us of our next appointment, be it in form of versatile positioning or surveillance systems tracking our each and every step.

Reframing the discussion of both Peter Weir's cinematic walkabouts and Willie Doherty's passage through troubled landscapes, the focus of this chapter is on the role of walking in the work of Canadian artist Janet Cardiff. Cardiff makes a strong case for the art of walking and its aesthetics of slowness, not only because she allows us to experience an often disorienting coupling of motion and perception and a concomitant layering of different temporal logics but also because her work does not shy away to embrace advanced technologies to detach the walking subject from the exigencies of everyday speed and structure. Walking, in Cardiff's work, is everything but a mere nostalgic yearning for bygone times and pleasures. On the contrary, in its very effort to intermix different temporal registers and histories, this work asks us to rethink what we have come to assume as the difference between new and old, progressive and regressive, modern and not modern, contemporary and passé in the first place. Cardiff clearly continuous Rousseau's, Baudelaire's, and Benjamin's tradition of flanerie. Her aim is to use the experience of physical motion and spatial passage to derail the habitual and open our perceptions toward the contingent and unexpected. What is most interesting about her work, however, is how Cardiff systematically employs the power of sound and acoustic perception in order to detach us from our "situation," to make us break away from a long tradition of frontal opticality and thus to reinscribe the flaneur's and wanderer's embodied intermingling of the virtual and the actual. Cardiff's aesthetic of slowness, her simultaneous effort to lodge perception in the materiality of the moving body and to disperse the vectors of linear time, is unthinkable without her interest in

technological manipulation of sound and listening. It is to how Cardiff uses sound to guide walkers through highly unsettled spaces and thus expand the limits of our senses that I turn my attention in the following pages.

2 /

Since the early 1990s Janet Cardiff's experiments with sound have situated her as one of the most interesting artists today seeking to release both the aesthetic and the virtual from its dominant association with the visual (figure 7.1). Cardiff is mostly known for her audio walks: binaural recordings engaging with local geographies that layer fragmented story elements and musical excerpts, on-location sounds and diverse sound effects into one hybrid soundtrack; invisible artwork meant to be heard with earphones while following the steps of Cardiff's recording procedure through cities such as New York, Münster, and London or museums such as MoMa or the Louisiana Museum in Denmark; art mimicking the ever more popular audio tour guides for art museums or urban tourist destinations, yet here confronting the listener with unsettled soundscapes that resist easy consumption, orientation, and clear directionality. The critical prominence of Cardiff's walks, often produced in collaboration with her partner George Bures Miller, should not distract us from the fact, however, that some of her other work—installations such as *The Killing Machine* (2007), *Road Trip* (2004), and *The Paradise Institute* (2001)—have pushed the role of the acoustic in contemporary art toward new experimental frontiers, precisely because these installations—similar to the walks—make us experience sound as a membrane decelerating our itineraries while connecting (and dissociating) body and environment, representation and perception, motion and affect, the virtual and the actual. In particular her 2001 installation *Forty Part Motet* will be of interest in a later section of this chapter, a work in which Cardiff placed forty speakers in a circle, with each speaker playing a recording of one voice of Thomas Tallis's sixteenth-century oratorio *Spem in alium*.

"Hello, do you hear me?" we hear Cardiff at the very beginning of her Louisiana Museum walk of 1996, her voice gently addressing the

FIGURE 7.1. Janet Cardiff at Work: *Jena Walk (Memory Field)* (2006). Audio walk. Commissioned by the Culture Department of the City of Jena, Germany. Courtesy of the artist and Luhring Augustine, New York.

listener, addressing "me" as the sole recipient of her work. "I want you to walk with me through the garden. Let's go outside." We hear steps traversing what sounds like a hardwood floor. We hear a door opening in front of us with a light squeak. Within seconds, the serene intimacy of Cardiff's voice has managed to make us want to align our own body movements and perceptions with the binaural sounds enveloping our ears. The essential question, of course, is not whether or not we can merely hear Cardiff's voice in these first seconds of her walk, whose opening resembles the opening of most of her other works in this genre. The decisive question, instead, is how long it might take before we allow ourselves to give up our resistance to be in her and our own world simultaneously, to walk our own body according to her measured pace and not feel entirely split into perceptual fragments. Two elements are of central importance to facilitate this process and make our initial entry into the world of the audio walk as smooth and effective as possible. The first has to do with the subdued eroticism and modulation of Cardiff's voice, the way in which this seemingly disembodied voice seems to address us directly, as if being right next to our ear or all around us;

as if bestowing us with some extraordinary form of proximity, trust, and openness; as if we had or should have never listened to voices other than this one. Here's how Madeleine Grynsztein has described her response to Cardiff's peculiar mode of address: "It's got this sort of Lauren Bacall resonance to it that's simply unforgettable and that gets under your skin. . . . It's seductive but creepy, too; in other words, it draws you in, but you know it's not good for you. It completely seduces you and absorbs you and compels you to go with her: I mean she hardly needs to say follow me, you would follow that voice almost anywhere. When she's acting, you know she's dangerous; her voice is a real element of danger, you know you're not safe, she says you're safe but you're not."[6] Recorded with the help of binaural technology, which for the listener creates hyperreal impressions of acoustic texture, position, directionality, and spatial depth, Cardiff's voice in the opening of each of her walks literally sweeps us off our feet. It urges us to suspend disbelief, to take on the danger of living in her world and moving in our own simultaneously, thus opening ourselves to the power of affect in its most basic understanding, namely the power to be moved, to move from one experiential state of the body to another, before certain classificatory languages and cultural codes interpret and label these states as what we then call a specific feeling or emotion.[7]

The second element important to us being pulled into Cardiff's worlds concerns the power of physical motion itself. "Let's walk down the stairs," Cardiff continues, at the beginning of her Louisiana walk. "Try to walk to the sound of my footsteps so that we can stay together . . . Do you hear the waves? . . . It's beautiful here." Cardiff's invitation, at the beginning of each of her walks, is not simply to listen to her, follow her instructions, and allow ourselves to be pointed by her voice toward things seen or unseen. Rather, it is to take on her very process of perception, memorization, and anticipation. It is to immerse ourselves acoustically into what she sees, hears, remembers, dreams, desires, and imagines without shutting down the operations of our own sensorium— our own perceptions, memories, dreams, and desires, our own sense of presence. The physical mobility of walking is of critical importance to this merging of perceptual registers, for it is the experience of our own body in motion that here enables us to open up to the possibility of

expanding the boundaries of ourselves and remap our bodies' and minds' relationship to the spaces around us. Far from simply being encouraged to exchange our identity and perceptual processes with those performed for us on Cardiff's soundtracks, we become aware of the extent to which perceptual awareness is embedded in often messy or ambivalent processes of bodily locomotion, in kinesthetic activity. What enables Cardiff to pull us effectively into her mobile perspective and perception is nothing other than her appeal to how bodily motion and location structure our perspective and perception to begin with, how physical mobility is essential in the interplay of memory, presence, and anticipation that is associated with each and every act of perception.

When Cardiff, in the first half of the 1990s, began to experiment with the idea of creating audio walks, she could look back to a more recent tradition turning the slow practice of walking into an artistic medium in its own rights.[8] No doubt the work of British artists Richard Long and Hamish Fulton stood out in this respect, both of them translating old British conventions of roaming the landscape into a viable mode of artistic production. In works such as *Line Made by Walking* (1967), Long's interest in finding new ways of mapping the paths by which he traversed various countrysides became the clearest. His work was dedicated to track the traces, visible or invisible, left by the walk itself; to document how the artist, in walking across various landscapes, had inscribed himself into the territory while at the same time becoming ever more sensitive to the various spatial markers and temporal pointers hidden in most ordinary geographical settings. Though Fulton's work shared many aspects with Long's, it has been less dedicated to producing "work" and more focused on rendering the very act of walking as an affective conduit to aesthetic experience and spiritual transcendence. Galleries and museums were no longer the final destination of Fulton's rites of passage and peripatetic encounter. Instead, Fulton's project was to emphasize the open process of walking itself, the very absence of what we call destination, the challenge of a direct engagement with the physical landscape and the myths, legends, and stories invested into it by various native populations.

Cardiff's work since the mid-1990s recalls some aspects of the interventions of conceptual walking artists such as Long and Fulton, but

in the end it does not really come as a surprise that most critics, due to Cardiff's pronounced interest in sound technology and mediation, pursue other avenues to make sense of our experience of her sound-tracks. Rather than juxtaposing Cardiff's walks with Long's and Fulton's conceptual and often austere exercises, critics tend to discuss the experience of Cardiff's works as a curious recalibration of the experience of film viewing—as a variation of the cinematic. Time and again we get drawn into complex narratives, often intermeshed with film noir story elements, sinister plotlines, and dramatic suspensions. Fragmented musical soundtracks evoke tension-ridden atmospheres, affects, and emotions. Guided by Cardiff's voice and the ongoing sound of her footsteps, we engage in the pleasure of moving images, just that these images—contrary to the tenets of 1970s apparatus theory—do not interpellate a fundamentally passive and regressive spectator, but instead are being animated and brought into motion by the moving viewer.

And yet the comparison of Cardiff's walks with filmic viewing in the end is perhaps more misleading than productive. Witness what happens next in the Louisiana walk. As Cardiff leads us into the museum's garden, a male voice will suddenly whisper into our left ear while we hear a helicopter going by overhead: "He'll meet you by the beach wearing a black suit," the voice pronounces secretively, as if trying to draw us into a B spy thriller, before Cardiff's voice continues to tell us that "I wanted to bring you here because I think that something strange has happened to me walking along this path. I've seen and heard things I don't understand." The resulting effect for the listener is, to say the least, disorienting and decentering. Our head may jerk up, but our eyes in all likelihood will fail to see a helicopter passing by. We may suddenly find ourselves on the lookout for some threatening individual somewhere close to us, yet either find only blank space or project hostile feelings onto innocuous pedestrians. More important for now, however, is the fact that Cardiff's layering of different voices, sound effects, and narrative temporalities situates the users in what cannot be experienced other than as a fragmented and fundamentally desynchronized multiplicity of different presents and pasts, of temporal vectors and trajectories. Unlike the filmic interface, whose time-

based representation, projected frontality, and spatial perspectivalism are often understood as central tributaries toward the emergence of new media,[9] Cardiff's use of sound resists any sense of temporal linearity, sequentiality, and chronology. Rather than absorb the viewer's temporal experience into some apparatus's rhythm, itinerary, and narrative forward drive, the binaural interface in Cardiff's work instead allows us the at once disturbing and exhilarating sensation of what this book considers the aesthetic of slowness: the copresence of incommensurable memories, narratives, and temporal dynamics. Rather than simply trying to hand over the element of movement in the experience of "motion pictures" to the viewer himself, Cardiff's audio walks create experiences whose defiance of frontality and forwardness run counter to and displace cinema's ability to affect the viewer's perception with temporal passage and dynamic space.

"Sound and space," writes Brandon LaBelle, "are inextricably connected, interlocked in a dynamic through which each performs the other, bringing aurality into spatiality and space into aural definition. This plays out in acoustic occurrence whereby sound sets into relief the properties of a given space, its materiality and characteristic, through reverberation and reflection, and, in turn, these characteristics affect the given sound and how it is heard."[10] Sound, LaBelle argues, is simultaneously boundless and site specific. It overflows defined spatial borders and pushes against the fixities of architecture, yet at the same time it cannot do without some material presence, some navigational dynamic emerging from, echoing through, and being bound to some very specific location. Sound brings to the fore the complexity of what it might mean to be in and perceive space in all its temporality and flux. It at once emerges from and transcends given rooms, it establishes and disrupts lines of connection, it "expands and contracts space by accumulating reverberation, relocating place beyond itself, carrying it in its wave, and inhabiting always more than one place; it misplaces and displaces."[11] Sound, precisely in drawing our attention to the dynamic and relational nature of space, stresses the fact that we cannot think space independently of temporality, as much as it, in all its apparent immateriality, reminds us of the conundrums of embodiment and embodied perception. Sound underscores that our bodies do not merely

operate as neutral receivers of preexisting percepts, but are dynami-
cally emplaced in the very landscape of possible impressions—that we,
with some skill, can each hear our own body hearing, because this body
is deeply embedded in the very materiality that is brought into relief by
the acoustic.

Janet Cardiff's audio walks are exemplary conduits to making our
bodies sense their own hearing. The technique of binaural recording,
in all of her works, complicates or even displaces ordinary routines of
detached, frontal looking and instead encourages the listener/viewer/
walker to direct her perception laterally and thus become emplaced in
various topographies and temporal horizons at once. As we listen to
helicopters passing by overhead and adjust our bodily postures and
movements accordingly, we cannot but be engaged in what LaBelle
considers the principal duality of sound, namely its site specificity and
its relative defiance of spatial fixity. In this way, Cardiff's aesthetics of
slowness sharpens our awareness not only for the fluidity and temporal
index of the material world but also for the fickleness, the contingency,
the unsteadiness of the perceiving body. In the scene described earlier,
the listener clearly experiences a moment of intensified presence—an
unrepeatable here and now, performed for our ears, reverberating
through and impacting on each fiber of our physical bodies. The close
passing of the helicopter puts our bodies and minds on alert. It chal-
lenges our sense of the integrity of corporeal boundaries. It causes im-
mediate sensorimotor responses as we may look for shelter, duck down,
or seek to move our bodies out of harm's way. And yet, rather than
laugh about our own hysteria when finally looking up and not seeing
any helicopter whatsoever, we move on deeply disturbed about what we
call our bodies and their presence in space and time. In Cardiff's work,
the experience of presence and embodied perception doesn't confine the
walker to the materiality of space and the bounds of her identity. On
the contrary, presence is what allows the walker to touch upon the
inconclusiveness and flux of his own body image. It places us in various
actual and virtual worlds at once and in this way allows us, with our
very haptic body, to sense and navigate acute contractions, expansions,
and multiplications of space. The body of Cardiff's walker is one that
gains little comfort or security about recognizing the extent to which
sight and hearing are lodged in the vagaries of corporeality. To acknowl-

edge the embodiment of perception here doesn't mean to (re)connect smoothly to one's physical surroundings. Instead, it means to accede to the fact that nothing about the perceiving body, nor about what this body might perceive, can be taken for granted and is made to last. Presence in Cardiff is what reveals our own ongoing nonpresence, our vulnerability, the sense of nonbeing that resides underneath the most intensified experience of embodiment. Presence and embodiment in Cardiff bring to the fore the essential unpredictability of all spatial relationships: of the space around us, the space of our own bodies, and the surfaces that connect and separate both.

It is interesting to note, in this context, that Cardiff, in her effort simultaneously to emplace and displace the walker's haptic body, makes use of various registers of recording voices within her audio walks. No minute will pass without her modulating her own voice and changing its tone, pitch, and intensity, at times speaking to us with great intimacy, at others addressing us as if being in the middle of a dream or with considerable reserve and distance. Repeatedly, she also inserts fragmented story elements into the audio walk that are centered around other recordings and sound transmissions: a sudden phone call, a found tape recording, a lost audio document. In so doing, Cardiff creates an ever greater multiplicity of voices for the walker, whereby many of these additional roles are regularly performed by George Bures Miller. What is essential about this multiplication of voices, however, is not only a curious accretion of unconnected temporal layers and memories within the space of the present (about which I will have to say more later in this chapter) but also Cardiff's play with the effect of technological storage and reproduction onto the very materiality of the human voice—its grain, its body, its resonance.

Consider how Don Ihde describes the experience of hearing our own voices on tape and thus hearing ourselves as others hear us: "When I speak, if I attend to the entire bodily sense of speaking, I feel my voice resonate throughout at least the upper part of my body. I feel my whole head 'sounding' in what I take to be sonorousness. This self-resonance that I take for granted does not appear on the tape, and I am initially surprised at the 'thinness' and the 'higher tone' my voice has on the recording."[12] While, for Ihde, the consideration of technological mediation is important for revealing the extent to which the hearing of our

own voice is categorically different from the hearing of any other voice, his description is of no less importance in understanding the dynamic of vocal register and layered reverberation in Cardiff's walks as well. To listen and walk to Cardiff's many voices is to undergo an at once seductive and perplexing disorientation about resonance, that is, the way in which the sheer materiality of the voice locates the speaker and listener in space. What is seductive and intimate in Cardiff's voice seems to speak directly to and from our body, and yet in spite of all its immediacy and directness this implanted voice of course misses the sonorousness Ihde considers essential for the experience of hearing our own voice. We don't feel Cardiff's voice resonating through our own chest or bone, no matter how much it succeeds in achieving closeness and prompting us to move our bodies forward. Whenever Cardiff's audio walks cut to diegetic sound recordings, she simply amplifies this curious experience of bodily disconnect, of intimacy and distance. When we hear Miller's voice on tape within the tape, we may feel transported to yet another time and space, but we don't really feel as if we now witnessed a voice of greater thinness, of less resonance, of less spatial gravity, than Cardiff's voice itself. Whatever their level of technological manipulation, the various voices in Cardiff's audio walks serve as media of ongoing displacement and ungrounding. Rather than encouraging the walker to lament a loss of authenticity and spatial mooring, the technological mediation of vocal resonance and sound in Cardiff thus reveals the extent to which our place in space is always precarious simply because we neither own and master what is around us nor our own very bodies. As we, without hesitation, follow Cardiff's voice for a walk, we quickly learn not to take anything for granted anymore about the relation of sound and space, vocal resonance and spatial certainty. We may ascribe vocal thickness to Cardiff's voices in spite of their actual absence; we may feel proximity to them no matter how far and old they might be. But, all told, what we experience is nothing other than the fact that both sound and space are utterly contingent, at once energizing and being energized by the very movements of our haptic bodies. What we learn is that our bodies don't precede mediation and that we, therefore, can never succeed in securely anchoring them in and administering mastery over space. What we can learn is

that everything could be fundamentally different from how it is and has been.

Space in Cardiff, then, never comes in the singular. To listen and walk is not simply to temporalize space but to touch upon it with our entire sensorium and thus experience what is temporal and multiple about space. It is to become receptive to the heterogeneous, unsettled, and intertwined nature of both the space we perceive and the space of the perceiving body. Unlike classical narrative cinema, Cardiff provides perceptions of movement that radically elude any sense of closure and plenitude; we cannot but remain suspended. Her voices get under our skin, touch us viscerally, but much of this concerns invisible rather than visible matter; it emerges from the unseen rather than from cinema's presentation of movement and time images. And, unlike walking artists such as Long and Fulton, whose work so productively pursues strategies of mapping the world aesthetically, Cardiff employs the medium of the walk and its aesthetics of slowness in order to explore the at once disorientating and liberating unmappability of space—space's refusal to be transformed into something static, be it text, image, or any other form of representation. It is to this link between the slowness of walking and the unmappable that we now turn.

3 /

Nothing is perhaps a more overused cliché than the one describing time, life, and human consciousness as a river, slowly but ineluctably flowing toward its final destination. It is often engaged with good intentions: to express the fluidity, historicity, and transformative nature of all matter. But in the end, the metaphor, in most of its uses, comes with heavier baggage, as it suggests a certain automatism of change, a uniform and hence predetermined progress or unfolding of something from its origin to end. Things might constantly undergo change, but change itself is preprogrammed, no alternative paths can be taken, no real surprises and sudden inversions will happen—fluidity as fate.

In the history of ideas, it was of course the work of Albert Einstein—his emphasis on the conundrums of space-time, his critique of Newtonian

notions of absolute time, his stress on temporal simultaneity and relativity—that should have infinitely complicated this metaphor. Einstein's groundbreaking intervention was to think of the river of time as one flowing with varying speeds and differential currents, one with eddies on one side and rapids on the other, one whose velocity would depend on whether you traveled on the water or observed its traveling from the river's banks. But Newton's notion of time as a unified river streaming through the fixity of space has proven to enjoy astonishing longevity, even in our post-Einsteinian universe. Though today, instead of speaking about rivers and water, we may refer to the bandwidth of electronic flows or the traffic density of metropolitan highways, assumptions about the uniformity and unified directionality of time, fluidity, movement, and change still hold great attraction.

There is no need to read Einstein in order to recognize the extent to which Cardiff's work, by threading different narratives into her soundtracks and by surrounding the walker with a multiplicity of different memories, observations, and anticipations, seeks to upset Newtonian certainties. "As on the soundtracks," Cardiff has articulated in an interview, "there is something interesting that happens when I relate my memories, they become immediate for the listener. For me, they'll always be past, but for the listener, they are part of the present. I'm interested in working with time in this way, flip-flopping between past and present, using memory and bringing it into the present."[13] Like Einstein, Cardiff's focus is on the whirlpools, the vortices, the inversions and differential speeds of our passage through time and space. It is on how each present contains a simultaneity of different pasts and future anticipations, such that it becomes virtually impossible to map this present conclusively from some external point of view, such that even our unconditional willingness to follow her steps and "go with the flow" might not really propel us forward in time or space in any conventional sense.

Nowhere does this perhaps become clearer than in Cardiff's 2000 walk *A Large Slow River*, commissioned by the Oakville Galleries and set in at Gairloch Gardens in Ontario, Canada, a spectacular eleven-acre site right at the shore of Lake Ontario. The walk begins inside the galleries, Cardiff's voice describing what appears to be a scene of destruction and disarray, not an inspiring exhibition venue. We then follow Cardiff out into the open for a walk through the gallery's gardens.

She describes the scenery: plants, flowers, the lakeside, waves hitting the shore. She imparts often fragmented parts of memories, dreams, and reflections, at times with greater, at other times with lesser intimacy. A second voice will eventually emerge from the soundtrack, the recorded voice of George Bures Miller, speaking with both great urgency and mystery, drawing our attention to some kind of film noirish wartime past whose narrative dimensions remain unclear and unresolved. There are long stretches where both voices seem to inhabit parallel universes. At other moments, however, they—to our utter surprise—do connect, speak to each other across whatever may actually divide them spatially and temporally. All kinds of sound effects add to our sense of mystery, our traversing of various pasts and presents, our witnessing of how recollection and presentness here form one hybrid imaginary, as unfixable as the waves washing up on the shore. We hear, among other things, an organ-grinder, opera singers, children's voices, sirens, animals, gunshots, and, once again, the unavoidable helicopter, some of these sounds being associated with Cardiff's, some with Miller's diegetic world, some clearly crossing the boundary between both and intermeshing into what becomes a highly dislocating acoustic experience for the walker. As it turns out toward the end of the walk, the protagonist's search was for some nameless man whose tape recording she had found at an earlier moment in these gardens—a tape that, like a message in a bottle, sought to speak from a present past to an unknown future. There are so many things we forget, Cardiff reflects at some point toward the end of the walk, "It's like being under water for most of our lives and we only come up for air every once in a while." This reflection precedes a moody recollection of having once taken a picture of a young couple in these gardens, an event she only remembers because a video was shot which she saw at a later point in time. "Time travels around me like a large slow river," Miller's voice (as recorded on tape) appropriately describes the inconclusive confluence of different memories and recollections in this walk, to which his voice—again speaking to us from the found tape—adds during the final minutes of the walk: "Einstein said time is like a river. It doesn't move with the same speed everywhere."

Time, not just in Einstein's river, but when following Cardiff's steps through Gairloch Gardens, indeed flows with different speeds, and it is

Cardiff's astonishing ability to make the walker receptive to the dynamic of these incommensurable velocities that is at the center of what I understand to be her work's aesthetics of slowness. The sight and sound of water, as perceived and described by the pedestrian observer, plays a critical role in *A Large Slow River* in order to communicate this idea of a differential logic of movement and hence the absence of absolute time. And yet what is decisive about the image of water in this particular walk is the fact that Cardiff, time and again, invokes the proximal sense of touch, rather than the distantiating ones of seeing and hearing, to articulate the unresolved copresence of heterogeneous times within the space of the present: "I'm at a beach on Lake Huron," Cardiff ruminates once, evoking a series of highly affective recollection images. "My toes squishing into the mud, feeling them disappear deeper as each wave washes over them, jumping off my father's wet shoulders into the water. Now I'm at another beach, it's night, the sound of the waves coming in through the screen windows." Memory enters Cardiff's splintered narratives less as something that was once experienced at the optical level. Rather, it emerges and is being communicated to the listening walker as a tactile or haptic image: toes touching the mud, the felt wetness of her father's shoulders, sound waves piercing the framing power of a window and making physical contact with the sleeper's ear.

In a different context, Laura Marks has argued that haptic visuality, as contrasted to optical visuality, stresses the surface and textures of certain objects, encouraging contemplative suspension rather than desires for narrative progression. Haptic visuality rests on bodily relationships between viewer and images that circumvent optical visuality's stress on abstraction, distance, and mastery. It privileges affect over effect, interpretation, and (e)motion. As Marks writes: "Haptic looking tends to move over the surface of its object rather than to plunge into illusionistic depth, not to distinguish form so much as to discern texture. It is more inclined to move than to focus, more inclined to graze than to gaze."[14]

Cardiff's immersion into the multicurrent river of time abounds with such scenes of haptic looking, with recollections of a past in which experiences of physical contact led Cardiff to graze rather than gaze, to register material surfaces rather than administer visual focus

and abstract distantiation. The resulting effect for the listener of Cardiff's walk is no doubt unsettling, not only because Cardiff's stress on tactile memory tends to derail the very narrative we desire to make sense of the different stories that haunt Cardiff's soundtracks but also because the pull of Cardiff's voice makes us want to take on Cardiff's haptic sensations ourselves, thus undergoing what Roger Caillois would call psychasthenia, namely a profound sense of depersonalization caused by our temporary inability to situate our bodies reliably in space.[15] Paradoxical as it may seem, it is Cardiff's very emphasis on haptic memory that, for the walker-listener, produces the most intense challenge to integrate body and subjectivity, place and perception. For Cardiff's walkers do not simply hear other voices inside their heads, they also start to assimilate to someone else's feeling or to wear the corporeal experience of other spaces and times on their own bodies. As a result, we may know precisely where we are, and yet we—like Caillois's patients—cannot but fail to locate and ascertain the exact subject inhabiting the spot at which we are, nor do we really know the "when" of this inhabitation. The haptic copresence of different memories and fragmented stories in Cardiff's audio walks in this way yields, less to a sense of schizophrenic dismemberment, than to a simultaneous experience of spatiotemporal shrinkage and expansion, a grazing of inner and outer impressions that meshes the actual and the virtual. We feel Cardiff's voice getting under our skin, as much as we feel the boundaries of our skin being opened, prompting us to sense ourselves from various spatial and temporal points of view. We become space, and yet we feel that space has no certainties to offer due to its inherent flux and becoming, its ineluctably temporal nature, the instability of memory. Our toes start to play with the mud of Lake Huron, even though we know all too well that our eyes rest on Lake Ontario's pebbly beach.

There are, of course, good reasons to argue that the acoustic knows of no viable distinction between the actual and the virtual. Though I wish I could hear the sound of voices, musical performances, and acoustical atmospheres from the past, in the end all we can really hear is a product of actual vibrations, the compression of air molecules first bumping into other molecules and finally bumping onto our tympanic membrane, the ear drum. Precisely because we are unable to shut our ears and filter out all external stimulation, the range of hearing imagined,

nonpresent vibrations appears rather limited. And yet it is nothing other than the meshing of actual and virtual dimensions that defines the core of Cardiff's work and how it, with the help of advanced sound technology, rearticulates the nineteenth-century flaneur's rejection of urban speed and homogeneous, trajectorial space. Whereas the experience of speed, in modernist aesthetic practice, often led either to a violent explosion or a regressive hardening of bodily boundaries, in Cardiff's work the slowness of the walk becomes a medium to playfully probe the extensions of the body in space and time without fearing factual disintegration or surrender. As Cardiff intermingles the virtual and the actual and thus encourages us to experience with our own moving bodies the weight of various other spaces and times, our enactment of psychasthenia here becomes an invitation to resuscitate the lost dimensions of our mimetic faculty—that is, a form of sensuous knowledge that results from yielding to rather than seeking to control the objective world around us—a form of knowing that rests on the gift of sensing similarities between dissimilar entities while seeking to relax, rather than explode or harden, the boundaries between subject and object.[16] Slowness allows the haptic to stand up against the modern privileging of the optical. It is what enables the perceiving subject to sense the differential speeds that structure our environments without assuming abstract postures of distantiation or feeling torn asunder by their force. To go slow, in Cardiff, means to recuperate our ability and desire to be and become other, to make contact with the differential river of time, to complicate the work of our eyes and temporarily suspend dominant modes of controlling space from sovereign point of views. Slowness is what allows us to get lost again: to bracket the templates of optical visuality; to experience the extent to which each actuality is charged with the virtuality of memory and the anticipation of a potential future; and, last but not least, to resist the idea we could own and master space and time through the work of visual representation. Slowness, as proposed by Cardiff, returns us to the heart of what the aesthetic might be all about, namely the intense and extraordinary feeling of being washed over and overwhelmed by something that exceeds our will and intention.

4 /

In the case of the most intense modes of musical listening, Don Ihde has argued, when music seems to wash over and through the listener, we encounter the possibility of a perceptual field "in which focal attention 'stretches' to the very boundaries of sound as present. This 'stretching' and 'openness' is again fully *spatio-temporal*. But this spatiality is also 'thick' in that I cannot find its limits. Although I may be 'immersed' in this 'sphere' of sound, I cannot find its boundaries spatially. The spatial signification of a horizon is obscure."[17] Musical listening at its most intense annuls our ability to determine the extension of certain sounds, the relative distance of their origins, the threshold between sound and silence. The world, in this kind of experience, becomes sound, with us as listeners being fully absorbed into its horizonless totality. We no longer ask for sources, extensions, and directions, for bodies producing and bodies receiving sound. We simply allow our own bodies to be or become a medium of the very reverberations and resonances that seem, void of any bounds, all around us.

Auditory experiences of music washing over and through the listener's body are perhaps most effectively generated by the rhythmic qualities and dynamic developments of certain musical compositions: music's beats and tempos, its power to drive time forward and in this way to swallow up or suspend time. In her *Forty Part Motet* (figure 7.2), first recorded with the Salisbury Cathedral Choir in 2001 and later installed in various locations, Janet Cardiff adds an interesting dimension to this, not only by exploring the affective thickness of polyphonic music, but by involving the listener and the activity of walking as a medium to slow down music's forward drive, to sample and resample the music's directionality and source, and precisely thus—and somewhat in contradistinction to Ihde's underlying assumption—intensify the auditory experience. *Forty Part Motet* can be seen and experienced as a recto to the audio walks' verso: whereas the latter bring sound to the perceiving subject so as to at once teach and complicate the slow art of walking, the earlier relies to a large extent on the deliberate moves of the walking subject to be enjoyed in all its complexity. But *Forty Part Motet* also manifests a remarkable questioning and reversal of Ihde's thoughts on intense auditory experience and, by extension, the grounds of aesthetic

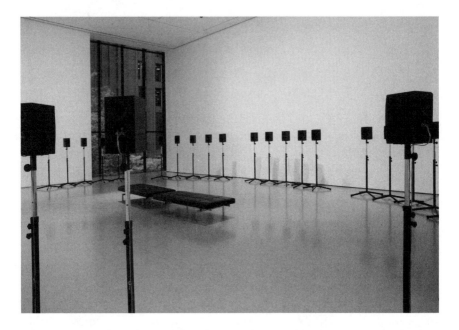

FIGURE 7.2. Janet Cardiff, *Forty Part Motet* (2001). Installation at MoMA, New York, 2005–2006. Sung by Salisbury Cathedral Choir. Recording and postproduction by SoundMoves. Edited by George Bures Miller. Produced by Field Art Projects. *Forty Part Motet* by Janet Cardiff was originally produced by Field Art Projects with the Arts Council of England, Canada House, the Salisbury Festival and Salisbury Cathedral Choir, BALTIC Gateshead, the New Art Gallery Walsall, and the NOW Festival Nottingham. Installation: forty-track sound recording, forty speakers, approximately fourteen minutes. Variable. Gift of Jo Carole and Ronald S. Lauder in memory of Rolf Hoffmann. Installation view of the exhibition, "Take Two: Worlds and Views from the Contemporary Collection." September 14, 2005 through July 3, 2006, the Museum of Modern Art, New York. Copyright © Janet Cardiff. Image copyright © the Museum of Modern Art/Licensed by SCALA/Art Resource, NY.

experience. Unlike Ihde, for whom the sensation of being washed over by boundless music involves a complete relinquishing of the subject's intentionality, acts of slow walking in Cardiff's *Forty Part Motet* serve a deliberate opening of the boundary between the intentional and the nonintentional, the subjective and the objective, the sensory and the aesthetic, the bounded and the boundless.

Forty Part Motet is based on *Spem in alium*, as mentioned earlier, an oratorio composed around 1570 by English composer Thomas Tallis for eight choirs at five voices each. At times, the motet's forty voices are intimately woven into each other, at other times Tallis stacked them polyphonically on top of each other. Though not necessarily a revolu-

tionary turning point in the history of Western (church) music, *Spem in alium* stands as a grandiose experiment and example of how early modern musical culture sought to shift emphasis from the melodic relationships of successive tones to the harmonic interactions of simultaneous sounds, so radical an experiment in fact that both past and contemporary listeners cannot help but feel often overwhelmed by the thick carpet of sounds reaching their ears. While the work itself only lasts about twelve minutes, its inner development and compositional dynamic seems to suspend any ordinary sense of temporal flow and structure. Each of the forty voices is constantly on the move: sometimes they sing, sometimes they are silent; sometimes they join other voices, at other times they pursue their own distinct melodic path; sometimes parts of the choir seem to call and answer to the singing of other parts of the choir, at other moments each of these parts seem to blissfully ignore each other. Etymologically, the word *motet* tangles the Latin *movere* and the Old French *mot* into one unity, thus describing a composition moving the listener through words or moving words to affect the listener. In Cardiff's rendition, this link between motion and the acoustic or linguistic experiences a curious turn, a more than literal interpretation that exposes the listener to the motet's curious suspension of linear temporal structure, yet at the same time also makes us think about and haptically explore the interconnection between hearing, affect, and movement.

Installed in various chapels, museums, and other exhibition venues since the early 2000s, Cardiff's version of Tallis's composition is based on a recording of the Salisbury Cathedral Choir, each voice of the members of the choir recorded separately and then being disseminated through one of the installation's forty speakers, all of them positioned in a huge circle, each of their membranes pointing toward the center. Rather than to ask the listener to take a seat in a frontal and static position, *Forty Part Motet* invites us to immerse ourselves into Tallis's piece by actively moving our bodies through the expanded sculptural field of the entire installation: to walk up to individual speakers and voices, to shift our attention to certain segments of the entire choir, and—yes, if we wish—to take a pause in the very center and hear it all as if it was meant to be performed for only one ideal listener. The user's physical motion thus emerges as a way of constructing the music in the first

place, of mixing and remixing specific tracks of the recording and of thus connecting certain voices with each other and absorbing the oratorio in ever shifting ways to our own aesthetic pleasure. Rather than operating as a mere passive receiver of an acoustic performance, the listener here, through his or her activity of walking, calls it into life to begin with, constantly and unpredictably creating and re-creating the sculptural relationships between Tallis's polyphonic voices. The question of how the interface of the loudspeakers in this installation might separate the actual from the virtual, the "real" performance from its mechanical reproduction, thus becomes an entirely moot question. For what Cardiff's installation renders experiential is the extent to which the virtual is always already embedded in the physical or actual, the idea of virtuality in this case expressing nothing other than the possibility of an unspecifiable and unpredictable engagement with the actual and the physical—our ability to interface with the present as a realm of open potentialities, of surprise and shudder—in short: of aesthetic displacement and incommensurability.

Thinking about the use and utility of advanced technology when designing her audio walks, Cardiff has emphasized the absolute centrality of technological equipment to her creative process: "If I didn't have audio editing computer software, I wouldn't be doing my walking pieces. It allows me to look at the audio track, to move things around in fractions of an inch, in a visual way. It's all visual information on the computer. You can take a chunk of this, you can take a chunk of that, and then you can shift them around, you can see right in front of you on the computer how much they are moving back and forth."[18] It is tempting to argue that in *Forty Part Motet* Cardiff empowers the listener to shift chunks of material herself and thus to serve as an interface able to probe ever new and different arrangements of acoustic information, with the only exception that the moving of material is not achieved and examined in visual form but through the listener's corporeal movements, the assumption of various and quite unpredictable listening positions. While technology in Cardiff's audio walks often exerts considerable control over the walking subject (no matter how seductively it approaches us and no matter how many uncalled-for imaginaries it may elicit), in *Forty Part Motet* much of this authority is passed on to the listener. The installation's complex technology of

recording and dissemination here enables the subject, through the medium of walking, to become a DJ of sorts, remixing the original composition with each of the steps of his body. Walking thus emerges as both technology and technique of corporeal engagement, a form of movement at once creating and allowing the subject to be affected by objects of aesthetic pleasure. Like Cardiff's editing software, deliberate steps into different areas of the installation here have the power not simply to realign the work's acoustic space and spatial relationships, but to shape them in all their polyphonic texture and in this way playfully investigate ever different possibilities of feeling washed away and washed through by Tallis's composition.

"Most people," John Cage once wrote, "think that when they hear a piece of music, they're not doing anything but that something is being done to them. Now this is not true, and we must arrange our music, we must arrange our art, we must arrange everything."[19] Due to an overall privileging of the visual, the writing on the aesthetics of new media since the mid-1990s has often been characterized by a similar set of binaries: the juxtaposition of doing and not doing, of the actual and the virtual, of mind and matter, of here and there, now and then, of strategic action and absorbed nonintentionality, of the tactile and the symbolic. Cardiff's *Forty Part Motet* allows us to envision a different, a more complex, though no doubt also a less tidy notion of the relation between the subject and the object of aesthetic pleasure, one in which the binaries of doing and "being done to," of the actual and the virtual, of action and perception, emerge as elements of a dynamic as inextricable as the many layered voices of Tallis's *Spem in alium*. In Cardiff's work, we simultaneously do something and something is being done to us. We move, yet, nevertheless, also feel deeply moved. We resample the work through the action of walking, but in doing so feel as if we were being pulled into some intense experience of presence, one far beyond any trace of intentionality. This curious duality is what I consider an essential ingredient of Cardiff's aesthetics of slowness. On the one hand, it allows intense aesthetic pleasures that, rather than completely effacing the limits of the auditory field as described by Ihde, make the listener oscillate between experiences of boundless and bounded acoustic perception, thus dramatically expanding the structures of our sensory systems while at the same time drawing awareness to their limitations.

At times, in Cardiff, we are all sound. At other times sound comes into being through us. Instead of being entirely absorbed by the pulses of musical temporality, what we come to enjoy in Cardiff's *Forty Part Motet* is a unique experience of perceptual suspension and ambivalence, a delaying of resolution and a dispersal of focus.

On the other hand, the simultaneity of active engagement and intense aesthetic absorption within Cardiff's sound space clearly breaks with certain progressivist twentieth-century notions of criticality, notions that champion self-reflexive exposures of the medium as a strategy to contain the seductive pull of the aesthetic and prepare the ground for emancipatory social interventions. While Cardiff's work situates the moving body as the most primal medium of aesthetic experience, installations such as the *Forty Part Motet* do not ask viewers and listeners to become cognitive critics of their own aesthetic seduction. *Forty Part Motet* nestles the auratic and the reproduced, the tactile and the immaterial, the actual and the virtual into one dynamic unity, yet it does so not in order to enable or debunk the possibility of some fully integrated and immersive total work of art, but, on the contrary, in order to allow us to expand our sensorium and in its very expansion recognize the respective limits of different sensory organs. Like Cardiff's audio walks, *Forty Part Motet,* too, catches us offguard, prompting us to suspend and probe our normal processes of inhabiting different topographies. In contrast to dominant models of progressivist art, however, Cardiff does not aim at critical reflections about the framing power of the medium, but instead encourages us to use our entire sensorium to produce aesthetic space-time as an open simultaneity of various voices and relations, pasts and presents, heres and theres. Meaning and pleasure here are being constituted through kinesthetic interventions, not through cognitive acts of distantiation or a critical deconstruction of the perceiving subject. And it is Cardiff's invitation to engage in such a playful expansion and exploration of the sensorium, her work's determined aim to make us experience indeterminate couplings of motion and affect, that constitutes one of the most important facets of her contribution to the contemporary aesthetic of slowness.

5 /

In our time of ceaseless migration, hypermobility, and accelerated electronic connectivity, to advocate the slow art of walking may be seen as respectable and apposite: a beneficial intervention resituating mind and body in the specificity of local place rather than the abstract and fast-spaced streams of global space. And yet the praise of walking is often colored by paradoxical strains of conservative thought and nostalgic longing: a desire not simply to turn one's back on the present but to employ acts of deceleration as merely a method to recharge our engines and thus make us run faster in our life at work, in front of our terminals, behind our wheels and windshields again. A similar tendency can possibly be seen at work in the understanding of contemporary walking and sound artists alike, the former not rarely belittled as romantic mystics hoping to step out of the circuits of the global art market, the latter often being considered as mere acoustic ecologists trying to gather different sonic impressions of the world, yet rarely seeking to retool the soundscapes of the present. Though much of more recent sound art by artists such as R. Murray Schafer and Hildegard Westerkamp, following LaBelle, is dedicated to revealing the submerged sonority of certain sites and thus complicating our perception of these locations,[20] what it seems to share with the practice of walking artists such as Long or Fulton is its strong emphasis on personal presence and experience, on subjectivity and measured control, on the realness of certain locations and on art's role in restoring authenticity and referentiality. The work of both sound and walking artists, it might be argued, is therefore essentially preservationist: it maps highly specific locations in the hope of counteracting the explosions of postindustrial space and refueling the engines of artists and recipients with the temporary bliss of unmitigated spatial identity.

The readings of this chapter suggest that we should not subject Janet Cardiff's aesthetics of slowness to similar interpretative perspectives. Slowness, in Cardiff's work, is neither meant to preserve the integrity of a specific place against centrifugal forces, the logic of dispersal and fragmentation, that drive postindustrial geographies and electronic space today. Nor is it designed as a means to harness the contours of

the subject's sensorium against the dissolution of stable temporal boundaries and spatial orientations. On the contrary. On the one hand, to the extent to which Cardiff charges her land- and cityscapes with haunting memories, inconclusive narratives, visionary anticipations, and ongoing movements, place no longer affords the kind of meanings and orientations usually associated with specific locations. Instead it becomes alien, other, displaced, and placeless. Though walking, in Cardiff, defines a process of physical engagement and immersion, it does not result in any sense of "grasping" a certain place, of knowing its bounds. Rather, what is site specific about the activity of walking here renders experiential that no site is ever specific enough to be knowable and predictable to begin with. Slow walking, in Cardiff, preserves neither space nor place. While it is often energized by certain mystic impulses and dark romantic longings, the figure of the walk in Cardiff describes the specificity of place as something that always comes in the plural, is charged with riddles and mysteries, and therefore escapes clarity, security, and conclusive conceptualization. In this way, Cardiff's aesthetics of slowness stresses the fact that places, in Michel de Certeau's words, are nothing more than "fragmentary and inward turning histories, pasts that others are not allowed to read, accumulated times that can be unfolded but like stories held in reserve, remaining in an enigmatic state, symbolizations encysted in the pain or the pleasure of the body."[21]

On the other hand, it is Cardiff's unique combination of bodily locomotion and the multidirectionality of sound that not only unsettles the legacy of Albertinian perspectivalism and its inherent logic of visual mastery but, in so doing, also leads to a profound aesthetic dissolution of the boundaries between subject and object, the intentional and the nonintentional. Far from defining the walker as a sovereign subject, Cardiff's aesthetics of slowness privileges the lateral over the frontal, the layered over the trajectorial, and precisely in this way emancipates the walker's body and perception from the legacy of detached and synthetic looking so central to Western notions of perspective, presence, and control. Cardiff's subject is one able to at once move forward and backward, to intend and to let go, to listen and to act mimetically, to project itself and to take in. Whereas dominant concepts and prac-

tices of visuality in modern culture have prompted us—in Maurice Merleau-Ponty's words—to "flatter ourselves that we constitute the world," Cardiff's emphasis on embodiment and the tactile reveals the degree to which experience is something that "adheres to the surface of our body; we cannot unfold it before us, and it *never quite becomes an object.* It is not I who touch, it is my body."[22] The slowness of walking, in Cardiff, allows the subject to partake of what is no longer or not yet structured by the templates of modern subjectivity. Slowness here situates the subject as an unstable, a malleable, a vulnerable factor of the world without necessitating that this subject shore up the instrumentalist mechanisms of self-defense and self-preservation. Though the decelerated speed of walking in Cardiff might thus indeed serve a certain ecological agenda, namely to intensify our awareness of the reciprocal dependency of all matter, there is little reason to fear (or hope) that Cardiff's aesthetic of slowness could ever fuel a preservationist rhetoric of authenticity, a rhetoric seeking to fix the identity of space in time. To walk, in Cardiff, is to relinquish modern civilization's hubris of control and learn to admit that we are neither sovereign anchors of perception nor have sovereignty over own bodies. It is to experience space as inherently temporal, as something we cannot but fail to ever fully map, let alone master or use to master ourselves.

In his polemical effort to promote a "psychogeography" of modern urban life, Guy Debord in the 1950s advocated the activity of drifting (*dérive*) as "a technique of transient passage through varied ambiences. The dérive entails playful-constructive behavior and awareness of psycho-geographical effects; which completely distinguishes it from the classical notions of the journey and the stroll. In a dérive one or more persons during a certain period drop their usual motives for movement and action, their relations, their work and leisure activities, and let themselves be drawn by the attractions of the terrain and the encounters they find there."[23] Echoes of the situationist experience of drift are at the center of Cardiff's aesthetics of slowness. To go slow, in Cardiff, is to combine the playful and the constructive. It allows us to let go of our usual intentions, drives, and itineraries, to relinquish our desire for mastery and control, for the sake of being drawn into and become reembodied by unexpected encounters. Similar to Debord,

Cardiff's audio work encourages the walker to drift into another geography hidden beneath physical space. Her aesthetics of slowness unlocks this other space, these other spaces: the unpredictable realm of the imaginary—of virtuality and potentiality, of memory and futurity—that helps constitute what we call our present.

1 /

Speed largely figured as modernity's new religion: a panacea for modern culture's logic of disenchantment, its loss of transcendental meaning and its growing pressures of calculability. If God no longer offered a safe haven for our desire to overcome mortality, ever more actions, events, and distractions needed to be cramped into the duration of a lifetime. Outspeed the brevity of your existence, modern culture preached its subjects, so as to transcend life's limits from within! Accelerate the pace of daily movements and enterprises so as to find plenitude and immortality in defiance of the body's inevitable drive toward failure and death!

The emergence of modern capitalism and ever faster technologies of transport and communication at once tapped into and energized the modern subject's restless quest for self-transcendence. For some, industrial culture's speed destroyed the possibility of contemplative attitudes and profound meanings. As early as 1825, Johann Wolfgang von Goethe described modern life as a regime of velociferous intensity, i.e., a form of negative theology fusing velocity and the luciferous into one vicious dynamic: "Everything just now is *ultra*. . . . No one understands himself or the place where he stands, or the matter he attempts

to fashion. Pure simplicity is out of the question, but there are plenty of absurdities. Young men are over-excited at an early age, and swept down by the whirlpool of time. Wealth and speed—these are the world's idols, and the objects of all its desires. Railroads, steam boats, stage-coaches, and all possible facilities of communication are the great aim and end of the civilized world in its desire for over-civilization, which must lead to permanent mediocrity."[1] Goethe's hero Faust was clearly no stranger to this modern whirlpool of time. His edgy quest for knowledge and fast-paced self-realization hoped to counteract the absence of divine securities and the finitude of human affairs. To go fast, for Faust, was to become *ultra*. To be velociferous. To fill God's vacated place with inner-worldly, albeit transient, architectures of meaning.

Whereas Goethe considered modern speed as diabolical, many others saw it as a source of religious elation and ecstasy, a well of ongoing movement effectively suturing the breach between the body's finite rhythms and the pace of social or technological progress. Speed liquefied hardened confines of modern individualization, and in doing so it prepared the subject for new kinds of bonds, relations, and connections, that is, for what religion in its most basic etymological sense is all about. "Eyes. Hands," Blaise Cendrars wrote in 1917, "The turning wheel. The hovering wing. The voice traveling along a wire. Your ear in a trumpet. Your sense of direction. Your rhythm. You melt into the world into the mold of your skull. Your brain hollows out. Unsuspected depths, in which you pluck the potent flower of explosives. Like a religion, a mysterious pill activates your digestion. You, get lost in the labyrinth of stores where you renounce yourself to become everyone."[2] In Cendrars's rapturous perspective, modern speed triggered profound out-of-body experiences. It redefined the human sensorium as a window opening on new oceanic sensations of belonging and community. Speed liberated the body from its stubborn biological pulses and measures, and it thereby disengaged the clocks of human mortality.

Not all modernist art and culture, of course, shared Cendrars's enthusiasm about speed and technological progress. On the contrary. Similar to Goethe's times, the first decades of the twentieth century witnessed many calls for aesthetic deceleration. For each modernist embracing speed as a new religion, we can identify another eager to

situate art as a tool for slowing down the tempos of industrial civiliza-
tion, preserving the possibility of contemplative experience, and rein-
stating the rhythms of the human body and mind as central measures
of things past, present, and future.[3] Think of the absorbed poses of
Aristide Mailloi's sculptural work around 1900 as a response to the
decentered and restless figures of Auguste Rodin, the latter hurling the
viewer into a present of ongoing movement, the former seeking to ex-
plore islands of tranquillity amid the storms of industrial progress.
Think of Giorgio de Chirico's images of seemingly timeless and deani-
mated spaces as a historical response to the futurist credo of speed and
technological progress. Think of the pensive and highly choreographed
shots of Weimar expressionist cinema as an answer to the quickening
of editing rhythms in international cinema since the 1910s, the has-
tening of cinematic time culminating in the frantic cutting practice of
Russian montage filmmakers. In betting on speed as a conduit to ec-
static meanings and experiences of the infinite amid a disenchanted
world, aesthetic modernism at once also formulated various positions
that sought to define art as the last repository of the contemplative, the
eternal, and the profound—as an enduring site within a restless mo-
dernity powerful enough to insist, in Rainer Maria Rilke's famous
words, that "you must change your life."[4]

The previous chapters of this book have theorized slowness not
merely as an attempt to decelerate and invert the speed of modern life,
but as a mode of movement, perception, and experience that allows us
to engage with the present in all its temporal multiplicity. Slowness to-
day, I have argued, can uphold what phenomenologies of speed tend
to deny, namely to encounter the present as a place of potentiality and
contingency. While it is true that many modernists embraced slow-
ness to question how modern culture installed speed as a new religion,
the point of my argument here has been to emphasize that slowness
is at once less and more than a mere inversion of the modern idolatry
of speed. Slowness instead allows us to behold the passing of time in
the first place, and in so doing it has the potential to complicate and
refract dominant understandings of movement, change, and mobil-
ity. Far more than a mere inversion of modernity's speed, slownesss
plays out the virtual against the deterministic, dispersal against the
trajectorial. As it invites us to hesitate and delay immediate responses,

slowness makes a case for the open rather than the timeless, but also for the finite and mortal rather than for stalwart visions of progress, for experience rather than fate.

In the context of early twentieth-century modernist culture, Siegfried Kracauer stands as one of the most ardent advocates of such a nuanced concept of slowness. In various essays of the 1920s, Kracauer praised the arts of boredom and waiting as critical responses to an accelerated world blinded by its own faith in ongoing mobility, technological progress, and radical disenchantment. "Perhaps," Kracauer wrote in 1922, "the only remaining attitude is one of *waiting*. By committing oneself to waiting, one neither blocks one's path toward faith (like those who defiantly affirm the void) nor besieges this faith (like those whose yearning is so strong, it makes them lose all restraint). One waits, and one's waiting is a *hesitant openness*, albeit of a sort that is difficult to explain."[5] For Kracauer, hesitancy permitted the modern subject to avoid both: taking flight into positions of disabling skepticism and fleeing headlong into the very textures of a fleeting present. To be hesitant meant neither to consider the past as a timeless measure of meaning and fulfillment nor to follow short-circuits whenever possible and pluck fruits long before they may be ripe. Contrary to the ideologues of both modern speed and stillness, then, hesitancy allowed one to encounter modern temporality head-on and engage with it in all its ephemerality and disenchantment. It enabled the subject to keep eyes, ears, and senses wide open without endorsing current projects of reenchantment, of religious self-transcendence and immortality. Those able to wait approached modern speed and mobility as true contemporaries. They didn't seek to turn their back onto the modern, nor to completely vanish into it, but to behold of it as a site of potentiality and becoming.

Kracauer's times are no longer ours. Over the last two decades or so, modernism's religion of speed has been replaced by a new post–cold war idolatry of slowness, the latter often praised as a cure to heal the mental aches of too much velocity, as a strategy to confront the haste and multitasking of digital culture with some sense of the timeless, the spiritual, the auratic. The international slow food movement decreed in its inaugural statement on December 10, 1989: "May suitable

doses of guaranteed sensual pleasure and slow, long-lasting enjoyment preserve us from the contagion of the multitude who mistake frenzy for efficiency. Our defense should begin at the table with Slow Food. Let us rediscover the flavors and savors of regional cooking and banish the degrading effects of Fast Food."[6] And in their manifesto of January 2010, the initiators of the slow media movement wrote: "10. Slow Media are timeless: Slow Media are long-lived and appear fresh even after years or decades. They do not lose their quality over time but at best get some patina that can even enhance their value. 11. Slow Media are auratic: Slow Media emanate a special aura. They generate a feeling that the particular medium belongs to just that moment of the user's life. Despite the fact that they are produced industrially or are partially based on industrial means of production, they are suggestive of being unique and point beyond themselves."[7] Applaudable as these interventions in many cases might be, what is stunning about their rhetoric is not only the extent to which they see slowness as a mere reversal of dominant speed, but couple their quest for deceleration and tranquillity to desires for reenchantment and salvation. Slowness, in these manifestos, reenergizes our postmetaphysical age with sacred meanings and sentiments. Slowness creates new bonds, obligations, and communities. Its principal task is to reduce complexity, intensify individual pleasure, and thereby warrant the possibility of the profound. Its ultimate promise is to reveal the old in the new, the lasting and sustainable amid the fleeting, the depth below the surface. Slowness, in this understanding, resists the mindless commotion of the present so as to recharge the spiritual batteries of individual existence and communal interaction—and hence to do what speed did for many modernist speed addicts, namely to recreate the possibilities of faith and religiousness amid the disenchanted routines of modern existence.

Kracauer's times are still ours, for his art of waiting still teaches us a thing or two about the role of speed and slowness in twentieth-first culture and about how we have come to attach redemptive meanings and sacred values to preferred logics of movement. "Those who wait will," Kracauer wrote in the 1920s, "be as hard as possible on themselves, so as not to be taken in by religious need. They would much rather lose the salvation of their soul than succumb to the rapture of

the moment and fling themselves into adventures of ecstasy and vision."[8] Like the speed addicts of the early twentieth century, slow life movements today often lack the patience or ability to put things on hold for the sake of refracting the temporal exigencies of the present. In their concerted effort to stay clear of the *horror vacui* of speed, they aspire to instant spiritual salvation and sensory gratification, whereas Kracauer's art of hesitation demanded nothing less than an at once dauntless and open attitude toward what is, what was, and what might be to come. Taking some of its cues from Kracauer's apology of waiting, this chapter explores the role of the sacred and auratic in contemporary artistic uses of slowness in greater detail. Like earlier chapters, it will concern itself with the copresence of various and often incompatible temporalities—continuity and rupture; geological, historical, and social time; the time of media technologies and the rhythms of perception. However, in addition to the perspectives of the earlier chapters, at this juncture I also add the existential temporality of the human body into the equation, i.e., the dimension of human finitude, frailty, and mortality and how we can think of slowness today as a postmetaphysical medium of experience that eschews the dominant understanding of deceleration as a portal toward the sacred, the auratic, and the timeless.

The primary witness in my argument is Don DeLillo's 2010 novel, *Point Omega*, in particular its highly evocative reference to Douglas Gordon's video installation *24 Hour Psycho* at MoMA in 2006. A meditation on the role of art that—in Alex Alberro's words—"rivals those channeled through the official organs of art criticism,"[9] DeLillo's novel will allow me to reflect in some greater detail about the temporality of installation art and its role as a paradigmatic strategy of the contemporary, but it will also—in the second half of this chapter— provide material to sketch out a contemporary poetic of slow writing and reading. Important objects of cross-examination are Bill Viola's *Tristan Project* (2004–2007) and the video triptych *Last Riot* by the Russian collective AES+F (2007), both works exemplifying the precarious ways in which slowness, for many today, has come to represent a search for new gods, whether these gods promise blissful redemption or strike the world with catastrophic destruction. How, so my central question for this chapter, can we envision slowness without

endorsing longings for religious adventures of ecstasy and vision? How can we effectively distinguish slowness as a category of the contemporary from the manner in which slowness often figures today as an aesthetic funnel collapsing human into eternal time?

2 /

Twenty-first century museums worldwide often present themselves as spaces of respite and reflection, offering pockets of attentiveness and contemplation within the relentless tempos of online culture and distracted multitasking. As is well known, the realities on the ground are often quite different as museums seek to attract massive crowds to blockbuster shows, museumgoers rarely spend more than a few seconds in front of individual artwork, and curators cram exhibition spaces with visual and auditory material that is no less distracting than what we experience when navigating various open windows on our computer screens. The rising prominence of video installations in contemporary museums has done very little to calm the kinetic frenzy of today's spectacle culture. On the contrary. Though video artists may often invoke extended structures of temporality and curators splice their work into demanding loops or prolonged series of individual films, few viewers are known to sit through what is presented on screen in its entirety. To dip in and out of individual screenings has become the order of the day—a highly select and arbitrary consumption of moving images that defines the viewer's moving body as analogous to the impatient thumb flicking through various TV channels at home. So much so that savvy video artists and curators today increasingly reckon with their viewers' durational unpredictability, whether they exhibit work whose length vastly exceeds any viewer's likely timetable and thus explicitly emancipates the viewer from a work's inherent temporality, whether they present videos that eschew narrative structures and thus seemingly accommodate arbitrary viewing habits, or whether they soften their temporal demands on the visitors by offering fixed and hence expectable viewing schedules that are not that different from what you get in your local television programming guide.

DeLillo's *Point Omega* begins with a bravura act of describing the phenomenology of contemporary installation viewing, paradigmatically centered around the visit to Gordon's *24 Hour Psycho*, i.e., a video installation vastly exceeding any limit of what most museums enable patrons to consume in one visit. We witness an anonymous man watching Gordon's two-sided screen from different positions of the gallery's wall. He is wholly familiar with Hitchcock's original, yet instantly stunned by how Gordon's dramatically reduced frame rate (about two per second) changes everything we know about the narrative and the film's choreography of the visible, to such an extent that something unsettling and unexpected emerges in front of the viewer's eyes.

> He found himself undistracted for some minutes by the coming and going of others and he was able to look at the film with the degree if intensity that was required. The nature of the film permitted total concentration and also depended on it. The film's merciless pacing had no meaning without a corresponding watchfulness, the individual whose absolute alertness did not betray what was demanded. He stood and looked. In the time it took for Anthony Perkins to turn his head, there seemed to flow an array of ideas involving science and philosophy and nameless other things, or maybe he was seeing too much. But it was impossible to see too much. The less there was to see, the harder he looked, the more he saw. This was the point. To see what's here, finally to look and to know you're looking, to feel time passing, to be alive to what is happening in the smallest registers of motion.[10]

Gordon's use of slow motion, rather than producing perceptual fatigue, kindles the visitor's attentiveness and concentration. To see particular actions broken into smallest components causes this visitor to attend to aspects never noticed before and experience forms of looking no longer impelled by the drive of narrative expectation and desire. Totally absorbed in the glacial pace of the images, he nevertheless feels like someone consciously watching a film, the contemplative and the reflexive strangely going hand in hand. "This film," he concludes, "had the same relationship to the original movie that the original movie had to real lived experience. This was the departure from the departure.

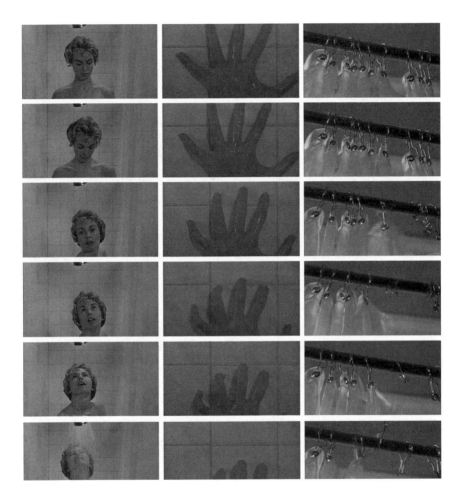

FIGURE 8.1. Alfred Hitchcock, *Psycho* (1960). Screenshots.

The original movie was fiction, this was real" (13). How, he cannot but wonder, would or should it be ever possible to walk out onto the street after this without feeling deeply disturbed about the real? How, after experiencing vision as medium of beholding the pure passing of time, could it be possible to return to all that which is normally taken for granted?

In stretching the projection of Hitchcock's 1960 horror classic across the duration of an entire day (figure 8.1), Gordon's *24 Hour Psycho* draws the viewer into a complex dynamic of anticipation and forgetting,

absorption and attention. We know where all we see will lead up to, but precisely because of this knowledge the viewer can explore each frame—virtually frozen for almost half a second at a time—on its own terms, as if liberated from the exigencies of narrative drive, desire, and teleology. What we know allows us to forget and to probe the film's visual unconscious. It invites us to enjoy cinema as if it were a mere compilation of still images after all, yet without repeating Henri Bergson's notorious ire about the cinematic in *Creative Evolution*, caused by the philosopher's confusion of film and cinema, film strip and projection situation. In the opening of DeLillo's novel, Gordon's curious suspension of narrative movement enables the anonymous man at the wall not only to contemplate seemingly marginal elements of Hitchcock's film (e.g., the particular number of curtain rings holding up the shower curtain in *Psycho*'s most famous sequence), but to reflect on the entire conditions of viewing the installation, his own physical relation to the screen, his plan to return at some other time to witness other segments of the film, and the rather impatient acts of viewing of other museum patrons. Though demanding utter concentration and intensity, the film's slowness allows the man, at the same time, to roam in thought and perception and hence to experience what contemporary online culture, with its imperatives of seamless connectivity, no longer permits: the bliss of drift, the productivity of boredom, understood in Kracauer's sense as a form of hesitant openness.

Planning to stay until the museum's closing hours and hence the imposed suspension of Gordon's work, the man at the wall eventually observes two other men entering the gallery space, one using a cane whose appearance reminds the man at the wall of a retired professor, possibly even a former film scholar, the other a much younger and much more casual male, perhaps an assistant professor. "He watched them a moment longer, the academics, adepts of film, of film theory, film syntax, film and myth, the dialectics of film, the metaphysics of film, as Janet Leigh began to undress for the blood-soaked shower to come" (8). As we will soon learn in the middle of the novel, the older man is Richard Elster, an intellectual who advised the American administration on strategies of warfare in Iraq; the younger man is Jim Finley, a filmmaker whose aim is to film an interview with Elster in his desert retreat, shot in a single take without any cuts or interruptions

and as if seeking to apply the openness of Gordon's work to the domain of political documentary. As it will turn out, however, we cannot be entirely certain about these characters' ontological status within the book's narrative. For *Point Omega* comes in three segments: the opening section located at MoMA and dated September 3; the main part apparently narrating several weeks in the desert of the American Southwest; and a final short part, returning the reader to MoMA, Gordon, and the man on the wall, dated September 4. Given the rather warped chronology of these three parts, it is tempting to read the main part of *Point Omega*—the encounter of Elster and Finley, as well as the story of Elster's daughter Jessica strangely disappearing in or even into the desert—as nothing more or less than a product of the man at the wall's imagination: a half-developed narrative sketch that emerges and vanishes again somewhere in the long pause between individual frames of *24 Hour Psycho*'s radically decelerated display; an imaginary propagated by the man's deliberate negotiation of contemporaneity—of space and time, reproducibility and presence—in the face of Gordon's installation piece.

But let's not jump ahead of ourselves and, like Elster and Finley, impatiently leave Gordon's *24 Hour Psycho*—his mesmerizing reproduction of one of the masterpieces of modern technical reproducibility—without some further deliberation. Installation art like Gordon's, Boris Groys has recently argued, is at the center of the topology of contemporary art. It allegorizes and embodies what contemporaneity after modernism and postmodernism is all about. Modernist art, in Groys's view, in its iconoclastic effort to break with the burden of traditions and create aesthetic value out of nothing, resulted in a paradoxical rejection and affirmation of the past. Modernist art pursued creative originality and a renewal of the auratic, not least of all in order to oppose the rise of modern mass culture and reproducibility. But, in polemically negating the repetition of traditional images, it, surreptitiously, reaffirmed their very normativity. "A creative act," Groys argues, "if it is understood as an iconoclastic gesture, presupposes a permanent reproduction of the context in which the act is effectuated."[11] Postmodern art aspired to move beyond this paradox, yet in doing so created or endorsed a new one. It embraced Benjamin's valorization of reproducibility and the postauratic and it thereby hoped to negate how high

modernist art negated the repetition of traditional images, narratives, and structures of evaluation. In its overdetermined effort to do away with a work's aura, however, postmodernism at once obscured and reinscribed the very context that enabled the rise of the auratic in the first place. Whereas modernism negated previous art but not its context, postmodernism negated the specificity of the context but not its art. Both of them remained deeply ambivalent about the role of the auratic and its relationship to the modern culture of technological reproducibility—an ambivalence only overcome with the emergence of contemporary installation art and its ability to produce an original out of a copy. For installation art, as Groys concludes, "nowadays the leading form in the framework of contemporary art, operates as a reversal of reproduction. The installation takes a copy out of an allegedly unmarked, open space of anonymous circulation and outs it—even if only temporarily—in a fixed, closed context of a topologically well-defined 'here and now.' . . . What differentiates contemporary art from previous times is only the fact that the originality of a work in our time is not established depending on its own form, but through its inclusion in a certain context, in a certain installation, through its topological inscription."[12]

Installation art, in Groys's view, is the hallmark of contemporary art, of contemporaneity, as it overcomes the reifying gestures and blind spots of both modernist and postmodernist art. An art of the auratic and the reproducible, installation art bears witness to the fact that, in our age of ubiquitous screens and storage devices, we can neither stabilize the copy as copy nor the original as original; that reproduction today can produce originality as much as the auratic may rely on reproducibility; and that, therefore, our decision to view something as copy or original has become entirely dependent on how we view its context, the scene in which images are presented to us. Contemporary art is art engaging the viewer to explore the role of context, framework, and situation in the production of the auratic or the postauratic. It is less about the exhibition of individual new works than it is about drawing our awareness to our own position as viewers in the contemporary production of presence and originality, of meaning and wonder. Installation art is by definition present and contemporary: it takes place in the here and now, even when reengaging older work such as

iconic horror classics such as Hitchcock's *Psycho*. Yet contemporaneity, in installation art, neither means to glorify the auratic and original nor to embrace the ephemeral and passing at all cost. Instead it serves as an optics, an analytic, to sensitize the viewer about the extent to which our responses to particular displays of art, be they contemplative or highly distracted, result from intricate and ongoing negotiations between artist, exhibition situation, and viewer. Contemporary art, in other words, invites the viewer to probe the temporality of producing and attending presentness—to explore this present's constitutive role in generating what appears lasting and what doesn't, eternal or not, open or closed to future change.

In the opening of DeLillo's novel, the glacial slowness of Gordon's *24 Hour Psycho* indeed opens such a space for producing and probing presentness: a sharpening of attention across an extended duration that enables the singular man at the wall not only to feel released from the usual drive of narrative progress but also to test multiple points of view and thereby explore the interaction of body and image, physical movement and seeing. The reproduction of Hitchcock's classic here permits a remarkable sense for the here and now of aesthetic experience, for the singularity of the specific viewing situation and moment. It gives the man pause to think about other ways and times of watching the film, even to meditate the viewing practice of other viewers in the MoMA gallery, without in the very least experiencing any slackening of his sense of focus and perceptual presence. "It takes close attention to see what is happening in front of you," DeLillo writes. "It takes work, pious effort, to see what you are looking at. He was mesmerized by this, the depths that were possible in the slowing of motion, the things to see, the depths of things so easy to miss in the shallow habit of seeing" (13). For DeLillo's museum visitor, to attend to what is at once known and unknown, a product of reproducibility and a unique experience of presence, goes hand in hand. The film's time, for him, does not hurl him into the future; it does not hinge him to what Hitchcock himself famously identified as the cinematic art of suspense, namely film's play with our anticipation of an impending threat, best manifested in chase sequences: "The closer the pursuer, the faster the tempo, the greater the suspense, the more powerful the thrill."[13] On the contrary. Instead of producing narrative thrill, installation art here

delimits a space for intricate meditations on the relation between time and space, past and present viewing, absorption and anticipation. It opens a fold in the fabric of ordinary time in which, arguably, the novel's main part—the story of Elster's desire to tap into the long breath of geological time, of Finley's failed long take film project, and of Jessica's mysterious disappearance—comes into being in the first place.

I will return to the representation of Elster's and Finley's search for slow experience in a moment in order to flesh out DeLillo's peculiar take on slowness as an aesthetic of the contemporary, and how *Point Omega*'s poetic plays out the finite and frail vectors of existential time against the oppressive and ever accelerating logic of social and technological temporality. To better prepare this argument, however, let me take a brief sidestep to illustrate that neither installation art nor slowness per se provides a royal avenue to contemporaneity in today's artistic practice and we therefore need to be cautious not to understand Groys's plea for the indeterminacy of contemporary installation art as a deterministic gesture itself, i.e., as an attempt to ascribe a distinct and unified politics to the material base and institutional context of aesthetic practice.

3 /

A notoriously thorny notion with a rich tradition of philosophical elucidation, the concept of experience is of critical importance in distinguishing slowness as an aesthetic strategy of contemporaneity from desires to slow or even halt the passing of contemporary time so as to reach out to the timeless and sacred. Drawing on Walter Benjamin as much as the writings of German theorists Alexander Kluge and Oskar Negt, the work of film scholar Miriam Hansen has given the concept of experience its perhaps most robust recent formulation: "Experience is that which mediates individual perception with social meaning, conscious with unconscious processes, loss of self with self-reflexivity; experience as the capacity to see connections and relations (*Zusammenhang*); experience as the matrix of conflicting temporalities, of memory and hope, including the historical loss of these dimensions."[14] Slow-

ness, as pursued through the pages of this book, seeks to warrant the possibility of what Hansen calls experience in the face of today's rampant processes of acceleration. It mediates the sensory with the reflexive, what is ephemeral with the durational. It opens a space to approach the present as a crossroad of diverse temporalities and explore these in all their relationality or disjuncture. Like experience in Hansen's perspective, aesthetic slowness negotiates the boundaries between subject and object, not in order to reinforce traditional notions of unified subjectivity and preordained meaning, but, on the contrary, to probe both the fragmentary, unfinished, and fragile contours of the self and the constitutive contingency of meaning in what we call modernity.

Video and installation art, as it invites the viewer to mediate the auratic and the reproducible, truly has the potential to make viewers slow down and probe the very conditions of experience in our age of fast-paced digital streams and ubiquitous audiovisual displays. Gordon sums this up nicely when describing how the space of 24 *Hour Psycho* invites the viewer to engage with conflicting temporalities in the very face of each and every of the projection's present images: "I was concerned above all with the role of memory. While the viewer remembers the original film, he is drawn into the past, but on the other hand also into the future, for he becomes aware that the story, which he already knows, never appears fast enough. In between, there exists a slowly changing present."[15] But video and installation art, pace Groys and Gordon, is by no means destined to automatically reclaim the grounds of experience and sharpen our perception for what is heterogeneous and conflicting, yet also changing and dynamic, about the present moment. Let me illustrate this with the help of two recent examples. In both, the music of Richard Wagner—often associated with glacial slowness, ponderous repetitiveness, redemptive excess, and overwhelming compositional authority—takes center stage. Though the understandings of Wagner in both works could not be more different, what they have in common is a vision of slowness as a logic of unbending, unified, and self-contained temporality—a mechanism denying what experience in Hansen's terms is all about.

At the 2007 Biennale in Venice, the Moscow-based collaborative AES+F (Tatiana Arzamasova, Lev Evzovich, Evgeny Svyatsky, and

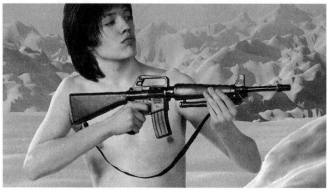

FIGURE 8.2. AES+F, *Last Riot* (2007). 3-ch HD video stills, c-print on barite paper, 15.6 × 81.2 cm. Courtesy of Triumph Gallery, Moscow. Copyright © AES+F. © 2013 AES/Artists Rights Society (ARS), New York.

Vladimir Fridkes) was invited to exhibit its animated video triptych *Last Riot* in the Russian pavilion. On three separate screens, the viewer encountered a battle over the end of human civilization, an animated doomsday scenario involving a number of teenagers attacking each other in utter slow motion, their various weapons time and again threatening each others' lives, yet never going for the final kill (figure 8.2). As if Benetton had outfitted the apocalypse, the combatants not only seemed to represent all the different skin colors of the globe, their attire also lived up to the standards of contemporary hipness and advertising. Moreover, *Last Riot* cloaked its fantasy of destructive violence—the complete erasure of both human and outer nature—into the visual iconography of video gaming, all characters and their movements achieving near realistic resolution. No hope seemed left in these violent games without frontiers, not even our hope for all of it coming to some kind of end. The film's images of deceleration and repetition, of inconclusive slow-motion replay, evaporated any notion of progressive or transformative time. Though everything here seemed to go to pot, the viewer remained in a state of painful suspension. Almost needless to say at this point that the video's sound track—aside from galvanizing techno music—blasted familiar motifs from Wagner's *Götterdämmerung*: thunderous beats and sounds of inevitable destruction, meant here to reinforce our sense of having slipped into a realm

beyond any modern view of progressive or postmodern notion of recyclable time. Once seen by Nietzsche and Adorno as overcharged with ideology, Wagner's monumental musical language in *Last Riot* turns into an acoustic illustration of the end of ideology and our ability to make any normative claims about the present. In the virtual reality of *Last Riot,* the bombastic drive of Wagner's music comes to signify the absence of signification, the way in which digital culture, fashion, and globalization today have erased difference, including that between heaven and hell, the paradisiacal and the infernal. In the collaborative's own words, "This paradise also is a mutated world with frozen time where all past epoch the neighbor with the future [sic], where inhabitants lose their sex, and become closer to angels. . . . The heroes of new epos have only one identity, the identity of the rebel of last riot. The last riot, where all are fighting against all and against themselves, where no difference exists any more between victim and aggressor, male and female. This world celebrates the end of ideology, history and ethic."[16]

AES+F's apocalyptic fusion of slow-motion video and Wagner might be seen as radically opposed to the redemptive reverie that shall serve as a second example of how a certain slowness in contemporary video and installation projects can make us long for meanings untouched by time: the so-called *Tristan Project*, a collaboration of video artist Bill Viola, stage director Peter Sellars, the Los Angeles Philharmonic under

its musical director Esa-Pekka Salonen, and the Paris Opera and its artistic director Gerard Mortier (figure 8.3). *Tristan Project* was staged for a limited number of times in both Paris and at Disney Hall in Los Angeles between 2004 and 2007 (and later, in a watered-down version, in New York as well), at times stretched out over three consecutive nights, at times the whole opera in one evening. In both versions, Sellars decided to distribute his performers in minimal costumes across the entire auditorium instead of mounting a full stage production. Given its boatlike design, in particular the interior of Disney Hall offered an apt setting for the music drama's story of physical and emotional traversal. More important, however, the quasi-Brechtian dispersal of the opera's singers in the moderately lit auditorium allowed Sellars to reserve the stage for the show's most noted attraction, namely the display of a high-definition video work by Bill Viola, a starkly anti-Brechtian window onto a world of profound affects and meditative visual meanings.

As indicated already in chapter 6, Viola's work over the last decades has been tightly associated with slow-motion photography. In works such as *The Reflecting Pool* (1977–79), *The Passing* (1991), *The Greeting* (1996), *The Passions* (2003), and *Ocean Without a Shore* (2007), Viola regularly embraced ultra-slow-motion photography as a means to investigate the mystic and metaphysics of human gestures, expressions, and emotional states. Slow motion in Viola's work frequently operates as a technique of radical subtraction and reduction: a means to strip the accidental from the essential, the contingent from the archetypical, thus creating a condition in which some deeper logic of transience and transformation might come to the surface of the visible. "This condition," as Donald Kuspit wrote in a review of *The Passing*, "seems to inhabit a spacetime all its own, which Viola's videos project precipitously into ours. They disclose universes of sensation and emotion that we never knew existed but that were there all along, for they are the fundament of our existence."[17]

Tristan Project continues this preoccupation with the metaphysics of the sensory by displaying a number of video sequences on two massive screens, all of them featuring scenes of transience, traversal, and transformation. Viola's videos accompanied and towered over the entire performance: mostly crisp, yet at various moments deliberately blurry images shot in Viola's signature technique of extreme slow mo-

FIGURE 8.3. Bill Viola, *The Tristan Project* at the Bastille Opera in Paris in 2005. Photo copyright © Ruth Walz, Berlin.

tion, showing two stand-ins in a ritual act of undressing and being cleansed, of traversing a large desert, of diving into a pool of water, of passing through a doorframe. Waves crashing against what is meant to be some Northern European shore but looks like the California coast. A wall of fire. A head piercing a water surface from below in extreme slowness. Illuminated candles lined up as in a church. Characters gliding through space as if they had learned how to defy gravity, thus amplifying the music drama's theme of transcendence, of redemption and self-levitation, of leaving the chains of individuation behind and immersing oneself in a rapturous realm of love.

Nothing, of course, could be more different than the way in which AES+F employed Wagner for staging catastrophic violence as an eternal

return of the same and how Viola/Sellars sought to amplify the teleo-
logical structure of narrative buildup and cosmic release that drives in
particular Wagner's 1865 opera toward Isolde's final *Liebestod*. And
yet, in both projects, the association of Wagner's music with a larger
cultural rhetoric of repetition and deceleration is taken for granted. In
both projects Wagner signifies slowness, and slowness is seen as a force
either undermining or redeeming us from the immanence of modern
temporality, its ephemerality and contingency, its dialectic of the unique
and the reproducible, myth and enlightenment. As a result, both projects
tend to foil Groys's hopes for video installation art as an art of the
contemporary, of making us explore a productive give-and-take be-
tween the reproduced and the unique or auratic.

As it reduces what chapter 6 discussed as the structural ability of
video to explore perceptions of interlaced time, *Last Riot* maps mod-
ern time as a permanent catastrophe, a disastrous repetition of al-
ways the same destructiveness. Whereas Wagner himself, famously,
condemned fashion as an expression of (French) self-indulgence and
lack of substance, *Last Riot* presents the cool look at contemporary
youth and computer gaming culture as a fundamental attack on the
foundations of Western notions of humanism and enlightenment prog-
ress. Wagner's music here is meant to underscore the fact that history,
in the age of both technology and fashion gone wild, has nowhere to
go anymore—that our hell is the here and now, as our present has lost
any remnant of transformative energy and instead repeats violent fan-
tasies with digital precision forever. In AES+F's bleak view of the pres-
ent, time indeed has become space as *Parsifal*'s Gurnemanz proclaimed,
and both Wagner and slow-motion photography appear as the most
appropriate tools to represent this violent collapsing of modernity back
into myth.

Slowness in Viola, at first, seems to serve a reverse reading of Wag-
ner, one according to which modernity never emancipated itself from
myth in the first place, one in which each present replays ahistorical
archetypes ingrained into the human soul long before the advent of
historical, chronological time, yet also one in which things do not drive
toward destruction and apocalypse, but rather utopian transcendence,
a vision of spiritual cleansing and levitation. Whereas in *Last Riot* the
combination of Wagnerian leitmotifs and decelerated video images ex-

presses a burden that cannot but destroy modern civilization, in Viola
slowness is to unearth, expose, and underscore the redemptive light-
ness of Wagner's music drama, its promise to carry us beyond our-
selves, defy the painful gravity of existence, and return—ascend—to
what has always already been there. And yet, in spite of their funda-
mental differences, it is difficult to overlook what both *Last Riot* and
Tristan Project share with each other. Instead of exploring slowness as
a conduit of heterogeneous, unpredictable, and open space-time, both
Viola and AES+F identify slowness as a direct correlate to what they
consider the merely mythic, ahistorical, and unbending nature of Wag-
ner's music, of Wagner's desire to erase historicity and produce stasis,
to seamlessly replace time with space. Whether they envision the
apocalypse of modern culture or the redemptive possibilities of self-
transcending love, both projects embrace slowness as a quasi-natural
sign of the inevitable, of the linearity of fate, of the lure or violence of
the mythic, whereas the true challenge would have been to explore
robust modalities of aesthetic experience that open our minds and
senses to the present in all its conflicting temporalities, memories, and
anticipations.

In spite of considerable difference in form and content, then, both
Last Riot and *Tristan Project* pursue slowness as medium to redefine
art as a form of contemporary religion: a site at which observation be-
comes observance; a site of pilgrimage at which the future of human
spirituality—eternal meanings and the idea of the human—is at stake;
a site to which viewers come in search of reenchantment or to mourn
the fundamental absence of the sacred. Terry Smith reminds us that
this desire to remap contemporary art as religion is far from idiosyn-
cratic and has many precursors: "It is commonplace in the discourse
surrounding culture that art, along with sport, has taken the place of
organized religion in modern societies. For centuries museums have
evoked the ethos of temples—museums of art especially so."[18] What is
remarkable, however, is the extent to which contemporary (installa-
tion) art in the work of AES+F or Viola, in communicating redemptive
desires for a world repopulated by gods and timeless spirituality, denies
its own contemporaneity. In *Last Riot* and *Tristan Project* the pre-
sumed slowness and mythical power of Wagner's music serves no other
purpose than to collapse temporal multiplicity and press it into one

authoritative form or narrative. Slowness, here, is to suspend the very back and forth between the unique and the reproducible that, for Groys, is at the core of the contemporary. While feeding directly into the heated circuits of the contemporary art market, its aim is to move us out and beyond time and thereby to obstruct the very possibility of experience rather than to make us face the disenchanted and messy presentness of incommensurable temporalities today head-on.

4 /

To experience what exceeds and denies experience, on the other hand, is at the center of *Point Omega*'s search for other times and spaces. Weary from providing American warfare in Iraq with conceptual frameworks, DeLillo's Elster seems to desire nothing so much than to account for the relativity of human affairs vis-à-vis the *longue durée* of geological time, the deep history of the landscape and of the earth. His desire is not to end desire, but rather to experience a different scale, a different analytic, of how to measure the passing of things. What he is after is not to find new gods or sources of spiritual enchantment in the desert, but to experience time in ways different from how cities, watches, modern transportation systems, global economies, and sur-veillance cameras have come to rationalize movements and structure possible transformations. If his ambition as an intellectual was to ex-plain and carry out war like a haiku poem—minimalist, with every-thing in sight, concise and compact, yet fully attentive to the passing of things—the desert's austerity offers a stage for reflection about the fail-ure of his former ambition. "Day turns to night eventually," Elster re-flects about his surrounds, "but it's a matter of light and darkness, it's not time passing, mortal time. There's none of the usual terror. It's different here, time is enormous, that's what I feel here, palpably. Time that precedes us and survives us" (44).

Though he has not much of track record as a filmmaker, Finley's own ambition, too, is to explore alternate temporalities of cinematic representation or in fact allow the presentational possibilities of the cinematic to take over the viewer's representational demands. Finley refers to Alexander Sokurov's monumental narrative film *Russian Arc*

(2000), shot in one ninety-six minute take while swiftly traversing a myriad of layers of Russian history, in order to explain his project. All he wants is Elster, situated in front of a naked wall, his face directed to the camera as he talks, thinks, pauses, and might talk again—an unedited record of the pure passing of time as being produced by, rather than merely reflected on, the interviewee's face. "Who you are, what you believe," he explicates the project to Elster, "Other thinkers, writers, artists, nobody's done a film like this, nothing planned, nothing rehearsed, no elaborate setup, no conclusions in advance, this is completely sort of barefaced, uncut" (53). Extreme long-take cinematography, for Finley, is to approximate Elster's search for deep time. It promises an ideal technique in order to explore the long breath of experience, understood as a matrix of conflicting temporalities; the embeddedness of human time in temporalities that exceed human finitude; the hovering of the subject between what can and what cannot be controlled, between the simple and the complex, the determined and the indeterminate, between global society's relentless speed and the landscape's almost unchangeable nature.

Concerned about the future of education in a rapidly industrializing society, in 1889 Friedrich Nietzsche wrote,

> The youth have to learn to *see*, they have to learn to *think*, they have to learn to *speak* and *write*: the object in all three cases is a noble civilization.—To learn to *see*—to accustom the eye to quietness, to patience, to reserve; to postpone judgment, to survey and comprehend each case from all sides. This is the *first* preliminary schooling for intellectuality: *not* to react immediately upon a stimulus, but to get the checking, the settling instincts in hand. Learning to *see*, as I understand it, is almost the same thing as in unphilosophical language is called strong will: the essential thing there is just *not* to "will"—the ability to defer decision.[19]

Though seemingly a text about the conundrums of aging, *Point Omega* might nevertheless be read as a novel centered around characters in search of Nietzsche's art of slow seeing. What both Elster and Finley perhaps desire most, in the respective stages of their careers, is to accustom their perception to quietness: to learn the art of hesitation and waiting; to lessen the pressures of the instincts, of producing

ongoing judgments, for the sake of increasing the space for reflection, for thought. To learn how to see and not to will here is meant to open a window on experience. It enables the subject to probe and relax its own contours in the face of what simultaneously exceeds and produces the hardened structures of subjectivity—the finitude of human time, the fact that we do not own our bodies and senses as we do an object. If Elster enters the novel as a man fatigued by the burdens of instrumental reason, the desert's art of seeing is meant to move him through fatigue beyond it and hence allow him to contemplate what resists contemplation, including the violence and absurdity of American war operations in Iraq and Afghanistan. Good seeing here becomes a portal to good thinking reminiscent of the way in which the Greek word for *theory* meant nothing less than to contemplate, to speculate, to look at things and thereby to behold of them.

Slowness, in Nietzsche's understanding, was the privileged medium of being timely and untimely at once: to face one's present head-on, yet not to yield to its relentless demands and pressures. Elster's retreat to the desert and Finley's project of slow filmmaking pursue something quite similar. Their desire is not to reduce complexity—the principal feature of modern life—to a zero degree, but to find appropriate vantage points to measure and assess the complex interactions between subjective and nonsubjective temporalities. The choice of the novel's title is paradigmatic in this respect. It is borrowed from the unorthodox Catholicism of Teilhard de Chardin, whose work described life on earth developing toward a maximum point of complexity and consciousness. Though Chardin's Omega Point, in the final analysis, resides outside, before, and beyond time, it describes the quasi-transcendental condition for the possibility of historical development and reflection. As the presumed culmination of human evolution, the merging of the human and the divine, it surely involves a certain teleological dynamic, yet, in contrast to the spiritualized humanism of a Bill Viola, Chardin's Omega Point knows of neither messianic nor redemptive impulses, nor of a desire to cancel the very work of both complexity and consciousness. Elster's retreat to the desert, his quasi-Nietzschean will to relearn the art of seeing and thinking, is driven by such a nonredemptive openness toward complexity, a heightening of consciousness and reflection based on a certain suspension of judgment and the instinctual. Elster's

slowness describes a project of neither fleeing into a spiritualist cele-
bration of timeless humanism nor into apocalyptic and posthistorical
antihumanism, but of seeing and thinking calmly in the face of the
complexities of the present—probing the contours of what may count
as human in the first place and refracting historically hardened no-
tions of subjectivity by exposing one's self to what is nonhuman and
incommensurable.

"Time falling away. That's what I feel here," Elster contemplates his
life in the desert toward the end of the novel. "Time becoming slowly
older. Enormously old. Not day by day. This is deep time, epochal time.
Our lives receding into the long past. That's what's out here. The Pleis-
tocene desert, the rule of extinction" (72). Elster's project of slowness
is twofold: it seeks to tap in and open up to temporalities that exceed
the human, yet in doing so it also aspires to reflect on and refract the
violence that shapes the contemporary, including the kind of violence
Elster himself advocated as a government intellectual. Unlike the os-
tentatious gestures of both AES+F and Bill Viola, this project of slow-
ness includes the possibility of its own failure. It rests on the insight
that neither life nor art is ever large enough to produce totality and
that contemporaneity cannot but frustrate any hope for finality and
redemptive closure. It is, perhaps for this reason that the internal struc-
ture of DeLillo's novel gives the reader plenty of reasons to think of
both Elster's and Finley's project as failures of sorts. While both men
ponder at some length about the relativity of human life and temporal-
ity in face of the desert's epochal time, the sudden and unexplained
disappearance of Elster's daughter will deeply unsettle their itineraries
and suspend their respective exercises in slowness, the real here bru-
tally stalling the efforts of thought and contemplation. But this sense
of failure, in the final analysis, might actually testify to what slowness,
as a strategy of the contemporary, is all about. It confirms at the level
of literary form what can be learned from watching Gordon's 24 *Hour
Psycho* attentively, namely that slowness at its best invites the subject
to recognize its own limitations while exploring the unstable space
between the unique and the reproducible, between the ephemeral and
the seemingly timeless, between the fickleness of human time and the
deep or steady temporality of geological formations and modern ma-
chines of information storage.

5 /

Computers are ultimately numb and dumb, says Korean philosopher Byung-Chul Han, because they—in spite or perhaps because of their enormous ability to process information—are unable to hesitate and ponder; they read data, infatigably as it were, as something entirely present and self-identical and thus precisely fail to turn textual folds and fissures into sites of meaning making.[20] DeLillo's *Point Omega* works hard to make the reader evade such numb- and dumbness. Like Gordon's *24 Hour Psycho*, DeLillo's text wants to be read two words a second. It leads the reader into a desert of language in which each word counts like a tiny plant creeping up between the rocks. While the novel itself is utterly short, it stretches right in front of the reader's eyes into something remarkably extended—a texture of epic proportions. Unlike other contemporary authors concerned with the theme of slowness (think of Stan Nadolny's 1987 *The Discovery of Slowness,* Milan Kundera's 1995 *Slowness,* and J. M. Coetzee's 2005 *Slow Man,* as well as the weaving prose of W. G. Sebald), DeLillo investigates slowness as a means to radically question the politics of narrative time and remake the modes of readerly attention. His writing withholds narrative riches and delays conclusive answers with the aim of awakening us from our ordinary numbness. Let's take a final closer look at some of the formal properties of *Point Omega* in order to understand DeLillo's programmatic poetics of slow reading in greater detail.

In an early review of *Point Omega*, John Banville describes Don DeLillo as a poet of entropy and calculated strategies of withholding: "The world he sets up in his fictions is a tightly wound machine gradually running down, and in it all action is a kind of lapsing drift. . . . It is as if in the last third of the twentieth century and the first, amazing decade of this one, public life has been so violently loud that anyone hoping to be heard must speak in an undertone that will call attention to itself by being fascinatingly unlike all the rest of the surrounding clamor."[21] *Point Omega* is an exercise in withholding noise and reconstructing the possibility of articulation. The author's language is terse and understated, a diction at the brink of trying to vanish into itself. Sentences appear clipped to their grammatical minimum or often even escape proper completion so as to avoid clutter and increase our sense

of density and precision. No word is wasted; no paragraph runs on for more than a few lines. Dialogues are sharp, yet often also packed with non sequiturs, with incantations whose challenging logic borders the surreal. Geoff Dyer considers DeLillo's mixture of the demotic and evocative, of utter simplicity and profundity, truly hypnotic.[22] What it does to the reader, however, is not to push and pull our reading forward, but to make us pause and hesitate. To take in each and every word as if language here spoke itself and wanted us to wonder about its own coming into being. To explore the spaces in between different letters, words, sentences, paragraphs, and sections as ruptures of unsettling memory and anticipation, of thought and fantasy; as sites that disturb our usual train of comprehension and attention and thereby suspend the linearity associated with ordinary reading. Each word, each phrase, strikes the reader as if being wrest away from the deserts of utter silence. Each mark on the page thus reverberates with and reminds us of everything that remains and must remain unsaid, that exceeds communicability no matter how much we desire to grasp the text's meaning.

It is tempting at first to think about the linguistic minimalism of *Point Omega*—language that engages with the very possibility of meaning and expression—as a perfect vehicle for audiences raised with text messaging, Twitter, and other forms of electronic short formats. DeLillo's prose, some might want to add, seems perfectly suited for readers with severely diminished attention spans, for readers no longer able or willing to navigate extended narrative arcs or expose their minds to unwieldy syntactic constructions. Yet nothing could be more wrong than to equate the experience of reading DeLillo's haikulike language with the way in which cell phones and other gadgets increasingly transform reading into something we do in mid-stride and on the fly, with little patience for semantic ambivalence and as an integral aspect of our accelerated movements through screen culture such that we rarely find ourselves in a position not to react immediately to a textual stimulus and not to defer possible judgments, decisions, and responses. To make us wait, hesitate, and delay instant reactions is what DeLillo's minimalism is all about. To explore the space and time in between individual words and sentences—the silent and unsaid as sites of potentiality or virtuality—is what DeLillo's compact prose encourages readers to do.

His ideal reader is not one reading on the fly and in mid-stride, but on the contrary one who no longer expects a text that takes us safely from one point to another and one who encounters the text as a fabric of unpredictable and often incommensurable temporalities.

In one of many recent publications on the art of reading, Pulitzer Prize–winner Jane Smiley considers the peculiar act of writing and reading a novel as a profound contribution to the process of Enlightenment—a kind of Enlightenment enlightened about itself and no longer repressing the other of reason: "The way in which novels are created—someone is seized by inspiration and then works out his inspiration methodologically by writing, observing, writing, observing, thinking through, and writing again—is by nature deliberate, dominated by neither by reason nor emotion."[23] According to Smiley, the act of reading a novel recreates an author's deliberate negotiation of affect and rationality. As readers follow the lines of a (good) book, they remain in relative control over the speed of their reading, able to pause when necessary, to hasten forward when desiring so, to reread certain passages at their leisure, and to close the pages of the book when overtaken by exhaustion. Good stories rely on intricate plots and narrative tensions, but they also situate readers as subjects freed from the temporal determination and teleological drive of other time-based media. Good books certainly have the power to move readers, but—following Smiley's logic—they will not curtail a reader's freedom to move along in the text at her own speed; hence they will allow this reader to simultaneously bring into play emotion and reason, the absorptive and the distant.

DeLillo's *Point Omega* advocates such an aesthetic of slow reading, slowness here expected not to open a therapeutic window to redemption and the eternal, but to help deliberate the multiple and conflicting streams of time that characterize our contemporary moment. Though much about this novel must remain enigmatic and obscure, there are good reasons to argue that it in fact offers the reader a potent allegory of how it wants to be read in the first place. Consider, once more, the book's at first rather puzzling architecture: the story of a haunting loss bookended, and perhaps even produced, by an anonymous man's experience of watching Norman Bates committing his heinous crime in

prolonged detail. The fates of Elster, his daughter, and Finley, we are led to believe, are nothing other than part of this man's mindscape: an imaginary that is shaped by certain motifs of Hitchcock's film, yet owes its existence to viewing Gordon's decelerated version and to how this installation, precisely by slowing down the speed of narrative time, enables viewers to make up their own stories. What the man at the wall does to Gordon doing to Hitchcock is what DeLillo wants his readers to do to his own prose as it captures the work of the man's imagination. Like Gordon's frames, DeLillo's sentences inch toward the monadic and static. Barely moving, they open up startling folds within the given textures of time in the hopes of encouraging the reader to travel toward what cannot be named or predicted by the text itself. If fast readers understand how to anticipate upcoming meanings and structures within the present window of perception, DeLillo's at once succinct and jagged prose asks us at once to read at our own pace and to allow the text to move our act of reading. It seeks to elicit both distance and absorption, the reflective and the hallucinatory, not in order to relish the temporal sovereignty of the reading subject, but rather to make us explore what remains hidden amid the maelstrom of anticipation and narrative time. To read slowly, here, means to become drawn into the sheer strangeness of linguistic expressions as much as it means to ponder what exceeds intuitive understanding and logic. Like Nietzsche's art of slow seeing, slow reading in DeLillo's perspective aspires to transport readers beyond expectations of control, willfulness, and mastery; it offers an interface across what exceeds the neoliberal stress of self-management. To read slowly, for the reader of *Point Omega*, is to be mindful of the fact that good reading requires the unsaid and the forgotten, a text's and the reader's unconscious, so as to touch upon a reader's life and challenge the strategically hardened boundaries of contemporary subjectivity. Like the man exposing himself to the experience of *24 Hour Psycho*, slow reading, at its best, is a matter of allowing oneself to be deeply unsettled by what is right in front of our eyes. It suspends our desire for instant judgments and interpretative decisions in order to open up our minds to nothing less than the possibility of the unexpected—of curiosity and wonder.

"He found his place at the wall," we read toward the very end of *Point Omega* as we return once more to MoMA, the man, and Gordon's installation, "He wanted complete immersion, whatever that means. Then he realized what it means. He wanted the film to move even more slowly, requiring deeper involvement of eye and mind, always that, the thing he sees tunneling into the blood, into dense sensation, sharing consciousness with him" (115). The immersive, in the man's understanding, neither entails an oceanic, quasi-Wagnerian loss of self and consciousness nor aims at collapsing temporal multiplicities into one grand spatial now. It instead constitutes itself as a curious effect of what Boris Groys's theorized as the contemporaneity of video installation art, namely the fact that reproducibility today can produce experiences of the unique and the auratic or, more precisely, that in contemporary media cultures our very awareness of the materiality of mediation and the institutional frameworks of display may no longer eliminate or control, but in fact produce the possibility of affect. The man's experience in front and in the midst of Gordon's installation is not that of Bill Viola's viewers who are meant to entirely surrender their subjectivity to the enveloping sights and sounds of timeless meanings. Nor is it that of AES+F's spectator cynically asserting that time and history have come to an end because they simply repeat themselves forever as a violent spectacle and that we therefore have nothing anymore to hope for. As contemplated by DeLillo's anonymous man, the slowness of immersion does not offer a mechanism to escape the present and redeem the subject from the demands of history—its losses, its ruptures, its movements, its promises. Instead it provides a site to practice what Kracauer considered the art of waiting and hesitant openness, understood as a peculiarly modern attitude of encountering the present as a place of potentiality, becoming, contingency, and finitude. For DeLillo's man and secret narrator (as for Kracauer), time is far too precious to be reduced to one unified logic, state, or vector. Slowness, for him, is what allows the subject to regain and warrant experience in its most emphatic sense: to sense time in all its heterogeneity and resist any impatient attempt to collapse temporal multiplicities into self-contained unity, whether we call this unity the state of redemption, the apocalyptic end of history, or the ecstasy of the now and its regime of accelerated time. As a strategy of the contemporary, slowness teaches

us the art of living in a world of modern disenchantment without being overcome by the absence of the eternal or the universal, including speed culture's myth of the infinity of real time.

"Real time is meaningless. The phrase is meaningless. There's no such thing. On the screen Norman Bates is putting down the phone. The rest has not happened yet" (115).

EPILOGUE

SLOWNESS AND THE FUTURE OF THE HUMANITIES

While the prized object of modern print culture, the book, may not have much of a lifespan anymore, our age will certainly not be remembered for a dearth of writing. The production and dissemination of written language today clearly trumps that of any other age, with e-mail defining new standards for the speed and instantaneity of mediated exchange, with blogs collapsing what previous eras considered the lines between the intimate and the public, and with text messaging serving as a virtual lifeline for an entire generation. Some twenty years ago the buzzword of academic and cultural criticism was that of a visual or pictorial turn, meaning not simply to register how images had come to replace words in postmodern culture, but to analyze how pictures in the widest sense possible increasingly served as conduits of thought, reflection, and theory.[1] The surfeit of electronic writing in the first decade of the twenty-first century should give us cause to wonder whether this turn toward the pictorial was as unified and complete as critics had argued, pedagogues had lamented, and media developers had envisioned. Even those once considered most susceptible to the vertiginous pull of advanced image cultures, namely children and teenagers, today perhaps read and write more than they have ever done before. No generation has been more agile and efficient in communicating with the help of the written word than the one of contemporary adolescents,

their thumbs intuitively utilizing ever new keyboard gadgets, their eyes proficiently scanning verbal messages from whatever screen may inhabit their surroundings.

Haunted by ever increasing publication pressures on the one hand, and on the other the looming displacement of the book as the principal conveyor belt and storage tool of knowledge, debate, and criticism, scholars in the traditional humanities may find little consolation in the recent surfeit of mobile electronic writing. We celebrate mobility in the academic job market and on the lecture circuit, we secretly admire those able to compose presentations, essays, or entire books while jet-setting from one conference to another. But a texter's strategies of writing on the fly remain far from meeting with widespread approval among academics as a preferred medium for communicating critical insight and analysis. Neither ungrammatical brevity nor traceless ephemerality are key to what writing in the humanities seems to be all about, while traditionally a certain absence of physical agitation has been considered to be a precondition for allowing better arguments to triumph over weaker ones. Writing and reading in the humanities have certainly been deeply affected by how the speed of digital culture has changed the way in which we process research, thought, and critical exchange; ubiquitous online resources and electronic dissemination formats allow people to write in ever shorter time frames, urge writers to develop strategies of compositional multitasking and promote analytical methods of distant over close reading, data mining over deep symbolic examination. At the same time, however, critical or not so critical writing practice in the humanities continues to be deeply associated with the slow time of an earlier century's bourgeois intellectual culture. We enjoy crafting complex grammatical structures and developing recognizable stylistic registers; we have vowed to check every quote and footnote at least three times before moving our essays on to publication; and we continue to hope for and presuppose readers willing to engage with each and every one of our words and arguments no matter how many other texts, images, sound bites, e-mails, Facebook updates, tweets, and apps may call for their attention at the same time.

In our twenty-first century culture of informational overflow and electronic mobility, the competition for enabling and maintaining attention may turn out the century's primary battleground. Amidst

ambient digital screens and seemingly unlimited streams of texts and images, sovereign might as well be he who rules over our ability to focus—she who succeeds in controlling the rhythms of our awareness, in managing how we dedicate prolonged periods of time to certain subjects while ignoring others and thus in manipulating our sense of recall, anticipation, and presence. Scholarly writing in the humanities today often appears ill prepared to participate in this raging battle over attention. With considerable envy and self-loathing, we try to meet the expectations of technological innovation, speed, mobility, and up-to-dateness imposed by our students, university administrators, and colleagues in the hard sciences, but at the same time we cannot help but feel obliged to hang on to the valuable traditions of pondering critical theory and slow hermeneutical or symbolic analysis. The result, in many cases, is one either of self-denial and opportunistic accommodation or of melancholic despair and withdrawal. A sense of pending defeat has thus in fact become part of the modus operandi of much of our writing in the humanities. Perpetually unhappy about what others denigrate as our unbending slowness, we have lost our zeal to explore new territories and take on the task—through our writing, arguing, and debating—to inspire and frame critical conversations about the itineraries of contemporary culture, including those itineraries that far exceed the range of our primary disciplines. Rather than urge continual reflection about the unequivocal relationships between technology and culture, progress and memory, instrumental reason and aesthetic experience, we either simply seek to emulate the methods of scientific inquiry in the hopes of receiving greater attention for our work or we consider our writing—cynically or narcissistically, as it were—as a practice marked by perpetual belatedness, as being fundamentally out of sync with the speed and technological exigencies of today's academy. At best, we boost our egos by closely following the frenzied wake of our colleagues in, say, the neurosciences and information technology. At worst, we glorify our perceived lack of public attention as our heroic mission, vindicating writing that is out of step with the dominant economies of attention as an academic author's most secret weapon.

If the readings of the preceding chapters have at least some validity, they should provide scholars in the humanities with some good argu-

ments to bolster their various endeavors and rethink the common (self-)perception of their writing as being helplessly behind the itineraries of the day. As understood throughout the pages of this book, aesthetic slowness fosters contemporaneity because it defies views of history as a linear and successive sequence of events according to which the new would simply displace the old, and the fast and instantaneous would erase the possibility of the hesitant and measured. Slowness, in other words, allows us to recognize the dynamic simultaneity of multiple speeds of change and movement without relegating some to the closed space of the past and celebrating others as singular pathways into the future. There is no reason why we should not apply this perspective to the presumed rivalry between the speed of scientific and technological innovation and the sluggishness and belatedness of literary or cultural inquiry. Humanist writing today, in fact, needs to learn how to turn its own (self-)perceived slowness into an engine of critical analysis and insight. Instead of mourning its possible demise, it needs to actively involve itself in and reflect on today's battle over attention, not least of all by arguing against monolithic visions of history, development, change, and movement. If mobility means more than merely moving most effectively from point A to point B, then our writing in the humanities should play a privileged role in providing maps of time and change in whose context the advances of scientists, engineers, economists, literary critics, and artists can be understood as contemporaneous no matter how much the speeds of individual trajectories of development might differ from each other. A frantic texter on the subway may not have time to follow the sprawling prose of a Marcel Proust or W. G. Sebald, but it is the critical task of humanist writing today to explicate that the output of the former doesn't simply replace the work of the latter because both, for instance, share similar concerns about the relation of movement and writing, and because the very act of writing is never entirely defined by the materiality of its specific medium alone. Silver halide film may be difficult to come by today, but academic writing in various branches of the humanities can illuminate the extent to which the codes and conventions of analogue photography continue to inform the practice of digital photographers today and thus remain essential to understand the meaning of photography in the first place. While many scholars in the humanities cannot help but see

themselves on the defense in their various institutional settings, their work remains of critical importance in providing differentiated accounts of progress and in revealing the copresence of different durations, of past and present, in our efforts to move into the future.

Let me conclude with a brief example.

A few miles east of the remote village of Tabant (figure 9.1), in one of those strikingly green valleys that dissect the mountains of the High Atlas in Morocco, hikers will come across a unique geological site showcasing a number of dinosaur footprints across a slate of gray limestone. Once you have reached the site and turn west, you will be able to capture the following within the frame of one photographic image: a whole series of dinosaur traces in the foreground, left in what must have been softer ground about 185 million years ago; a pole used during harvest periods to chase a chain of mules in circles and have them thrash wheat; Berber houses built out of mud, clay, and brick, their materials once quarried on the spot, their particular architectural style solely to be found in certain parts of Morocco, Yemen, and Afghanistan; a satellite TV dish, mounted on the wood-and-straw roof of a nearby house and pointing up to the southern sky so as to capture signals for all those who, aside from their cell phones, desire additional means of connecting to the world beyond the valley; a small mosque on the left, its minaret sticking into the blue sky, loudspeakers on either side replacing the imam's unmediated voice during prayer time. While trying to take your picture, local kids will inevitable surround you, at times sneaking up from behind, at times brightly smiling at you. And if you hang on a little longer, it is also quite likely that some residents will invite you for sweet mint tea and try to find out what may have brought you to this rather isolated corner of the world.

D'Ilbakliwine, the site's transcribed name, has the potential to keep a whole group of scientific researchers busy with lots of different projects. Paleontologists could research the different types of dinosaurs that, during the Jurassic age, populated this area. Geologists could research the peculiar formations and transformations of the ground enabling the preservation of these traces. Climatologists could analyze long-term weather patterns helping to petrify softer grounds without washing away imprints on the earth's surface. Architectural historians could examine the historical development of Berber architecture and,

FIGURE 9.1. D'Ilbakliwine, Morocco (2010). Courtesy of the author.

in collaboration with migration historians, advance models of transcultural influence and exchange. Scholars of agriculture could explore the effectiveness of traditional harvesting methods and the limits of Western models of technological modernization within small-scale and patchwork farming communities. Sociologists and pedagogues could investigate the role of child labor in everyday life and its impact on family or community structures. Communication experts, economists, and cultural anthropologists could examine the impact of mass media, such as satellite television and cell phone connectivity, on highly traditional lifestyles, and explain the financial as much as the cultural flows that now connect faraway regions to metropolitan centers. And experts of religious and media studies could jointly illuminate the extent to which technologies of mechanical amplification and reproduction have changed religious rituals and prayer routines.

The photographic image, to be shot at less than 1/250th of a second to meet the intensity of Northern African light, tells a somewhat different story, though. Our researches may at first think of what we see in this picture as a rather typical contradiction of developing nations. The copresence of the seemingly archaic and the modern, for them as for many others, might be indicative of an uneven and hence precarious path toward Western modernity, one that may yield all kinds of potential problems and violent outbursts in the long run. What the photographic image encourages us to do, however, is to recognize the meeting of various durations, temporal rhythms, and stories as an opportunity and a promise, as a scene of contemporaneity instead of contradiction, of pluralistic notions of mobility instead of unresolved progress. Rather than anticipate future calamity where multiple logics of development encounter each other, the image urges us to understand this particular moment and space, not as one somehow partially frozen in the past, but as one fully embedded in the now and its transition toward an open future. The utter slowness of geological time here coexists with the speedy connectivity of the digital age; the circular temporality of agricultural routines and religious rituals is rendered visible with the help of the disruptive shutter of the camera; the unpredictable vagaries of the climate appear as copresent with the relative stability of architectural traditions and building materials.

Similar to the photograph one may take at D'IIbakliwine, what this book has examined as contemporary slowness is our ability to perceive and represent the simultaneity of different temporalities within the space of the present; it sharpens our sense for the coexistence of old and new, the fast and sluggish, the continuous and the disruptive, without necessarily asking us to prioritize one over the other or conceptualizing different timelines and durations as part of a unified (or, for that matter, dialectical) dynamic. No matter how fast our own times may have become, slowness is what allows us to recognize given spaces as heterogeneous because it allows us to see dissimilar rates of change, movement, and mobility at work at the same time. Our writing in the humanities, however slow and outdated it may be perceived by other scientists and administrators, has the potential to achieve something quite similar. Instead of dedicating itself to the examination of one specific trajectory of change alone, it has the unique ability to make us hesitate and think about the interaction of various dimensions of temporal progression and their impact on the production of cultural meanings, orientations, and values. And, instead of allowing itself to be marked as being out of step with the clocks of technological or scientific progress, the slowness of work in the humanities has every right to claim unconditional contemporaneity whenever it aspires to complicate existing templates of progress and mobility and thus help envision alternate mobile futures. To go slow, for scholars in the humanities, does not automatically mean to yearn for a pretechnological past or resist what drives us into the future. It simply means to take the time to gaze straight into the face of the present, to comprehend this present in all its multiplicity and obscurity—and, hence, to do exactly what, according to Giorgio Agamben, it takes to be a contemporary, namely to be able to be timely and untimely at once.[2]

In book 11 of his *Confessions,* Saint Augustine famously grappled with trying to define the nature of time: "I know well enough what it is, provided that nobody asks me; but if I am asked what it is and try to explain, I am baffled."[3] In order to overcome his state of perplexity, Saint Augustine offered the notion of *distentio animi,* of the distention or extension of the mind. Accordingly, time cannot be thought without considering the mind's ability to stretch in different directions and constantly negotiate the ground between expectation, memory, and

attention. In order to explain the nature of time, in other words, we need to investigate the movements of the mind as it anticipates, attends, and remembers certain events from the vantage point of a transitory present.[4] Slow writing today, whether it unfolds in the arenas of academic inquiry, literary fiction, or electronic communication, remains dedicated to such acts of temporal stretching. It may harbor legitimate doubts about the value of compacting each and every exchange into user-friendly packages of 160 characters. But in its efforts to be contemporaneous to the march of time, it cannot afford not to attend to the various speeds of life that mark our present and to recall and anticipate alternate models of extending, through writing, the mind (and, as post-Augustinians, body) into various pasts and futures. Slow writing today is not restricted to one medium alone. Its principal aim, however, is to explore and exhibit the manifold movements of the embodied mind and advance our attentiveness amid the ever increasing pressures of digital instantaneity and connectivity. To make us hesitate and baffle, to stun us with confusion, uncertainty, and wonder, is perhaps the single most important gift slow writing, in all its different technological configurations, has to offer today.

N O T E S

INTRODUCTION: ON SLOWNESS

1. For informative discussions and overviews, see, among many others, Carl Honoré, *In Praise of Slowness: How a Worldwide Movement Is Challenging the Cult of Speed* (San Francisco: HarperCollins, 2004); and Christian McEwen, *World Enough and Time: On Creativity and Slowing Down* (Dublin: Bauhan, 2011).

2. Victor Burgin, *In/Different Spaces: Place and Memory in Visual Culture* (Berkeley: University of California Press, 1996), 184.

3. See, for instance, Andreas Huyssen, *Present Pasts: Urban Palimpsests and the Politics of Memory* (Stanford: Stanford University Press, 2003).

4. See, for instance, Hans Ulrich Gumbrecht, *Production of Presence: What Meaning Cannot Convey* (Stanford: Stanford University Press, 2004).

5. For two general and useful approaches to the category of the contemporary, see Terry Smith, *What Is Contemporary Art?* (Chicago: University of Chicago Press, 2009); and Julian Stallabrass, *Contemporary Art: A Very Short Introduction* (New York: Oxford University Press, 2006).

6. Giorgio Agamben, "What Is the Contemporary?" *What Is an Apparatus? and Other Essays*, trans. David Kishik and Stefan Pedatella (Stanford: Stanford University Press, 2009), 41.

7. Ibid., 52.

8. Olafur Eliasson, *Your Mobile Expectations: BMW H$_2$R Project* (Baden: Lars Müller, 2008), 282.

9. Peter Weibel's term, ibid., 288.

10. Miriam Hansen, *Babel and Babylon: Spectatorship in the American Silent*

Film (Cambridge: Harvard University Press, 1991), 12–13; see also, by the same author, *Cinema and Experience: Siegfried Kracauer, Walter Benjamin, and Theodor W. Adorno* (Berkeley: University of California Press, 2010).

11. Rudolf Arnheim, *Film as Art* (Berkeley: University of California Press, 1957), 117.

12. For more on rhetorical relation between computing and neoliberalism, see David Golumbia, *The Cultural Logic of Computation* (Cambridge: Harvard University Press, 2009).

1. SLOW MODERNISM

1. Henri Bergson, *Time and Free Will: An Essay on the Data of Immediate Consciousness*, trans. F. L. Pogson (London: Dover, 2001), 10–11; Suzanne Guerlac, *Thinking in Time: An Introduction to Henri Bergson* (Ithaca: Cornell University Press, 2006), 47.

2. For the most comprehensive and insightful elaborations of these arguments, see Stephen Kern, *The Culture of Time and Space, 1880–1918* (Cambridge: Harvard University Press, 1983); Wolfgang Schivelbusch, *The Railway Journey: The Industrialization of Time and Space in the Nineteenth Century* (Berkeley: University of California Press, 1977); and Andrew Thacker, *Moving Through Modernity: Space and Geography in Modernism* (Manchester: Manchester University Press, 2003).

3. The connection between late nineteenth-century urbanization, the rise of aesthetic modernism, and increases in nervousness has best been analyzed with regard to the case of Germany. For paradigmatic work, see Michael Cowan, *Cult of the Will: Nervousness and German Modernity* (University Park: Pennsylvania State University Press, 2008); and Joachim Radkau, *Das nervöse Zeitalter: Deutschland zwischen Bismarck und Hitler* (Munich: Hanser, 1998).

4. Aldous Huxley, "Wanted, a New Pleasure," in *Aldous Huxley: Complete Essays*, ed. Robert S. Baker and James Sexton (Chicago: Ivan R. Dee, 2001), 3:263. For an insightful discussion and apology of Huxley's text, see Enda Duffy, *The Speed Handbook: Velocity, Pleasure, Modernism* (Durham: Duke University Press, 2009), 17–57.

5. For a paradigmatic version of this argument see, Peter Weibel, *Die Beschleunigung der Bilder* (Bern: Benteli, 1987).

6. See among other, Kobena Mercer, ed., *Cosmopolitan Modernisms* (Cambridge: Institute of International Visual Arts, 2005); Terry Smith, Okwui Enwezor, and Nancy Condee, eds., *Antinomies of Art and Culture: Modernity, Postmodernity, Contemporaneity* (Durham: Duke University Press, 2008); Miriam Hansen, "Foreword," in *Public Sphere and Experience: Toward an Analysis of the Bourgeois and Proletarian Public Sphere*, by Oskar Negt and Alexander Kluge, trans. Assenka Oksiloff and Peter Labanyo (Minneapolis: University of Minnesota Press, 1993); and, by the same author, *Cinema*

and Experience: Siegfried Kracauer, Walter Benjamin, and Theodor W. Adorno (Berkeley: University of California Press, 2011).

7. As it will become clearer later, my definition of aesthetic slowness is deeply indebted to the work of cultural geographer Doreen Massey, whose *For Space* (London: Sage, 2005) has played a crucial role in developing the arguments of this entire study.

8. Rosalind Krauss, *A Voyage on the North Sea: Art in the Age of the Post-Medium Condition* (London: Thames and Hudson, 2000); and "Two Moments from the Post-Medium Condition," *October* 116 (Spring 2006): 55–62.

9. Christine Poggi, *Inventing Futurism: The Art and Politics of Artificial Optimism* (Princeton: Princeton University Press, 2009), 27–29.

10. Filippo Tommaso Marinetti, "Technical Manifesto of Futurist Literature," in *Selected Poems and Related Prose,* ed. Luce Marinetti, trans. Elizabeth Napier and Barbara Studholme (New Haven: Yale University Press, 2002), 77–80.

11. Luigi Russolo, *The Art of Noise,* trans. Robert Filliou (New York: Great Bear Pamphlet, 1967).

12. Filippo Tommaso Marinetti, "The Foundation and Manifesto of Futurism," in *Art in Theory (1900–2000),* ed. Charles Harrison and Paul Wood (Oxford: Blackwell, 2003), 148.

13. Ibid., 148.

14. Ibid., 147.

15. Poggi, *Inventing Futurism,* 10; Poggi's reference here is to Sigmund Freud's thought on shock perception and protection in *Beyond the Pleasure Principle,* trans. James Strachey (New York: Liveright, 1950); to Walter Benjamin's appropriation of Freud's shock theory in "On Some Motifs in Baudelaire," in *Selected Writings,* vol. 4: *1938–1940,* ed. Howard Eiland and Michael Jennings (Cambridge: Belknap, 2003), 313–355; and to Jeffrey Schnapp's work on Futurism, "Crash (Speed as Engine of Individuation)," *Modernism/Modernity* 6, no. 1 (1999): 1–49.

16. Mary Ann Doane, *The Emergence of Cinematic Time: Modernity, Contingency, the Archive* (Cambridge: Harvard University Press, 2002), 87.

17. Consider, for instance, J. C. Taylor's 1961 interpretation: the figure "strides forth, a symbol of vitality and strength, yet its impetuous steps rests lightly on the ground as if the opposing air gave the figure wings. It is muscular without muscles, and massive without weight. The rhythms of its forms triumph over the limitations of the human stride to suggest unending movement into infinite space." Quoted in Ester Coen, *Umberto Boccioni* (New York: Abrams, 1988), 218. See also Poggi's more recent discussion in *Inventing Futurism,* 170.

18. Umberto Boccioni, "Technical Manifesto of Futurist Sculpture," ibid., 241.

19. Duffy, *The Speed Handbook,* 173.

20. Walter Benjamin, *The Arcades Project,* trans. Howard Eiland and Kevin McLaughlin (Cambridge: Harvard University Press, 2002), 105.

21. Benjamin, "On the Concept of History," *Selected Writings,* 4:392.

22. Ibid., 4:263; Miriam Hansen, "Benjamin, Cinema and Experience: 'The Blue Flower in the Land of Technology,'" *New German Critique* 40 (Winter 1987): 179–224.

23. Duffy, *The Speed Handbook,* 93.

24. Odo Marquard, "Zeit und Endlichkeit," *Zukunft braucht Herkunft: Philosophische Essays* (Stuttgart: Reclam, 2003), 220–233.

25. Lutz Koepnick, "0–1: Riefenstahl and the Beauty of Soccer," in *Riefenstahl Screened: An Anthology of New Criticism,* ed. Neil Christian Pages, Mary Rhiel, and Ingeborg Majer-O'Sickey (New York: Continuum, 2008), 52–70.

26. Ernst Bloch, *Heritage of Our Times,* trans. Neville Plaice and Stephen Plaice (Cambridge: Polity, 1991).

27. Siegfried Kracauer, "Those Who Wait," in *The Mass Ornament: Weimar Essays,* ed. and trans. Thomas Y. Levin (Cambridge: Harvard University Press, 1995), 138.

28. Paul Virilio, *Aesthetics of Disappearance,* trans. Philip Beitchman (New York: Semiotext(e), 1991); *Negative Horizon: An Essay in Dromoscopy,* trans. Michael Degener (New York: Continuum, 2008); Fredric Jameson, *Postmodernism, or, the Cultural Logic of Late Capitalism* (Durham: Duke University Press, 1991); and "The End of Temporality," *Critical Inquiry* 29, no. 4 (Summer 2003): 695–718.

29. Jameson, *Postmodernism,* 310.

30. Massey, *For Space,* 77.

31. Ibid., 24.

32. J. M. Bernstein, *Against Voluptuous Bodies: Late Modernism and the Meaning of Painting* (Stanford: Stanford University Press, 2006), 7.

33. See, for instance, Laura U. Marks, *Touch: Sensuous Theory and Multisensory Media* (Minneapolis: University of Minnesota Press, 2002); Vivian Sobchack, *Carnal Thoughts: Embodiment and Moving Image Culture* (Berkeley: University of California Press, 2004); Mark B. N. Hansen, *New Philosophy for New Media* (Cambridge: MIT Press, 2004); and *Bodies in Code: Interfaces with Digital Media* (New York: Routledge, 2006); Caroline A. Jones, ed., *Sensorium: Embodied Experience, Technology, and Contemporary Art* (Cambridge: MIT Press, 2006); Anna Munster, *Materializing New Media: Embodiment in Information Aesthetics* (Hanover, CT: Dartmouth College Press, 2006); and Bernadette Wegenstein, *Getting Under the Skin: Body and Media Theory* (Cambridge: MIT Press, 2006).

34. See, for instance, Barbara Maria Stafford, *Echo Objects: The Cognitive Work of Images* (Chicago: University of Chicago Press, 2007).

2. OPEN SHUTTER PHOTOGRAPHY AND THE ART OF SLOW SEEING

1. Henri Cartier-Bresson, *The Decisive Moment* (New York: Schuster and Schuster, 1952), n.p.

2. László Moholy-Nagy, "A New Instrument of Vision," *Telehor* 1, no. 2 (1936), quoted in Liz Wells, ed., *The Photography Reader* (New York: Routledge, 2003), 94. For a useful discussion of Moholy-Nagy's work on photography during the Weimar years, see Eleanor M. Hight, *Picturing Modernism: Moholy-Nagy and Photography in Weimar Germany* (Cambridge: MIT Press, 1995).

3. For a detailed discussion of Moholy-Nagy's tempo-driven filmscript *Dynamic of the Metropolis* (1925), see my *Framing Attention: Windows on Modern German Culture* (Baltimore: Johns Hopkins University Press, 2007), 152–157.

4. The reference here is to Marshall Berman's famous appropriation of Karl Marx's famous line, in *All That Is Solid Melts Into Air: The Experience of Modernity* (New York: Simon and Schuster, 1982).

5. For more on the industrialization, reconfiguration, and standardization of time in the late nineteenth century, see among other Stephen Kern, *The Culture of Time and Space, 1880–1918* (Cambridge: Harvard University Press, 1983); Richard Morris, *Time's Arrows: Scientific Attitudes Toward Time* (New York: Simon and Schuster, 1985); Robin le Poidevin, *Travels in Four Dimensions: The Enigmas of Space and Time* (Oxford: Oxford University Press, 2003); and Peter Galison, *Einstein's Clocks, Poincare's Maps: Empires of Time* (New York: Norton, 2004). China's unique continued clinging to the idea of one national time zone today reminds us, in reverse, of the way in which modernization placed considerable pressures on locally specific measures of time.

6. Charles Baudelaire, *Prose and Poetry*, trans. Arthur Symons (New York: Boni, 1926), 63.

7. For more on the material and symbolic history of the window in Western culture and its relation to twentieth and twenty-first centuries media cultures, see Anne Friedberg, *The Virtual Window: From Alberti to Microsoft* (Cambridge: MIT Press, 2006); Koepnick, *Framing Attention,* 1–26; and Sabine Eckmann and Lutz Koepnick, *Window | Interface: Screen Arts and New Media Aesthetics 2* (St. Louis: Mildred Lane Kemper Art Museum, 2007).

8. Siegfried Kracauer, "Cult of Distraction," in *The Mass Ornament: Weimar Essays*, trans. Thomas Y. Levin (Cambridge: Harvard University Press, 1995), 313.

9. Christian Metz, "Photography and Fetish," *October* 34 (Autumn 1985): 81–90. See also the intriguing discussions about the relation of fetishism to contemporary image culture in various chapters of W. J. T. Mitchell, *What Do Pictures Want? The Lives and Loves of Images* (Chicago: University of Chicago Press, 2005).

10. Walter Benjamin, "Paralipomena to 'On the Concept of History,'" in *Selected Writings*, ed. Howard Eiland and Michael W. Jennings (Cambridge: Harvard University Press, 2003), 402.

11. Lynne Kirby, *Parallel Tracks: The Railroad and Silent Cinema* (Durham: Duke University Press, 1997).

12. For more on trains and modernity, see, among others, Wolfgang Schivelbusch, *The Railway Journey: Trains and Travel in the Nineteenth Century*, trans. Anselm Hollon (New York: Urizon, 1979); and Todd Presner, *Mobile Modernity: Germans, Jews, Trains* (New York: Columbia University Press, 2007).

13. Heinrich Heine, *Lutetia*, pt. 2, quoted and trans. in Wolfgang Schivelbusch, "Railroad Space and Railroad Time," *New German Critique* 14 (Spring 1978): 34.

14. Norbert Elias, *Über den Prozeß der Zivilisation: Soziogenetische und psychogenetische Untersuchungen* (Frankfurt: Suhrkamp, 1976) II: 337–8. For more on networks, see also Michael Hardt and Antonio Negri, *Multitude: War and Democracy in the Age of Empire* (New York: Penguin, 2004).

15. For more on different concepts of the network, see, most effectively, Alexander R. Galloway, *Protocol: How Control Exists After Decentralization* (Cambridge: MIT Press, 2004), 29–53. For recent work on digital network culture, see, among many others, Lee Rainie and Barry Wellman, *Networked: The New Social Operating System* (Cambridge: MIT Press, 2012); Jose van Dijck, *The Culture of Connectivity: A Critical History of Social Media* (New York: Oxford University Press, 2013).

16. See, for instance, Hartmut Rosa, *Beschleunigung: Die Veränderung der Zeitstruktur in der Moderne* (Frankfurt: Suhrkamp, 2005), 112–160.

17. Doreen Massey, *For Space* (London: Sage, 2005), 107.

18. Gertrud Koch, "The Richter-Scale of Blur," *October* 62 (1992): 133–142.

19. For a theoretical scaffold helpful for analyzing the duality of the apparatical and the phenomenological, see Mark B. N. Hansen, *New Philosophy for New Media* (Cambridge: MIT Press, 2004); and *Bodies in Code: Interfaces with Digital Media* (New York: Routledge, 2006).

20. For more on the notion of existential and phenomenological custodianship, see Terry Eagleton, *After Theory* (New York: Basic Books, 2003), 208–222.

21. Quoted in Claire Bishop, ed., *Participation: Documents in Contemporary Art* (London: Whitechapel, 2006), 40.

22. For the latter, see, in particular, Eduardo Cadava, *Words of Light: Theses on the Photography of History* (Princeton: Princeton University Press, 1998).

23. Charles Baudelaire, *The Painter of Modern Life,* ed. and trans. Jonathan Mayne (New York: Da Capo, 1964).

24. Hal Foster, *The Art-Architecture Complex* (London: Verso, 2011).

25. Max Horkheimer and Theodor W. Adorno, *Dialectic of Enlightenment: Philosophical Fragments,* ed. Gunzelin Schmid Noerr, trans. Edmund Jephcott (Stanford: Stanford University Press, 2002), 230.

26. Karen Beckman and Jean Ma, eds., *Still Moving: Between Cinema and Photography* (Durham: Duke University Press, 2008), 17.

3. GLACIAL VISIONS, GEOLOGICAL TIME

1. Filippo Tommaso Marinetti, "The Pope's Monoplane: Political Novel in Free Prose," *Selected Poems and Related Prose*, ed. Luce Marinetti, trans. Elizabeth Napier and Barbara Studholme (New Haven: Yale University Press, 2002), 43.

2. Gertrude Stein, *Picasso* (1938; Boston: Beacon, 1959), 49–50.

3. Olafur Eliasson, *Colour Memory and Other Informal Shadows* (Oslo: Astrup Fearnley Museet, 2004), 92.

4. Michael Hambrey and Jürg Alean, *Glaciers*, 2d ed. (Cambridge: Cambridge University Press, 2004), 73.

5. Mark Twain, *A Tramp Abroad* (1880), quoted in Robert Macfarlane, *Mountains of the Mind: Adventures in Reaching the Summit* (New York: Vintage, 2004), 132–133.

6. Mark Godfrey, "Pierre Huyghe's Double Spectacle," *Grey Room* 32 (Summer 2008): 52.

7. Rosalind Krauss, *A Voyage on the North Sea: Art in the Age of the Post-Medium Condition* (London: Thames and Hudson, 2000).

8. www.ilanahalperin.com/new/greenland.html.

9. Peter Wollen, "Fire and Ice," *Photographies* 4 (April 1984): 118–120; reprinted in *The Photography Reader*, ed. Liz Wells (London: Routledge, 2003), 78.

10. Macfarlane, *Mountains of the Mind*, 108–109.

11. For a longer version of this argument, see my contribution to Sabine Eckmann and Lutz Koepnick, *[Grid < > Matrix]: Screen Arts and New Media Aesthetics 1* (St. Louis: Mildred Lane Kemper Art Museum, 2006), 47–75.

12. Rosalind E. Krauss, "Grids," in *The Originality of the Avant-Garde and Other Modernists Myths* (Cambridge: MIT Press, 1985), 8–22.

13. *Hiroyuki Masuyama*, ed. Beate Ermacora and Andrée Sfeir-Semler (Krefeld: Kaiser Wilhelm Museum, 2004), 9.

14. See, in particular, the work of Martin J. Rudwick, *The New Science of Geology: Studies in the Earth Sciences in the Age of Revolution* (London: Ashgate, 2004); *Lyell and Darwin, Geologists: Studies in the Earth Sciences in the Age of Reform* (London: Ashgate, 2005); *Bursting the Limits of Time: The Reconstruction of Geohistory in the Age of Revolution* (Chicago: University of Chicago Press, 2005); and *Worlds Before Adam: The Reconstruction of Geohistory in the Age of Reform* (Chicago: University of Chicago Press, 2008). See also Ralph O'Connor, *The Earth on Show: Fossils and the Poetics of Popular Science, 1802–1856* (Chicago: University of Chicago Press, 2007); and Richard Holmes, *The Age of Wonder: How the Romantic Generation Discovered the Beauty and Terror of Science* (New York: Vintage, 2010).

15. Macfarlane, *Mountains of the Mind*, 44.

16. John Ruskin, *Modern Painters: Of Mountain Beauty* (London: Smith, Elder, 1856), 4:353.

17. Slavoj Žižek, *The Parallax View* (Cambridge: MIT Press, 2006), 17.

18. A similar argument can, and perhaps should, of course, be made about the work of both Marey and Muybridge as well, freeing the experiments of both from narratives of cinematic paternity and thus interrupting the presumed path that lead from photography to chronophotography and then culminated in cinema. For more on this, see, for instance, Tom Gunning, "Never Seen This Picture Before: Muybridge

in Multiplicity," in *Time Stands Still: Muybridge and the Instantaneous Photography Movement* (New York: Oxford University Press, 2003), 223–228.

19. Laura Mulvey, *Death 24x a Second: Stillness and the Moving Image* (London: Reaktion, 2006); Barbara Klinger, *Beyond the Multiplex: Cinema, New Technologies, and the Home* (Berkeley: University of California Press, 2006). See also Gabriele Pedullà, *In Broad Daylight: Movies and Spectators After the Cinema* (London: Verso, 2012).

20. Raymond Bellour, "The Pensive Spectator," trans. Lynne Kirby, *Wide Angle* 9, no. 1 (1987): 10.

4. DREAM I TIME CINEMA

1. Walter Benjamin, "The Work of Art in the Age of Its Technological Reproducibility," in *Selected Writings*, vol. 4: *1938–1940*, ed. Howard Eiland and Michael Jennings (Cambridge: Harvard University Press, 2003), 266.

2. Béla Balázs, *Early Film Theory: Visible Man and The Spirit of Film*, ed. Erica Carter, trans. Rodney Livingstone (New York: Berghahn, 2010), 169.

3. Stephen Prince, "The Aesthetics of Slow-Motion: Violence in the Films of Sam Peckinpah," in *Screening Violence*, ed. Stephen Prince (New Brunswick: Rutgers University Press, 2000), 185.

4. Erkki Huhtamo and Jussi Parikka, "Introduction: An Archeology of Media Archeology," in *Media Archeology: Approaches, Applications, and Implications*, ed. Erkki Huhtamo and Jussi Parikka (Berkeley: University of California Press, 2011), 3.

5. See, among others, Margo Neale, ed., *Emily Kame Kngwarreye—Alhalkere Paintings from Utopia* (Brisbane: Queensland Art Gallery, 1998); Terry Smith, "Aboriginality and Post-Modernity: Parallel Lives," in *Transformations in Australian Art* (Sydney: Craftsman House, 2002), 2:144–167; and Annette Van den Bosch, *The Australian Art World: Aesthetics in a Global Market* (Sydney: Allen and Unwin, 2005).

6. Terry Smith, *What Is Contemporary Art?* (Chicago: University of Chicago Press, 2009), 139.

7. W. E. H. Stanner, *On Aboriginal Religion* (Sydney: University of Sydney, 1964), 26.

8. For an early exploration of this topic on Herzog's work, see Eric Rentschler, "The Politics of Vision: Herzog's Heart of Glass," in *The Cinema of Werner Herzog: Between Mirage and History*, ed. Timothy Corrigan (London: Methuen), 159–181.

9. Brad Prager, *The Cinema of Werner Herzog: Aesthetic Ecstasy and Truth* (London: Wallflower, 2007).

10. For a good overview and preliminary summary of the various explorations and research activities, see Jean-Marie Chauvet, Elitette Brunel Deschamps, and Christian Hillaire, *Dawn of Art: The Chauvet Cave* (New York: Abrams, 1996); and Jean Clottes, *Chauvet Cave: The Art of the Earliest Times* (Salt Lake City: University of Utah Press, 2003).

11. For different overviews of what inspired early cave art and whether we should consider it as art in the first place, see, among many others, Max Raphael, *Prehistoric Cave Paintings*, trans. Norbert Guterman (New York: Pantheon, 1946); Ellen Dissanayake, *Homo Aestheticus: Where Art Comes From and Why* (Seattle: University of Washington Press, 1995); Jean Clottes, *Cave Art* (London: Phaidon, 2008); David Lewis-Williams, *The Mind in the Cave: Consciousness and the Origins of Art* (London: Thames and Hudson, 2002); and David S. Whitley, *Cave Paintings and the Human Spirit: The Origin of Creativity and Belief* (Amherst: Prometheus, 2009).

12. Jean-Louis Baudry, "Cinema: Effets ideologiques produits par l'appareil de base," *Cinethique* 7/8 (1970): 1–8.

13. Thomas Elsaesser and Malte Hagener, *Film Theory: An Introduction Through the Senses* (New York: Routledge, 2010), 68.

14. Robert Craan has suggested a similar juxtaposition. Though inspired by his argument, I, however, do not follow the Jungian trajectory of his examination. See Robert Craan, *Geheimnisvolle Kultur der Traumzeit: Die Welt der Aborigines* (Munich: Knaur, 2004), 63–65.

15. Peter Sutton, ed., *Dreamings: The Art of Aboriginal Australia* (New York: Braziller, 1988), 17.

16. Lewis-Williams, *The Mind in the Cave*, 214.

17. Laura U. Marks, *The Skin of Film: Intercultural Cinema, Embodiment, and the Senses* (Durham: Duke University Press, 2000), 125.

18. For more on the term *expanded cinema*, see A. L. Rees, Duncan White, Steven Ball, and David Curtis, *Expanded Cinema: Art, Performance, Film* (London: Tate, 2011).

19. No matter how well-meaning his intentions, the protagonist of Weir's *The Last Wave* fails in his quest because he gets stuck in between two different and ultimately incompatible notions of what to consider as image. Unlike traditional Aborigine art, which shuns the use of symmetrical pictorial frames and instead uses irregularly shaped materials such as bark and rock for the act of image production, Burton's approach to Aborigine dreaming remains caught within the limits of a conventional aesthetic of pictorial framing and narrative containment. Weir's repeated use of diegetic framing devices signifies the extent to which Burton's desire to go native hangs onto some of the most cherished aspects of Western identity and spectatorship, namely their stress on willfulness, control, distance, and sovereignty. Burton's paradox is to intend the unintentional, to frame the unframed, to conceptualize the inexpressible, to merely imagine what it might mean to get in touch with different sensory realities. Though eager to reach out to Aborigine dreaming, Burton's rationalism keeps him from relinquishing esteemed notions of the subject as being in full control over perceptual processes and the world around him.

20. Bruce Chatwin, *The Songlines* (New York: Penguin, 1987), 14.

21. In Moira Gatens and Genevieve Lloyd's words, "In understanding how our past continues in our present we understand also the demands of responsibility for

the past we carry with us, the past in which our identities are formed. We are responsible for the past not because of what we as individuals have done, but because of what we are." Moira Gatens and Genevieve Lloyd, *Collective Imaginings: Spinoza, Past and Present* (London: Routledge, 1999), 81; also quoted in Doreen Massey, *For Space* (London: Sage, 2005), 191–195.

22. Sue Mathews, *35 mm Dreams: Conversations with Five Directors About the Australian Film Revival* (Melbourne: Penguin, 1984), 95.

23. For more on this, see Lutz Koepnick, "Tonspur und Gewalt: Zur Akustik des zeitgenössischen Action-kinos," in *Hörstürze: Akustik und Gewalt im 20. Jahrhundert,* ed. Nicola Gess, Florian Schreiner, and Manuela Schulz (Würzburg: Könighausen und Neumann, 2005), 131–146.

24. Henri Bergson, *Matter and Memory,* trans. by N. M. Paul and W. S. Palmer (New York: Zone, 1991), 17.

25. Lewis-Williams, *The Mind in the Cave,* 225.

26. Ibid., 226.

27. Lutz Koepnick, "Archetypes of Emotion: Werner Herzog and Opera," in *A Companion to Werner Herzog,* ed. Brad Prager (Chichester: Wiley-Blackwell, 2012), 149–167.

28. Michel Chion, *Audio-Vision: Sound on Screen,* trans. Claudia Gorbman (New York: Columbia University Press, 1994), 66–94.

29. For more on this, see, among many others, Robert Fink, *Repeating Ourselves: American Minimal Music as Cultural Practice* (Berkeley: University of California Press, 2005).

30. Miriam Bratu Hansen, *Cinema and Experience: Siegfried Kracauer, Walter Benjamin, and Theodor W. Adorno* (Berkeley: University of California Press, 2011), 19.

31. Mary Ann Doane, *The Emergence of Cinematic Time: Modernity, Contingency, the Archive* (Cambridge: Harvard University Press, 2002).

32. W. J. T. Mitchell, *What Do Pictures Want? The Lives and Loves of Images* (Chicago: University of Chicago Press, 2005), 98.

33. Mitchell's phrase, ibid., 27.

5. FREE FALL

Special thanks go to Nele Willaert for many invaluable exchanges about Tykwer's films. Her thesis, "Bewegungen und Begegnungen: Die Ästhetik des Raumes in den Filmen Tom Tykwers" (M.A. thesis, Department of Germanic Languages and Literatures, Washington University in St. Louis, 2005), was of crucial importance in guiding my own approach to Tykwer's work. Thanks also to Eric Rentschler and Carsten Strathausen for their helpful comments on an earlier version of this chapter.

1. For more on shifting ASL rates, see the data produced by cinemetrics experts at www.cinemetrics.lv/. See also David Bordwell, *The Way Hollywood Tells It* (Berkeley: University of California Press, 2006), 121–138.

2. David Bordwell, "Aesthetics in Action: Kungfu, Gunplay, and Cinematic Expressivity," in *At Full Speed: Hong Kong Cinema in a Borderless World*, ed. Esther C. M. Yau (Minneapolis: University of Minnesota Press, 2001), 76.

3. Laura Mulvey, *Death 24x a Second: Stillness and the Moving Image* (London: Reaktion, 2006), 181.

4. Gabriele Pedulla, *In Broad Daylight: Movies and Spectators After Cinema* (London: Verso, 2012).

5. D. N. Rodowick, *The Virtual Life of Film* (Cambridge: Harvard University Press, 2007).

6. Nora Alter, "The Mobile Anti-Aesthetic," unpublished lecture delivered at the annual convention of the Modern Language Association, Philadelphia, December 2009.

7. Marco Abel, *The Counter-Cinema of the Berlin School* (Rochester, NY: Camden House, 2013); *Berlin School Glossary: An ABC of the New Wave in German Cinema*, ed. Roger F. Cook, Lutz Koepnick, Kristin Kopp, and Brad Prager (Bristol: Intellect, 2013).

8. Jacques Rancière, "Aesthetic Separation, Aesthetic Community," in *The Emancipated Spectator* , trans. Gregory Elliot (London: Verso, 2009), 72.

9. Kathleen Stewart, *Ordinary Affects* (Durham: Duke University Press, 2007), 19.

10. See the discussion and critique of Virilio's and Jameson's work in chapter 1.

11. Galileo Galilei, *Dialogues Concerning Two New Sciences,* trans. Henry Crew and Alfonso de Salvio (New York: Dover, 1914), 179.

12. Norbert Elias, *Time: An Essay*, trans. Edmund Jephcott (Oxford: Blackwell, 1992), 107–115.

13. The historical character of Jean-Baptiste Grenouille in *Perfume* (2006), Tykwer's only film thus far not situated in the present aside from his contribution to the cross-historical *Cloud Atlas* (2012), is of course exempted from this argument.

14. William J. Mitchell, *Me ++: The Cyborg Self and the Networked City* (Cambridge: MIT Press, 2003), 158.

15. Fiona Robinson, *Globalizing Care: Ethics, Feminist Theory, and International Relations* (Boulder: Westview, 1999); Doreen Massey, *For Space* (London: Sage, 2005), 177–195.

16. Quoted in Sylviane Agacinski, *Time Passing: Modernity and Nostalgia*, trans. Jody Gladding (New York: Columbia University Press, 2003), 60.

17. Tom Gunning, "An Aesthetics of Astonishment: Early Film and the (In)Credulous Spectator," *Viewing Positions: Ways of Seeing Film*, ed. Linda Williams (New Brunswick: Rutgers University Press, 1995), 114–133.

18. Ilya Prigogine and Isabelle Stengers, *Order Out of Chaos: Man's New Dialogue with Nature* (New York: Bantam, 1984), 8.

19. For more on the renegotiation of art and the popular, the national, and the global in German filmmaking since the early 1990s, see Eric Rentschler, "From New German Cinema to the Post-Wall Cinema of Consensus," in *Cinema and Nation*, ed. Mette Hjort and Scott MacKenzie (Routledge: London, 2000), 260–277; Sabine

Hake, *German National Cinema* (London: Routledge, 2002); Lutz Koepnick, "Reframing the Past: Heritage Cinema and Holocaust in the 1990s." *New German Critique* 87 (Fall 2002): 47–82; Christine Haase, *When Heimat Meets Hollywood: German Filmmakers and America 1985–2005* (Rochester, NY: Camden House, 2007); Randall Halle, *German Film After Germany: Toward a Transnational Aesthetic* (Champaign: University of Illinois Press: 2008).

20. Michael Hardt and Antonio Negri, *Multitude: War and Democracy in the Age of Empire* (New York: Penguin, 2004), 100.

21. Rancière, "Aesthetic Separation, Aesthetic Community," 82.

6. VIDEO AND THE SLOW ART OF INTERLACING TIME

1. Yvonne Spielmann, *Video: The Reflexive Medium* (Cambridge: MIT Press, 2008).

2. Ernst Jünger, "Photography and the 'Second Consciousness': An Excerpt from 'On Pain,'" trans. Joel Agee, in *Photography in the Modern Era: European Documents and Critical Writings, 1913–1940*, ed. Christopher Phillips (New York: Metropolitan Museum of Art/Aperture, 1989), 207–210.

3. "Simulation means the whole of an action being orchestrated in the brain by internal models of physical reality that are not mathematical operators but real neurons whose properties of form, resistance, oscillation, and amplification are part of the physical world, in tune with the external world." Alain Berthoz, *The Brain's Sense of Movement*, trans. Giselle Weiss (Cambridge: Harvard University Press, 2000), 22.

4. Robert Buch, *The Pathos of the Real: On the Aesthetics of Violence in the Twentieth Century* (Baltimore: Johns Hopkins University Press, 2010), 22–23.

5. For more on the homeopathic in particular in the history of postwar German cinema, see Eric L. Santner, *Stranded Objects: Mourning, Memory, and Film in Postwar Germany* (Ithaca: Cornell University Press, 1990), 19–26; and Caryl Flinn, *The New German Cinema: Music, History, and the Matter of Style* (Berkeley: University of California Press, 2004), 1–25.

6. Maurizio Lazzarato, *Videophilosophie: Zeitwahrnehmung im Postfordismus* (Berlin: b_books, 2002).

7. See, for instance, Carl Honoré, *In Praise of Slowness: How a Worldwide Movement Is Challenging the Cult of Speed* (San Francisco: HarperCollins, 2004); Erik Pigani, *L'art zen du temps* (Paris: Presses du Châtelet, 2005); Manfred Folkers, *Achtsamkeit und Entschleunigung: Für einen heilsamen Umgang mit Mensch und Welt* (Bielefeld: Theseus, 2003).

8. For more on the role of beauty in sport, see Hans Ulrich Gumbrecht, *In Praise of Athletic Beauty* (Cambridge: Belknap, 2006).

9. For more on the film's tension between Zidane's absorption and his being in the limelight, see Michael Fried's insightful review, "Absorbed in the Action," *Artforum* 45 (September 2006): 332–335.

10. Thomas Hylland Eriksen, *Tyranny of the Moment: Fast and Slow Time in the Information Age* (London: Pluto, 2001); Paul Virilio, *Negative Horizon: An Essay in Dromoscopy*, trans. Michael Degener (New York: Continuum, 2006).

11. Michael Fried, "Art and Objecthood," *Artforum* 5 (June 1967): 12–23.

7. THE ART OF TAKING A STROLL

1. For an insightful analysis, see Anke Gleber, *The Art of Taking a Walk* (Princeton: Princeton University Press, 1998).

2. Jean-Jacques Rousseau, *The Confessions* (Harmondsworth: Penguin, 1953), 158; also quoted in Rebecca Solnit, *Wanderlust: A History of Walking* (New York: Penguin, 2000), 19, to which this chapter owes much of its inspiration.

3. Rousseau, *The Confessions*, 158.

4. Solnit, *Wanderlust*, 26.

5. Elizabeth Grosz, *Architecture from the Outside: Essays on Virtual and Real Space* (Cambridge: MIT Press, 2001), 116.

6. Mirjam Schaub, *Janet Cardiff: The Walk Book* (Vienna: Thyssen-Bornemisza Art Contemporary, 2005), 176.

7. For more on this notion of affect, see in particular Brian Massumi, *Parables of the Virtual: Movement, Affect, Sensation* (Durham: Duke University Press, 2002).

8. For an excellent overview, see *Gehen, bleiben: Bewegung, Körper, Ort in der Kunst der Gegenwart/Going, Staying: Movement, Body, Space in Contemporary Art*, ed. Volker Adolphs and Philip Norten (Ostfildern: Hatje Cantz/New York: Distributed Art, 2007).

9. See, for instance, Lev Manovich, *The Language of New Media* (Cambridge: MIT Press, 2001).

10. Brandon LaBelle, *Background Noise: Perspectives on Sound Art* (New York: Continuum, 2007), 123.

11. Ibid., xi.

12. Don Ihde, *Listening and Voice: Phenomenologies of Sound*, 2nd ed. (Albany: State University of New York Press, 2007), 136.

13. Carolyn Christov-Bakargiev, *Janet Cardiff: A Survey of Works Including Collaborations with George Bures Miller* (Long Island City, NY: P.S. 1 Contemporary Art Center, 2001), 27.

14. Laura U. Marks, *The Skin of Film: Intercultural Cinema, Embodiment, and the Senses* (Durham: Duke University Press, 2000), 162.

15. Roger Caillois, "Mimicry and Legendary Psychasthenia," *October* 31 (1984): 17–32. See also the discussion in Grosz, *Architectures from the Outside* 36–40; and in Mark B. Hansen, *Bodies in Code: Interfaces with Digital Media* (New York: Routledge, 2006), 126–137.

16. For more on this notion of mimesis, see Walter Benjamin, "On the Mimetic Faculty," in *Reflections: Essays, Aphorisms, Autobiographical Writings*, trans. Edmund

Jephcott (New York: Harcourt Brace Jovanovich, 1978), 333–336; Michael Taussig, *Mimesis and Alterity: A Particular History of the Senses* (New York: Routledge, 1993); and the discussion in Marks, *The Skin of Film*, 138–145.

17. Ihde, *Listening and the Voice*, 102

18. Christov-Bakargiev, *Janet Cardiff*, 28.

19. Quoted in LaBelle, *Background Noise*, 16.

20. Ibid., 201–217.

21. Michel de Certeau, *The Practice of Everyday Life* (Berkeley: University of California Press, 1988), 108.

22. Maurice Merleau-Ponty, *Phenomenology of Perception*, trans. Colin Smith (London: Routledge, 1992), 316, also quoted by Marks, *The Skin of the Film*, 148.

23. Quoted in Chris Jenks, "Watching Your Step: The History and Practice of the Flâneur," in *Urban Culture: Critical Concepts in Literary and Cultural Studies*, ed. Chris Jenks (London: Routledge, 2004), 37.

8. THOSE WHO READ

1. *Goethe's Opinions on the World, Mankind, Literature, Science, and Art*, trans. Otto Wenckstern (London: Parker and Son, 1853), 42.

2. Blaise Cendrars, "Profound Today," reprinted in *Manifesto: A Century of Isms*, ed. Mary Ann Caws (Lincoln: University of Nebraska Press, 2000), 133.

3. For an extended version and illustration of this claim that movement and stasis are reciprocal and compensatory in modern art and culture, see the various contributions in Markus Brüderlin, ed., *Die Kunst der Entschleunigung: Bewegung und Ruhe in der Kunst von Caspar David Friedrich bis Ai Weiwei* (Ostfildern: Hatje Cantz, 2011).

4. "Du mußt dein Leben ändern." Rainer Maria Rilke, "Archaischer Torso Apollos," in *Ausgewählte Gedichte* (Frankfurt: Insel, 1932), 47.

5. Siegfried Kracauer, "Those Who Wait," in *The Mass Ornament: Weimar Essays*, ed., trans., and with an introduction by Thomas Y. Levin (Cambridge: Harvard University Press, 1995), 138.

6. www.slowfood.com/about_us/eng/manifesto.lasso.

7. http://en.slow-media.net/manifesto.

8. Kracauer, "Those Who Wait," 139.

9. Alexander Alberro, "Life Models," *Frieze* 148 (June-August, 2012), www.frieze.com/issue/article/life-models/.

10. Don DeLillo, *Point Omega* (New York: Scribner, 2010), 5–6.

11. Boris Groys, "The Topology of Contemporary Art," in *Antinomies of Art and Culture: Modernity, Postmodernity, Contemporaneity*, ed. Terry Smith, Okwui Enwezor, and Nancy Condee (Durham: Duke University Press, 2008), 72.

12. Ibid., 74.

13. Quoted in Peter Wollen, "Speed and Cinema," in *Paris Hollywood: Writings on Film* (London: Verso, 2002), 267.

14. Miriam Hansen, *Babel and Babylon: Spectatorship in the American Silent Film* (Cambridge: Harvard University Press, 1991), 12–13; see also Miriam Bratu Hansen, *Cinema and Experience: Siegfried Kracauer, Walter Benjamin, and Theodor W. Adorno* (Berkeley: University of California Press, 2010). For a commanding overview of the philosophical history of the concept, see Martin Jay, *Songs of Experience: Modern American and European Variations on a Universal Theme* (Berkeley: University of California Press, 2005).

15. Quoted in Katrina M. Brown, *Douglas Gordon* (London: Tate, 2004), 26.

16. www.aes-group.org/last_riot.asp.

17. Donald Kuspit, "Bill Viola: The Passing," *Artforum* 32, no. 1 (September 1993): 144.

18. Terry Smith, *What Is Contemporary Art?* (Chicago: University of Chicago Press, 2009), 200.

19. Friedrich Nietzsche, *The Twilight of the Idols and The Antichrist*, trans. Thomas Common (Mineola, NY: Dover, 2004), 38.

20. Byung-Chul Han, *Müdigkeitsgesellschaft* (Berlin: Matthes und Seitz, 2011), 43.

21. John Banville, "Against the North Wall," *New York Review of Books*, April 8, 2010, www.nybooks.com/articles/archives/2010/apr/08/against-the-north-wall/.

22. Geoff Dyer, "A Wrinkle in Time," *New York Times*, February 7, 2010.

23. Jane Smiley, *13 Ways of Looking at the Novel* (New York: Knopf, 2005), 176.

EPILOGUE: SLOWNESS AND THE FUTURE OF THE HUMANITIES

1. W. J. T. Mitchell, *What Do Pictures Want? The Lives and Loves of Images* (Chicago: University of Chicago Press, 2005), 5–6.

2. Giorgio Agamben, "What Is the Contemporary?" in *What Is an Apparatus? and Other Essays*, trans. David Kishik and Stefan Pedatella (Stanford: Stanford University Press, 2009), 39–54.

3. Saint Augustine, *Confessions*, trans. R. S. Pine-Coffin (London: Penguin, 1961), 264.

4. For the perhaps most insightful discussion of Saint Augustine's notion of *distentio animi*, see Paul Ricoeur, *Time and Narrative*, trans. Kathleen McLaughlin and David Pellauer (Chicago: University of Chicago Press, 1984), 1:5–30.

INDEX